MACHINES for LIVING

MACHINES
for LIVING

modernism and domestic life

VICTORIA ROSNER

OXFORD
UNIVERSITY PRESS

OXFORD

UNIVERSITY PRESS

Great Clarendon Street, Oxford, OX2 6DP,
United Kingdom

Oxford University Press is a department of the University of Oxford.
It furthers the University's objective of excellence in research, scholarship,
and education by publishing worldwide. Oxford is a registered trade mark of
Oxford University Press in the UK and in certain other countries

First Edition published in 2020

Impression: 1

Published in the United States of America by Oxford University Press
198 Madison Avenue, New York, NY 10016, United States of America

British Library Cataloguing in Publication Data
Data available

Library of Congress Control Number: 2019945426

ISBN 978–0–19–884519–5

Printed and bound by
CPI Group (UK) Ltd, Croydon, CR0 4YY

to Mary McLeod

ACKNOWLEDGMENTS

The project that became *Machines for Living* was sparked decades ago when, as a graduate student doing research in London archives, I was directed to the Women's Design Service (WDS), a now-defunct organization dedicated to gender and the built environment. On arrival, I was invited to peruse their modest library. As I sat on the floor and read through their holdings, I began to make connections across literature, architecture, design, science, and technology, and to understand that the revolution that was modernism was profoundly connected to domestic life.

This book has been a long time in the making, and as it draws to a close I am very much aware of the many people who contributed to it their wisdom or their encouragement, and often both. Kevin Dettmar and Mark Wollaeger invited me to bring a proposal to Oxford University Press, and offered key guidance at an early stage. The anonymous readers helped set a direction for the book and as my research continued over the years I found myself returning to their reports at regular intervals. At Oxford University Press I have had the generous support of Jacqueline Norton and Aimee Wright, and the patient guidance of Brian North and Sinduja Abirami. Kevin Sani's skill made possible the appearance of one of Virginia Woolf's renovation plans, and Maur Philippe Dessauvage brought artistry and judgment to the reproduction of images.

This book has also been enriched by the numerous archives that opened their doors to me, most of all The Berg Collection of the New York Public Library, The British Library, Columbia University Rare Book and Manuscript Library, The Keep/University of Sussex Special Collections, the Museum of Modern Art, and the Victoria and Albert Museum. At the V&A I would like to thank in particular Sonnet

Stanfill and Alice Bailey for helping me to obtain access to the papers of Margaret Jourdain.

My thinking about modernism has been shaped by a generation of scholars and writers who continue to inspire me with the range and thoughtfulness of their work, including Jessica Berman, Jessica Burstein, Mikhal Dekel, Marian Eide, Jed Esty, Christine Froula, Diana Fuss, Vesna Goldsworthy, Eric Hayot, Maggie Humm, Mark Hussey, Darryl Jones, Stephen Kern, Douglas Mao, Laura Marcus, Celia Marshik, Deborah Nelson, Liesl Olson, Christopher Reed, Paul Saint Amour, Jeffrey Schnapp, Vince Sherry, Stefanie Sobelle, Kamy Wicoff, and Rebecca Walkowitz.

My colleagues at the Columbia University School of General Studies, in the Department of English, and across the university have made this book possible in a hundred ways, most of all by providing a fertile community in which to nurture and develop the ideas found here. In particular I'd like to thank Rachel Adams, the late Peter Awn, Sarah Cole, Julie Crawford, Jennifer Crewe, Nick Dames, Jeremy Dauber, Eileen Gillooly, Matt Hart, Marianne Hirsch, Lisa Hollibaugh, Jean Howard, Bob Hymes, Laura Kaufman, Hazel May, Edward Mendelson, Curtis Rodgers, and Lisa Rosen-Metsch.

I am especially grateful to Rachel Adams, Sarah Cole, Marianne Hirsch, and Jay Prosser, who read chapters in various stages of development and offered crucial guidance on shaping the project and making the most of it. Their insights showed me the way forward when I struggled to find it on my own. Special thanks to Jean Howard for fixing me with her gaze and asking me when I would be done at tactful intervals over the past several years.

My work on this book began a few years after I moved from Texas back to New York, a difficult passage through which my extended family and friends kept me going. I am lucky to have a family that I don't just love but love to be with, and I thank them for believing in me. I am so grateful to my father, William Rosner, who line-edited every sentence; to my husband Eric Goldsmith, for helping me in recent years to make time for this; and to my son Judah, for his pride in his mom's work.

Since graduate school, Laura Frost has been my first reader; with her wide knowledge, tuned ear, and critical sophistication, she has improved this book tremendously and saved me from myself more times than I can count. Nancy K. Miller, my once-upon-a-time dissertation director and now my brilliant friend, has seen me through every trial with verve, acuity of judgment, and no small amount of grit.

I first met Mary McLeod when she graciously agreed to serve as outside reader on my PhD defense. We have since become interschool colleagues, and sometimes co-instructors of courses on modernism, gender, and architecture. Most recently we have been co-editors on the web-based project Pioneering Women of American Architecture, sponsored by the Beverly Willis Architecture Foundation. From the very first days I have been inspired by her intelligence, energy, seriousness, and capacity for kindness. Writing and teaching with her continues to be a thrilling education. This book has flourished under her generous guidance and owes much to her extraordinary knowledge of the history of modernist architecture and design. It is dedicated to her, with love, admiration, and gratitude.

<div align="center">* * *</div>

An early version of Chapter 6 appeared in *The Edinburgh Companion to Virginia Woolf and the Arts* (2010, Edinburgh University Press), edited by Maggie Humm, and I am grateful for permission to reprint.

"The Lily" and "Spring and All" by William Carlos Williams are from *The Collected Poems: Volume I, 1909–1939*, copyright William Eric Williams and Paul H. Williams (1982), reprinted by permission of New Directions Publishing Corp.

The poetry of T. S. Eliot is reprinted by permission of Faber and Faber Ltd.

CONTENTS

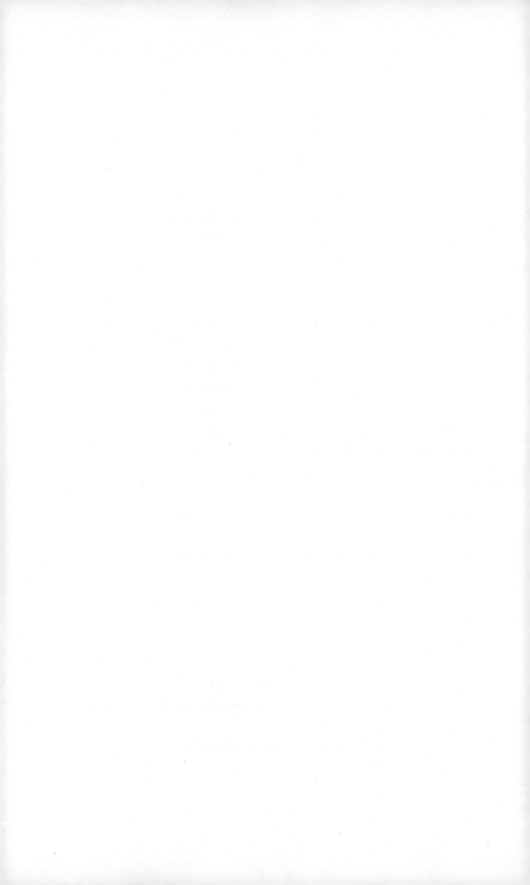

LIST OF FIGURES

1

INTRODUCTION

Modernism and domestic life in the machine age

Modernist literature and the modernization of the early twentieth-century home exist in an uneasy tension, illustrated by the young woman typist who appears at the center of T. S. Eliot's great poem of modernity, "The Waste Land" (1922). She is first given to us as "the typist home at teatime," and in a crisp sequence we learn that she is a modern woman who lives alone in her flat, eats out of tins, and washes her own dishes. She receives a guest, "the young man carbuncular," who sexually assaults her and departs with a "final patronizing kiss," leaving the typist alone to recover, which she does in silence, looking at herself in the mirror. In our last glimpse of her, she "smooths her hair with automatic hand, / And puts a record on the gramophone."[1] The new accouterments of modern life—tins, gas stoves, gramophones—surround the young woman until she seems an automaton, her "automatic hand" continuous with the arm of the record player. Yet in her reach for the transcendence of music enabled by the gramophone, the young woman exceeds the terms of her environment and confirms her own humanity, linking technology and aesthetics, mechanization and domestic life.

As Le Corbusier put it in his famous 1923 phrase, from which this book takes its title: "Une maison est une machine-à-habiter," or as translated by English artist and architect Frederick Etchells in 1927, "a house is a machine for living in."[2] The phrase is a provocation: What could be more antithetical to the cozy, individualistic spaces of the house/home ("maison" is both) than a machine? What could the spontaneous, organic process of living

have to do with mechanization? The young woman typist provides a mixed answer: the conversion of her home into a machine for living, accessorized with modern conveniences, seems to drain her life of some of its humanity and routinize her sexual violation, even as it also grants her access to the grace of music. The machine, for Le Corbusier and others in the early twentieth century, was a potent symbol for many of the values associated with modernity. These values transformed the workplace, and the shapers of the modern home began to look to them for inspiration as well, setting in motion a fundamental reconception of the home and domestic life.

The early twentieth-century home was a site of experimentation and transformation, its population diminished by a decline in the birth rate and a shrinking pool of household labor; its plan altered by the addition of indoor plumbing and the migration of the kitchen from the margins to the center of family life; and its appearance revitalized by electrification and a new understanding of hygiene that rejected dark Victorian interiors and ornamentation. The technologies that enabled modernization originated in the late nineteenth century, but not until the 'twenties and 'thirties were they widely available. In both England and the U.S., more household appliances moved from innovation to necessity during this period than in all the previous hundred years.[3] A new allure surrounded housework, as the invention of the "Rational Household"—a counterpart to the rising supremacy of efficiency in the workplace—conveyed a novel prestige on housecleaning. Changes in the routines of domestic life were among the most striking social phenomena of the period between the wars. The home came into focus as a problem to be solved: re-imagined, streamlined, electrified and generally cleaned up.

These were crucial years for the modernization of the home, but they were also critical years in the development of modernism. Modernist writers understood themselves to be living in an epochal moment when the design and meaning of home life were reconceived. Their participation in this endeavor is at the heart of the cultural project of modernism, as modernism's famous program of rupture and renewal intertwines with the drive for renewal in the home. These concurrent revolutions share many

features, including an emphasis on the quotidian, a profound commitment to rethinking human relations, and an ambition to expand and transform sensory experience. From the pride of William Carlos Williams in new household machinery ("This is the kitchen– / We have a new / hotwater heater and a new / gas-stove to please you"[4]), to the disapproval of Eliot ("mechanization comes to kill local life"[5]), to the vitriol of D. H. Lawrence ("Tin people!…with india rubber tubing for guts and tin legs and tin faces"[6]), modernist writers were fascinated by the changes in the home and their implications for culture.

The modernization of the home underwrote many modernist experiments with literary form. Modernist formal innovations participate in the tensions and contradictions posed by the modernization of the home: the allure of new technologies in conjunction with the tedious and repetitive nature of housework; the spread of efficiency science and mass production countered by attendant anxieties about the devaluation of creativity; the scientific norming of child development set against the value of individuality; the sensory and moral appeal of the new hygiene undermined by fears of the inadequacy of human senses. Modernist writers were drawn to the theoretical and conceptual framing associated with modernization and embodied these new ideas in literary form. Such adaptations accompanied writers' strong stated objections to aspects of modernization. Eliot and Lawrence both fulminated against the machine age, but each also found valuable models in the new rhythms of production and the standardization of household tasks. Aldous Huxley worried that mechanization produced efficiency by sacrificing creativity, but he was fascinated by new, rationalized approaches to human development and remade the arc of the *Bildungsroman* in response. As Virginia Woolf sought new narrative shapes for her novels she looked to modern architecture for inspiration, using her own house as a design laboratory.

These are not contradictions. They are aspects of what I consider a generative ambivalence on the part of modernist writers, an ambivalence that yields a layered engagement with modernity's changes and challenges. That is, even as modernist writers criticized the expanding reach of

modernization into the home, they drew on its conceptual vocabulary to develop both the thematic and formal commitments of literary modernism. Williams looked to emerging technologies of housecleaning to conceive of the poet's vision as a hygienic tool. Modernism's nonlinear approach to the *Bildungsroman* in novels by Huxley and others responds to the "rational" narratives of child development advanced by newly professionalized childhood experts. Ford Madox Ford and Ivy Compton-Burnett looked to the new doctrine of "minimum dwelling" and found inventive models for what I will call "minimum writing."

Machines for Living shows how the modernization of the home led to profound changes in domestic life and relied on a set of emergent concepts, including standardization, scientific method, functionalism, efficiency science, and others, that form the basis of literary modernism and stand at the confluence of modernism and modernity. "Modernism" and "modernity"— these two terms are generally understood to be somewhat at odds. The title of the leading journal in modernist studies, *Modernism/modernity*, separates them with a dividing bar, accentuating the space between them even as it brings them into relation. In its 1994 debut issue, founding editors Lawrence Rainey and Robert von Halberg wrote that their "difficult objective is to bring into dialogue writers in the social sciences engaged by issues of modernity and modernization and scholars of the literary and fine arts committed to the history of the fine arts."[7] Twenty-five years later, my objective in this book is to discard the dividing bar and examine how sea changes in the household wrought by what was often called "the machine age" participated in the formation of both the thematic and formal agendas of modernist literature.[8]

Critics of modernism have largely bypassed the home, perhaps because modernist writers themselves often insulted and dismissed domesticity and its ideologies. But this book suggests the need for a re-evaluation of many of modernism's foundational aesthetic commitments, including its discourse of originality, its didacticism, its commitment to verbal concision, and its understanding of emotional attachment, all of which, I argue, are forged in the specific historical context of the modernization of the

4

home. Returning literary modernism to this context leads to a profound reassessment of some of the stories modernism tells about itself, its originality, its difficulty, its autonomy, its interiority—and its putative rejection of all things domestic. I do not dismiss these stories, but I try to uncover the ideas, connections, and circumstances that underwrite them, and in this way hold up to scrutiny some of the foundational claims that define modernist studies.

* * *

The story of the creation of a "Rational Household" is the backdrop for this book, dramatizing the significant and rapid changes that modernization wrought in the home. In the 1920s and 1930s, new theories of scientific management that transformed the nature of industry moved into the home. The rational household was born, with a commitment to reform along ostensibly scientific lines; it stood for planning and efficiency, for modernization and mechanization, and for the professionalization of housework as performed by the woman of the house. Machine-inspired design, the principles of mass production, and the industrial workplace became, in many ways, models for domestic life. Industrial experts like Frederick Taylor and Frank Gilbreth showed that efficient arrangement of the work process and the creation of specific tools to aid workers in their tasks enhanced factory production, and the same methods could be applied to the home.[9] The rise of the rational household also dramatizes the gendered stakes of modernization, with women homemakers eager to redefine their roles and harness the prestige and power of modernization to elevate the status of domestic labor.

The rational household produced and promoted the notion that both the housewife and the working woman could be relieved of drudgery and turned into modern paragons of efficiency and professionalism using techniques like those that had transformed the workplace: efficiency studies, motion science, assembly line production, and mechanization of work processes. The modern home, experts argued, should draw inspiration from the factory. Manufacturers, home economics experts, women's

magazine editors, and the authors of innumerable books and pamphlets joined in urging women to rationalize their households and adapt the principles of the efficiency movement.

The rationalization of the household rested on the notion that the principles that governed the workplace could reform domestic labor.[10] This comparison challenged the popular idea that the home should be a spiritual haven with its own resident Angel, a place kept strictly apart from the putative degradation of the male world of commerce and industry. The cozy, inefficient, and cluttered world of the nineteenth-century middle-class kitchen became a room filled with hard surfaces and gleaming machines. The home was rethought through the lens of science and posited as a place where women could pursue coeval status with men, working side by side to bring domesticity into the modern era.

The postwar economy drove the rise of the rational household. Factories that produced munitions during World War I needed to find other objects to manufacture, and some shifted to the production of the new home appliances. In addition, during the war many women previously employed as domestic servants found more regular and satisfying employment in factories, filling jobs once held by men. After the war, these women were reluctant to return to domestic service if they could find other work and, in any case, fewer households could afford outside help. At the turn of the century in England, one-third of working women were in domestic service. By the interwar period, that number declined to one-quarter.[11] The shortage of domestic labor was acute and many middle-class women began to clean their own homes. The rationalization of the household helped these women to draw a dividing line between the work they did and what their servants had done previously. Rationalization conveyed prestige on housecleaning and granted those who did the work a professionalized status, even if they were unpaid. The professionalization of the role of the domestic worker meant that housework and child care could no longer be seen as "natural" endowments of true womanhood, something that women instinctively knew how to do. Rational housework had to be learned.

In the rational household, housewives became domestic engineers who followed complex schedules, used scientific methods to increase their efficiency, and implemented the latest technologies for cooking and cleaning. While these ideas were class-bound and not universally embraced, they did gain purchase and marked a break from the kitchens of the previous generation, which looked more like other rooms in the house. The modern kitchen, writes Juliet Kinchin and Aidan O'Connor, became "a theater of social, cultural, and political debate."[12] Household manuals from this era emphasize the need for operational principles in the home. In 1936, Thelma H. Benjamin advised housewives that

> The application of method is perhaps the most important factor towards the smooth running of a household. Muddle must at all costs be avoided. You can contrive so that there is no overlapping, that one task is finished and out of the way before another is commenced, that unnecessary steps are saved, and energy conserved and made easy to direct into the way it should go.[13]

In addition to the rationalization of the work process, housewives were aided by new machinery designed to reduce labor: washing machines, dishwashers, and small electric tools. The new household machines changed the very meaning of housework by standardizing and regulating human motions.[14] In many cases, the machines actually did save labor as they claimed. This was most true for laundry, which previously occupied one full day a week, but which the new machines reduced to a few hours of labor.

Christine Frederick, one of the best-known writers about domestic engineering in the early twentieth century, popular in both the U.S. and Europe, urged women to "route" their work, that is, to analyze the way they moved about in their kitchens in order to reduce waste motions. Frederick also stressed the need for homemakers to have the latest and most advanced in electrical gadgetry to further the cause of efficient housekeeping. As she argued,

> The chief difference in work as done under factory or shop conditions as compared with work done in the home, is that industry has invented and

utilized machinery and modern equipment whereas the home still clings to the traditional, old-fashioned, and often entirely unsuitable devices of other days. The washboard instead of the power washer, the corn broom instead of the vacuum cleaner, the heavy iron pot instead of the light, sanitary utensils—are only some of the examples of and reasons why housekeeping may still be drudgery![15]

Frederick wrote these words in a pamphlet called "Come into my Kitchen" (1922), published by the Vollrath Company, manufacturers of home appliances. Companies like Vollrath paid Frederick to promote the use of their wares, an occupation aligned with her mission to modernize housework. Female consumerism went hand in hand with the modernization of the home in the early twentieth century, and many of the advertisements for appliances show men treating appliances almost like tokens of affection, offered to buy their beloved's favor.[16]

In urging women to persuade their husbands to buy machines to alleviate the burdens of housework, Frederick argued that women deserved to have the same aids and conveniences at home that men had at work. She, like most domestic reformers of her time, did not make the more radical argument that women should be able to join the workforce and men do housework; Frederick's ideas pushed for women's equivalence, not equality. In her 1913 book, *The New Housekeeping*, Frederick praised her husband for "stimulat[ing] me in every point to regard homemaking as a profession as equally worthy as his own."[17] Some promoted mechanization of the home as a way to increase women's authority via the acquisition of a professional identity and the mastery of a body of professional labor, but critics have questioned the presumption that "the new housekeeping" actually empowered women to attain greater leisure or expanded participation in public life. Still, as Mary McLeod has argued, the attention directed at the remaking of the home made the domestic sphere the object of serious and professional inquiry.[18] And there is little doubt that for women who were also working outside the home, the rationalization of the household decreased the burden of housework. From the perspective of this book, it is important to note that the terms

of the debate over the rational household—women's changing roles, the impact of mechanization on modern life, the new equivalence between the public and private spheres—were all central questions for modernism.

The tenets of the rational household also extended to child-rearing. Children were the product of the home, and their development could be improved with insights gained from mass production. As Daniel Beekman writes in *The Mechanical Child*, "All that seemed to be required of the family was that the parents submit to the same kind of systemization and discipline in the handling of their children as was routinely demanded of factory workers on a production line."[19] The analysis of tasks through motion study and their division along an assembly line might not seem to be processes readily applicable to child-rearing. However, childhood experts urged mothers to regiment the nursery and use behaviorist techniques to instill appropriate habits in the young. Developmental psychology established a periodization of childhood: a map, punctuated by milestones, that children were expected to traverse to reach maturity successfully. Though Freudian thought and theories of sexual deviance have been more influential in literary studies to date, there were many other, and often better-known, approaches to psychology on the rise in the 1920s and 1930s, and behaviorism was among the more prevalent.[20]

The rise of the rational household and the broader transformation of the home wrought by mechanization is a signal event in the history of modernity. It helped to redefine the meaning of personal life and the private sphere, a process that was of great interest and concern to many modernist writers. The reconceptualization of housework as a professional activity altered the perception of the middle-class housewife's labor and created a new continuity between the worlds of industry and family. The foundational insight that women's professionalization and modernity were intertwined was basic to modernism, articulated most notably by Virginia Woolf in *A Room of One's Own* (1929), where she argued that the opening of the professions to women was one of the great events in human history.

Most modernist writers were far less supportive than Woolf of the changes that modernity brought to the home, and they were particularly

suspicious of the seeming elimination of the private sphere. T. S. Eliot voiced concerns that the scope of private life was gradually losing its distinct character and worried in a 1939 essay that, "imperceptibly this domain of 'private life' becomes smaller and smaller, and may eventually disappear altogether."[21] Two years earlier he had expressed a similar concern that social pressures would "put an end to man's private life altogether"[22] and that the public domain would overtake the whole of human existence. Eliot's concerns about the diminution of private life were rooted in his feeling that, in contrast to those who took a more positive outlook, the world of industry and mechanization was invading the home. In 1937, he wrote that, "a large part of our failure has been the failure to control, for the purposes of living, the mechanical world (mechanical in the largest sense, including our systems of production, distribution and finance) which has sprung up everywhere almost of itself."[23] He chastised the migration of modernization and its industrial practices and attitudes into the home as a symbol of humanity's misguided attachment to materiality in lieu of spirituality, its abandonment of the sanctity of private life, and its preference for the man-made over the natural.

For members of the working class, the home had long been visibly a place of work. But middle- and upper-class families in the nineteenth century habitually went to great lengths to hide the labor of maintaining their homes. Kitchens and servants' quarters were so separate from the family rooms as to form, as nearly as possible, a separate residence. Servants stopped working and left the room if a family member entered. The kitchen was located as far as possible from the dining room, in part to reduce food smells but also to divorce the work of food preparation from its consumption. As more middle-class women took up housekeeping, the middle-class home shifted to a different spatial organization, one that increased the visibility of housework. The kitchen migrated from the periphery to the center of the home, where it often remains today.

The rational household thus marks a significant break from nineteenth-century bourgeois domesticity, which idealized the home as a retreat from commerce and industry and offered a space for the flowering of a private

self. Walter Benjamin famously described the character of this space in "Paris, Capital of the 19th Century": "The private individual, who in the office has to deal with reality, needs the domestic interior to sustain him in his illusions."[24] The establishment of a robust public arena for civil engagement finds its opposite in a more sequestered private domain and the image of the home as a spiritual retreat from the impurities and depersonalizations of the commercial world became a sustaining fantasy.[25] This fantasy flowed from, above all, the distinction between the feminine character of the home rather than from the masculine public sphere, as famously celebrated by John Ruskin in *Sesame and Lilies* (1865). In *The Arcades Project*, Benjamin depicts the nineteenth-century domestic interior as isolating its occupant:

> We must understand dwelling in its most extreme form as a condition of nineteenth-century existence. The original form of all dwelling is existence not in the house but in the shell. The shell bears the impression of its occupant. In the most extreme instance, the dwelling becomes a shell.[26]

Benjamin's image invokes the sense of a womb, a nurturing space that protects the dweller from the world outside. The hardness of the shell, together with its singularity, suggests the way in which the nineteenth-century interior was intended not only to sequester its inhabitants but also, through its furnishings, to reflect the nuances of the individual personality. Quirks, habits, and interests that had no place in the collective world of work could find expression in the home. Oscar Wilde's Dorian Gray, for instance, fills his home with objects that, like their owner, are both poisonous and perfect: jewels, perfumes, religious vestments; the prototype of the collector is perfectly attuned to late nineteenth-century domesticity.[27] Charles Dickens's Miss Havisham creates a home that is closed off even from the passage of time, a home that is a living shrine to her obsession with her aborted wedding.[28]

Early twentieth-century design broke with this approach. In the final scene of *The Picture of Dorian Gray*, Dorian's most private possession, his closely hidden self-portrait, is exposed to the eyes of strangers along with

Dorian's corpse, an invasion that portends the new direction in domestic life. Benjamin writes, "The twentieth century, with its porosity and transparency, its tendency toward the well-lit and airy, has put an end to dwelling in the old sense."[29] The border between the public space of work and the private space of leisure began to dissolve; Benjamin's "well-lit and airy" home indicates a new style and points to changes in artificial lighting and interior ventilation. Woolf, in similar terms, describes her move from the Victorian streets of Hyde Park Gate to the modern world of Bloomsbury. In her old Victorian home, as she wrote, "The walls and the rooms had in sober truth been built to our shape."[30] In the Victorian home, the inhabitant isolates himself; in the modern home, as in Benjamin, influences from the outside world come pouring in. After her move, "The light and the air after the rich red gloom of Hyde Park Gate were a revelation," Woolf tells us.[31] When she had the chance to make her own home in Bloomsbury, Woolf was open to the idea of experimentation and modernization.

As I have already suggested, the goal of opening the home to the influences of industry and forging an analogy between them did not find universal favor, particularly in England. Even the women who billed themselves as domestic efficiency experts saw the limitations of their agenda. Coventry Patmore's grandson, the author Derek Patmore, wrote a 1936 book on the decoration of his own home in which he recorded a conversation with just such an expert, Mrs. Darcy Braddell (Dorothy Adelaide Busse). Braddell was an award-winning designer and home planner in interwar England who advocated labor-saving in the home through careful planning. As she told Patmore,

> I am always hearing the kitchen described as the 'workshop of the house.' . . . They cannot really want to make the daily work of the housewife comparable with that of the factory hand, yet they would appear at times to have you look upon the cook in her kitchen as being on all-fours with the research chemist in his laboratory, or the factory hand in a perfectly appointed workshop where efficiency is the one and only object in view.[32]

Braddell questions the equivalence between the home and the workplace that was the foundation of the rational household. As she suggests, the analogy between the housewife and the research chemist or factory worker could become strained. Despite the elaborate propaganda served up by manufacturers and the exhortations of efficiency experts, women's magazines, and advice books, the idea of recreating the home in the image of the workplace could succeed only in limited ways. The analogy was aspirational rather than exact, revealing how women and the home were seen, or wanted to be seen. Housework was generally repetitive rather than productive, solitary rather than collective, generalist rather than specialized, and perhaps most important of all, unpaid. Second-wave feminist critics argued that the rationalization of the household was not necessarily progressive for women, since it focused their energies on housework rather than directing them to professional and compensated labor that would actually, rather than analogically, place them in a position equal to men.[33] As Woolf argued, the professionalization of women remained a frustratingly incomplete project, even as modernization improved people's everyday lives and decreased the amount of time needed for housecleaning.

The reformers who created the rational household did in part achieve the goals of efficiency, increased leisure, and rationalization of the work process. By extracting factory techniques from the context where they had utility, the rational household also transformed these techniques into something else—a style. The rational household made a visible commitment to the machine age, but with technology sometimes deployed for its own sake, rather than to save labor.[34] Buster Keaton mocks this approach in his 1922 film *The Electric House*, where a well-to-do family commits to electrifying their home, but many of the "efficiencies" introduced are showy flourishes rather than actual labor-saving practices. For instance, dinner is served via an electric toy train that runs from the kitchen to the dining room on tracks around the table, stopping in front of each diner so that a plate can be removed. Meanwhile a traditional uniformed maid hovered in the kitchen.

Industrial innovations such as standardization, mass production, and efficiency could become style when they entered the home—symbols of modernity rather than the functionalist expedients they were created to be. For example, in the 1930s, streamlining was introduced as a design technique that made trains, cars, and planes more aerodynamic by decreasing wind resistance. Streamlining lost its function in the design of many household objects; applied to a toaster or any stationary object it served no functional purpose and merely symbolized the value conferred by modern aesthetics. As R. L. Rutsky notes, "The 'machine aesthetic' of modern design was, then, precisely that: an aesthetic, a style, a simulation of the rationalized, standardized forms of machines and factories, often abstracted from any functional or instrumental context."[35] We will see this technique used by modernist writers, who adapted modern values like hygiene into the context of literature where they had no strictly functional application, since literature could not actually be clean or dirty.

The story of the rational household forms an important backdrop for this book because it combines and animates many of the ideas that I argue are at the heart of the modernization of the household, ideas taken up in force and in conflict by modernist writers. If the nineteenth-century interior was personal, idiosyncratic, and sheltering, the rational household, by contrast, was systematic, standardized, and modeled on the workplace. The rational household was powered by new mechanical devices and inspired by the values associated with mechanization, including efficiency, standardization, and functionalism. In his 1935 manifesto, "Towards a Rational Aesthetic," British architectural writer J. M. Richards described the advent of a rational aesthetic as moving toward a system in which "interference by the personal factor . . . is reduced to a minimum."[36] Accordingly, the rational household moved domestic life away from individual tastes and habits and toward universal standards.

With its model kitchens, daily schedules detailed to the minute, and focus on method, the rational household sought to modernize both the home and private life itself. The rational household postulated an ideal home that was regular in its routines, mechanical in its systems, and efficient in its approach

to the feeding, cleansing, and raising of its inhabitants. To substantiate their principles, the early twentieth-century American time management experts Frank and Lillian Gilbreth raised twelve children; they would demonstrate the family's efficiency by blowing a whistle and then timing with a stopwatch how long it took for all the children to assemble.[37] The idea that even child-rearing could be subject to rationalization, raised "cheaper by the dozen," in the Gilbreths' phrase, signals the strength of the popular idea that modernization could productively transform private life as well as public. The idea of evacuating the personal from private life was hard to countenance for many modernist writers, who were nonetheless captivated by many of the features of the modernized home.

Scarcity may have contributed to the allure of domestic modernization. Despite the enthusiasm of modernization's proponents, the dissemination of modernization's major innovations into the home took decades and unfolded across the early decades of the twentieth century. For example, although Thomas Edison invented the incandescent light bulb in 1879, there were no electrical networks in Europe or the U.S. through the 1890s.[38] In 1900, there was still public speculation about whether electricity could ever replace gas power.[39] In England in 1918, only 6 percent of private homes received electricity from a central supply; by 1939 nearly 70 percent did. The figures from America are equally striking. In 1902, only 8 percent of homes in the U.S. received electricity from power stations; by 1948, 78 percent of homes had power from a central source.[40] The same decades saw the mass introduction of indoor plumbing and hot water, which Sigfried Giedion dates, in the U.S., to 1921–3, though change came more slowly in rural areas.[41] Indoor plumbing required immense retrofitting of existing homes. In *The Evolving House*, Bemis shows us that in 1930, only 30 percent of homes in Great Britain and 60 percent of those in the United States had bathrooms.[42]

Electricity and plumbing were central to the advent of modernization in the home. Electricity provided better light and granted households with sufficient means the ability to acquire the latest household appliances, many of which required electricity. Plumbing enabled more rapid and

thorough cleansing of both the home and the body and underpinned new conceptions of hygiene, as well as eliminating the labor necessary to gather and move water. The two decades that saw a steep rise in the mechanization of the home, roughly 1920 to 1940, were also key years for the articulation and consolidation of the aesthetics of literary modernism, and as such, they roughly provide the boundaries for this study.

The slow advent of the modernization of the home was not lost on modernist writers. As early as 1909, H. G. Wells expressed the sense that modern homes, long expected, had not yet arrived. In his 1909 novel *Tono-Bungay*, the forward-looking entrepreneur Teddy Ponderevo is working on an advertisement for "The Ponderevo Patent Flat, a Machine you can Live in," but the flat Ponderevo lives in is distinctly Victorian, with "something...hung about or wrapped round or draped over everything."[43] Ornament is clearly not a crime at the Ponderevos'. Twenty years later, Woolf opened her last novel, *Between the Acts*, with another scene of modernization deferred: "It was a summer's night and they were talking, in the big room with the windows open to the garden, about the cesspool. The county council had promised to bring water to the village, but they hadn't."[44]

These references suggest something of the excited anticipation with which modernization was frequently greeted. This excitement could seem particularly keen for women. In Lawrence's novel *Women in Love* (1920), when Birkin appears in the school classroom where Ursula is teaching and switches on the lights, the effect on her is transformative: "[Birkin] switched on the strong electric lights... [Ursula] looked like one who is suddenly wakened."[45] Something similar happens for Natalia, the main character in H.D.'s 1930 novella *Nights*; electricity seems to bring her to life: "She was sexless, being one chord, drawn out, waiting the high-powered rush of the electric fervor. It crept up the left side, she held it, timed it, let it gather momentum, let it gather force..."[46] Electrification literally turns these women on; their power derives in part from the mechanical transformation of the home, presided over by women. All this power was not necessarily empowering, however. Modernization seemed to bring new

possibilities for women—but as in the case of Eliot's typist, women could also be modernization's victims, a potent paradox.

Reyner Banham writes that modernization "brought small, woman-controlled machinery into the home, notably the vacuum cleaner. Electrical techniques brought the telephone as well, and for the first time domestic and social communication did not depend on the sending of written or remembered messages."[47] Women operated vacuums, washing machines, and new kitchen appliances, and advertising for these new products targeted the woman consumer. The home, often previously understood as a refuge from modernity, a "separate sphere" apart from the processes of modernization underway in the workplace and the city, was in fact a central site of modernist energies that was transformed by modernization, particularly among the middle and upper classes who could better afford the new technologies.

It is difficult to separate the histories of early twentieth-century domesticity in England and the United States, for though each has its own flavor, they mix together, and accordingly I will discuss both contexts in this book. Osbert Sitwell's reference, in a 1935 essay, to "Mr Ford of Dagenham and Detroit" exemplifies this blending by pairing Dagenham, the East London site of the largest automobile factory in Europe, owned by Ford, and Detroit, Ford's American headquarters.[48] In England, the embrace of new technology proceeded more slowly than in the U.S., and movements such as the Gothic Revival and Arts and Crafts repudiated mechanization in the home and promoted individuality, self-expression, and simplicity. Household mechanization entered England partly through the Modern Movement, as it spread through Europe via the work of modern architects and designers like Le Corbusier, Walter Gropius, Mies van der Rohe, and Adolf Loos, who promoted the elimination of decorative flourishes in favor of smooth surfaces and simplified forms.

Broadly put, architecture helped to drive the European movement, while in the U.S. function and efficiency were the prime movers and the embrace of household mechanization was more direct. If the European movement grew substantially out of the social principles of the Arts and Crafts, the

American influence looked toward the worldlier Ford, whose Model Ts helped originate standardization and mass production. America spawned the assembly line, the science of motion study, and the practices of scientific management. These innovations suggested a domestic vision of practicality and utility rather than adherence to a particular visual aesthetic. On both sides of the Atlantic, Victorian traditions of elaborate decoration gave way to stripped-down forms and functionalism, based on a belief that design should dictate utility. In contrast to the effusive use of ornament, eclectic juxtaposition of period imagery, and profuse textiles and decorative objects that characterized Victorian design, functionalism's design philosophy valued efficiency and economy, and found inspiration in machines. American and British domestic styles overlapped and influenced one another; the desire to reconcile American efficiency with Continental design was at the heart of the popular credo that "form follows function." The reconciliation of efficiency and design was central to Le Corbusier's notion of the *objet type*, which sought to develop the ideal version of a given object and then mass produce it.

Like all those who work in multiple disciplinary contexts, I have tried to develop my own methods of inquiry in this book. *Machines for Living* investigates the ways in which modernist literature develops and communicates meaning through a new vocabulary of form substantially derived from non-literary discourses of modernity. I am interested in how ideas central to modernization migrate across different forms of cultural production and gain new meanings in the process, and have sought to understand how certain aesthetic practices in modern literature connect to the modernization of the home. I hope that these cross-disciplinary inquiries can suggest a richer comparative understanding of modernism, one that attends to the specificity of different forms of cultural production, and also accommodates the broad ideas that encompass the modern movement across its many fields of practice. Modernism's capaciousness as an aesthetic is one of its defining features, and this book explores the contours of that ambitious reach. In bringing literary texts together with sources from architecture, design, science, and other fields, I do not imply that the

connections among them are straightforwardly causal or literal, but rather that certain issues and subjects arose in the first part of the twentieth century that all these fields confronted. At times these issues involved actual space and objects, while in other instances the connections are more metaphorical. Nor was there consistent alignment among fields—in some cases there was radical opposition, underscoring the diversity and complexity of modernism.

The relation between modernism and modernity, a consistent preoccupation of modernist studies over the last 20 years, is an important subject for this book. Some of modernity's innovations intersect in especially apt ways with modernist preoccupations: the discovery of the X-ray, with its ability to open the interior of the body to view, coincides nicely, for instance, with modernism's interest in interiority. We can see the convergence in Woolf's novel *To the Lighthouse* (1927), when Lily Briscoe looks at Charles Tansley and sees, "as in an X-ray photograph, the ribs and thigh bones of the young man's desire to impress himself lying dark in the mist of his flesh."[49] Tansley's physical self communicates his emotional needs, and X-ray technology suggests an apt figure for Lily's insight. Woolf's famous advice to writers of modern fiction to "look within" participates in the broader values of modernity, with its cultivation of technologies of visual enhancement, including not just the X-ray but also the microscope and the camera.[50] Because Lily's interior monologue occurs at Mrs. Ramsay's dinner table, and because Lily is both an artist and a woman, it seems that domestic life and women's new grasp on technology inform Lily's authority as an observer. She responds to Tansley's appraisal of her confidently and ambitiously, with her own penetrating gaze.

While modernist studies has not yet, in my view, taken account of the centrality of domesticity to the modernist project, some of the most resonant critical thinking about the early twentieth century does reunite the narratives of Anglo-American modernism and modernity through the cultural history of technology, necessarily a key term for modernization. Critical attention, up to this point, has focused on the public sphere rather than the home, including valuable analyses of the experience of motorized

speed,[51] the impact of technologies of attention and perception,[52] the import of writing machines,[53] the mechanization of the body through prosthetics and related technologies,[54] public works projects,[55] military technologies,[56] and others.[57] Several factors help to explain the relative neglect of the modernization of the home in the critical literature, including the general contempt of European modernist artists and architects for domesticity.[58] In addition, as Mary Wilson has discussed, many modernist writers explicitly rejected domestic ideologies, seeing them as retrograde and overly feminine, and critics have followed their lead.[59]

In an attempt to redress this critical neglect, this book shows how modernist writers drew inspiration from the modernization of the home and domestic life, and most broadly from the spaces of private life. The novel as a form is particularly concerned, as Ian Watt noted, with "the delineation of the domestic life and the private experiences of the characters who belong to it: the two go together."[60] The modernization of the home alters our sense of what it means to be human, and in so doing it shows us how modernization redefines intimate human experiences involving the body, the family, and the routines of domestic life. As historian Sigfried Giedion summarizes the meaning of the modern age, dramatizing the conflation of private life, personal identity, and the new modern technologies, "mechanization penetrated man's inner existence,"[61] and the documentation of that inner existence is one of modernism's great projects.

Interdisciplinary projects need to constitute their own critical archives, drawing from a range of fields, and many sources have underwritten my research, beginning with cultural historians who have described the advent of the technologies that transformed the early twentieth-century home and the concomitant reorganization of household labor. Preeminent among them is Giedion, whose monumental 1948 work, *Mechanization Takes Command: A Contribution to Anonymous History*, inspired me to try and create a cultural counterpart to his volume. I also found resources in models in the work of Walter Benjamin, Adrian Forty, Diana Fuss, Stephen Kern, Kristin Ross, Wolfgang Schivelbusch, Jeffrey Schnapp, Anthony Vidler, Janet Ward, and Mark Wigley. In the 1980s, feminist historians first took the

home and domestic labor as a topic of serious academic inquiry, among them Ruth Schwartz Cowan, Caroline Davidson, Christine Hardyment, Dolores Hayden, and Susan Strasser.[62]

More recent studies of modernist literature and technology have led me to think of literature as itself a technê, a fusion of art and craft. In *Beautiful Circuits: Modernism and the Mediated Life*, Mark Goble argues that "the experience of technology" is "an occasion for aesthetic experiment."[63] Sara Danius writes, "technology is in a specific sense *constitutive* of high-modernist aesthetics," and Alex Goody concurs that "technology is part of the cultural vocabulary that modernist innovation drew on for its renewing power, with many writers and artists taking terminology, ideas and scientific models from the technological realm to explore their particular visions of aesthetic recreation."[64] These claims model how technological change, an important driver of the transformation of the modern home, informed modernist aesthetics and position technology and culture as mutually influential participants in the broader, multifaceted discourse of modernism.[65] Technics and aesthetics present intertwined, inter-reliant discourses of modernity.[66] A through line in this book follows the transformation of modernist ideas as they move among different areas of technical and aesthetic practice. I explore, for instance, the ways in which literary and architectural form share design principles, and how hygiene connects public health and poetry. Literature is foremost in this study, but I am primarily interested in its intersections with other disciplines including urban planning, architecture, interior design, visual art, epidemiology, public health, and developmental psychology.[67]

My approach to the question of technics and aesthetics is less concerned than that of other critics with machines and mechanization itself—that is, with the things that technology makes—and more with the ontological and epistemological concepts related to the production of technology.[68] The concepts in the chapters of this book include standardization, functionalism, rationalization, the elimination of ornament, repetition, hygiene, and human development; each is closely associated with modernity (though some have a longer pre-history) and each becomes a term of art

for both modernist writers and theorists of technics. I do not present an exhaustive catalogue of such concepts; my selection is eclectic and often informed by the portability of certain concepts, based on their appearance in different technical and aesthetic settings. For modernist writers, concepts like standardization and functionalism are not purely technical (if such a thing were possible). They challenge us to rethink what it means to be human, to perceive the world, to create, and to dwell.

Each chapter in this book explores a concept at the intersection of domesticity, modernization, and literary modernism, offering a history of each idea and showing its migration across different forms of modernist cultural production. Chapter 2, "Minimum Writing," traces the origins of the idea that the use of ornament in design is antithetical to modernity. In 1932 Czech architect Karel Teige proclaimed the age of "the minimum dwelling," joining Adolf Loos, Le Corbusier, and other architects in pursuing a design aesthetic that eschewed the trappings of historical styles and decoration. Minimum dwelling rejected traditional images of domesticity and promoted pure functionalism in both design and use. I examine a strand of literary modernism that I call "minimum writing," which sought to eliminate the "decorative" aspects of literary expression and its development through the work of Ford Madox Ford, Ezra Pound, T. S. Eliot, and Ernest Hemingway, culminating in an extended discussion of the novels of Ivy Compton-Burnett. Critics, Elizabeth Bowen among them, have generally considered Compton-Burnett a writer who continued the conventions of the Victorian novel in her output. I argue that Compton-Burnett, whose lifelong partner was the design historian Margaret Jourdain, adopted the tenets of minimum writing and used them to disorient her readers and destabilize traditional domestic life in her novels.

Chapter 3, "'Fear in a Handful of Dust': Modernism and Germ Theory," begins from the late nineteenth-century scientific discovery that microorganisms cause disease. The chapter tracks the migration of germ theory into the home, where it spawned new approaches to hygiene that transformed housecleaning and housewifery. To understand why poets like Ezra Pound and William Carlos Williams came to believe that poetry should be

"hygienic," I show how epidemiologists, physicians, and public health workers instructed housekeepers (refashioned as domestic engineers) to establish new standards and practices for cleaning the home. Recapturing the lively public conversation of the 1920s and 1930s about hygiene documents how literature participated in these exchanges and helps elucidate ideas about human sensation, urbanism, medicine, contagion, race, and class that informed emerging theories of hygiene. As germ theory moved into public consciousness, it engendered a fear of the imperceptible and attached new value to cleanliness, clarity, and transparency. The writers I analyze forge an imaginative link between cleanliness and clarity in writing, proposing the poet's vision as a means of remediating the inadequacy of human senses to detect bacterial threats.

Chapter 4 moves from the microscope to the factory and examines an idea that was foundational for the modernization of the home: standardization. "'Regular Hours and Regular Ideas': Originality in an Age of Standardization," explores the idea that modernism's prominent preoccupation with originality is animated in part by concerns about the degradation and devaluation of originality in a culture increasingly seduced by copies, standard forms, artificial experience, and fake sensations. The writers I discuss—including T. S. Eliot, Osbert Sitwell, and Gertrude Stein—denounced the spread of standardization to the home, but also adopted and elaborated ideas connected to mass production in creating the formal and ideological innovations of their literary modernism.

Standardization helped give rise to the rational home, and it also impacted ideas about child-rearing. Psychologists turned their attention to the ways in which children grow and develop, and began to ask if the insights of modernization, particularly rationalization and efficiency science, could be deployed to help raise children more efficiently and effectively. The new doctrine of behaviorism told parents that they could engineer their children to grow up in any way the parents might prefer. In Chapter 5, "Modernism's Missing Children: Mass Production and Human Reproduction," I argue that writers responded to the new science of child development by reconfiguring the *Bildungsroman* as a literary form in which

human development could happen in multiple ways. In so doing, writers like Aldous Huxley challenged the linear framework of developmental milestones and denigrated the human consequences of propounding a model for children's growth that was rigidly prescriptive. Many modernist writers went beyond offering a critique of behaviorist models by composing their own stories for children, depicting models for growth that neither celebrate mechanization nor look sentimentally back at its precursor eras.

Chapter 6, "The House that Virginia Woolf Built (and Rebuilt)," takes a somewhat different approach. It focuses on Woolf, a writer who, in addition to her literary output, also experimented in architecture and design. This chapter takes as its corpus something that might seem inconceivable, given her popularity—undiscussed works by Woolf, about half of a dozen of them. These are not literary works but rather architectural projects that Woolf carried out at Monks House, the country home she shared with her husband Leonard in the southeast English county of Sussex. Given that so many members of Woolf's intimate circle, including her sister Vanessa Bell, undertook multiple forms of artistic practice like pottery, painting, interior design, and more, it came as a surprise to me that this aspect of Woolf's oeuvre had previously not been discussed by critics. In neglecting Woolf's architectural work, critics have missed an opportunity to see how Woolf went about redesigning her home both to modernize it and to construct a space for her writing. Woolf's domestic architectural practice aligns in interesting ways with her writing; the two bodies of work comment directly on each other, together offering a signal example of modernism's cross-disciplinary conversation.

* * *

For architects like Le Corbusier, machines symbolized an ideal to which the home should aspire: minimal in furnishing, rational in planning, and designed in accordance with established standards rather than individual tastes. Modernist literature complements this account of the modern home with the realities of the particular, everyday lived experience of domestic life. I would like to conclude this introduction with a vivid example of how

modern literature participates in modernization by complicating accounts of modern architecture and the modernization of domesticity. Evelyn Waugh's 1928 novel *Decline and Fall* offers an ambivalent account of what happens when a modernist architect is commissioned to renovate an old Tudor home, King's Thursday, recently purchased by Margot Beste-Chetwynde, a wealthy modern woman. Before Margot takes it on, King's Thursday has remained intact for three centuries, as Waugh writes: "In the craze for coal gas and indoor sanitation, King's Thursday had slept unscathed by plumber or engineer."[69] The house has neither telephones nor electricity nor running water.

In this condition, Margot purchases it and hires Otto Friedrich Silenus, a young architect whose previous major project was a rejected design for a chewing-gum factory, published in a progressive Hungarian quarterly. Margot tells her architect to build her something "clean and square" and then goes off on a world tour, leaving him to interpret and execute the commission. Silenus tells a reporter interested in the King's Thursday project that, "the only perfect building must be the factory, because that is built to house machines, not men. I do not think it is possible for domestic architecture to be beautiful, but I am doing my best" (159). His disdain for domestic architecture represents an extreme version of a sentiment prevalent in continental modern architectural theory—the idea that the factory and the machine presented contemporary aesthetic ideals, and that the home was somehow their dowdy antithesis. The architect's disdain for the domestic seems tied to a broader misanthropy; he also opines, "Man is never beautiful; he is never happy except when he becomes the channel for the distribution of mechanical forces" (159).

As an architect, Otto Silenus sees his task as the creation of what Le Corbusier called "machines for living." The house he builds for his client resembles a factory most obviously in its prominently industrial materials, chief among them ferro-concrete, aluminum, and rubber. The rebuilt King's Thursday is full of modern conveniences, including lifts, automated window blinds, and bathrooms with elaborate fittings. Yet despite the architect's loathing of humanity and his gloomy disposition, he cannot help

building a house that is not only beautiful but also designed to inspire the contemplation of beauty.

Waugh has been characterized in the critical literature as a critic of modernity who preferred established architectural tradition and equated renovation with destruction, not just in *Decline and Fall*, but also in later works including *A Handful of Dust* (1934) and *Brideshead Revisited* (1945).[70] But passages in *Decline and Fall* describing the rebuilt King's Thursday are lyrical in tone and sentiment and call attention to the luminous reflective beauty of the house's modern surfaces. We are given "the great colonnade of black glass pillars [that] shone in the moonlight" (168), the "luminous ceiling in Mrs. Beste-Chetwynde's study" (189), and "the meadow of green glass [that] seemed to burst into flower" in the drawing room (177–8). The novel's protagonist, Paul Pennyfeather, travels to the top of the house and observes its resplendent vistas: "They took him up in the lift to the top of the great pyramidical tower, from which he could look down on the roofs and domes of glass and aluminium which glittered like Chanel diamonds in the afternoon sun" (189). Perhaps the zenith of the house's ability to use light to inspire the contemplation of the beautiful can be found in the "little drawing room, of which the floor was a large kaleidoscope, set in motion by an electric button" (189). Form is on display here, but there is no apparent attendant function.

In Otto Silenus's rebuilt King's Thursday, glass and metal combine not to further the ends of production or to serve a practical function, but rather to create beauty, inspire wonder, and reflect the light of the sun and moon. In all of these aims, he (or Waugh) might have been inspired by Paul Scheerbart's 1914 well-known manifesto, "Glass Architecture," where Scheerbart writes of the need to embrace "glass architecture, which lets in the light of the sun, the moon, and the stars, not merely through a few windows, but through every possible wall, which will be made entirely of glass—of coloured glass."[71] The kaleidoscope in the drawing room floor combines light and colored glass; mechanization exists only to create beautiful optical effects.

Critics reading *Decline and Fall* have seen in Otto Silenus and his creation little more than another vehicle for Waugh's satirical dismissal of modern architecture. "The purpose of Otto Silenus's inclusion in *Decline and Fall* is not only to mock modern architects such as Le Corbusier; rather, the point is equally that his replacement for King's Thursday is poorly conceived, impractical," comments Bruce Gaston.[72] Tammy Clewell agrees that Waugh "roundly criticizes" Silenus's architectural practice as "coldly mechanistic,"[73] and for James Buzard, Silenus's work represents "modernist totalitarianism."[74] Waugh does depict his architect as moody and eccentric, but to dismiss him as a representative of the dehumanizing aspects of modernist architecture is to overlook the evident beauty of his work, a beauty generated by the use of modern materials and modern technology. Waugh makes fun of his architect, but the forces of modernization that produce the design for King's Thursday are the engine propelling his novel, and among those forces is the professionalization of women. As *Decline and Fall* ends, Margot Beste-Chetwynde has unloaded her aristocratic surname and assumed one that signals her affiliation with modern life: Margot Metroland.[75]

This introduction both begins and ends with women who are the heads of their households and earning their own livelihoods—Margot Beste-Chetwynde/Metroland and Eliot's unnamed typewriter girl. Neither is a heroine, or even the protagonist of her story. Both have bridged the old gap between home and work, with different results: Margot conducts her business from her study at King's Thursday, and the typist is still a mechanical creature even during sex. In the 1920s and 1930s, women were exhorted to remake the private self and cultivate workplace values like efficiency and rationality. Modernist alienation derives in part in this evacuation of the idiosyncratic and personal from the world of the hearth, now remade as a hygienic range and tended by a professional operator.

William Carlos Williams's poem, "The House" concludes on a note of expectation: "the whole house / is waiting – for you / to walk in it at your pleasure– / It is yours."[76] These lines offer Williams's wife both a gift and a

job description. In this paradoxical joining of pleasure and discipline; of the leisure of unmeasured time cross-hatched with the efficient tick of the punch clock; of the woman who can be at once queen and slave, that I think we may find the generative and interrelated contradictions of modernism and of twentieth-century domestic life.

Notes

1. T. S. Eliot, *The Waste Land: A Facsimile and Transcript of the Original Drafts Including the Annotations of Ezra Pound*, ed. Valerie Eliot. New York: Harcourt Brace Jovanovich, 1971, 47.
2. Le Corbusier, *Towards a New Architecture*, trans. Frederick Etchells (1931; New York: Dover Publications, 1986), 4.
3. As Sigfried Giedion notes, "We designate the period between the two World Wars as the time of full mechanization." Giedion, *Mechanization Takes Command: A Contribution to Anonymous History* (Oxford: Oxford University Press, 1948), 41.
4. William Carlos Williams, "The House," in *The Collected Poems of William Carlos Williams, vol. 1 1900–1939*, ed. A. Walton Litz and Christopher McGowan (New York: New Directions, 1986), 340.
5. T. S. Eliot, "Religious Drama: Medieval and Modern," *University of Edinburgh Journal* 9.1 (Autumn 1937), 17.
6. D. H. Lawrence, *Lady Chatterley's Lover* (1928; New York: Bantam, 1983), 238.
7. Lawrence Rainey and Robert von Halberg, "Editorial/Introduction," *Modernism/Modernity* 1.1 (1994): 2.
8. In Lewis Mumford's 1934 work *Technics and Civilization*, he states in the opening lines that "people often call our period the 'Machine Age.'" Mumford, *Technics and Civilization* (San Diego, CA: Harvest, 1963), 3.
9. See Martha Banta, *Taylored Lives: Narrative Productions in the Age of Taylor, Veblen and Ford* (Chicago, IL and London: University of Chicago Press, 1993).
10. Glenna Matthews, *"Just a Housewife": The Rise and Fall of Domesticity in America* (New York and Oxford: Oxford University Press, 1987), 171.
11. Alison Light, *Mrs. Woolf and the Servants: The Hidden Heart of Domestic Service* (London: Penguin, 2007), 179.
12. Juliet Kinchin and Aidan O'Connor, *Counter Space: Design and the Modern Kitchen* (New York: The Museum of Modern Art, 2011), 9.
13. Thelma H. Benjamin, *Everyday in My Home* (London: Ivor Nicholson and Watson, 1936), 1–2.
14. Sigfried Giedion, "Mechanization Enters the Household," in *Mechanization Takes Command*, 512–627.
15. Christine Frederick, *Come Into My Kitchen* (Sheboygan, WI: The Vollrath Co., 1922), 6.

16. See Ellen Lupton, *Mechanical Brides: Women and Machines from Home to Office* (New York: Princeton Architectural Press, 1993).

17. Christine Frederick, *The New Housekeeping* (Garden City, NY: Doubleday, Page & Company, 1913), 200–1.

18. Mary McLeod, "Domestic Reform and European Modern Architecture: Charlotte Perriand, Grete Lihotzky, and Elizabeth Denby," in *Modern Women: Women Artists at the Museum of Modern Art*, ed. Cornelia Butler and Alexandra Schwartz (New York: The Museum of Modern Art, 2010), 174–91.

19. Daniel Beekman, *The Mechanical Child* (Westport, CT: Lawrence Hill & Company, 1977), 113.

20. See, for instance, Mark Micale, ed., *The Mind of Modernism: Medicine, Psychology, and the Cultural Arts in Europe and America, 1880–1940* (Stanford, CA: Stanford University Press, 2003); Paul Peppis, *Sciences of Modernism: Ethnography, Sexology, and Psychology* (Cambridge: Cambridge University Press, 2014); Anna Katharina Schaffner, *Modernism and Perversion: Sexual Deviance in Sexology and Literature 1850–1930* (Basingstoke and New York: Palgrave Macmillan, 2012).

21. T. S. Eliot, *Christianity and Culture* (San Diego, CA and New York: Harcourt, 1960), 15.

22. Eliot, "Religious Drama," 13.

23. Eliot, "Religious Drama," 14.

24. Walter Benjamin, "Paris, the Capital of the Nineteenth Century," in *The Arcades Project*, ed. Rolf Tiedemann, trans. Howard Eiland and Kevin McLaughlin (Cambridge, MA and London: Harvard University Press, 1999), 8. 1935 version.

25. Contemporary critics have demonstrated convincingly that no simple distinction between public and private spheres can be drawn for Victorian society. Rather, these realms were constituted through a complex, if often occluded interchange. See, for instance, Judith Chase and Michael Levenson, *The Spectacle of Intimacy: A Public Life for the Victorian Family* (Princeton, NJ and Oxford: Princeton University Press, 2000) and William Cohen, *Sex Scandal: The Private Parts of Victorian Fiction* (Durham, NC: Duke University Press, 1996).

26. Benjamin, *The Arcades Project*, 220, Convolute I4, 4.

27. Oscar Wilde, *The Picture of Dorian Gray*, ed. Robert Mighall (1891; London: Penguin, 2000).

28. Charles Dickens, *Great Expectations* (1860–1; London: Penguin, 1996).

29. Benjamin, *The Arcades Project*, 221, Convolute I4, 4.

30. Virginia Woolf, "Old Bloomsbury," in *Moments of Being*, 2nd edn, ed. Jeanne Schulkind (San Diego, CA: Harvest/HBJ, 1985),183.

31. Woolf, "Old Bloomsbury," 184.

32. Derek Patmore, *I Decorate My Home* (London: Putnam, 1936), 163.

33. In Dolores Hayden's foundational study, *The Grand Domestic Revolution* (1981), she writes that, "Lillian Gilbreth and Christine Frederick became the key ideologues for the antifeminist, pro-consumption, suburban home....both Frederick and Gilbreth created surrealistic sets of procedures whereby the housewife 'managed' her own labors 'scientifically,' serving as executive and worker simultaneously. Corporations and advertising agencies then hired Frederick and Gilbreth as

consultants to promote their products with their pseudoscientific management schemes, and ultimately Frederick became a specialist on selling things to women." Hayden, *The Grand Domestic Revolution: A History of Feminist Designs for American Homes, Neighborhoods, and Cities* (Boston, MA: MIT Press, 1982), 285. See also Matthews, "*Just a Housewife,*" 171 and Caroline Davidson, *A Woman's Work is Never Done: A History of Housework in the British Isles, 1650–1950* (London: Chatto and Windus, 1982).

34. For discussions of the fetishistic nature of the design and performance of house-work, see Anne McClintock, "Imperial Leather: Race, Cross-Dressing, and the Cult of Domesticity," in *Imperial Leather: Race, Gender, and Sex in the Colonial Contest* (New York: Routledge, 1995), 132–80 and Lupton, *Mechanical Brides* (cited above).

35. R. L. Rutsky, *High Techne: Art and Technology from the Machine Aesthetic to the Posthuman* (Minneapolis and London: University of Minnesota Press, 1999), 11.

36. J. M. Richards, "Towards a Rational Aesthetic," reprinted in *The Rationalists: Theory and Design in the Modern Movement*, ed. Dennis Sharp (California: Architectural Press, 1978), 134.

37. Frank B. Gilbreth, Jr. and Ernestine Carey, *Cheaper By the Dozen* (New York: Thomas Y. Crowell Company, 1948).

38. Buffalo, NY conceived the first plan in 1896. There are several accounts of the advent of electric light; see, e.g. Wolfgang Shivelbusch, *Disenchanted Night: The Industrialization of Light in the Nineteenth Century*, trans. Angela Davies (Berkeley, Los Angeles and London: University of California Press, 1988).

39. Giedion, *Mechanization Takes Command*, 559.

40. Adrian Forty, *Objects of Desire: Design and Society Since 1750* (London: Thames and Hudson, 1992), 189; Christina Hardyment, *From Mangle to Microwave: The Mechanization of Household Work* (London: Basil Blackwell, 1990), 28.

41. Giedion, *Mechanization Takes Command*, 685.

42. Alfred Bemis, *The Evolving House* (Cambridge, MA: Technology Press, 1933–6).

43. H. G. Wells, *Tono-Bungay* (1909; Lincoln and London: University of Nebraska Press, 1966), 47.

44. Virginia Woolf, *Between the Acts* (San Diego, CA: Harvest/HBJ, 1941), 3.

45. D. H. Lawrence, *Women in Love* (1920; New York: Penguin, 1995), 50.

46. H.D. (as John Helforth), *Nights* (1930; New York: New Directions, 1986), 51.

47. Reyner Banham, *Theory and Design in the First Machine Age*, 2nd edn (New York and Washington: Praeger Publishers, 1960), 10.

48. Osbert Sitwell, "Let's All Be Alike!" in *Penny Foolish: A Book of Tirades and Panegyrics* (London: Macmillan Publishing, 1935), 96.

49. Virginia Woolf, *To the Lighthouse* (1927; New York: Harcourt Brace Jovanovich, 1981), 91.

50. Rachel Crossland, "Exposing the Bones of Desire: Virginia Woolf's X-Ray Visions," *Virginia Woolf Miscellany* 85 (Spring 2014): 18–20.

51. See Enda Duffy, *The Speed Handbook: Velocity, Pleasure, Modernism* (Durham, NC: Duke University Press, 2009); Jeffrey T. Schnapp, "Crash (Speed as Engine of Individuation)," *Modernism/Modernity* 6.1 (1999): 1–49.

52. See Sara Danius, *The Senses of Modernism: Technology, Perception, and Aesthetics* (Ithaca, NY and London: Cornell University Press, 2002) , and Jonathan Crary, *Suspensions of Perception: Attention, Spectacle, and Modern Culture* (London and Cambridge, MA: MIT Press, 1999).

53. Friedrich Kittler, *Gramophone, Film, Typewriter*, trans. Geoffrey Winthrop-Young and Michael Wutz (Stanford, CA: Stanford University Press, 1999); Morag Shiach, *Modernism, Labour and Selfhood in British Literature and Culture, 1890–1930* (Cambridge: Cambridge University Press, 2004).

54. Tim Armstrong, *Modernism, Technology and the Body: A Cultural Study* (Cambridge: Cambridge University Press, 1998); Hal Foster, *Prosthetic Gods* (Cambridge, MA and London: MIT Press, 2004); Mark Seltzer, *Bodies and Machines* (New York and London: Routledge, 1992).

55. Michael Rubenstein, *Public Works: Infrastructure, Irish Modernism, and the Postcolonial* (Notre Dame, IN: University of Notre Dame Press, 2010).

56. See Alex Goody, *Technology, Literature and Culture* (Cambridge: Polity Press, 2011).

57. The elision of domesticity from studies of modernism and technology also implies the relative neglect of gender; as Sara Danius writes, "the relation of gender and technology in literary modernism is a crucial yet strangely undertheorized topic, one that will no doubt change our understanding of the modernist project." *Senses of Modernism*, 11.

58. Christopher Reed, ed., *Not at Home: The Suppression of Domesticity in Modern Art and Architecture* (London: Thames and Hudson, 1996). See also Rebecca Anne Gershenson Smith, "Framed: The Interior Woman-Artist-Observer in Modernity," 2009, University of Michigan, PhD dissertation.

59. Mary Wilson writes, "Domesticity, and the concepts that cluster under this umbrella term, have been underexplored in the study of modernism, in no small part because many modernists explicitly signaled their own departures from the domestic ideologies that, they felt, structured the social, political, and emotional lives of previous generations and warped their ability to fully represent modern life in fiction": Wilson, *The Labors of Modernism: Domesticity, Servants, and Authorship in Modernist Fiction* (New York and London: Routledge, 2016), 5.

60. Ian Watt, *The Rise of the Novel: Studies in Defoe, Richardson, and Fielding* (Berkeley and Los Angeles: University of California Press, 2001), 175.

61. Giedion, *Mechanization Takes Command*, 44.

62. Ruth Schwartz Cowan, *More Work for Mother: The Ironies of Household Technology from the Open Hearth to the Microwave* (1983); Caroline Davidson, *A Woman's Work Is Never Done: A History of Housework in the British Isles, 1650–1950* (1982); Christine Hardyment, *From Mangle to Microwave: The Mechanization of Household Work* (1988); Dolores Hayden, *The Grand Domestic Revolution* (1981); and Susan Strasser, *Never Done: A History of American Housework* (1982).

63. Mark Goble, *Beautiful Circuits: Modernism and the Mediated Life* (New York: Columbia University Press, 2010), 11.

64. Danius, *Senses of Modernism*, 2–3, italics in original. See also Goody, *Technology*, 14.

65. See Astradur Eysteinsson, *The Concept of Modernism* (Ithaca, NY and London: Cornell University Press, 1990), 16–17 and Frederic Jameson, *A Singular Modernity: Essay on the Ontology of the Present* (London and New York: Verso, 2002), 142.

66. Critics have described in a range of related ways how literature and other forms of cultural production interact with science and technology. For Michael Whitworth, it is through metaphor that science and literature find a shared domain (Whitworth, "Physics," in *A Concise Companion to Modernism*, ed. David Bradshaw (Oxford: Blackwell, 2003), 200–20). Roger Cooter and Stephen Pumfrey have argued that the transmission of scientific ideas into the public sphere is not a one-way process but rather a mutual process through which a "network of alliances" is formed (Cooter and Pumfrey, "Separate Spheres and Public Places: Reflections on the History of Science Popularization and Science in Popular Culture," *History of Science* 32 (1994): 250). For Stephen Kern, the "similarity between developments inspired by technology and those independent of it suggests that a cultural revolution of the broadest scope was to take place, one that involved essential structures of human experience and basic forms of human expression" (Kern, *The Culture of Time and Space 1880–1918* (Cambridge, MA and London: Harvard University Press, 2003), 6). These critics, and others like them, espouse a "one culture" approach, as articulated by George Levine in his 1987 collection *One Culture: Essays in Science and Literature* (Madison: University of Wisconsin Press, 1987) and in distinction to C. P. Snow's 1959 work "The Two Cultures," where he argued that Western society was split into two cultures, the sciences and the humanities, and the split was a pernicious one.

67. A number of critical works have traced relationships between literature, science, and technology, and in his recent survey (2016), Mark Morrisson is skeptical of those who draw thematic connections between science and literature without demonstrating clear historical links. He writes, "Anachronistic or overly vague assertions of connections and influences have at times undermined research on modernism and science...they can obscure the wealth of understanding available through more careful attention to the scientific contexts of the period." Morrisson, *Modernism, Science, and Technology* (London and New York: Bloomsbury Academic, 2017), 73.

68. David Ayers, "Modernism's Missing Modernity," in *Moving Modernisms: Motion, Technology, and Modernity*, ed. David Bradshaw, Laura Marcus, and Rebecca Roach (Oxford: Oxford University Press, 2016), 49.

69. Evelyn Waugh, *Decline and Fall* (1928; Boston, MA: Little, Brown and Company, 1956), 152. Further references given parenthetically in the text.

70. See, for instance, Bruce Gaston, "'But that's not what it was built for': The Use of Architecture in Evelyn Waugh's Work," *AAA: Arbeiten aus Anglistik und Amerikanistik* 41.2 (2016): 23–48.

71. Paul Scheerbart, "Glass Architecture," reprinted in *Form and Function: A Source Book for the History of Architecture and Design 1890–1939*, ed. Tim Benton and Charlotte Benton with Dennis Sharp (London: Crosby Lockwood Staples in association with The Open University Press, 1975), 72.

72. Gaston, "Use of Architecture," 33.
73. Tammy Clewell, *Mourning, Modernism, Postmodernism* (New York: Palgrave Macmillan, 2009), 98.
74. James Buzard, "Perpetual Revolution," *Modernism/Modernity* 8.4 (2001): 562.
75. Metroland, or Metro-land, was the name of the suburbs built by the railways in the northwest of London after World War I to meet the demand for postwar housing.
76. Williams, "The House," 341.

2

MINIMUM WRITING

Slowly and blissfully he read into the general wealth of his comfort all the particular absences of which it was composed. One by one he touched, as it were, all the things it was such rapture to be without.

Henry James, "The Great Good Place" (1909)

In his 1914 essay, "On Impressionism," Ford Madox Hueffer (as he was known then) expounded his literary method, presenting a model drawn not from literature but from visual art, and specifically from the work of the eighteenth-century caricaturist William Hogarth. Ford describes admiringly Hogarth's "drawing of the watchman with the pike over his shoulder and the dog at his heels going in at a door, the whole being executed in four lines."[1] And he draws his version of Hogarth's drawing in the text of his essay (Figure 2.1).

Ford calls Hogarth's drawing "the high-water mark of Impressionism" because, he claims, Hogarth in just a few strokes provides enough for the viewer to imagine the rest. Here is Ford's commentary on the sketch:

If you look at those lines long enough, you will begin to see the watchman with his slouch hat, the handle of the pike coming well down into the cobblestones, the knee-breeches, the leathern garters strapped around his stocking, and the surly expression of the dog which is bull-hound with a touch of mastiff in it. (170)

No matter how long I look, I confess I cannot see every detail that Ford ascribes to his drawing. I will have to wait to explain why until the end of this chapter, when the full story of the drawing will become clear. What I'd like to consider at this point is the commitment that underlies Ford's praise

Figure 2.1 Ford Madox Hueffer, "On Impressionism" (author's sketch).
Poetry and Drama 2.2 (June and December 1914).
Courtesy of the Columbia Rare Books and Manuscript Library.

of Hogarth, which I take to be a belief in restricting his literary effort to the minimum presentation of the writer's impressions, with no additional commentary or judgment of any kind. For Ford, what is admirable in Hogarth is the simplicity of his sketch, without any extraneous or superfluous detail. As Ford states, "The point I really wish to make is, once again, that—that the Impressionist gives you as a rule, the fruits of his own observations and the fruits of his own observations alone. He should be in this as severe and as solitary as any monk. It is what he is in the world for" (170).

Ford's admiration for Hogarth stems from what he sees as his discipline in offering viewers only what is absolutely necessary to expose a particular scene. This doctrine was not only Ford's, but shared with Joseph Conrad (with whom Ford developed his style), as well as with other modernists of the Imagist school—William Carlos Williams, Ezra Pound, H.D., and

others, each of whom enacted it differently. Ford's commentary on Hogarth's drawing is not especially representative of literary impressionism in general, which was suggestive, associative, and fragmentary rather than restrictive in the sense Ford describes. Nor was Ford's writing itself consistent in its dedication to his avowed principles; in his novel *The Good Soldier*, for instance, published a year after "On Impressionism," Ford's guiding principle is strategic omission, rather than the approach described above. In his essay, however, Ford offers what he calls "some notes towards a working guide to Impressionism as a literary method" (167), and places what we might call writerly restraint at the top of his list of priorities.

What form does this restraint take, and why might a writer want to practice it? The monkish discipline Ford locates in Hogarth is grounded in omission and forbearance. Rather than draw in the hound, the garters, and the cobblestones, Hogarth leaves space for the viewer to supply these aspects in a kind of generative communion between artist and viewer. The great challenge for the artist, Ford suggests, is to realize everything that can be omitted from the drawing and still provide the viewer with all that is necessary for this communion to take place. The artist deliberately restricts himself or herself to the minimum possible to engage the viewer's imagination.

I will return to Ford's interpretation of Hogarth as this chapter concludes. But first, I will try to account for modernist literature's attraction to what I will be calling "minimum writing." Minimum writing came to figure as a practice that was not just aesthetically desirable but also progressive, relevant, and even morally superior. Minimum writing appears in different forms in the works of the writers I'll discuss—Ezra Pound, T. S. Eliot, Ernest Hemingway, and Ivy Compton-Burnett. Its salient influences come not just from visual art but from major movements in architecture and design based in a commitment to functionalism and a rejection of ornament that acquired the force of morality. Because I locate minimum writing in the context of the first decades of the twentieth century, modernist minimum writing needs to be distinguished from subsequent conversations about "minimalism," although the two are often conjoined.

The concept of the minimum has been loosely and liberally deployed in twentieth-century criticism. "Minimalism" is a term most commonly used to describe a movement in U.S. painting in the 1960s and 1970s, painting that uses simple and often massive forms, as in the work of Frank Stella or Donald Judd. In literature, the term has also been applied to postwar American writers of short fiction, notably Raymond Carver and Frederick Barthelme, who have in common a clipped and avowedly masculine prose style.[2] But the usage has expanded back further and been given a broader application by critics, with particular reference to writers that include Albert Camus and Samuel Beckett.[3] As Kenneth Baker summarizes the debates, "The word 'minimal' is used loosely . . . in reference to any stylistic austerity in the arts."[4]

To invoke "the minimal" as Baker describes it is to misunderstand the term's place in the history of modernism and to overlook its origins in the visual arts. Hal Foster argues that minimalism's significance lies in its challenge to the modernist conception of the autonomy of art, an autonomy which becomes displaced through minimalism's literalist treatment of the object. As Foster writes, "minimalism appears as a historical crux in which the formalist autonomy of art is at once achieved and broken up, in which the idea of pure art becomes the reality of one more specific object among others."[5] Foster's treatment of minimalism is more complex than this single formulation, but his notion of the simultaneous achievement and destruction of formalist autonomy helps to distinguish the practice of minimalism from the kind of aesthetic practice that Ford propounds.

For Foster, minimalism emerges at a specific moment in the history of twentieth-century aesthetics. It dramatizes the autonomy of art even as it anchors the object to its social reality (as in the case of Robert Smithson's land art, for example). This dynamic of coupling and disconnection is specific to visual art—and even more specifically, to sculpture—since it depends on the artist's ability to integrate artistic practice with real-world context. Foster's minimalism marks a pure tribute to aesthetic form; this is the meaning of late twentieth-century minimalism—a riposte to

modernism that looks forward to a return of the avant-garde impulse in art in later movements.

Ford's admiration of Hogarth springs from his belief in Hogarth's presentation to the viewer of *the minimum* needed to spark the imagination, whereas Foster's account of minimalism in the visual arts is bound up with a particular transition in the history of aesthetics quite remote from that belief. Discipline is the key for Ford, not the relationship of the work of art to social reality. To understand Ford's practice, we need to set aside the postwar minimalist tradition and turn to earlier traditions in architecture and design. In that arena, Ford's idea of formulating an aesthetic practice based on the rejection of excess is a familiar one, developed in the first decade of the twentieth century as a rejection of both ornament and the centuries-old progression of architectural style. Restoring modernist literature to this tradition establishes a context for the minimum writing of Ford and others and uses the idea of the minimum in a way that is historically specific. It contributes to the history of the minimum across the very long arc of twentieth-century aesthetic debates.

Critics tend to agree that among the first to urge the repudiation of excess—defined as ornament—was Adolf Loos's landmark essay "Ornament and Crime."[6] Loos presented the main ideas of "Ornament and Crime" in numerous public talks beginning in 1909; these talks often appeared in the press, allowing the main ideas to circulate well in advance of the actual publication of the essay.[7] "Ornament and Crime" was first published, in French, in *Les Cahiers d'Aujourd'hui* in 1913, translated by Marcel Ray,[8] and reprinted in 1920 in *L'Esprit Nouveau* (edited by Le Corbusier, Paul Dermee, and Amédée Ozenfant), evidence of its influence and wide circulation. Christopher Long calls "Ornament and Crime" Loos's "stump speech."[9] For Reyner Banham, Loos was a key figure in early twentieth-century design history, "laying further foundations to the idea that to build without decoration is to build like an engineer, and thus in a manner proper to a Machine Age."[10]

Loos formulates his central claim in this way: *"the evolution of culture is synonymous with the removal of ornamentation from objects of everyday use."*[11] In

this statement Loos does not imagine objects as becoming free of ornament through a deliberate process but rather being born free of ornamentation. This both resonates with and differs from Ford's account, since what Ford sees in Hogarth is a refusal to set down anything superfluous (ornamental) rather than a process of stripping away. However, at other points in "Ornament and Crime," Loos seems quite far from Ford's commitment to disciplined austerity, choosing instead to extol the aesthetic virtue of what is simple. Here is Loos:

> When I want to eat a piece of gingerbread, I choose a piece that is plain, not a piece shaped like a heart, or a baby, or a cavalryman, covered over and over with decoration...The supporters of ornament think my hunger for simplicity is some kind of mortification of the flesh. No, my dear Professor of Applied Arts, I am not mortifying the flesh at all. I find the gingerbread tastes better like that.[12]

In this passage, the elimination of ornament is not a form of monkish renunciation but the expression of a preference associated with taste and modernity.[13] The ideal to seek is the unadorned, that which has not been covered "over and over" but is simply itself. For Loos, no restraint is involved in selecting plain gingerbread; he merely prefers the unadorned. Many different ethical and aesthetic commitments can lead to the renunciation of ornament.

Reading Loos without looking at his architecture yields only a partial view of his work and how his ideas about the elimination of ornament found material form. In structures like Villa Müller (Figure 2.2), Loos offered designs that were startlingly simple, with their cubic forms, flat roof, and lack of any exterior sculpture or molding. In Villa Müller, form itself is the focal point—the addition of any trim or decoration would be distracting and superfluous. The lack of ornamentation emphasizes the rigorous beauty of the building's structure.

Loos's approach to building recalls Ezra Pound's call for "direct treatment of the thing" in poetry. Pound's directive, published in 1913 in an essay for *Poetry* magazine, is now enshrined as one of the principles of Imagism.

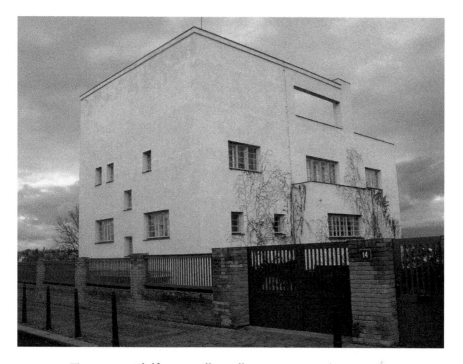

Figure 2.2 Adolf Loos, Villa Müller, 1930 (2007 photograph).
Wikimedia Commons.

Pound insists that the poet "use absolutely no word that does not contrib-
ute to the presentation."[14] He echoed Loos even more explicitly in writing
(in the same essay) that the poet should "Use either no ornament or good
ornament."[15] For Loos, ornament is waste—wasted labor, wasted health,
wasted material, and wasted capital. He sees an ethical imperative that
eschews waste and so cultivates a preference for the unadorned.

For Ford and Pound, however, working outside the economies of manu-
facture and building, ornament does not imply waste. What would it mean
to "waste" words in literature? In the transition from three-dimensional
design to words on the page, anti-ornamentalism becomes more aesthetic,
less economic. But the logic of economy inheres in the literary transliter-
ation, and aesthetic choices also drive the emergence of minimum design
and architecture. In all the variations of this shared impulse, a stable defin-
ition eludes unification among the various forms that advocacy for the

unadorned can take, including a taste for plainness, a moral commitment to renounce decoration, a doctrine of austerity, a preference for the minimal, and a disapproval of waste. Yet all these writers elevate their aesthetic preferences to the level of moral choice, and in so doing create a philosophy that finds expression as a style.

We can follow the development of this line of thinking from the early views of Pound and Loos through a number of significant texts of architectural modernism: Ozenfant and Le Corbusier's manifesto of the Purism movement (1918–25); Le Corbusier's "law of ripolin," about the value of the whitewashed wall (1925); Adolf Behne's *The Modern Functional Building* (1926); Sigfried Giedion's *Liberated Dwelling* (1929); Karel Teige's *Minimum Dwelling* (1932); and other similar works that describe the ethical, economic, and aesthetic value of living with less, of creating a domestic space that is free from ornament. In tracing the adaptations and transformations of Loos's formulation, I want to understand better the ways in which value becomes attached to different theories of the minimum. This emergent network of values can provide a foundation for elucidating the place of minimum writing in modernist literature.

The publication history of "Ornament and Crime" shows the spread of Loos's concept. Le Corbusier and Ozenfant chose to reprint the essay in *L'Esprit Nouveau* in 1920, shortly after they published their theory of Purism in their 1918 book *Après le Cubisme*. Purism is heavily influenced by Loos— though among the many "isms" that proliferated in post-World War I Europe, it is probably fair to say that Purism is not one of the more successful or better known. Certainly it did not succeed in its stated goal of displacing Cubism, Dada, and Surrealism, though it has been argued that Purism was the most influential of all the modernist movements because of its formative role in defining the International Style.[16] It produced several exhibitions; at the first, in 1918, at the Galerie Thomas, about a third of the works were by Le Corbusier himself, at that date still known as Charles Edouard Jeanneret. The movement's fame spread primarily through writing, and especially through the journal *L'Esprit Nouveau*, published by Ozenfant and Le Corbusier between 1920 and 1925.

Loos believes that European man represents a progressive step in human evolution, and that this progress is "synonymous with the removal of ornamentation."[17] As Anne Cheng notes, "According to Loos, as modern men mature and evolve, they must also learn to relinquish the regressive pleasures of ornamentation."[18] In establishing the doctrine of Purism, Le Corbusier and Ozenfant, by contrast, see the elimination of ornament not as a renunciation, but rather as a form of purification activated by the advent of mechanization—because of the principle of economy that the machine requires. As they state, "The machine has applied with a rigor greater than ever the physical laws of the world's structure."[19] The masculinist rhetoric of the Purist doctrine—held in common with other avant-garde manifestoes such as Futurism—shows how the Purist commitment to structure carries with it a kind of manly moralism.

In machinery, as in the physical world, form follows function. Since ornament is by definition superfluous to function, it is proscribed. If the machine has come to dominate culture and defines the ideal in design, then ornament has no place. This approach would seem to share with Loos a rejection of waste or excess. However, Le Corbusier and Ozenfant eschew waste not because it is an ethical breach but because it does not deliver the efficiency required by the machine. They argue, "one might say that the machine has led fatally to the strictest respect for, and application of, the laws of economy" (57). The ideal expressed is to find one's way to an aesthetic that is organized around identifying and eliminating anything that can be considered unrelated to an object's function.

Le Corbusier and Ozenfant place themselves explicitly in dialogue with Loos by echoing his reference to "the Papuan." For Loos, "the Papuan" seems to represent an abstract and racially hierarchical idea of human primitivism. Loos writes in "Ornament and Crime," "The Papuan covers his skin with tattoos, his boat, his oars, in short everything he can lay his hands on. He is no criminal. The modern person who tattoos himself is either a criminal or a degenerate."[20] For Loos, in his racial-historical teleology, the Papuan, who lives outside modernity, finds ornament appropriate; if the contemporary European embraces ornament, however, it is a

sign of atavism. Le Corbusier and Ozenfant would seem to invoke Loos when they argue for the cultural specificity of the reception of design, as follows:

> If I hold up a primary cubic form, I release in each individual the same primary sensation of the cube; but if I place some black geometric spots on the cube, I immediately release in a civilized man an idea of dice to play with, and the whole series of associations which would follow.
>
> A Papuan would see only an ornament. (55)

Le Corbusier and Ozenfant echo Loos in assigning to the Papuan a design standard different from that of a European, but their reasoning is distinct. For Loos, the Papuan has a different (and lesser) standard because his values are primitive; for Le Corbusier and Ozenfant, it is because the Papuan has his own set of cultural referents that he has divergent values in design. It is significant that Le Corbusier and Ozenfant import into their own manifesto this aspect of Loos's work, suggesting that establishing a doctrine of modernity relies on the creation of an abstracted and racialized inferior subject to which modern man can be favorably compared.

Purism's abandonment of ornament is not primarily associated, as it is for Loos, with an expression of elite taste. Instead, it is an inevitable consequence of the acceptance of the logic of the machine, which eliminates both waste and taste, driven by functional requirements. By linking the elimination of ornament with technology and science, by establishing the ornament's eradication as a process of purification rather than one of renunciation, by shifting the history of ornament from a design teleology to a cultural dialogic, Purism complicates and alters Loos's model and prepares the way for a richer conversation between architecture and technology. Underpinned by the advent of mass production (discussed in Chapter 4), Purism also moves in the direction of the *objet type*, an object refined to its simplest and most functional form.

Following his break with Ozenfant, Le Corbusier continued to promote housing organized around both the core functions of private life and the

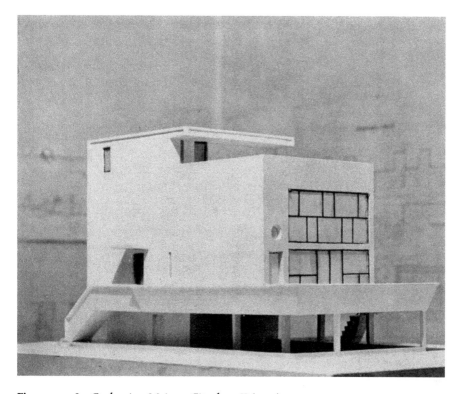

Figure 2.3 Le Corbusier, Maison Citrohan II (1922).
Le Corbusier and Pierre Jeanneret, *Oeuvre complète 1910–1929* (Zurich: Editions d'Architecture, 1964),
© F.L.C./ADAGP, Paris/Artists Rights Society (ARS), New York 2019.

eradication of decorative encumbrance. The destruction of World War
I required rebuilding on a vast scale at a time when European housing
shortages were already acute; many private homes were for the first time
acquiring centralized plumbing and electricity. In this context, Le Corbusier
promoted a style epitomized by his Maison Citrohan II (Figure 2.3), devel-
oped in 1922 and shown at the Salon d'Automne. The structure, built
according to the tenets of Purism, was designed to be efficient and repro-
ducible on a mass scale. The building's lack of exterior ornamentation led
the viewer to focus on the geometric forms that compose the façade.

Le Corbusier's best-known work in England, *Vers une Architecture* (1923),
was translated by Frederick Etchells into English in 1931 and published as

Towards a New Architecture. Le Corbusier offers a functionalist argument about what the house should and should not contain; rooms, for instance, should be limited to "one for cooking and one for eating. One for work, one to wash yourself in and one for sleep."[21] Rooms have become too overloaded with decoration that should be eliminated: "Your chandeliers hurt the eyes. Your imitation stone stucco and your wall-papers are an impertinence, and no good modern picture could ever be hung on your walls, for it would be lost in the welter of your furnishings."[22]

As discussed in Chapter 3, the law of ripolin, or whitewashing, gave the home-dweller the ability to see things for what they were. But the value of ripolin went beyond cleanliness; it also enabled clarity and distinctness of form. In 1925 Le Corbusier wrote in, "A Coat of Whitewash: The Law of Ripolin,"

> Imagine the results of the Law of Ripolin. Every citizen is required to replace his hangings, his damasks, his wall-papers, his stencils, with a plain coat of white ripolin. *His home* is made clean. There are no more dark, dirty corners. *Everything is shown as it is.*[23] (original italics)

In actuality, Le Corbusier's houses and interiors used plenty of color, but the law of ripolin was a powerful metaphor for the need to eliminate the superfluous in modern design and architecture. Above all, Le Corbusier was suspicious of the bourgeois need to overload the interior with objects connoting status or sentiment. Whitewash needed to be elevated to the status of law because citizens might not choose to eliminate all traces of ornament.[24]

This is a confusing dictate for a doctrine that espouses democracy by making good housing available to the masses, but Corbusier follows Loos: "the ideal I preach is the aristocrat," where aristocracy is based on intellectual strength rather than on inheritance.[25] Le Corbusier shares with Loos a disdain for the common man, but such is his confidence in "The Law of Ripolin" that once having been pushed down the correct path, the virtues of the new order will prove persuasive to the masses. Elitism leads not to a walling-off of the higher design virtues, as Loos suggested, but to an

educational program engendering a universal aesthetic. The value of whitewash goes beyond the elimination of antiquated design elements; whitewash supports a range of modern values, including hygiene, honesty, legibility, and transparency. Still, by associating these qualities with whiteness, Le Corbusier again suggests that a denigrated racial other is the necessary supplement to his vision of European modernity.

In "The Law of Ripolin," Le Corbusier recovers the Loosian elitism that was de-emphasized in the Purist manifesto, supporting not just functionalism but also the simplicity of Classical orders like the Doric. The role of technology is also defended in "Ripolin," where the author goes beyond his Purist statement in fusing the machine with art: "The product of the machine age is a realist object capable of high poetry. We approve so much of this object, we are so fond of it, we would so much like to live with it, that our desire adds to its utility the higher dignity of beauty!" (188). Le Corbusier's explanation moves machine-made objects into the realm of aesthetics—through the enthusiastic approval that accretes to the forms of the machine age. Raising utilitarian and mass-produced objects to the level of art is a populist gesture; all would have access to the finest art in their homes—art worthy of a museum. Less than ten years later, in 1934, the Museum of Modern Art in New York mounted its famous "Machine Art" exhibition, with the works of contemporary manufacturers on display in a setting formerly reserved for non-utilitarian art objects.

More notably, Le Corbusier seems to be falling in love with one of the central symbols of the modern age, the mass-produced object, in the form of the *objet type*. But in bestowing an aesthetic status on a functional or an everyday product, in calling the can-opener or the wine bottle beautiful, it seems that Le Corbusier has granted these objects a decorative status. In defining the affective state of the object as something that can accrue fondness, the object becomes once again more than utilitarian. Paradoxically, Le Corbusier's feelings for the objects he praises take them out of the category that first inspired his feelings.

The love that Le Corbusier feels for the "realist object" leads him to remove the object from the zone of utility and bring it into the home

where, ironically, it becomes decorative. As Mark Wigley states in his book-length commentary on Le Corbusier's essay, "Having been stripped of decoration, the white surface takes over the space-defining role of decorative art."[26] Whiteness itself becomes a form of decoration. The category of decoration, rejected by Loos, by Purism, and by Le Corbusier, invariably returns, whether through the fetishization of the machine aesthetic or the covering of whitewash on the bare wall. As Wigley continues, "Purist rather than pure, the building exhibits the look of the naked, the clothing of nakedness, the clothes that say 'naked.'"[27] In Wigley's deconstructive turn, nakedness is signified in the whitewashed wall rather than enacted there. Ornamentation turns out to be difficult if not impossible to eliminate, both because "fondness" for the functional object imbues it with an ornamental dimension and because almost anything can be seen as decorative.

Purism connected anti-ornamentalism with technology and the everyday, while "The Law of Ripolin" complicated that position by raising the admiration of the ordinary to an aesthetic principle. Anti-ornamentalism becomes something more like the promotion of a stripped-down, undecorated style (which is still, following Wigley, a form of decoration). Both these lines of argument are present in Loos, who rejected ornament as immoral and expressed a preference for the unadorned (as in the case of the ginger cookie). What is new in "The Law of Ripolin" is the concession that once the refusal of ornamental excess is elevated to a design principle, it too becomes a style rather than a purely functional choice. The undecorated or whitewashed surface becomes something to love. When I shift into a discussion of expressions of the minimum in modernist literature, both the machine-inspired stripped-down style and the love of the minimum for its own sake will come into play. Before that discussion, we should follow the philosophy of the minimum into architecture and building to see how these aesthetic principles translate into physical form. In this process, the incommensurability of buildings and texts will be apparent—but so will certain lines of continuity and interaction.

Behne and Teige consider more practically than Loos how to translate the minimum into a living built environment. Adolf Behne, a German architectural critic, was one of the first writers to attempt to synthesize and describe the multiple lines of thought developing under the umbrella of European architectural modernism. *The Modern Functional Building* [*Der modern Zweckbau*], written in 1923 and published in 1926, helped to move Germany beyond the sentimental and craft-driven aesthetic typified by Hermann Muthesius and the prewar German Werkbund (the German equivalents of the Anglo-American Arts and Crafts movement). Behne was one of the most influential critics of his generation, though *The Modern Functional Building* was not translated into English until 1996. He was also a critic with significant literary interests, as demonstrated by his place on the executive committee of PEN, the international literary organization. Behne wrote widely on architectural and art historical topics, publishing popular books about contemporary illustrators and writing critical essays in museum studies.[28]

For Behne, the 1890s were a pivotal moment in European aesthetic history, a moment when people shifted decisively in their priorities from form to function. He writes in his Foreword,

> With the turn of the century came a victorious breakthrough: appreciation of light, conciseness, and clarity. It opened people's eyes to the beauty of things suited to their purpose. Defying expectations, sensibilities refused to find beauty in the superfluous and willingly followed the logic of the functional.[29]

It was perhaps a small step from William Morris's famous advice to "have nothing in your houses that you do not know to be useful or believe to be beautiful," to say that beauty and utility were one and the same. The values that Behne praises align with those celebrated in *Towards a New Architecture*. Behne also follows Loos, whom he cites, in diagnosing a change in human nature that is foundational to modernity. Behne describes this change as a shift in emphasis from form to function; in keeping with this belief, and as for many modernists, Behne saw the factory rather than the private home

49

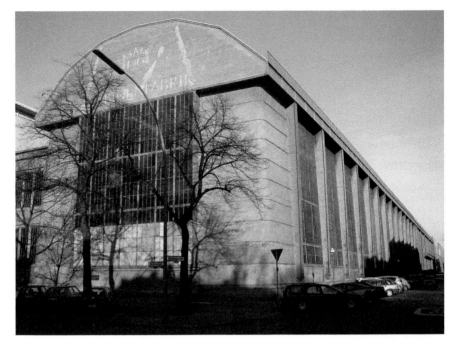

Figure 2.4 Peter Behrens, AEG Turbine Factory, 1909 (2008 photograph).
Wikimedia Commons, Doris Antony –CC BY-SA 4.0.

as best fulfilling the potential of the new architecture. Describing the Turbine Hall (Figure 2.4) designed by Peter Behrens in Huttenstrasse around 1909, he wrote,

> there suddenly emerged an industrial building that was a new type, a new life: no longer a "house," no longer a shed, no longer convention, and no longer a cross between various historical types … Decoration, ornament, and form were swept away. The building was itself form, it needed no forms.[30]

For Behne, functionalism, taken to its limits, succeeded in eradicating past forms. Without applied form, ornament cannot exist, since ornament is nothing but form. This victory of functionalism is most appropriate to the space of work, and specifically machine production, where the requirements of production seemed to dictate its housing. Work of a particular kind should be contained in a space that is purpose-built to support it.

It might seem appropriate to conflate Behne's functionalism with utilitarianism, since his approach to design is practical, impersonal, scientific, and rational. But Behne argues that while the utilitarian approach always favors the practical, the functionalist approach considers the principle of how best to embody function in form. Of course, as Behne concedes, this task cannot be accomplished perfectly: "To be fully consistent the functionalist would make a building into a pure tool. He would necessarily arrive at a negation of form, as he could only completely achieve his ideal of absolute adaptation to the events in a space by means of movement."[31] Functionalism cannot ever achieve its full aim but rather represents a contingent coupling of the requirements of function with the architect's views and aesthetics—and in this sense, it is opposed to the rationality of mass production and urbanism.

In looking at Behne's work, we may seem to be at some distance from Ford Madox Ford's commitment to providing the minimum necessary to express the work of art. Certainly the tone is different—where Ford is playful and elusive, Behne tends toward the prophetic, heralding a new ideology of building. Behne shares with Ford both a belief in the value of austerity and an acceptance of the contingencies that necessarily undermine a perfect realization of principle in a physical creation. Both Behne and Ford eschew ornament, though perhaps for somewhat different reasons connected to their respective fields of practice. These field distinctions will become important when I turn to the novels of Ivy Compton-Burnett, and try to imagine what functionalism and anti-ornamentalism in literature might mean.

As Aaron Kunin has pointed out, as we move away from Loos's ironic mode and into the architectural tradition Loos helped to inspire, the tone becomes increasingly urgent, increasingly serious.[32] In eliminating ornament, Behne might suggest, we do something far more important than choose a style. In the work of the Czech modernist Karel Teige, the elimination of ornament has become a way of lifting the masses out of decrepitude. Teige took the concepts of functionalism, mass production, and related ideas and turned them toward the project of designing

housing for the masses; the result, published in Czech in 1932, was his work, *The Minimum Dwelling.*[33] Teige met both Ozenfant and Le Corbusier in Paris in 1921, a meeting that was formative for Teige—although he later broke publicly with Le Corbusier in the debate known as the "Mundaneum affair."[34]

For Teige, Le Corbusier's monumentality and insistence on aesthetic values like the golden proportion linked back to the tradition of architectural styles, and neglected architecture's responsibility to design for the working classes. Although *The Minimum Dwelling* did not appear until 1932, Teige had declared as early as 1924 that the new architecture should be "antidecorative," functional, and should evolve in dialogue with technology. Teige's notion of "the minimum dwelling" derives less from aesthetic concerns (as in the cases we have considered until now) than from economic ones. *The Minimum Dwelling* attempts to contend with the tremendous housing crisis in eastern and central Europe. Teige is concerned primarily with the population he refers to as the *existenčni minimum*, literally "existential minimum" (a common architectural phrase in Europe), the large portions of the population living at a subsistence level.

Teige's commitment to using modern architecture to improve the lives of workers included a trenchant critique of the actual impact of the rational household on the lives of women. As I discussed earlier, the rational household purported to improve women's lives by importing the principles of scientific management into the home. But Teige was quick to see that efficiency science did nothing to mitigate the outsize share of domestic responsibility that falls upon women. He argues,

> Today's architects and feminists frequently claim that a well-equipped modern household will ease and simplify domestic chores to the point that a working woman will be able to work a full eight-hour day in her profession, manage her household without help, beget and rear her children, and still find enough time to live like a cultured human being . . . Reality has shown that such a lifestyle promoted for a modern working woman is either an absurd delusion or a self-deception fostered by an impotent reformism—if not a cunning fraud. (173)

Early domestic reformers like Christine Frederick, Grete Schütte-Lihotzky, and Erna Meyer tried to convince women that their homes could become like factories and that efficiency would free them from drudgery. Teige, on the other hand, was clear-eyed about the burden imposed on women by bourgeois family life: "If women are to become completely equal with men, they cannot be expected to work simultaneously at two jobs: one in production and the other at home" (173). For Teige, more radical reforms like the collectivization of food preparation and housekeeping and the elimination of the shared spousal bedroom (which he saw as "a hatching place of the most wretched forms of bourgeois sexual life" (163)) were better ways forward. For Teige, modernism offered the chance to design a way out of the retrograde social structures of the nineteenth century and forge a more sanitary, egalitarian, and livable life for all levels of society.

In Teige's vision for minimum dwelling, all decorative items are eliminated, beginning with all the objects of Victorian display—bric-a-brac, breakfront displays, antiques, folkloric talismans, and more. Next to be eliminated are all nonessential pieces of furniture, by which Teige means all furniture not related to the basic human activities of eating, sleeping, and working. Would Teige's "existential minimum" want to live in the built environment he would create for them? Teige's conception of the minimum derives from a functionalist view of private life: "the furniture inventory of a minimum dwelling must be as spare as possible. For this reason, each and every room has to be equipped with furniture that will satisfy its specific dwelling functions" (267). Teige cites Behne, taking Behne's commitment to functionalism beyond architecture and into the realm of everyday life; he treats the activities of daily life as tasks for which the home can be rationally—and minimally—equipped. Economic necessity, fusing the ideals of modernism with practicality and the needs of the workers, drives Teige's pursuit of "minimum dwelling."

Teige's tone drips with frustration and negative judgment of the utopian visions of modern architects whose great plans express their individual vision rather than an understanding of the human needs to be served, and which remain unbuilt works on paper. "Paper projects for

rational and hygienic small apartments are not enough," he exhorts his readers, and yet even for Teige, the elimination of ornament is an aesthetic as well as a utilitarian endeavor (270). Why else would he advise workers to strip the ornament from inherited pieces to reveal the "functional core" of each?

My survey of Loos and his successors describes a movement that began with the expression of a preference for the unadorned—a preference that some subsequent architects saw as a style itself, rather than a rejection of style—and expanded under the influence of the machine age. Though the critics I have cited are chiefly European, their ideas were frequently echoed in the writings of progressive Anglo-American architectural critics. The Welsh critic A. Trystan Edwards, who studied under Reginald Blomfield, questioned the value of architectural ornament in his 1926 book *Architectural Style*: "It may be a quite useful exercise to try to design buildings entirely without ornament."[35] Howard Robertson, who was born in Utah and wrote and practiced architecture in England, argued in 1932 that "A great deal of ornament is termed 'meaningless.' It may be so because its general character has no particular relationship to the type of building on which it is placed; but a more serious criticism is the lack of its significance in relationship to the general scheme of the design."[36] Lewis Mumford, the great philosopher of early twentieth-century urbanism and architecture, wrote in his 1934 work *Technics and Civilization* that

> The aim of sound design is to remove from the object, be it an automobile or a set of china or a room, every detail, every moulding, every variation of the surface, every extra part except that which conduces to its effective functioning. Toward the working out of this principle, our mechanical habits and our unconscious impulses have been tending steadily.[37]

For Mumford, the movement to eliminate ornament was part of a broader cultural drive that extended to every aspect of design and architecture, and even operated on an unconscious level. The elimination of ornament was bigger than any single form of cultural, or even industrial, production. It was the next step in the evolution of aesthetics.

These ideas might seem to fit incompletely with literature, if at all, and yet they were stimulating and relevant for a number of early twentieth-century writers, who developed in various ways what we might, following Teige, call "minimum writing." Writers who created a practice of minimum writing were up to something more specific than what Baker broadly terms "any stylistic austerity in the arts." They both were influenced by and contributed to ideas about terms of common interest to writers, architects, and designers: rationalism, functionalism, and mechanization. These notions, together with the doctrine of anti-ornament that contained a belief in its own cultural and moral superiority, offered an appealing framework for writers at the time. A range of modernist writers worked with these concepts in diverse and interesting ways, beginning with some who might be considered the obvious prospects for such an inquiry—Ford Madox Ford, Ezra Pound, and Ernest Hemingway—and ending with a less predictable figure for inclusion in this group, the novelist Ivy Compton-Burnett.

I am arguing, in other words, that the practice of concision in writing has its own history, such that "stylistic austerity" (or, to return to my preferred term, "minimum writing") imparts different cultural values and takes different forms at different times. Specifically, minimum writing had a particular urgency in the early twentieth century as the many facets of the minimal came to acquire the force of a moral agenda. This agenda derived from issues including Loosian concerns about cultural progress, the imperative to provide livable urban housing, and the migration of efficiency and rationalization from the workplace into private life.

To see the shared Machine Age values between architecture and writing we need look no further than the central statement of the most famous rhetorician of modern times, William Strunk, who in the original 1918 edition of *The Elements of Style* (which E. B. White reworked decades later) advised,

> Vigorous writing is concise. A sentence should contain no unnecessary words, a paragraph no unnecessary sentences, for the same reason that a drawing should have no unnecessary lines *and a machine no unnecessary parts*.[38]

Strunk's guidance to writers was later to be itself condensed into "omit needless words," but the original formulation explains the reasoning for the famous dictum. What is the "reason"—which Strunk finds so obvious that he does not provide it—that machines should not have "unnecessary parts"? The design of a machine is understood to derive wholly and exclusively from its function. If a part is not needed to render the machine functional for its purposes, then that part should be omitted.

In drawing an analogy among machines, drawing, and writing, Strunk assumes that the same functionalist principles can apply to all three practices, going one step beyond Ford Madox Ford's call in 1914 for a shared commitment to the minimum in drawing and writing. Strunk's third term, the machine, supplies what was an unstated part of the model for Ford as well. Le Corbusier points out, in his reframing of Loos, that it is the logic of the machine that gives rise to functionalism. Sigfried Giedion argues that the impact of mechanization on all aspects of human life is incalculably large: mechanization, he writes, "impinged upon the very center of the human psyche, through all the senses,"[39] and without a doubt mechanization impinged on areas with which its principles were imperfectly aligned. Strunk might have contended that rhetoric has the function of argument, and on that basis connected its successful practice to the functionalism of mechanization. By contrast, the idea of a functionalist literature cannot be understood literally, since there is no ready consensus to be had on the function of literature.

Strunk offers a famous example of how principles of rationalism, functionalism, and mechanization transfer into writing, but modernist literary history offers many other examples. The correspondence between Ford Madox Ford and Ezra Pound shows Pound trying out similar ideas and seeing how they might be embodied in literary practice. Here is Pound writing to Ford in September 1920: "Structure, inner form, (thence departmentalization, which ultimately demands a metric, a rhythmic organization, each part necessarily of the whole, just as in prose (H.J[ames].) *each word must have its functioning necessary part.*"[40] In the same vein, Pound writes to Ford in May 1921: "the writer shdnt have his *citron* filled with semblable

clots of ancient furniture sentimental, traditional, purely decorative et bloody cetera."[41] Old furniture becomes a reference point for Pound through which to make the case for a modern minimal writing. He toggles back and forth between the lexicons of literature and design, treating them as interchangeable.

Pound's phrase "each word must have its functioning necessary part" is especially evocative, taking the words of a piece of writing as analogous to the parts of a machine, comprising a unity that, taken together, fulfills a particular function. Ford expresses his view in his 1932 introduction to the Modern Library edition of Ernest Hemingway's *A Farewell to Arms*, where he praises Hemingway because "he had then and still has the discipline that makes you avoid temptation in the selection of words and the discipline that lets you be remorselessly economical in the number you employ."[42] The notion of economy that Ford brings into the discussion of minimum writing is also central to Le Corbusier and Ozenfant in formulating the doctrine of Purism. They commingle economy and mechanization, as we have seen, arguing that a culture organized around the values of the machine leads "to the strictest respect for, and application of, the laws of economy." Pound confessed that Ford taught him respect for minimum writing using, appropriately enough, no words at all. When Pound, in 1911, shared with Ford a new book of poems that Pound wrote in Provençal forms and using an ornamental vocabulary, Ford fell down laughing and rolling on the floor. "That roll," Pound later recalled, "saved me three years."[43]

For Pound and his circle, poetry could and should respond to the inspirations of the machine age. As such, poetry needed to move away from heroic and grandiose themes and focus on everyday life—a shift that parallels Le Corbusier's emphasis on the *objet type*. Additionally, as Pound expressed in his Imagist principles, poetry should use "absolutely no word that does not contribute to the presentation." Literature's function, in this familiar formula, is *to present*, and each offered word must be tied to that function. Pound's well-known account of the composition of his two-line 1913 poem "In A Station of the Metro" can be read as an exercise in minimal

writing achieved through the elimination of excess words rather than the initial articulation of the fewest possible. Pound's origin story for the poem is as follows:

> I wrote a thirty-line poem, and destroyed it because it was what we call a work "of secondary intensity." Six months later I made a poem half that length; a year later I made the following hokku like sentence:—
> 'The apparition of these faces in the crowd:
> Petals, on a wet, black, bough.'[44]

In Pound's account, he begins by *writing* a thirty-line poem, but as he goes through the process of refining the poem to its minimal form, the verb shifts to *making*, a somewhat unusual choice: "I *made* a poem half that length...I *made* the following hokku like sentence." The shift from "writing" to "making" is a shift from art to craft, a shift to technics that aligns Pound with other makers: inventors, engineers, designers.[45] The poem itself depicts life in the underground machine-world created by the makers who built the Paris subway station, life that seems vitiated and dead, but also compelling and beautiful. Pound's composition process argues that the elimination of words makes the poem stronger and more intense; its lack of transitions also allows the reader to receive the poem as an image in an instant of time. In the same essay Pound comments, "One is tired of ornamentations, they are all a trick, and any sharp person can learn them." There is something honest for Pound in the elimination of ornament.

Cutting "unnecessary" text might be seen as equivalent to the architectural elimination of ornament. Pound's two-stage editing of his "Metro" poem, which extends over eighteen months, depicts composition as a thoughtful process of condensing language until each word carries maximum impact and meaning, and also paring away any inessential word. What falls away is continuity and transition; critics have commented that this poem's static quality derives from its lack of verbs and time markers. Although the second line of the poem is arguably an analogy to the first, there is no "like" or "as" in the structure; a colon serves as both an implicit structure of comparison and as an intensifier.

If the story of the composition of "Metro" is one of the great anecdotes of Anglo-American modernism, another is the story of Pound's edit of T. S. Eliot's *The Waste Land* (1922). Pound removed the narrative sections from Eliot's original manuscript: the first fifty-five lines of "Burial of the Dead," the seventy-two lines of Fresca's morning toilette from "The Fire Sermon," and eighty-three lines—almost the entirety—of the "Death by Water" section.[46] In Pound's notes on the manuscript he pushes Eliot to greater precision and tautness, writing in the margins of "The Fire Sermon" comments including "Too loose" and "rhyme drags it out to diffuseness."[47] Later in this section of the poem, he boxes the word "Perhaps" and comments "Perhaps be damned." Pound similarly boxes and crosses out "may" in Eliot's characterization of the typist's post-coital blear: "Across her brain one half-formed thought may pass." His marginal comment is even more decisive in pushing Eliot to clarity: "make up yr. mind. You Tiresias if you know know damn well or else you don't."[48] Pound's drastic cuts to *The Waste Land* and push for the elimination of wordiness and equivocation resemble his editing process for "Metro," cutting whatever can be construed as extraneous and praising whatever in the poem is most Eliotic. His greatest term of praise in his marginal comments is "Echt"—meaning most authentic, truest to the spirit of the whole.

I call attention to Pound's editorial comments not because *The Waste Land* is the best possible example of minimum writing, but to stress the implicit value that literary modernists placed on clarity of function in writing, and on the elimination of the extraneous. Like Le Corbusier, Pound loved precision. Pound's approach to instilling functionalism in literature was primarily formalist, but many other writers treated the topic more thematically. Edith Wharton, for instance, made the narrator of her 1911 novel *Ethan Frome* an engineer, one who used, in Wharton's words, "economy of expression."[49] Wharton was well aware of contemporary debates in architecture and design, and was co-author, with architect Ogden Codman, of *The Decoration of Houses* (1897). Kunin has also shown the prevalence of anti-ornamentalism in texts such as Charlotte Perkins Gilman's "The Yellow Wallpaper" and Henry James's "The

Jolly Corner," both of which define ornament as a restraint on the individual's spirit.[50]

Probably no modernist writer is more closely associated with economy of expression than Ernest Hemingway. Hemingway has close ties with the writers I have been discussing; as a young writer he was mentored by Pound, and Hemingway also worked with Ford Madox Ford on *The Transatlantic Review*. Some refer to Hemingway's famed concision of expression as the "iceberg theory" because of Hemingway's own descriptions of his method. In his 1932 work on bull-fighting, *Death in the Afternoon*, Hemingway explained,

> If a writer of prose knows enough about what he is writing about he may omit things that he knows and the reader, if the writer is writing truly enough, will have a feeling of those things as strongly as though the writer had stated them. The dignity of movement of an ice-berg is due to only one-eighth of it being above water.[51]

Critics have adumbrated a number of different influences to account for Hemingway's minimal writing practice. Some credit Hemingway's early career as a journalist and the emphasis on brevity associated with daily media, while others cite Hemingway's invocation of Henry James's 1915 statement that World War I had defeated language: "The war has used up words; they have weakened, they have deteriorated like motor-car tires."[52] James's analogy between words and motor-car tires suggests that he, like the other writers I have been discussing, connected language and writing with mechanization. At the same time, James's ornate prose seems far removed from Hemingway's declarative, sparse style.

Hemingway also drew analogies between his own form of cultural production, writing, and architecture. He asserts, "Prose is architecture, not interior decoration, and the Baroque is over."[53] This multi-layered statement allies prose with the structured, functional practice of architecture and eschews the more frivolous and ornamental practice of decoration. As I argue in Chapter 6, Woolf also connects writing and architecture

on the basis of structure, but while Woolf looked to architecture for ideas about form she could translate diversely into her writing, Hemingway pursued a more unified and consistent voice. He rejects decoration because of its association with femininity, represented here by the fabulously ornamental Baroque style, and perhaps more specifically with late Baroque Rococo. Hemingway describes his writing in similar fashion in the posthumous *A Moveable Feast*: "If I started to write elaborately...I found that I could cut that scrollwork or ornament out and throw it away."[54]

For Cecelia Tichi, in her suggestive 1987 book *Shifting Gears*, Hemingway's rejection of architectural ornament comes from his commitment to functionalism. "From the bullfight to camping," she writes, "this aesthetics of mechanism is part of Hemingway's deliberately efficient style...He reduced the sentence to its essential, functional components. The famous Hemingway style was essentially the achievement, in novels and stories, of the engineers' aesthetic of functionalism and formal efficiency."[55] Tichi's account of Hemingway captures the writer's interest in work process, the analysis of the sequence of tasks that lead to catching a fish, slaying a bull, or, for that matter, writing. To assess whether Hemingway's writing has "formal efficiency," on the other hand, would mean the use of the fewest words possible to convey his meaning.

Hemingway's often-imitated style employs relatively short, declarative sentences and simple words, frequently repeated. David Lodge quotes from Hemingway's "In Another Country" of 1927 and notes that Hemingway employs "very repetitive syntax, stringing together declarative sentences without subordinating one to the other."[56] Hemingway's use of repetition appears at odds with the doctrine of efficiency (though repetition, as I discuss in Chapter 4, is central to standardization and mass production) and limits the direct application of such principles to literature, which is not a machine. If we treat minimal writing as a practice in dialogue with architecture rather than dictated by it, we can allow for literature's difference. Consider, for instance, one of Hemingway's brief descriptions of his writing process in *A Moveable Feast*:

> I sat in a corner with the afternoon light coming in over my shoulder and wrote in the notebook. The waiter brought me a *café crème* and I drank half of it when it cooled and left it on the table while I wrote. When I stopped writing I did not want to leave the river where I could see the trout in the pool, its surface pushing and swelling smooth against the resistance of the log-driven piles of the bridge. The story was about coming back from the war but there was no mention of the war in it.[57]

As Tichi observes, Hemingway is sensitive to process, including his own writing process, and carefully sets out the conditions that enable his writing—a café, a drink, lack of interruption. Hemingway's fidelity to process seems related to the doctrines of mechanization—the breaking down of a task into its constituent parts, the rationalization of work, and most evidently here, the inseparability of process and product.

However, the above passage could have been written more efficiently—if Strunkian concision, using the fewest words possible, is understood as the measure of verbal efficiency. There are, however, other ways of understanding Hemingway's approach to minimum writing. The lack of punctuation, for instance, induces a monotonous pacing that accords with the rhythms of mechanization. Further, Hemingway's affinity for monosyllables calls particular attention to any passage that includes longer words. In the excerpt above, this happens when Hemingway moves from describing the café where he is writing, to describing the fish of his story. In describing the café, Hemingway clusters the word "it" ("I drank half of it when it cooled and left it on the table"), a usage that is gratuitous grammatically, but establishes an emptiness that is then filled in the next sentence by the image of the trout. Hemingway writes of the trout's "surface pushing and swelling smooth against the resistance of the log-driven piles," creating a contrast between the pedestrian setting of the café and the vivid and lyrical world he describes. The description of the trout is also set off by the only punctuation (besides periods) that Hemingway employs in the passage.[58]

If the function of language is to convey meaning, Hemingway's distinction between the drabness of the quotidian and the intensity of fiction is

formally enacted in this passage by his choice of words that vary from banal ("it") to vivid ("pushing and swelling"). The quickly shifting rhythms, from the static chop of the description of the coffee service to the lyrical language employed for the trout, emphasize the gap between the two descriptions. The coffee stands still and the imaginary fish swims, a contrast that plays out through rhythm, vocabulary, and syntax, so that the form of the language follows its function.

In addition to this expression of functionalism, Hemingway follows Ford (whom he disparages in *A Moveable Feast*) and Pound in his philosophy of literary omission.[59] The absence of "ornamental" language in Hemingway's work has been well documented; he uses few adjectives or adverbs. But Hemingway's elimination of excess language goes further than this; though Hemingway is writing a story meant to convey his ideas about coming back from the war, he points out in the above passage that "there was no mention of the war in it." Leaving out almost any mention of the central subject, though it might sound self-defeating for a writer, is a recurrent practice in literary modernism, employed in different ways by Henry James in "The Figure in the Carpet," by Ford in *The Good Soldier*, by Beckett in *Waiting for Godot*, and by Woolf in her recurring image of a defining central emptiness.

Hemingway's characteristic omission of the central subject of his narrative takes place, Adam Gopnik has argued, through deliberate excision rather than organic absence. Gopnik argues, "The art comes from scissoring out his [Hemingway's] natural garrulousness, and the mystery is made by what was elided."[60] Gopnik makes his case by looking at the words and phrases Hemingway strikes out of his manuscripts, a practice which recalls Pound's approach to editing, but also the philosophies of Loos and Le Corbusier, eliminating ornament so that primary forms can emerge. As in the case of Le Corbusier's whitewashed walls, the omitted continues to manifest as a ghostly presence, impossible to eradicate completely and becoming the crucial subtext of the story.

Hemingway's prose is also, in Strunk's terms, "a machine with no unnecessary parts"; it is writing that calls attention to its own function as

writing. Hemingway shares this attribute with his contemporary architects and designers, a joint commitment to forge aesthetic practices that eliminate the nonessential and that flaunt their austerity. In the remainder of this chapter, I want to turn to the work of a writer who is not readily identified with the kinds of aesthetic programs shared by Ford, Pound, and Hemingway: the British novelist Ivy Compton-Burnett. Though Compton-Burnett shared with Hemingway an affinity for telling a story through dialogue, she shared little else. She wrote domestic fiction exclusively, often set in Edwardian enclaves into which modernity scarcely seems to have intruded. Hilary Spurling has written that "Membership in the [Modern] movement was hardly a claim Compton-Burnett would have cared to make, nor indeed one that could reasonably be made on her behalf."[61]

I want to take up the work of Compton-Burnett in part because she may seem an unlikely figure to associate with minimum writing, though I believe her work can be productively interpreted through this lens. Until this point, my aim has been to reanimate the interarts conversation in the early twentieth century about the rejection of ornament and the rise of functionalism, and to show how these ideas informed modernist literary practices. In turning to Compton-Burnett, I will look in greater detail at the formal expression of minimum writing in modernist prose, both to understand how it is informed by contemporary architectural discourse, and to explore the place of modernist minimum writing within the larger world of literary modernism.

Compton-Burnett began her writing career at the age of 41, with the 1925 publication of *Pastors and Masters* (excepting the 1911 *Dolores*, later disavowed by its author) and published almost twenty additional novels before her death in 1969. Born in 1884, she grew up in Middlesex as one of twelve children, attended boarding school, and went on to pursue a Classics degree at Royal Holloway. Her family was marked by tragedy: her brother Guy, with whom she was particularly close, died in 1901 of pneumonia; another brother was killed at the Battle of the Somme. In 1917, two of her younger sisters died together in a suicide pact. None of her eleven siblings had children, and all eight of the girls remained unmarried.

Though Ivy Compton-Burnett did not marry, in 1919 she joined house-holds with the woman who was to be her lifelong companion, the furniture and design historian Margaret Jourdain. Jourdain had already begun her own career as a writer when she moved in with Compton-Burnett. She began by ghost-writing the text for a book on English mansions, but thereafter published under her own name, starting with her 1922 work, *English Decoration and Furniture of the Later XVIIIth Century (1760–1820)* and followed by numerous other works on topics in eighteenth-century furniture and decoration, a field she helped to create. She also was an active journalist, writing in the 1920s for magazines including *Country Life*, *Burlington Magazine*, and *Apollo*.

As a design historian, Jourdain did not comment on contemporary trends in architecture and decoration. But her focus on the eighteenth century was driven by a personal preference for simplicity and minimal ornament. As James Lees-Milne and Spurling note, Jourdain "spearheaded a shift in taste away from Victorian ostentation, fussiness, and clutter to an earlier simplicity and severity.... She was the first to rediscover English Palladian design."[62] Her belief that decorated interiors can only be understood in relation to their historical moment animated all her writing; for example, her posthumous work, *English Furniture: The Georgian Period*, opens with the categorical pronouncement, "English furniture derives its style and character from English social history."[63]

Jourdain's enthusiasm for Georgian design derived in part from a growing consensus that the unornamented Georgian home could provide a model of minimum dwelling for the government's large-scale postwar housing expansion. In 1918, J. Alfred Gotch noted that

There are indications that after the war a vast number of workmen's dwellings will have to be built. A survey of the domestic architecture of the last three hundred years is fruitful of suggestions for this undertaking, although it will be one demanding little or no ornament. Such a survey points ... to treating the houses themselves with a simplicity corresponding to the simplicity of their requirements. The smaller Georgian houses which we find so charming, furnish admirable suggestions.[64]

Gotch seems to anticipate modern architects in their desire to use architecture to deal with the tremendous need for sanitary, affordable housing, though he looks back to the Georgians and most European modernists could look to their contemporaries. Gotch's comment provides a context to Jourdain's preferences for the Georgian and Palladian styles, associating the rejection of ornament with economy, rational design, and modernity.

I begin my discussion of Compton-Burnett with a consideration of Jourdain's career for a number of reasons. First, Jourdain's career suggests that Compton-Burnett was involved, on a daily basis, in conversations about design aesthetics both with her companion and with the large circle of scholars and critics with whom Jourdain worked; she had many collaborators and protégés and the couple entertained frequently in their South Kensington flat. In addition, I want to recapture the interarts conversations that underwrote the modernist ambition to see art as a gateway to an entirely reimagined daily life. Bringing to light the web of connections between literature and other fields shows the conduits along which shared ideas could and did travel.

Finally, placing Compton-Burnett's work in relation to that of her partner captures how modernism was forged through partnerships and alliances that enabled disciplinary cross-fertilization. Pound's comments on Eliot's manuscripts pushed Eliot to greater linguistic density and concision and created a new kind of functionalism in literature, activated in part by Pound's interest in art, architecture, and design. What Jourdain and Compton-Burnett shared, by contrast, was a discipline of expression, in which the writer's viewpoint was scrupulously withheld. Jourdain, lively and opinionated in person, sticks to the facts in her historical work; Compton-Burnett's work can be disorienting for readers, who feel they have been dropped into the social world of her novels without a guide or point of reference. Her novels have a notable absence of narration and are composed chiefly of dialogue, with so little background provided that readers must independently construe both relations between characters and signal events on the basis of vague and indirect character speech. Compton-Burnett's writing is minimal because its author seems absent,

offering the reader little in the way of explanation, moral guide, setting, or transition. Similar to Ford, Compton-Burnett seems to have set herself to give the reader "the fruits of [her] observations and the fruits of [her] own observations alone."

Commentators have assimilated Compton-Burnett's work to the Edwardian world it depicted. Elizabeth Bowen contended that Compton-Burnett was "not merely copying but actually continuing the Victorian novel" and Phillippa Tristram argues that the novels of Compton-Burnett "are not only set in the nineteenth century, but conceived in its terms."[65] These claims seem off the mark, though perhaps suggested by the Edwardian interiors and large insular families that are staples of Compton-Burnett's work. But Compton-Burnett's novels disorient and defamiliarize the reader in ways that are distinctively modern; if the setting is Victorian, the form and content are not.

Jourdain's criticism, as I have discussed, focused exclusively on period styles. But in her papers, archived uncatalogued at the Victoria and Albert Museum (V&A), many direct encounters with modernism can be found: quotations from books copied out in Jourdain's hand, newspaper articles clipped and saved, and her own notes on modern design, forming an unbound commonplace book.[66] In explicating Compton-Burnett's approach to minimum writing, I have interspersed some items from Jourdain's archive to suggest the ideas shared across the different genres of their work. By taking account of the passages that Jourdain saw fit to copy out and preserve, we can discover, among other things, evidence that Jourdain and Compton-Burnett were well aware of and engaged by modernist ideas.

Compton-Burnett's first mature novel, *Pastors and Masters*, was not published until its author had left behind her complex family, was six years into her life with Jourdain, and had reached the age of 41. Perhaps Compton-Burnett thought she would never launch herself as the writer she finally became. The novel presents many characters who feel for different reasons that they have not accomplished enough, but its central story of regret belongs to 70-year-old Mr. Herrick, who styles himself a writer, albeit a

critic rather than an author of original works. Compton-Burnett provides close to no authorial commentary in her novels on the interior lives of her characters, but we are given one sentence of insight into Mr. Herrick: "Herrick lived in his disappointment that in letters he had done only critical work."[67]

The plot of *Pastors and Masters* is generated by Herrick's announcement in one of the opening scenes that he has at last conceived a book, "turning real author at seventy" (20), an event he says was triggered by the recent death of his friend Crabbe at the age of 90. The book, Herrick goes on to say, at present has no words, but rather is a shape held in its author's mind. "I have been letting it grow in my head. Because of course in a way it has been there for some time. It was the form of it that flashed on me" (21). The entirety of the book, he explains, "came upon me" (70).

Though we may not give much regard to a book that has no existence on paper—and indeed never finds more tangible expression in the novel—the idea of a book that has only form and no content is one that might make sense in the modernist context, where form is paramount. Virginia Woolf offers a related sentiment in *A Room of One's Own*, where her speaker explains "a book is not made of sentences laid end to end, but of sentences built . . . into arcades or domes."[68] If Herrick has visualized the arcade or dome in his head, then he can readily select his sentences to fit the shape. The book grown in his head might be compared to a structural design with no cladding, no detail, no flesh, an image discoverable in Jourdain's papers in a passage that Jourdain copied out of C. Delisle Burns's 1938 work, *The Horizon of Experience*, adding her own title: "Modern architecture" (Box 2.1). Like the building in the passage Jourdain copied out, Herrick's book exists only in structure (form), and has no decoration (words).

There are other models of writing in *Pastors and Masters* of a more quotidian variety, though they are less significant to the story than Herrick's mental novel. The Reverend Henry Bentley writes after breakfast, and the narrative tells us that "Mr. Bentley's writing was held to have bearing on his property, and it gave him the position of the breadwinner" (58). Herrick's sister Emily tells us that she keeps a diary that will not outlive her; she says,

BOX 2.1 MODERN ARCHITECTURE

Architecture has often been wrongly conceived to be in the decoration rather than in the structure of the [*sic*] building. In a certain architectural exhibition in New York there was a drawing of a steel structure, in reference to which the official guide remarked that "the architecture had not yet been put on."

C. Delisle Burns, *The Horizon of Experience*, 1938, p. 157

"I must put in my will that it is to be destroyed at my death" (80). These writings are sentence-to-sentence, undertaken on a daily basis, and with no formal ambition. They serve quotidian ends and cannot ensure their authors' immortality in the way that a book like Herrick's can—or could, were it able to be translated onto paper.

In the end of *Pastors and Masters*, the feat of a book that is pure form remains unrealized in material reality. On the day that Herrick has offered to read his book out loud to his friends and family, he refuses to go forward and the reader is left to suspect that the book will remain suspended in immanence. Compton-Burnett herself, one would imagine, carried the form of her books in her head for some time. Her entire body of work has remarkable consistency and originality of form, and critics have pointed out that the same sentences recur almost exactly in different novels, creating a practice of repetition that unexpectedly ties her to writers like Hemingway. The titles of the works seem interchangeable as well, almost always involving a word pair and alliteration or internal rhyme: *A House and Its Head*, *Brothers and Sisters*, *A Family and a Fortune*, *A Father and His Fate*, *A God and His Gifts*, *Manservant and Maidservant*, and so forth.

Is *Pastors and Masters* for Compton-Burnett what Herrick's book might have been for him? It is tempting to read *Pastors and Masters* as, among other things, an allegory for Compton-Burnett's own anxieties of writing (and not-writing) and attempt to realize, in sentences, the idea of a book she may have long carried in her head. The text abounds with descriptions of individuals who neglect their duties, who feel they have wasted their

lives, and who cannot write despite their ambition to do so. "'I never look back on my life,' said Emily. 'It seems to be lacking in too much'" (16), we hear in Emily's first appearance. And yet she seems to do very little but look back with regret. In the same vein, one of Herrick's friends, Bumpus, tells us, "I have wanted to write all my life, felt it was this, it was mine to want. And it seemed not to come to me, after the early time when things happened as we know" (25).

In the books Compton-Burnett went on to write after *Pastors and Masters*, she enlarged upon her practice of minimum writing, keeping authorial narration to a minimum, building her novels almost out of dialogue alone, and dispatching major events so quickly that the reader can easily miss them. Indeed, Compton-Burnett's minimum writing never lets readers forget that they are reading, so acute an attention do her works demand. I noted with amusement that every copy of her novels that I borrowed from my university library had a reader's list of the *dramatis personae* penciled in the endpapers, in what seemed an attempt by an anonymous reader to keep track of characters who appear without much introduction and then can disappear for many pages, resurfacing without preamble. Compton-Burnett's minimum writing here dovetails with the modernist dictum of difficulty, and modernist writers' general willingness to make reading arduous and confusing.

My reading of *Pastors and Masters* amounts to a thematics of minimum writing, embodied in the text through a book that is never written down. In turning to Compton-Burnett's 1933 novel *More Women than Men*, I offer an analysis of the forms that minimum writing takes in Compton-Burnett's works and connect these forms to notions of rationalism, functionalism, and mechanization. Such terms may seem to go against the grain of Compton-Burnett's period Edwardian settings and reproduction of period customs and manners. But that is where Compton-Burnett's relationship to modernism can be found—in her formally innovative treatment of a pre-modern social world.

Like *Pastors and Masters*, *More Women than Men* has an academic setting. The novel is set in an all-girls' school located "in a prosperous English

town" and run by the 55-year-old Mrs. Josephine Napier, whose life is at the center of the work. The school is successful, and sustains a community of the mostly unmarried women who are its resident teachers. Also in residence are Mrs. Napier's husband, Simon, and her nephew, Gabriel, whom she has raised as her son. Nearby lives Mrs. Napier's brother, Jonathan Swift, who shares his home with a former pupil, Felix Bacon, and a boarder, Mr. Fane. Their little social world is upended by the late-night unexpected arrival of an old friend of the Napiers, Elizabeth Giffard, who has fallen on hard times and whom Mrs. Napier offers a post as housekeeper, leading to a series of complicated relationships and discoveries that include two weddings, two deaths, two bequests, and general upheaval.

Despite this impressive lineup of events, the novel mainly consists of people sitting around talking indoors. As we saw with Hemingway, Compton-Burnett's writing is heavy with repetition, echoing words in her dialogue from one speaker to another. In the following short example, Felix, Jonathan, Simon, and Fane chat during the all-male after-dinner interlude:

> "I don't believe in *sex distinctions*," said Felix.
> "Ah, a wise woman knows we cannot *manage without them*," said Fane.
> "I always *manage without them*."
> "I *saw you* open the door for Mrs. Napier."
> "But I did not *see you*. And you and she do believe in *sex distinctions*. You both keep explaining it. I was adapting myself to others. And I don't call that a *sex distinction*."
> "*Living in a stream* of women as you do, you must be qualified to judge," said Fane to Simon.
> "*Living in the stream?*" said Simon, looking up. "I should rather say that I watch it flowing, and every now and then get touched by the spray."[69]

As my italicizing of the repetitions within this passage is meant to indicate, the characters pick up on each other's words and pass them back and forth like balls. The lack of consistent authorial tagging of character speech

means that we cannot always be sure who is speaking, adding to the sense that one line of dialogue blurs into the next. Compton-Burnett practices minimum writing by eliminating almost all authorial intrusion and letting her characters tell the story by themselves.[70]

The repetition within Compton-Burnett's dialogue is also a form of minimum writing, since it offers an extreme economy of words, reusing words rather than introducing new ones. This form of repetition happens not just across different characters, as above, but also within the speeches of single characters, as when Mrs. Napier explains to her husband why she has offered Elizabeth Giffard, her husband's long-ago love interest, the job of school housekeeper:

> That is what she wanted. That is what I perceived her to want. That is what I ought to have perceived before. That is what I offered to her, when I perceived she wanted it. That is what she forgave me for not offering, when she accepted it. Well, is that all you want to know? (53)

In this speech, repetition is not limited to the recurrence of particular phrases ("That is what," "I perceived") but also enacted through the repeated use of particular grammatical structures like infinitives ("to want," "to have," "to know"). Mrs. Napier progressively refines her point as she explains how she and Elizabeth Giffard moved toward a mutual understanding and agreement around Mrs. Giffard's desire, Mrs. Napier's perception of that desire, and their employment contract. Mrs. Napier's clipped parallel sentences convey both economy and repetition, implicitly making the case to her husband that her response to Mrs. Giffard is logical rather than emotional. In fact, Mrs. Napier is really battling back against the accusation that, decades ago, she kept her husband from the knowledge that Mrs. Giffard had been widowed. Her mechanistic and logical diction, together with her minimal means of expression, suggest that she is incapable of acting other than reasonably.

As a narrator, Compton-Burnett keeps her expressions to a minimum not just in dialogue scenes but also when significant events occur in the

novel. Her authorial restraint is keenly in evidence in the two scenes of violent death that take place in *More Women than Men*, both instigated by Mrs. Napier. In the first, during a school open day, Mrs. Napier asks Mrs. Giffard to go and fetch a portfolio of drawings to show to one of the visiting parents. Mrs. Giffard bridles under Mrs. Napier's authority ("I am yours to command, as we are both aware" (100)) and to irritate Mrs. Napier, Mrs. Giffard asks Simon Napier to accompany her on the errand. Not trusting the two alone together, Mrs. Napier goes to check on the pair, and finds Simon climbing a ladder to take down the portfolio:

> Simon steadied himself on the ladder where he stood and turned toward Elizabeth. A step was heard at the door, Josephine's step; and Elizabeth sprang away from the ladder, unconscious that she held it, unconsciously tightening her hold. Its balance was shaken, and it fell to the hearth, carrying Simon with it, and casting his head against the marble curb.
>
> Josephine entered and started forward to her husband, who lay as he had fallen. The two women bent over him together, stood up together, and faced each other, as the truth was flung upon them . . . (102)

This is minimal writing, with only one adverb and one adjective in the entire passage. Simon Napier, the character who meets his death in the passage, is not granted any perspective at all, and seems more object than person. The repeated use of the passive voice contributes to the passage's extraordinary impersonality, such that no agency at all is ascribed to what might plausibly be characterized as manslaughter, if not a plain murder of opportunity. The passage describes the ladder acting seemingly of its own behest: "its balance was shaken, and it fell to the hearth," but Elizabeth Giffard who pulls the ladder out from under Simon, causing him to fall to his death, perhaps because of Josephine's entrance.

Another element of the passage's impersonality lies in the absence of excitement or emotion; the tone is cold and impersonal, despite both the extremity of the event and its proximate causes—Mrs. Napier's fear and jealousy, Mrs. Giffard's shock and guilt, and Simon's traumatic pain and death. The women's feelings are what combine to bring about the events of

the scene, but go unmentioned; Compton-Burnett instead composes a tone that is rational, measured, and detached. Her word choices around the violence are so restrained as to efface the event; it is the ladder, not Simon, that falls; Simon is merely carried with it. His head is cast against the hearth, not shattered or broken.

Compton-Burnett's minimum writing in this passage also vacates authorial perception and judgment, prerogatives ceded to her characters. In what might be seen as a version of Ian Watt's delayed decoding, we watch as Mrs. Giffard and Mrs. Napier come to recognize the fact of Simon's death. This recognition takes place not while they examine Simon's body, but subsequently: "The two women . . . faced each other, as the truth was flung upon them . . .". "Flung" is perhaps the word of greatest violence in the entire passage, and it refers not to Simon's fall but to Mrs. Giffard's and Mrs. Napier's mutual realization, a truth they learn from each other as much as from Simon. The two women, not the narrator, come to the truth and they derive from one another as much as from the corpse beside them.

Parallels to Compton-Burnett's approach to minimum writing can be found in the work of other British writers trying to articulate a modernist aesthetic program that extends across the arts. In Clive Bell's 1914 polemic *Art*, from which Margaret Jourdain copied out a lengthy passage that I have reproduced below, Bell argues strenuously that architecture must not be ornamental; to continue to mount decoration on the facades of modern buildings is an absurd display. Again, Jourdain has given the passage her own title, perhaps as a way of remembering why she thought the passage worth copying (Box 2.2).

The term Bell put forward as the guiding principle for all modern aesthetics is "significant form," meaning that form alone should signify and provoke feeling in the observer. It should be noted that Clive Bell was not primarily known as a critic of architecture. Bell, together with Roger Fry, were largely responsible for bringing Post-Impressionist art to the attention of the British public through gallery shows, journalism, and other vehicles. As a member of the Bloomsbury Group, Bell's views were

BOX 2.2 BELL ORNAMENT IN ARCHITECTURE

You have only to look at almost any modern building to see masses of elaboration and detail that form no part of any real design and serve no useful purpose. Nothing stands in greater need of simplification than architecture, and nowhere is simplification more dreaded and detested than among architects. Walk the streets of London; everywhere you will see huge blocks of ready-made decoration, pilasters and porticoes, friezes and facades, hoisted on cranes to hang from ferro-concrete walls. Public buildings have become public laughing-stocks. They are as senseless as slag-heaps and far less beautiful. Only where economy has banished the architect do we see masonry of any merit. The engineers, who have at least a scientific problem to solve, create, in factories and railway-bridges, our most creditable monuments. They, at least, are not ashamed of their construction, or at any rate, they are not allowed to smother it in beauty at thirty shillings a foot.

the subject of many discussions among his circle, which included the painters Vanessa Bell and Duncan Grant, the writers Virginia Woolf, Leonard Woolf, and E. M. Forster, and many others. The question of ornament, for instance, was not specific to architecture, but potentially germane to all forms of cultural production at the time.

Bell and Compton-Burnett share a preference for restraint in authorial gesture. Architects, says Bell, should refrain—even when economy does not demand it—from the excesses of decoration. They should deploy design in the service of function and function alone. Compton-Burnett is not limited in her words by economy, surely, but her work uses understatement, minimal writing, repetition, and muteness, and rejects décor and authorial embellishment. It is more than a little ironic that Jourdain copied the quotation from Bell on the back of what appears to be stationery from the British weekly *Country Life*, a journal dedicated to British country society. Jourdain began writing about the decorative arts for *Country Life* in the 1920s. The magazine did not assimilate modernism easily, and tried to recast the new movement as a version of English Classicism, or as a follow-on to Arts and Crafts.[71]

Simon's murder is bookended in *More Women than Men* by a similarly muted murder later in the novel. Following Simon's death, and against Mrs. Napier's will, Mrs. Napier's son Gabriel marries Mrs. Giffard's daughter Ruth. Ruth is taken ill shortly after the marriage, and Mrs. Napier, who is nursing Ruth, allows the delirious young woman to stand in a draught, though the doctor has decreed that "the slightest exposure might be fatal" (157). A draught is a peculiarly passive murder weapon; this, like Simon's death, is a crime of opportunity enacted by natural forces rather than by direct strike. Without some authorial explanation, even the most attentive reader might fail to recognize this as murder. Compton-Burnett gives the reader just this:

> The sick girl raised herself with all her strength, and seemed to be summoning it again to leave the bed.
> Josephine sprang to prevent her, but stopped and stood with an arrested look, that seemed to creep across her face and gather to a purpose. (158)

That "purpose" remains unexplained, and Josephine Napier's murderous motive can only be deduced from the narrator's word choices, which seem to raise the specter of guilt: "arrested," and "creep." This murder is even more subtle than the first, consisting as it does of the murderer standing still while the victim gets out of bed and allows air to blow on her body. Ruth dies the next day.

Though I am convinced that both Simon and Ruth are murdered, another reader might plausibly reach a different conclusion, or simply not notice the hints in Compton-Burnett's text. The reader must work actively to interpret (or decode) the text, and different readers may come away from the text with different impressions. What impression should the reader take away, for instance, at the end of the novel when Mrs. Napier enters into an arrangement with one of the school's mistresses, Miss Rossetti, to become partners in running the school? Mrs. Napier declines this partnership at the beginning of the novel; she learns subsequently that Miss Rossetti is actually Gabriel's biological mother, despite her brother's longstanding claim that she is a widow. Whether the knowledge that Miss

Rossetti is Gabriel's mother influences Mrs. Napier's decision to take Miss Rossetti as a partner we are not told, but they strike the deal, and suddenly embrace: "[Mrs. Napier] caught the eyes of her companion, and, starting forward, fell into her arms, and the two women stood locked in their first embrace" (199).

This is a very different female coupling than the previous one, when Mrs. Napier and Mrs. Giffard stood staring at each other over the dead body of Simon Napier. Has the removal of the male figure opened a path for the expression of female same-sex desire? Each reader must find an individual answer, but the posing of the question suggests how Compton-Burnett's minimum writing can be related to functionalism. If one function of modern literature, as Ford suggests, is to draw the reader into the work of interpretation, then Compton-Burnett's minimum writing accomplishes this by omitting authorial judgment and conclusions, revealing even major plot points (like murder) through omission, and refusing to explain the significance of character actions (like two women embracing). The form of Compton-Burnett's prose, it might be said, suggests that its function is to promote the reader's role in the interpretation of the text.

Readers of her books will complain that they have to work very hard to discern what is happening in the story. There is the same complaint about Ford's *The Good Soldier*, for much the same reason—narrative exposition and authorial commentary are far less frequently offered than the thoughts and speech of an individual and usually unreliable character—though Compton-Burnett's narrator is bone-dry, while Ford's is a character whose sadness and stoicism create the novel's emotional tone. These writers risk diversity of interpretation, as well as the inevitable readerly complaints; they are not, as Bell would have it "ashamed of their construction." Ford calls this "the fruits of his own observations alone," Le Corbusier calls it "everything shown as it is," in *Pastors and Masters* Compton-Burnett's Herrick calls it "form," and Clive Bell calls it "significant form." Let me conclude by going back to Ford's story of Hogarth to develop what may be a common thread.

Ford was not the only writer to find inspiration for the modern age in Hogarth. Margaret Jourdain copied out a passage from his 1772 work *The Analysis of Beauty: Written With a view of fixing the fluctuating Ideas of Taste* in her notes (Box 2.3).

BOX 2.3 ANALYSIS OF BEAUTY

... convenience, and neatness of workmanship, to a very great degree of perfection, particularly in England; where plain good sense hath preferred these more necessary parts of beauty, which everybody can understand, to that richness of taste which is so much [to be] seen in other countries, and so often substituted in their room.

Hogarth, *Analysis of Beauty* Chapter VIII

What Jourdain drew from Hogarth seems very similar to what Ford took away: Jourdain's extract finds Hogarth praising English design for its simplicity and emphasis on craft. Hogarth, a Georgian, lived in the period on which Jourdain focused her interest very much for the reasons that Hogarth describes in this passage—she favored its pure clean lines. Ford, as you may recall from the beginning of this chapter, felt much the same: praising Hogarth for conveying the whole of his picture in just four straight lines.

Although Ford's admiration for Hogarth is evident—he calls Hogarth's drawing "the high-watermark of Impressionism"—it is interesting to note that his reproduction of Hogarth's original drawing is not especially accurate. In Figure 2.5 the two drawings are side by side for comparison, with Hogarth's original on the left and Ford's version on the right. The comparison reveals that Ford's drawing flips the details across the center axis, adds the additional detail of a fork coming off the top diagonal, and omits the letters A, B, and C that Hogarth includes.

Ford's drawing may be in the spirit of Hogarth's, but his deviations are significant. Ford's description that I quoted above of "slouch hat, the handle of the pike coming well down into the cobble-stones, the knee-breeches,

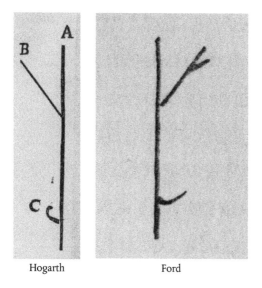

Hogarth Ford

Figure 2.5 Hogarth drawing from James Parton, *Harper's Magazine* (June 1875).
Courtesy of the Columbia Rare Books and Manuscript Library.

the leathern garters strapped around his stocking, and the surly expression of the dog" is hard to square with Hogarth's account of his drawing. Hogarth composed his drawing after boasting he could draw in only three lines "a sergeant carrying his pike, entering an ale-house, followed by his dog."[72] When his bet was taken, he offered the drawing in Figure 2.5, explaining that "A is the perspective line of the door; B, the end of the sergeant's pike, who has gone in; C, the end of the dog's tail."[73] In Hogarth's account, as his explanation documents, the sergeant and the dog are not visible in the drawing, because they have already gone in the door. It appears, then, that all of Ford's details of breeches, garters, and canine grimace are Ford's alone and could not have been extrapolated from Hogarth's drawing, at least not as Hogarth understood it.

While Hogarth's account of his drawing is schematic, Ford's is ekphrastic, bringing to life a scene which, as we understand by looking at Hogarth's original, only exists in Ford's imagination. Another key difference between the two drawings and the written accounts of them lies in the role assigned to the viewer. Hogarth's description of the drawing leaves very little work

for the viewer's imagination. Once we know about the door, the pike, and the tail, we can readily see what we are told to see. Ford's description, on the other hand, leaves the viewer to supply a great deal, including the breed of the dog. Many interpretive responses to Ford's drawing are possible: many sergeants, many pikes, and many dogs.

I hope it is evident that I intend no critique of Ford or his memory. In reworking Hogarth's drawing and what the drawing is meant to represent, Ford makes what he needs of this history, and his ends are quite different from Hogarth's. Hogarth wants to win a bet. Ford wants to make the viewer work, imagine, create alongside the artist; he prefers to produce a work that accommodates the proliferation of a wide range of meanings.

The participation of the reader in the modernist work is not exclusive to modernist minimum writing—the difficulty, allusions, and obscurity of modernist literature all make heightened demands on the reader to work harder, to participate more actively in creating the meaning of the text. Modernist minimum writing differs in that it compels the reader's participation through a characteristic gesture of withholding—whether it is Hemingway omitting any mention of war from a story on that topic, Pound leaving the majority of his text in the wastebasket, or Compton-Burnett refusing to narrate her story. All of these writers draw the reader in through what they leave out. Their work is porous—with space for the reader to enter—because they have punched holes in it. Cutting text, rather than initially putting fewer words on the page, is the signal compositional strategy of the modernist minimum writer. This strategy finds parallels in its contemporary architectural practices, in which modern architecture creates more space for habitation with the elimination of interior walls and decorative elements.

The stripping away of ornament—whether in art, architecture, design, or literature—moves form to the forefront. This attraction to the minimum leads back to Loos, and his idea that plain gingerbread is intrinsically better than decorated gingerbread (or even further, to eighteenth-century Georgian simplicity). As theorists of architecture and design developed the

doctrine of anti-ornament, it became imbued with functionalism and economy—reasons beyond taste to restrict aesthetic expressions to the minimum. The idea of the minimum is broader than any single form of cultural production. Ernst May, city architect and planner for the city of Frankfurt, coined the term *existenzminimum* around 1927, evoking the totality of minimum living. For Ford, explaining the value of the minimum takes him out of the domain of writing into the visual.

Ford's efforts to make visual art provide an exemplar for literature do not, perhaps, carry him very far. His account of Hogarth is a wishful one, and Ford's own drawing cannot bear the interpretive burden he places on it. I am well aware of the difficulties of moving from one form of cultural production to another, especially as I have attempted the same task as Ford in this chapter, moving, in my case, from architecture and design to literature. There are greater incommensurabilities among the formats I have sought to compare than between those Ford selected: architecture and design rest as much on science and technology as they do on art; they have a far closer relation to function than does literature.

Yet echoes of functionalism reverberate through minimum writing, despite the indeterminate meaning of function *in* literature. In fact, as minimum writing takes hold, the responsibility of writing to communicate declines and one of writing's key functions takes a backseat. For the writers I have looked at, their commitment to minimum writing, to withholding key information from readers, is far more important than realizing any particular meaning in their work. It does not matter, for Ford, if you see the same dog he sees; it does not matter for Compton-Burnett if you understand that a character has been murdered. They prefer to leave out as much as they can, and leave it to the reader to fill in the blanks. In this sense, minimum writing creates a new role for the reader, who the minimal text coopts to participate in the writing of the text as it is being read. As in Ford's redrafting of Hogarth, the reader of minimum writing must take what is given, and continue to build.

Notes

1. Ford Madox Hueffer, "On Impressionism," *Poetry and Drama II* (1914): 169–70. Further references given parenthetically in the text.

2. Cynthia Hallett, for instance, characterizes minimalism in literature in this way: "Collectively, the most identifiable of the varied features of minimalist short fiction include: (1) a blunt, lean, apparently uncomplicated prose; (2) a compact prose that by individual artistic design effects a complex pattern of trope which expands from what first appear to be trivial matters into universal concerns; (3) more dialogue than exposition with no evident auctorial intrusion, and little, if any, narratorial intrusion; (4) non-heroic characters who resemble everyday people doing everyday things; (5) a sense that all 'action' either appears to have occurred a while ago, or occurred just moments before the story began, or occurs later 'offstage,' that is, not within the moments of the story." Hallett, *Minimalism and the Short Story— Raymond Carver, Amy Hempel, and Mary Robison* (Lewiston, NY: Edwin Mellen Press, 1999), 25. See also Robert C. Clark, *American Literary Minimalism* (Tuscaloosa: University of Alabama Press, 2014) and Warren Motte, *Small Worlds: Minimalism in Contemporary French Literature* (Lincoln and London: University of Nebraska Press, 1999).

3. See, for example, L. A. J. Bell, "Between Ethics and Aesthetics: The Residual in Samuel Beckett's Minimalism," *Journal of Beckett Studies* 20.1 (2011): 32–53; Sarah E. Cant, "In Search of 'Lessness': Translation and Minimalism in Beckett's Theatre," *Forum for Modern Language Studies* 35.2 (1999): 138–57.

4. Kenneth Baker, *Minimalism: Art of Circumstance* (New York: Abbeville Press, 1988), 9.

5. Hal Foster, *The Return of the Real: The Avant-Garde at the End of the Century* (Cambridge, MA and London: MIT Press, 1996), 54.

6. Origins are always tricky, and in beginning my genealogy with Loos I am following convention rather than staking a claim. Certainly critics prior to Loos asserted that the machine age demanded a new approach to ornamental tradition. See, for example, Henry Van de Velde's 1901 essays, "The New Ornament" and "The Role of the Engineer in Modern Architecture," in *Die Renaissance im modernen Kunstgewerbe* (Berlin: Cassirer, 1901).

7. There has been much misdating of "Ornament and Crime." For a careful account of the essay's origins and subsequent circulation, see Christopher Long, "The Origins and Contexts of Adolf Loos's 'Ornament and Crime,'" *Journal of the Society of Architectural Historians* 68.2 (June 2009): 200–23.

8. Long, "Origins and Contexts," 215.

9. Long, "Origins and Contexts," 214.

10. Reyner Banham, *Theory and Design in the First Machine Age*, 2nd edn (New York and Washington: Praeger Publishers, 1960), 97.

11. Adolf Loos, *Ornament and Crime: Selected Essays*, trans. Michael Mitchell (Riverside, CA: Ariadne Press, 1998), 167.

12. Loos, *Ornament and Crime*, 169.
13. See Kirsten Blythe Painter, *Flint on a Bright Stone: A Revolution of Precision and Restraint in American, Russian, and German Modernism* (Stanford, CA: Stanford University Press, 2005).
14. James Spurr makes a similar connection in his essay, "An End to Dwelling: Reflections on Modern Literature and Architecture," in Astradur Eysteinsson and Vivian Liska's *Modernism: A Comparative History of Literatures in European Languages* (Amsterdam and Philadelphia, PA: John Benjamins Publishing Company, 2007), 469–86.
15. Ezra Pound, "A Few Don'ts by an Imagiste," *Poetry* 1.6 (March 1913): 37–8.
16. See, for instance, Amâncio Guedes, "The Paintings and Sculptures of Le Corbusier," *Architecture SA/Argitektuur SA* (Johannesburg) (January–February 1988): 250–5.
17. Loos, *Ornament and Crime*, 167.
18. Anne Anlin Cheng, *Second Skin: Josephine Baker and the Modern Surface* (New York: Oxford University Press, 2011), 24.
19. Le Corbusier and Amédée Ozenfant, "Purism," in *Modern Artists on Art*, 2nd edn, ed. and trans. Robert L. Herbert (New York: Dover Publications, 2000), 57. Originally published in 1920. Further references given parenthetically in the text.
20. Loos, *Ornament and Crime*, 167.
21. Le Corbusier, *Towards a New Architecture*, ed. and trans. Frederick Etchells (New York: Dover Publications, 1986), 114.
22. Le Corbusier, *Towards a New Architecture*, 116.
23. Le Corbusier, "A Coat of Whitewash: The Law of Ripolin," in *The Decorative Art of Today*, trans. James I. Dunnett (Cambridge, MA: MIT Press, 1987), 188. Further references given parenthetically in the text.
24. Naomi Schor frames the shift to whitewashing in relation to Loos's immersion in Viennese Secessionism, with its love of gold. "Loos writes in a beyond of ornamentalism, announcing in apocalyptic tones the coming of a golden age of functionalism, a golden age which will be a white age, white being the modern color par excellence." Schor, *Reading in Detail: Aesthetics and the Feminine* (New York: Routledge, 2007), 60.
25. Janet Stewart, *Fashioning Vienna: Adolf Loos's Cultural Criticism* (London: Routledge, 2000), 87.
26. Mark Wigley, *White Walls, Designer Dresses: The Fashioning of Modern Architecture* (Cambridge, MA: MIT Press, 1996), 19.
27. Wigley, *White Walls*, 23.
28. Rosemarie Haag Bletter, "Introduction," in Adolf Behne, *The Modern Functional Building*, ed. Bletter, trans. Michael Robinson (Santa Monica, CA: The Getty Research Institute for the History of Art and the Humanities, 1996), 34.
29. Adolf Behne, *The Modern Functional Building*, ed. Rosemarie Haag Bletter, trans. Michael Robinson (Santa Monica, CA: The Getty Research Institute for the History of Art and the Humanities, 1996), 88.
30. Behne, *Modern Functional Building*, 109.

31. Behne, *Modern Functional Building*, 123.
32. Aaron Kunin, "Decoration, Modernism, Cruelty," *Modernism/modernity* 17.1 (2010): 87–107.
33. Karel Teige, *The Minimum Dwelling*, trans. Eric Dluhosch (Cambridge, MA and London: MIT Press (in association with the Graham Foundation for Advanced Studies in the Fine Arts), 2002). Further citations given parenthetically in the text.
34. See, for instance, Ana Miljački, *The Optimum Imperative: Czech Architecture for the Socialist Lifestyle, 1938–1968* (New York: Routledge, 2017).
35. A. Trystan Edwards, *Architectural Style* (London: Faber and Gwyer, 1926), 133.
36. Howard Robertson, *Modern Architectural Design* (London: The Architectural Press, 1932), 155.
37. Lewis Mumford, *Technics and Civilization* (San Diego, CA: Harvest, 1934), 352.
38. William Strunk, Jr., *The Elements of Style* (New York: Harcourt, Brace and Company, 1918), 24, emphasis mine.
39. Sigfried Giedion, *Mechanization Takes Command: A Contribution to Anonymous History* (1948; New York: Norton, 1969), 42.
40. Ezra Pound, *Pound/Ford: The Story of a Literary Friendship*, ed. Brita Lindberg Seyersted (New York: New Directions, 1982), 43, emphasis mine.
41. Pound, *Pound/Ford*, 59.
42. Ford Madox Ford, "Introduction," to Ernest Hemingway, *A Farewell to Arms* (New York: Modern Library, 1932), xvi.
43. This anecdote is related in Hugh Kenner, *The Pound Era* (Berkeley and Los Angeles: University of California Press, 1971), 80.
44. Ezra Pound, "Vorticism," *Fortnightly Review* NS 96 (September 1914): 461–71. The story of Pound's account of the poem's composition can be found in William Logan, "Pound's Metro," *The New Criterion* 33.8 (April 2015): 20.
45. Hugh Kenner has also considered mechanization's influence on Pound, though his focus is on Vorticism and the concentration of energy. See Kenner, *The Mechanic Muse* (New York: Oxford University Press, 1987).
46. Marshall McLuhan, "Pound, Eliot, and the Rhetoric of *The Waste Land*," *New Literary History* 10.3 (1979): 573.
47. T. S. Eliot, *The Waste Land: A Facsimile and Transcript of the Original Drafts Including the Annotations of Ezra Pound*, ed. Valerie Eliot (New York: Harcourt, 1971), 39.
48. Eliot, *The Waste Land*, 47.
49. Edith Wharton, *A Backward Glance* (1934), qtd in Celia Tichi, *Shifting Gears: Technology, Literature, Culture* (Chapel Hill and London: The University of North Carolina Press, 1987), 218.
50. Kunin, "Decoration, Modernism, Cruelty."
51. Ernest Hemingway, *Death in the Afternoon* (1932; New York: Scribner, 2002), 154.
52. Qtd in Zoe Trodd, "Hemingway's Camera Eye: The Problem of Language and an Interwar Politics of Form," reprinted in *Bloom's Modern Critical Interpretations: Ernest Hemingway's A Farewell to Arms*, ed. Harold Bloom (New York: Infobase Publishing, 2009), 209.

53. Hemingway, *Death in the Afternoon*, 153.

54. Ernest Hemingway, *A Moveable Feast* (New York: Charles Scribner's Sons, 1964), 12.

55. Tichi, *Shifting Gears*, 226, 216. Murray Roston also makes connections among architectural functionalism, Purism, and Hemingway's writing, arguing that Hemingway draws on these influences to develop a new kind of hero appropriate to his age. See "Minimalism and the Hemingway Hero," in Roston, *Modernist Patterns in Literature and the Visual Arts* (Basingstoke and London: Macmillan Press, 2000), 118–48.

56. David Lodge, *The Art of Fiction* (New York: Viking Penguin, 1992), 90.

57. Hemingway, *A Moveable Feast*, 76.

58. Hemingway lifts the passage about the trout directly from his story ("Big Two-Hearted River"), another form of literary efficiency.

59. Like his friend Pound (also a prominent character in *A Moveable Feast*), Hemingway could be a drastic editor. He writes that he cut the final nine pages out of "Big Two-Hearted River": Letter from Ernest Hemingway to Robert McAlmon, November 1, 1924, qtd in http://www.thehemingwayproject.com/the-war-in-big-two-hearted-river-a-guest-post-by-professor-allen-josephs/.

60. Adam Gopnik, "A New Man," *The New Yorker*, July 3, 2017, 64.

61. Hilary Spurling, "I. Compton-Burnett: Not One of Those Modern People," *Twentieth-Century Literature* 25.2 (1979): 153–64, 153.

62. James Lees-Milne, "(Emily) Margaret Jourdain," rev. Hilary Spurling, *Oxford Dictionary of National Biography*, ed. H. C. G. Matthew and Brian Harrison (Oxford: Oxford University Press, 2004). Online edn, ed. David Cannadine, October 2007. June 24, 2017. http://www.oxforddnb.com/view/article/37619.

63. Margaret Jourdain and F. Rose, *English Furniture: The Georgian Period (1750–1830)* (London: Batsford, 1953), 21.

64. Qtd in Elizabeth McKellar, "Representing the Georgian: Constructing Interiors in Early Twentieth-Century Publications, 1890–1930," in *Journal of Design History* 20.4 (2007): 340.

65. Phillippa Tristram, "Ivy Compton-Burnett, An Embalmer's Art," *Studies in the Literary Imagination* 11.2 (Fall 1978): 28; Elizabeth Bowen, "Ivy Compton-Burnett I–II," *Collected Impressions* (London: Longmans, Green and Co., 1950), 89.

66. Jourdain's archive, I learned from the curators at the V&A, originally contained additional personal writing, but these have been removed and destroyed.

67. Ivy Compton-Burnett, *Pastors and Masters* (1925; London, Hesperus Press, 2009), 16. Further references given parenthetically in the text.

68. Virginia Woolf, *A Room of One's Own*, ed. Susan Gubar (1929; New York: Harcourt, 2005), 76.

69. I. Compton-Burnett, *More Women than Men* (1933; London: Eyre & Spottiswoode, 1948), 35. Further references given parenthetically in the text.

70. Barbara Hardy comments on how Compton-Burnett's conversations make demands on the reader in Hardy, *Ivy Compton-Burnett* (Edinburgh: Edinburgh University Press, 2016), 28–39.

71. See Julian Holder, "'Design in Everyday Things': Promoting Modernism in Britain, 1912–1944," in *Modernism in Design*, ed. Paul Greenhalgh (London: Reaktion Books, 1990), n.p.
72. James Parton, "Caricature in the Hogarthian Period," *Harper's Magazine* 51 (June 1, 1875): 35–49, 45.
73. Parton, "Caricature," 45.

3

"FEAR IN A HANDFUL OF DUST"

Modernism and germ theory

Why do we want to be clean? Since the seventeenth century scientists knew that there were forms of life that could not be seen with the unaided eye, but the knowledge that some microorganisms could engender disease came much later. In the 1860s Louis Pasteur theorized that spoilage and fermentation occurred because of the presence of microorganisms. Pasteur further opined that the application of heat, filtration, and exposure to certain chemicals could reduce or eliminate the presence of germs. Florence Nightingale emphasized the importance of aseptic and antiseptic nursing during her service in the Crimean War, and she began to explicitly espouse germ theory around 1884 after Robert Koch demonstrated that the cholera bacillus was the cause of cholera.[1] Pasteur's and Koch's discoveries eventually caused a slow transformation in medical practice, where doctor-transmitted infections had long been a leading cause of patient death. Moving from one patient to another without cleaning their hands, doctors unwittingly transported bacteria and spread infection.

Germ theory, the idea that microorganisms cause infectious disease, asks us to be wary of something that we can neither see, hear, smell, taste, nor touch. In the latter part of the nineteenth century, scientists came to believe that imperceptible, microscopic agents dwelling among us spread serious illness and infection; this theory hardened over time into accepted scientific fact. Germ theory replaced miasma theory, the previously prevalent idea that a mist of decomposed matter was responsible for the spread of much illness. Miasma, unlike germs, was believed to be apprehensible through the

senses because of its characteristic foul odor, rising from the sewers and drifting through the nighttime air.[2]

The transition from believing in the harmful properties of miasma to those of germs eliminated the role of the human senses in perceiving threats to health; this swing in thinking placed scientists, with their sense-enhancing instruments like microscopes, in the role of guardians of public health. Germ theory's advent produced a shift in cleaning and cleanliness, from Victorian crusades of sanitary reform into twentieth-century hygienic education aimed at the elimination of germs. Above all, the shift to germ theory required a tremendous leap of imagination and faith for non-scientists, who had to trust in the existence of germs most of them would never see for themselves.

The transition to germ theory had the profoundest consequences. In the United States and western Europe, in the first decades of the twentieth century—and particularly after World War I—average life expectancy rose dramatically and prevalent causes of death moved away from communicable disease and toward degenerative and human-engendered ailments.[3] Pneumonia, typhoid, and tuberculosis, once common causes of grave illness and death, became more manageable threats whose spread could be checked by public health measures and, later, by the use of antibiotic medicines. Still, miasma theory continued to have its proponents and sometimes was combined with germ theory.[4] Germ theory required a slow but massive alteration in popular views and practices that included improved sanitation and personal hygiene, modernization within the home, and the implementation of childhood vaccination.[5]

Given its importance and influence, it may seem surprising that germ theory was acknowledged slowly and unevenly, both outside and inside hospitals. As Nancy Tomes writes, "The first apostles of the germ faced a considerable challenge in convincing their contemporaries that such an intangible being as a germ existed, much less that it caused potentially deadly illnesses."[6] In fact, it was not until the beginning of the twentieth century that antiseptic and aseptic practices became part of standard medical care.[7] And it would be another few decades before the new

standards and practices began to transform the conduct of ordinary domestic life. A 1910 article in *Life* magazine carried the still-skeptical headline: "The Germ Theory: Is It True?"[8]

"Twentieth-century public health," writes Joseph Amato, "was defined by the previous century's mounting concern for national health and by the bacteriological revolution."[9] By the time World War I broke out, germs were seen as deadly enemies on a par with foreign invaders, and the 1918–19 influenza epidemic that killed 20 million people in the United States and Europe confirmed the immediacy of the threat. International hygiene exhibitions took place all over both North America and Europe during the 1920s and 1930s, and hygiene education sprouted in schools and in the workplace. Such educational initiatives were not based solely on disease prevention; cleanliness also served as a symbol for a range of social values including middle-class status, racial purity, and respectability.[10]

The struggle to eliminate infectious microbes has a material reality, and material consequences. But it is also a battle with a strong imaginative dimension, as we wield our antibacterial cleansers with gusto, eliminating dirt that we cannot see but believe in with a powerful faith. It seems potentially significant from a cultural perspective that the years that saw the shift from miasma theory to germ theory in the Anglo-American context, typically given as 1890–1920, are coterminous with the emergence of the modernist aesthetic program. In this chapter I consider the concomitant dissemination of modernist aesthetic practices and germ theory and examine the possibility of an interrelationship. More precisely, the idea I hope to explore here is that the cultural assimilation of germ theory gave rise to a new relationship between the sensory and the hygienic. The senses came to lose their authority over the evaluation of cleanliness—just as cleanliness was being redefined as necessary for the prevention of disease.

I hope to show that this rupture in the relationship between the senses and hygiene had a considerable impact on the formation of modernist aesthetics across a range of forms of cultural production, including literature, the visual arts, and architecture and design. Vision, and more specifically, the pursuit of perfect visual clarity, assumed a greater importance,

despite the impossibility of seeing germs with unaided vision. Writers, artists, and designers promoted a heightened sensorial acuity and came to equate clarity of perception with hygiene. As should already be apparent, the extension of the senses was an anxious project, consigned to failure from the outset, since the imperceptible threat of bacterial life was outside the grasp of even the most finely tuned human sense. Modernism participated in the redefinition of hygiene and cleanliness, and it also developed strategies to contend with the senses' dangerous inadequacies. I will draw attention to the intense value attached to vision and a strong desire to render dirt, contamination, and even germs, visible so that they could be eliminated. However, assimilating germ theory meant acknowledging the reality of a pervasive but imperceptible—and certainly nonvisual—menace. This abiding contradiction gave rise, in modernism, to a range of aesthetic practices organized around the value of transparency, clarity, and hygiene.

I begin with a brief analysis of nonliterary writings to understand the emergent discourse of hygiene and germ theory and to indicate its impact and scope. Next, I turn to a review of diverse literary works of the late nineteenth and early twentieth centuries by writers from Europe, England, and the United States that engage directly with germ theory and the public health campaigns it provoked. The chapter builds to a discussion of some modernist poetry that articulates an aesthetic agenda organized around perception, hygiene, and the threat of infection. In the final section of the chapter, where I enlist the work of the poet William Carlos Williams, the very project of developing a brief for modern poetry becomes bound up with the quest for asepsis and hygiene.

* * *

Germ theory was a revelation in the laboratory; in the messy worlds of the street and the home, the theory was slower to gain acceptance and to change health habits. Victorian reformers had pressed hard on the idea that disease was atmospheric and had environmental causes, and such miasmatic claims about the origins of disease endured alongside the

newer biological explanations. As Eileen Cleere has recently argued, "the protracted and uneven assimilation of contagionist discourse in the nineteenth century owes as much to pervasive confusion about the unseen world of microorganisms as it does to an abiding cultural investment in sanitation reform as a moral narrative."[11] Bacteriologists and their sanitation reform predecessors overlapped in their enthusiasm for cleanliness—the former propounding asepsis and germ control, while the latter continued to campaign against sewer gas, bad air, and similar phantasms.

One prominent aspect of the dissemination of germ theory was an increasing focus on personal cleanliness. In both the U.S. and in England, short beards or clean-shaven faces came into fashion for men, the thought being that bare skin would provide a less congenial habitat for germs. For women, hemlines rose so that skirts would no longer drag the floor and gather up effluvia.[12] These trivial examples bespeak an increased interest in both bare surfaces and clear outlines. Public health venues and popular publications picked up on the new ideas about cleanliness. A *Harper's Weekly* editorial, for example, argued that men should get rid of their beards partially on the grounds that "the theory of science is that the beard is infected with the germs of tuberculosis and is one of the deadliest agents for transmitting the disease to the lungs."[13] As this quotation suggests, popular understanding of germ theory could be incomplete, but people readily grasped the new emphasis on personal hygiene, and the idea that personal cleanliness would promote health. As Suellen Hoy writes, "personal cleanliness . . . became the new rallying cry in the twentieth century [as] the 'new public health' converged with domestic hygiene practices."[14]

Trimming hair and raising skirts could not do anything either to reveal or to eliminate germs, but both activities seem motivated by an impulse to expose germs that might be lurking on or around the body. While the body received the most heightened scrutiny under the auspices of germ theory, the home ran a close second. The care and cleansing of the body was often based in the home, and the mechanization of the home, also underway in the first decades of the twentieth century, meant that kitchens and bathrooms were being redesigned to promote greater

hygiene. Rosie Cox writes, "The rise of germ theory coincided with the widespread development of manufactured and branded cleaning products, which offered homeowners ever more effective whitening and brightening."[15] The invisibility of germs meant that housecleaning became a more urgent process, even as the successful removal of germs through cleaning was unverifiable by the cleaner.

The widespread interest in germ theory and the associated changes in both personal care and the home are reflected in domestic advice manuals in the 1920s and 1930s, which struck a very different tone on the topic of cleanliness than did similar works of the previous generation. Victorian manuals tended to emphasize topics like cooking and the proper management of household servants. The best known of these nineteenth-century works was Isabella Beeton's *Book of Household Management*, a 1000+ page text first published in 1861 and reissued in numerous editions thereafter.[16] Mrs. Beeton emphasized the mistress's role as the emotional center of the house and the "happy companion of man," whose reward for her good management was "respect, love, and affection" (19) from all those around her. The mistress's role was as emotional as it was practical, and domestic manuals aimed at helping women conform to upper-middle-class household practices like paying calls.[17] Here is Mrs. Beeton's top-line principle on the topic of household hygiene: "Cleanliness is also indispensable to health, and must be studied both in regard to the person and the house, and all that it contains. Cold or tepid baths should be employed every morning, unless, on account of illness or other circumstances, they should be deemed objectionable" (2). Cleanliness is included in the list of household rules, but the discussion is limited and laissez-faire, since baths can be omitted if "other circumstances" deem it "objectionable." The tone struck by the advice giver is that of one woman murmuring confidentially to another, sharing tips for running a proper household.

Mrs. Beeton may seem reasonably tolerant of the unwashed; more broadly, it can be hard to countenance the extent to which household dirt was, until relatively recently, considered innocuous or even friendly. Consider Lytton Strachey's fond and amiable memories of the filthiness of

his well-to-do fin-de-siècle London childhood home: "Visitors, perhaps, might not particularly notice, but *we* knew by heart all the camouflaged abysses . . . we plumbed and numbered 'filth-packet' after 'filth-packet'—for such was our too descriptive phrase."[18] Strachey's casual affection for household dirt would have placed him at odds with some of the stricter Victorian sanitary reformers, but in his time what we might now consider overly casual housekeeping was neither a moral nor a hygienic failure. Sociologist Lydia Martens writes, "The idea of dirt as something which should be banished from the house as a threat to the inhabitants' health is a relatively new one. For many hundreds of years domestic dirt as we know it today was not a source of great anxiety—particularly not on health grounds."[19]

By contrast, domestic advice manuals of the 1920s and 1930s adopted a far more professional and scientific manner and were positively urgent on the topic of cleanliness, although they continued to conflate environmental (miasmatic) and biological (germ) models of disease transmission. Kate Kennedy's 1935 *The Science of Home-Making*, for instance, warns urgently, "Dust is one of the deadly enemies of the housewife. There is a continual war raging between them. Dust brings germs of disease and ill-health in its trail."[20] Kennedy's combination of science and the battlefield elevates the significance of the homemaker's work by characterizing it as a life-or-death struggle. Her depiction of the antagonistic battle between the homemaker and household dirt raises the stakes of the conflict to the highest possible degree, although the war metaphor may now seem an inapt vehicle for an "enemy" so small and innocuous as dust.

Yet dust was frequently identified as antipathetic. In *The Hygiene of Life and Safer Motherhood* (1934), P. L. Garbutt writes that, "In the modern house the cleaning is more hygienic and aims at removing the dirt as dustlessly as possible."[21] The new technology of vacuum cleaning was embraced in part because of its superior dust-removing potential. In essence, dust served as a visible substitute for germs, and as we shall see, interior designers came to favor shiny sealed surfaces in large part because they allowed dust to be seen more easily and eliminated. Kennedy's sense that dust was actually

dangerous finds a distant echo in T. S. Eliot's famous line from *The Waste Land*, "I will show you fear in a handful of dust." The image evokes the metonymic relation of dust to invisible germs, and is followed closely by what is only the first of many failures of the human senses in the poem: "I could not / Speak, and my eyes failed." Dust is frightening because its visible dirt stands in for the bacteriological "dirt" that cannot be seen—because the eyes cannot register their dangerous presence and can only perceive the pestilence that follows—at least in *The Waste Land*—in the form of a bad cold, or a carbuncle.

Another way for public health advocates to deal with the invisibility of germs in their educational efforts was to make them visible through photographic illustration. Jean Broadhurst's *Home and Community Hygiene: A Text-Book of Personal and Public Health* (1918, rev. edn 1923) was written as a textbook for "mature but non-technical students" and dedicated to these readers: "nurses, teachers, and mothers."[22] The book's first chapter is titled "Bacteria and Other Micro-Organisms" and opens with a large illustration of a compound microscope (Figure 3.1). Most of Broadhurst's readers would not have encountered such an instrument, and by placing this diagram at the front of her book on hygiene, the author seemed to wish to wed cleanliness and acuity of vision, and to establish the scale of microscopic life as salient to housekeeping. Broadhurst could not equip her readers with microscopes—nor does she suggest that possession of one is necessary for good housekeeping. However, in her textbook she does offer the reader depictions of what could be seen through the eyepiece, and how important it was for her readers to be aware, at least theoretically, of the existence of microorganisms in designing an approach to hygiene in the home and community. Looking through the microscope conveys a knowledge, for Broadhurst, that has a far-ranging effect on hygienic practices, a knowledge that must lead to action. The normally invisible forces massed on the microscope's stage become the basis for the writer's call to hygienic arms.

If the first figure in *Home and Community Hygiene* acquaints the reader with the microscope, the second gives the reader a view through its eyepiece. Broadhurst chooses an ordinary kitchen vegetable, a tomato, leaves it to

EYE PIECE

LENS

OPENING

MIRROR

Figure 3.1 Jean Broadhurst, *Home and Community Hygiene* (1919).

rot, and then observes the activity of the bacteria that have colonized the tomato (Figure 3.2).

When Broadhurst turns to the subject of housecleaning, the standard for cleanliness she offers is similarly based on its impact on household microscopic life. To demonstrate the superior cleaning ability of a vacuum cleaner, compared with a damp or dry broom, she exposes an agar-coated plate in a room cleaned using each method, and waits to see which plate will collect the densest population of microorganisms. Though the vacuum cleaner would be no better than the other methods at eliminating dangerous pathogens, it seemed able to reduce the overall presence of microscopic life, and the elimination of such sub-visual activity was the standard of cleanliness that Broadhurst and her fellow educators encouraged.

Germs provoked fear both because they were the cause of virulent disease and because they were imperceptible. As medical historian John

Figure 3.2 Jean Broadhurst, *Home and Community Hygiene* (1919).

Waller writes, "A recognition of the deadly threat posed by unseen germs also had an enormous public impact . . . [S]tudies found potentially lethal bacteria on clean fabrics, food and household objects, even children's toys boxed up and then taken out for the amusement of the next generation."[23] With germs potentially lurking even in a box of childhood memories, experts urged the eradication of germs through methodical and intensive cleaning. Fresh air and sunlight were also considered antiseptic, a holdover from the era of miasma. The discourse on these topics was widespread across both the U.S. and Europe, although the Americans advanced most quickly in both modernization and household reform.

One popular household manual of the 1920s was Benzion Liber's *The Child and the Home: Essays on the Rational Bringing-Up of Children*. Liber was a Romanian-born physician and public health advocate, and the author of

dozens of books. *The Child and the Home*, translated into French, German, and Romanian warns:

> A room may seem clean and tidy on the surface. The table-cloth is snow-white, the floor is oiled, the door-knobs shine. But look under the table and the beds, examine the dark corners, spy into the kitchen and the bath room, and the real facts will reveal themselves. Gaudy or faultlessly smart garments, or even elegant and tasteful dress, or new and perfectly brushed clothes as well as freshly laundered linen, may deceive us into believing that the body is clean. But—how are the knees and the toes and the ears? If we are friends of true cleanliness, we will not be content even with the daily bath. We will desire a still deeper and more important cleanliness. We will want to have clean internal organs, pure blood, and we will live accordingly.[24]

"Pure blood" is an appallingly suggestive phrase, invoking racial thinking, eugenics, and the doctrines of empire. The new discourse of hygiene was not applied evenly and was directed with especial forcefulness at immigrant communities.[25] "Hygiene" was a term that could be translated into emotional or moral terms, as well as the purely physical language of health and cleanliness. As Robin Schulze has argued, for those engaged in debates about racial degeneration, "cultural hygiene" was seen as a solution.[26]

Liber introduces a strong parallel between the home and its occupant, both of which may be apparently clean but are actually harboring dirt. Liber's depiction is initially reassuring in its suggestion that careful perception—spying and probing—can uncover hidden filth. But when he moves on to his vision of clean organs, he has gone far beyond the capacities of standard human sense-perception. While the "friends of true cleanliness" may seek the total elimination of pestilence, the human sensory array is inevitably inadequate to the task. How could cleaners know when microscopic dirt was eliminated? How could one possibly assess the cleanliness of one's internal organs?[27] The body itself was reconceived as a potential source of contagion, an important element of the transition from miasma to germ theory. W. H. Hornibrook's 1934 essay on home hygiene reminds the reader that

No matter how dry the air we breathe, we always send it back thoroughly
soaked with water, saturated with water vapour, and at the same time we
add any disease germs which may be caught in the outflowing draught. Thus
it will be seen that air which has been breathed is not a pleasant or useful
thing to take into our bodies.[28]

Hornibrook's emphasis on air as potentially unhealthy harks back to
miasma, but his depiction of air contaminated by diseased human lungs
shows the role of germ theory. His description posits the body's unavoid-
able exhalations as a dangerous disease vector, and depicts the body itself as
a source of dirt and danger.

In Hornibrook's words—as in Liber's and Broadhurst's—there is an
effort to render perceptible the traces of dangerous germs, in the case of
the former by visualizing the process and product of human exhalation.
The body's difficult-to-discern traces, both Liber and Hornibrook want to
suggest, can be visible markers for germ vectors, and so it becomes
important to attend to them. More subtly, these sources seem to place a
tremendous emphasis on visibility as a category, going so far as attempting
to render the invisible visible.

In architecture and design, as in advice literature, hygiene assumed a new
prominence in the early 20th century. A dramatic preference for the bared
surface was among the most prominent manifestations of the new con-
sciousness of germs. As with the shaved face, the bare surface seemed
intrinsically less hospitable to germs; it was easy to clean and offered no
place to hide. Modernist designers favored sealed, flat, and transparent
surfaces, and waxed hyperbolic in their critique of decorative flourishes.[29]
In Alfred Bemis's depiction of an ideal "modular" hall and living room
(Figure 3.3), nearly every surface is bare and sealed. The designer has
imposed a geometric grid structure on the living space aligned with Bemis's
theory of "rational design." Moreover, everything in the space is immedi-
ately visible—there is no unseen space under a table, or behind a door. The
flatness of the surfaces in the rooms, reinforced by the grid, also suggests
impermeability.

(a)

(b)

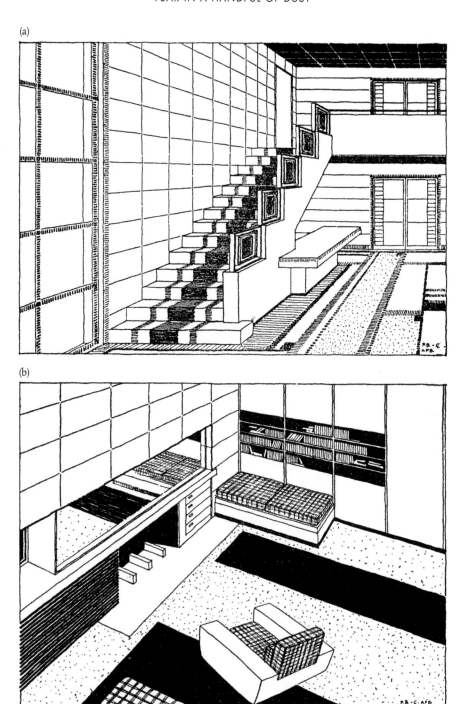

Figure 3.3 Albert Farwell Bemis, *The Evolving House, Volume 3: Rational Design* (1936).
Reprinted courtesy of The MIT Press.

The interest in transparency was most palpable in the expanded use of glass. Glass architecture seemed to embody a perfect visibility, as in Mies van der Rohe's 1922 utopic design for a Glass Skyscraper, followed in later decades with Mies's Farnsworth House, perhaps the most famous example of glass in domestic architecture, echoed by Philip Johnson in the Glass House. On a grander scale, German writer Paul Scheerbart propounded a theory of international glass architecture that he believed would lead to a utopian age for human civilization; Scheerbart was an enthusiastic supporter of Bruno Taut's Glass Pavilion at the Werkbund Exhibition of 1914.[30]

As Jeffrey Schnapp has discussed, transparency-based aesthetics were placed in the service of germ theory in numerous hygiene exhibitions mounted for the public. At the 1911 *Dresden International Hygiene Exhibition*, for instance, "the stars of the show were the translucent organs of *Der Mensch*: actual human organs, dehydrated, stabilized by means of chemical agents, and transformed into gossamer structures."[31] The organs of the body, rendered fixed and transparent, seemed to express both a fascination with the new techniques of glass fabrication and with glimpsing the body's insides, rendered fully viewable. At the 1903 precedent Dresden Hygiene Exhibition, bacteria magnified by thousands allowed the public a view of the invisible enemy.[32] The famous logo for the 1911 exhibition designed by Franz von Stuck featured an all-seeing eye, hovering in the cosmos, suggesting the primacy of vision in mastering the bacterial world. The eye in the exhibition logo is God's eye, omniscient; it is also a cosmological eye, eternal and unblinking.

Public health concerns appeared in other iconic elements of modernist architecture, as architects began to understand themselves as responsible for designing housing that promoted cleanliness and helped to prevent disease. Margaret Campbell and others have argued, for example, that the flat roofs designed by Le Corbusier and others were influenced by the role of sunbathing in curing tuberculosis.[33] The well-known Garden City movement, launched in 1898 in England, aimed at the creation of planned communities with liberal amounts of greenery. Garden cities

sought to promote public health through improved housing conditions that emphasized hygiene.

Product design, too, demonstrated a commitment to supporting the new theories of hygiene. It was in the early years of the twentieth century that household appliances supporting cleanliness proliferated in earnest: vacuum cleaners, flushing toilets, improved cookers, washing machines, and much more. Such innovations were not ubiquitous and tended to be more prevalent among the middle classes and in cities. The new appliances required electricity to run, and while the United States moved more quickly than England in establishing an electrical network, it took decades before most homes ran on electric power. Retrofitting homes run on coal with electricity was an expensive proposition, and in England fewer than 30 percent of homes had been wired by 1931.[34] In the same year, the journal *Electrical Merchandising* estimated that out of over 30.5 million homes in the U.S., nearly 20.5 million were wired.[35]

Interior design also responded to the call for healthier homes. Kitchen plans, such as those promoted by American efficiency expert Christine Frederick, were driven by the new understanding of hygiene. Frederick gave this advice to those planning a kitchen: "Everything about the kitchen should be as sanitary as possible. Painted plaster with a high gloss finish is, in the author's opinion, the most preferable finish to any kitchen surface because it can be wiped down so easily and affords no protection to germs."[36] A flat, shiny, white surface rendered any speck of dirt as visible as possible; in Frederick's writings and more generally, dirt and dust functioned as metonyms for the invisible disease-carrying germs not discernible on the countertop, however shiny: eliminate the one, and you would eliminate the other.[37]

The promotion of sealed and impermeable surfaces carried over from the kitchen to the bathroom. Indoor plumbing, like electricity, made a slow transition into the home. For those who had access, experts urged the use of ceramic tiles rather than wallpaper so that dirt (and germs) could not seep into the walls and other surfaces.[38] The public bath movement, which began in Europe and England and soon spread to the United States, sought

to ensure that those whose homes did not have bathtubs still would have a convenient means of bathing. In the U.S., private bathrooms spread more quickly than some other forms of modernization; a 1918–19 United States Bureau of Labor study of housing conditions for the poor in twenty cities found that just over half the families had baths.[39] Sigfried Giedion places the tipping point for widespread availability of running water in U.S. bathrooms in the early 1920s.[40]

The elimination of ornament is among the most well-known tenets of modernist design, and its proponents were outspoken about the hygienic basis for the proscription on flourishes and extraneous motifs. As Paul Overy contends, "In the literature of hygienicism, ornament and decoration were proscribed as the enemies of the hygienic and healthy home: harbouring dust, dirt, germs, infection, and disease."[41] Adolf Loos's infamous screed "Ornament and Crime," first delivered as a lecture in 1910 and published in 1913, is explicit about what Loos sees as the moral debasement inherent in ornamentation. Similarly, Le Corbusier asserted in *Vers une architecture* (translated into English in 1927 by Frederick Etchells) that "We are to be pitied for living in unworthy houses, since they ruin our health and our *morale*."[42] Modernist architecture aimed not just at beauty and functionalism, but also at a new way of life informed by science.

While design and avant-garde architecture were important manifestations of a concern with personal and environmental hygiene, debate about hygiene spread further and found its way into literary and cultural criticism, especially in the United States. Leo Stein (older brother of Gertrude Stein), for instance, writing in the short-lived American little magazine *The Seven Arts* opined with enthusiasm that hygiene has come

to stand quite in the forefront of contemporary interest, which has in many ways, by its conquests, revolutionized our attitudes, and is as yet only on the threshold of its achievement. Indeed so infinitely various and so dominating are the influences of hygiene on the conduct of life in our time that ours might well be called the age of hygiene, of constant and deliberate concern with health.[43]

For Stein, hygiene was inseparable from germ theory; it was the awareness of germs and the possibility of reorganizing life around their systematic avoidance that excited him most of all. As he noted, "Hygiene has freed the human spirit from some of its most oppressive horrors and rendered less fearful others that it could not utterly remove." "Hygiene" was an apparently benign and domesticated term, but its evil twins were horror and fear—of deadly diseases that Stein seemed to have in mind as he wrote. The notion that through attention to personal habits and housecleaning these specters could be avoided seemed, to Stein at least, like the miracle of the age. The migration of "hygienic" discourse into literary circles was notable; even in a literary magazine at Eton one of the contributors, writing on modern poetry, praised Ezra Pound as "a master of this clean, white spirit of disinfection."[44]

Germ theory demanded an impossible degree of vigilance to provide confidence in a germ-free environment. Being free of germs looked the same as being covered with germs: either way, nothing could be seen. Architectural historian William Braham writes, "For the newly developed gaze of cleanliness, the target of observation was the microscopic germ. The modern body depended upon hygienic intervention for defense against those germs."[45] But how could the germ be observed or positively identified? Visual vigilance seemed required despite its inadequacy.

Germ theory also directed attention to the experts who had discovered the danger and described it to the public—doctors, public health officials, and bacteriologists. All these figures make appearances in literary works of the time—sometimes as heroes who delivered an unsuspecting public from death, but at other times as excoriated prophets whose explanations and prescriptions resulted only in inaction either because of economic exigencies or bemused incredulity. Given the general skepticism of modernist writers regarding both professionalism and technological excess, the acceptance of trained experts who can identify and defend against microscopic invaders represents an unusual exception in the literary record. Sinclair Lewis, whose work I will take up below, was generally cynical about the professions in *Main Street* (1920) and *Babbit* (1922), but in

Arrowsmith (1924), he shows us both scientists and doctors who valiantly pursue scientific truths in the service of ending disease.

Yet the senses fail in the face of germ theory, and this failure requires an adjustment to the story that critics of modernism have generally offered about the history of sense experience. This adjustment may seem a bit dampening in its effect, since it asks us to see beyond the ecstatic pleasures of modernist sensory extension.

Modernist literary critics have argued that the techno-scientific innovations of the early twentieth century led to a new emphasis on sensory experience and an expanded human sensory apparatus, coupled with an expanded sense of human agency. Technology, in this account, enlarges human perception, as through the enhanced visual power of the camera, the exhilarating feel of speed made possible by the internal combustion engine, or other means from medical prosthetics to the phonograph. Cinema is widely understood as one of the most important aspects of this sensory enhancement; as Miriam Bratu Hansen writes, "commercial cinema appeared to realize Johann Gottlieb Fichte's troping of reflection as 'seeing with an added eye' in an almost literal sense . . . Hollywood . . . produced and globalized a new sensorium."[46] Hansen's exuberance around the expanded sensorium generated by the cinema echoes across many other influential accounts of modernism. For Schnapp, it is speed and the fusion between car and driver rather than the cinema that opens up new worlds of sensory experience, but the result is the same—in Schnapp's phrase, "an enriched sensorium."[47] Tim Armstrong, in his chapter on "Prosthetic Modernism," provides a similar account of how mechanization seems to make the body stronger, more capable, and more able to receive information from its environment. As he puts it, "Technology offers a re-formed body, more powerful and capable, producing in a range of modernist writers a fascination with organ-extension, organ-replacement, sensory-extension; with the interface between the body and the machine which Gerald Heard, in 1939, labeled *mechanomorphism*."[48]

The excitement of these critical accounts reflects modernism's own stories of thrilling encounters with new technology as well as fresh ways

of interacting with the world potentiated by the great technological innovations of the early twentieth century. The body was at once armored by prosthetics and machines and rendered newly sensitive to stimuli, a paradoxical but glorious combination. Sara Danius, in her history of the senses in modernism, describes "an interiorization of technological modes of perception," in which technology is used to enhance and extend the senses.[49] Technology, then, is not merely a supplement to human modes of perception in modernist modes of understanding. It integrates itself with the body and allows for new powers of feeling and perception. New forms of sensory engagement seem to lead directly to new ways of knowing the world.[50]

I do not want to contest but rather to supplement these accounts of the modernist sensorium by accounting for the influence of germ theory. The glory of new human powers and senses is certainly present in the discovery of the microscopic world. These discoveries were made possible by advances in optical technology that also yielded new developments in camera lenses and the technology of the motion picture. The identification of certain bacilli as causative of disease allowed for a tremendous expansion in disease prophylaxis; very few sensory enhancements are more significant than the extended lifespan made possible by the bacteriological revolution. Even the much-touted new hygienic practices brought with them alterations in sensory experience; as indoor plumbing permitted more frequent bathing, for instance, the smells and sights of the body changed.

At the same time that germ theory aligns with the model of sensory expansion and wonderment described by critics of modernism, I have been suggesting that it raised awareness of the limits of both the human senses and science. The clearest example of these limits was the 1918 influenza pandemic, which infected about a third of the world's population and caused at least 50 million deaths. The pandemic confirmed that the advent of bacteriology had not rendered humanity safe from devastating disease, as scientists and doctors were stunned by the high fatality rates and rapid spread. The editors of *The Journal of the American Medical Association* wrote in the October 5, 1918 issue: "It seems that if in the course of evolutionary

processes there suddenly is liberated a form of infectious agent against which large numbers of people offer little or no resistance and which is transmitted readily from person to person under the most diverse hygienic and geographic circumstances."[51] Though the influenza bacillus had been identified in 1892, the genesis of the 1918 strain of the virus was not clear. Even hygienic practices, as the editors explained, did not seem to curb the spread of the illness.

The 1918 crisis seemed to offer the most damning possible evidence that the identification of germs would not by itself render humanity safe from the scourges of infectious disease. The new identification of bacteria could actually activate an anxious vulnerability about the natural limits of the human senses and their inability to perceive the presence of disease-causing agents. In this way, germ theory, rather than allowing human beings to see with an "added eye," inculcated an awareness of humanity's blindness to the microscopic world, a world that was capable of lethally striking down human beings.

Modernist literature dramatized the exuberance of technological innovation and the sensory adventures technology offered. But it also reflected, explicitly and implicitly, deep concerns about the limits of the senses and about the meaning and value of cleanliness. These concerns are evident in a number of modernist literary tropes: the pursuit of precision and perfect clarity in poetic language, the comparisons proffered between writers and scientists, the inherent tension between rationalism and irrational drives, the establishment of cleanliness as a value in writing, and more. What we see in this literature, rather than a heady excitement at the senses' omnipotence, is a heavy recognition of their limits. Though technology may offer some prosthetic enhancements to human vision, it also reminds us that we must live and interact, in the main, on the limited human scale. I'll begin to establish these points by looking at novels by H. G. Wells, Thomas Mann, and Sinclair Lewis, together with a play by Ibsen. These all engage directly with epidemiology, germ theory, and physician-scientists. More broadly, in the final section of this chapter I will take up the work of William Carlos Williams and, to some extent, Ezra Pound, as a case study

for the foundation and expression of both hygiene and transparency in modernist poetics.

Germ theory is surprisingly prominent in modernist narratives, perhaps because it lends scientific verisimilitude, mystery, and a suspense plot to any story. Bacteriologists are seen as heroes, and public health experts cast as martyrs who are castigated by their communities because they fight to act upon unwelcome or frightening truths. H. G. Wells's 1895 short story, "The Stolen Bacillus," for instance, opens in the home laboratory of a bacteriologist who is showing his germ samples to a visitor. The visitor makes off with what he believes to be a vial of Asiatic cholera and plans to start an epidemic in London to further the Anarchist cause. The bacteriologist, in explaining the power of the test tube to his visitor, makes much of the elusive nature of the enemy. "Only break such a little tube as this into a supply of drinking-water, say to these minute particles of life that one must needs stain and examine with the highest powers of the microscope even to see, and that one can neither smell nor taste . . . and death . . . would be released upon this city."[52] The bacteriologist emphasizes the asymmetrical relationship between the negligible register of the bacillus on the human sensorium in comparison with its massive potential impact on the well-being of the city. This is a frightening inversion that Wells makes sure to quash by having his bacteriologist confess to his wife that he switched the vials and the one in the property of the anarchist is a harmless dye.

Only the bacteriologist commands the tools that render the bacillus visible; only the bacteriologist has the power to detect and destroy the deadly enemy. Wells also famously makes much of the lethality of germs in *The War of the Worlds* (1897), in which unstoppable invaders from outer space are defeated, after every other attack has failed, by native Earth germs against which Martians have no inbred immunity. With graceful symmetry, the novel begins with a vision of the bacteriological world, but with humans under the microscope rather than bacteria. Wells writes,

No one would have believed, in the last years of the nineteenth century, that human affairs were being watched keenly and closely by intelligences

greater than man's and yet as mortal as his own; that as men busied themselves about their affairs they were scrutinized and studied, perhaps almost as narrowly as a man with a microscope might scrutinize the transient creatures that swarm and multiply in a drop of water. With infinite complacency men went to and fro over this globe about their little affairs, serene in their assurance of their empire over matter. It is possible that the infusoria under the microscope do the same.[53]

The advent of bacteriology suggests to Wells a hierarchy of surveillance; if we can watch others through our microscopes, then we also can be watched. But just as in "The Stolen Bacillus" the scientist's power of observation are no safeguard against epidemic. In *War of the Worlds* the scientist's ability to observe microbial life is no safeguard against attack—in this case, from an observing intelligence above. When the bacteria in the human scientist's view attack the Martians, the surveillance has come full circle. In both narratives, the scientist's powers of observation cannot provide any kind of protection; only chance seems to do—or not do—that.

In Wells's repeated references to the limited human ability to contend with what the microscope reveals, he raised questions about the limits of the senses that other writers shared. Henrik Ibsen's 1882 play *Enemy of the People* dramatizes the difficulty in convincing the public to fear an invisible enemy, especially if that belief cuts against economic priorities. The play also highlights the public's tendency to rely on the evidence of the senses despite scientific evidence of their fallibility. The "enemy" of the title can be seen either as the cholera bacilli that have infiltrated the water supply of the town where the play is set, or as the doctor who, having identified the risk, seeks to shut down the town baths that are the source of the town's economic prosperity. In a scene of confrontation, Morten Kiil, the doctor's father-in-law, mocks Dr. Stockmann for his contention that the water contains invisible agents of death.

MORTEN KIIL (resting his hands and his chin on the handle of his stick and winking slyly at the DOCTOR). Let me see, what was the story? Some kind of beast that had got into the water-pipes, wasn't it?

DR. STOCKMANN. Infusoria—yes.

MORTEN KIIL. And a lot of these beasts had got in, according to Petra—a tremendous lot.

DR. STOCKMANN. Certainly; hundreds of thousands of them, probably.

MORTEN KIIL. But no one can see them—isn't that so?

DR. STOCKMANN. Yes; you can't see them.

MORTEN KIIL (with a quiet chuckle). Damme—it's the finest story I have ever heard!

DR. STOCKMANN. What do you mean?

MORTEN KIIL. But you will never get the Mayor to believe a thing like that.[54]

Morten Kiil, who owns the tannery that is the source of the contamination, feels quite safe when the apparent absurdity of the doctor's theory is made clear to him. The idea that an enormous number of "beasts" are living in the water-pipes and causing a dreadful disease seems ridiculous. Kiil predicts that neither the mayor nor the townspeople will take the story seriously. This turns out to be the case, and the town turns against Dr. Stockmann, who is left with nothing but the satisfaction of his knowledge and the company of his principles. For Kiil and the towns-people, the evidence of the senses is all that can be trusted. The audience and doctor are the only witnesses to the illogic of this viewpoint, the only ones who will acknowledge the presence of microscopic life that cannot be seen by human eyes.

In *Enemy*, Dr. Stockmann is a Cassandra figure, one who can see the coming danger but is powerless to prevent it. Lacking the scientific equip-ment necessary to test the water, he collects samples and sends them to a nearby university for analysis. Without the right lenses he cannot visualize the infecting organisms himself and cannot physically show them to the townspeople. Although he has a letter from the university scientists attest-ing to the water's danger, his inability to show evidence within the realm of the senses turns out to be a critical failing. As Timothy Matos argues, "In its dramatic use of the emerging sciences of sanitation and prophylaxis, *An Enemy of the People* extends . . . to the triumphs and promises of the newly

applied germ theory that was transforming the medical and social land-scape of disease."[55] Germ theory fails to carry the day in *Enemy* because it cannot be demonstrated to exist without the scientific equipment needed for sensory extension.

Dr. Stockmann in *Enemy of the People* is a scientist as well as a doctor, a conflation of roles that recurs in Sinclair Lewis's *Arrowsmith* (1925), a novel that he wrote together with the bacteriologist (and popular science writer) Paul de Kruif. *Arrowsmith* is considered Lewis's most idealistic novel, lacking the heavy satire and ubiquitous derision of *Main Street* or *Babbitt* and featuring instead a protagonist who is admirable and principled. Martin Arrowsmith's career encompasses lab science, medical practice, and public health, and is defined by his battles against infectious germs, in laboratories, factories, dairies, hospitals, and on the scene of epidemics. Indeed, Arrow-smith spends his life combating invisible microscopic enemies, frequently in the face of indifference or outright hostility from disbelieving or uncar-ing communities. Written some forty years after *Enemy*, *Arrowsmith's* lay-people are willing to concede that infusoria (an obsolete term referring to a large group of microorganisms) might well, though invisible, be present in water, or lurking on and in human beings. But non-experts display the same inveterate skepticism seen in Ibsen's characters when their own livelihoods or loved ones are implicated in the diagnosis of a contagion.

From his first day in medical school, Arrowsmith commits to bacteri-ology, to "discover enchanting new germs."[56] His idol is Max Gottlieb, a pure scientist who demonstrates the transmission of anthrax by the inocu-lation of two guinea pigs. The demonstration captivates Arrowsmith, who devotes his career to the mysteries of disease transmission and the extra-ordinary powers of the bacteriologist who can control the unseen, deadly hordes. As in *Enemy of the People*, Arrowsmith propounds his scientific belief and is more often than not scorned by laypeople. In his first job as doctor and public health officer for a small North Dakotan town, he begins to make himself unpopular when he sets out to trace the source of a recurrent typhoid outbreak. The locals believe a group of squatters to be responsible, but Arrowsmith traces the infection to a local and beloved seamstress who

unwittingly carries the disease from house to house. He not only is denounced as heartless, but when he later tells a prominent dairyman that three of his cows have streptococcus-laden udders, he makes powerful enemies throughout the town. Arrowsmith's scientific approach to medical practice is contrasted with that of his superior officer, who sets his twin daughters to trumpeting empty public health slogans like "A healthy mind in A clean body" (193) and "Germs come by stealth / And ruin health" throughout the town (211). Arrowsmith's final attempt to bring science to medicine takes place when he travels to the Caribbean to try to test a possible cure for plague; he is precluded by local officials from establishing a control group that can definitively demonstrate the validity of his serum. In *Arrowsmith*, as in works by Wells and Ibsen, knowledge of the invisible world made visible by science is frequently a burden and not a protection to those who bear it. The scientist or doctor, far from being a privileged figure or hero, becomes a martyr to his own knowledge.

In the end of the novel, Arrowsmith leaves his professional community, as well as his wife and his son, and goes to a crude laboratory in rural Vermont to devote the rest of his life to pure research. The cost of Lewis's idealism in the novel is high. Lewis seems to assert that the distance between the physician-scientist who understands the microbial world and human society that prefers ignorance is impassable. The more Arrowsmith understands about the microscopic domain, the less able he is to live in society. Only once he is ensconced in his crude cabin, away from everyone but his lab partner, can his vocation find expression.

> He would yet determine the essential nature of phage; and as he became stronger and surer—and no doubt less human—he saw ahead of him innumerable inquiries into chemotherapy and immunity; enough adventures to keep him busy for decades.
> It seemed to him that this was the first spring he had ever seen and tasted.
>
> (425)

As Arrowsmith toils in isolation, his work produces a range of inter-related consequences; the work of understanding the invisible galaxy of

disease-bearing agents advances. With this advance comes a diminution in Arrowsmith's humanity and a concomitant increase in the sensitivity of his senses. Arrowsmith's unrelenting focus on the tiny agents seems to have heightened not just his vision but his sense of taste as well. The novel seems ultimately to suggest that doctors and scientists, through the nature of their work with germs, become separate from the rest of humanity, a separation that is closely connected to their sensory capacities—their ability to see the unseen.

The novel that most famously brings together epidemiology, germ theory, and expanded sensory powers is Thomas Mann's 1924 work *The Magic Mountain*, which tells the story of a young man, Hans Castorp, who journeys to a tuberculosis sanitarium to visit his ailing cousin Joachim. Joachim is passing an extended stay in a place that feels like it is part-hospital, part-resort, and part-spiritual retreat. As the term of his planned visit draws to an end, Castorp contracts a cold and allows himself to be examined by the sanitarium's physician. He is diagnosed tubercular and must stay at the hospital and take its cure. Castorp has considered himself healthy and felt well until that moment, but he defers to the doctor's greater knowledge and becomes a patient.

The doctors' authority is understood to derive from their knowledge of physiology, which is depicted in *The Magic Mountain* as an ability to look beneath or see through the surface appearance of humans. Dr. Hofrat Behrens is a painter of portraits as well as a physician, and he explains to Castorp that his ability as a painter derives from his specialized visual knowledge of the human form:

> An artist who is a doctor, physiologist, and anatomist on the side, and has his own little way of thinking about the under sides of things—it all comes in handy too, it gives you the *pas*, say what you like. That birthday suit there is painted with science, it is organically correct, you can examine it under the microscope.[57]

It is Behrens's superior powers of vision—augmented both by his studies and by his tools—that make him a superior painter. He claims to be able to

paint with microscopic fidelity to the human form; moreover, his knowledge of what lies under the surface of the skin gives his work additional verisimilitude.

Behrens's conflation of artist with doctor and scientist may also present an intriguing formulation for the modernist writer; it recasts Virginia Woolf's famous command in her essay "Modern Fiction" to "look within" the human mind in order to write with conviction and authenticity. The modernist writer, as we will see by the end of this chapter, attempts to acquire the enhanced visual power of the physician-scientist in order to write with greater fidelity to the object of representation. Ironically, for Dr. Behrens, his portraits are not the finest works of art—they are merely the most accurate. Still, Castorp is fascinated by the doctor's anatomical knowledge and visual power, augmented not just by the power of the microscope but by another technology that was still quite new in 1924 and that provided even deeper insight into the human being: the X-ray.

The diagnosis of tuberculosis surprises Hans Castorp and implies that the doctors see something in him that he could not see in himself. He looks forward with excitement to the day when he and his cousin will be X-rayed, eight days after the initial diagnosis, and given the chance to look into their bodies. Joachim is the first to undergo the procedure, and Castorp, given permission to look into his cousin, steps up curiously:

> [The doctor] studied the spots and lines, the black festoon in the intercostal space; while Hans Castorp gazed without wearying at Joachim's graveyard shape and bony tenement, this lean *memento mori*, this scaffolding for mortal flesh to hang on. (218)

Castorp experiences a religious fascination at the sight of his cousin's interior. He is prompted to thoughts of death by the infrastructure of the skeleton, the parts of the body that remain when the softer tissues have rotted away. Next it is Castorp's turn in the machine, and he begs the doctor to be allowed to see his own revealed form, the skeleton of his hand, "what it is hardly permitted man to see, and what he had never thought it would

be vouchsafed him to see: he looked into his own grave" (218). Castorp goggles at the sight of his own bones and turns away from the sight with hesitation, reluctant to lose the expanded visual landscape provided by the machine.[58]

The knowledge of the body's interiors has a sacred cast and the priests are the doctors who preside over the sanitarium. Their uncanny status derives in part from their enhanced sensory powers, which include the vision of the X-ray machine. The doctors also appear to have sophisticated powers of hearing: as part of the patient's examination, the doctors thump and sound the chest of the patients, deriving from tiny sounds what lies inside. Doctor Behrens, in his initial examination of Castorp, pounds him all over, but returns repeatedly to one area near the left collarbone, tapping it again and again. "'Hear that?' he asked Dr. Krokowski. And the other, sitting at the table five paces off, nodded to signify that he did" (179). For their powers of vision the doctors rely on a machine, but they have also trained their hearing to be unusually sensitive and attuned to the sounds of disease process. Castorp is aware of how much he has not seen, not heard, until coming to the sanitarium. He cannot see the features his doctor delineates on his X-ray, but he trusts they exist. He treats the X-rays as talismans, carrying around with him the X-ray of a fellow-patient with whom he has fallen in love (666). Castorp's own sensory abilities may be inferior, but he places his well-being in the keeping of the doctors who can see and hear more than he can.

It is common for doctors to be seen as possessing special abilities and having authority in their worlds. What seems particular to the texts I have been discussing, however, is the derivation of their authority and power specifically from their sensory abilities and their savvy use of mechanical sensory extenders. These abilities allow them to perceive the invisible presence of germs and their traces. Using microscopes, X-ray machines, stethoscopes, or specially trained hearing, doctors and scientists in these texts use their expanded sensory range to identify dangerous intruders into the body. Their attentiveness to the evidence their senses provide, either on their own or with the use of mechanical extensions, contrasts with that of the laypeople around them, who at worst scorn the doctors' claims of

dangerous, invisible presences or, at best, are merely unable to comprehend the evidence pointing to the traces of these presences.[59]

These texts draw a sharp contrast between those who have sensory abilities that have been extended by modernist technology and those who are outside the circle of enlightenment. This contrast—with its focus on an elite inner circle created by a dedication to science—differs from technologies like the cinema and motor car that do not require dedicated study and the deliberate pursuit of knowledge. These sensory enhancements must be sought and earned; though the general population can benefit from the fruits of specialists' knowledge, they do not have access to their abilities. Wells's anarchist in "The Stolen Bacillus" can see nothing when he first peers through the bacteriologist's lens—the scientist must make adjustments and guide the amateur. Having at last visualized the infusoria, the visitor still cannot tell the difference between a deadly specimen and a harmless one.

The senses can both mislead and confound. Vision, often considered the dominant sense, can become unreliable when it fails to perceive the presence of dangerous microorganisms. In my next readings, I will move away from the direct representation of germ theory in modernism and toward its broader and more abstract influence, which I believe lies in modernism's commitment to an aesthetic of cleanliness and hygiene articulated through a new emphasis on visual clarity in representation. If the expanded use of glass and interest in transparency in modernist design and architecture were responses to an increased interest in hygiene and visibility, then we can consider whether a similar set of preoccupations was at work in the formulation of modernist literary aesthetics.

"Transparency" in language means something quite different from transparency in glass architecture; similarly, to speak of "hygiene" in poetry is distinct from the practice of hygiene in kitchen design. Yet the use of common terms suggests shared or overlapping values and preoccupations across different forms of modernist cultural production. As different as these forms of practice may be, they share an interest in personal and environmental cleanliness, the avoidance of disease, and the practice of

hygiene, whether in a metaphorical or material sense. The architectural critic Mark Wigley argues that for modern architecture, "the argument is not about hygiene per se. It is about a certain look of cleanliness. Or, more precisely, a cleansing of the look, a hygiene of vision itself."[60] Cleaning is certainly an aesthetic practice, motivated by a set of choices that distinguish between the clean and the dirty; this imaginary dimension of cleaning is apparent in antiseptic hygiene, which is deeply ritualistic in its quotidian implementation. Modern architecture, in other words, practices cleanliness as an aesthetic that both offers to the eye a clean surface and defines vision itself as a cleansing act.

For the modernist poet, hygiene finds meaning not through the aesthetics of the surface but through the representation of the physical world using the medium of language. It is visual and verbal clarity that produces the experience of cleansing. The pursuit of a perfected clarity of representation of the object in language equates with hygienic and sanitary practice. As William Carlos Williams argues, "the cleansing of the 'word,'... is the work poets have in hand."[61] Cleansing, for Williams, is important work, vital work, and the poet accomplishes it through the composition of poetry that is *clear*—lucid, precise, transparent, and direct. Cleanliness mingles with clarity, and in this mingling we see the influence of germ theory, since it is the new microscopic clarity of the bacteriological gaze that redefines the meaning of cleanliness while also endowing it with heightened value. Clarity enables cleanliness, and cleanliness is also a form of clarity.

With these ideas in mind I would like to conclude with a closer look at Williams, a practicing physician throughout his writing career and so positioned at the juncture of the medical and poetic discourses of health and hygiene.[62] Williams grew up in Rutherford, New Jersey, a town he would go on to serve as a doctor for more than forty years. Following high school, he matriculated at the University of Pennsylvania to study medicine. It was there that he met Ezra Pound, a pivotal encounter for the young man who was already immersed in the world of poetry. "Before meeting Pound is like B.C. and A.D.," Williams later recalled.[63] Pound schooled Williams in the ways of Imagism and introduced him to H.D., Pound's

girlfriend at the time; indeed, Williams remained very much under the influence of Imagism's tenets long after Pound had moved on to Vorticism. Williams managed two full-time careers, as writer and doctor, which demanded much from him in time management and diligence, but he never seriously considered setting aside his medical practice—not least because it afforded him an income during the long decades before his writing started to be recognized and generate income.[64]

Williams always claimed that his two professions—writer and doctor—complemented one another; as he explained, "as a writer I have never felt that medicine interfered with me but rather that it was my very food and drink, the very thing which made it possible for me to write."[65] For Williams, poetic language seems to offer something that medicine cannot: the chance for clarity and cleanliness, a stripped-down form of expression that reveals the essence of the thing. In this way, the cleansing power of modernist language compensates for the burdens of new scientific knowledge. The perceptive capacities of the senses may not be equal to the task of grasping the threatening microbial world, but the poet's powers of perception can offer a compensatory aesthetic equivalent. It can enlist language in the service of a hygiene that cannot be fulfilled in the physical world, and certainly not in the messy sphere of medical practice.

Williams was hardly the only writer to posit an equivalence between science and poetry, scientist and poet. Ezra Pound compared the two roles throughout his essays, as Kimberly Kyle Howey has shown in her study of Pound's scientific rhetoric. As Pound expostulated in 1916, "But if one can't, *parfois*, write 'as a physician, as a savant, as a historian,' if we can't write plays, novels, poems or any other conceivable form of literature with the scientist's freedom and privilege, with at least the chance of at least the scientist's verity, then where in the world have we got to, and what is the use of anything, *anything*?"[66] For Pound, perhaps even more than for Williams, science was a legitimizing discourse for poetry, establishing the continuing relevance, vitality, and centrality of poetic praxis. Science also offered a means of establishing an objective metric for the evaluation of poetry. Pound argued, "This brings us to the immorality of bad art.

Bad art is inaccurate art. It is art that makes false reports. If a scientist falsifies a report either deliberately or through negligence we consider him as either a criminal or a bad scientist."[67] Like Williams, Pound sees in science a model for creating a hard distinction between truth and falsity, clarity and inaccuracy.

Moreover, science and medicine, in Pound's understanding, articulated methods that offered the chance to break decisively with poetry of the past and establish a new model for poetic composition. He wrote, "As there are in medicine that art of diagnosis and the art of cure, so in the arts, so in the particular arts of poetry and of literature."[68] In his *ABC of Reading* (1934), for example, Pound opens with the well-known anecdote of the scientist Louis Agassiz and the decomposing fish, suggesting that the responsibility of the writer is attentive observation to the subject of representation.[69] For Pound, writers, like their scientific counterparts, must maintain "the very cleanliness of the tools, the health of the very matter of thought itself."[70] One of Pound's most novel combinations of visual enhancement, technology, and aesthetics was his participation in the 1916 creation of the Vortoscope, a machine that produced non-representational photographs.[71]

Fidelity to the subject was made possible by a perfect clarity of vision, expressed in its most famous form in Pound's second principle of Imagism. As Pound wrote in 1913, poetry should present the "direct treatment of the thing, whether subjective or objective"; Williams reformulated this principle as, "no words but in things." It was no small matter to understand what "direct treatment" or hygienic expression might mean in poetic language, and this was exactly the challenge that Williams pursued throughout his work. In the prose sections of *Spring and All* (1923) Williams can be seen struggling to understand and explain how clarity of vision can be translated into words:

The man of imagination who turns to art for release and fulfillment . . . contends with the sky through layers of demoded words and shapes. Demoded, not because the essential vitality which begot them is laid waste—this cannot be so, a young man feels, since he feels it in himself—but because meanings have been lost through laziness or changes in the form of existence which

have let words empty.... Such work...is typified by the use of the word "like" or that "evocation" of the "image" which served us for a time.[72]

Poetic language, Williams asserts, has become degraded through the use of habitual formulations that lack communicative content and put distance between the object of representation and the reader. Williams particularly objects to the use of prepositions, evocations, or images, all of which he feels have been overused and have an attenuating effect on poetic discourse. The essence of his critique seems to show Williams struggling with the intrinsic nature of English grammar, which assigns a representative function only to certain parts of speech, and which tends to form patterns and to rely on habitual structures of expression.

For Williams, poetic expression should use language as though it were glass—a medium that interposes but does not distort. Later in *Spring and All*, he continues,

There is no form to prose but that which depends on clarity. If prose is not accurately adjusted to the exposition of facts it does not exist. —Its form is that alone. To penetrate everywhere with enlightenment—
Poetry is something quite different. Poetry has to do with the crystallization of the imagination.[73]

Both prose and poetry embrace clarity, but for poetry Williams evokes crystal as his model for clearness. "Clarity" contains the sense of lightness and brightness; "crystalline" and "enlightenment" similarly evoke the idea of transparency or glassiness; both terms relate to optics, directness, and vision. This rhetoric is liberally sprinkled through Pound's writings as well; as Pound wrote to Amy Lowell in 1914, "Imagism stands, or I should like it to stand for hard, light, clear edges."[74] The word "clear" echoes through Williams's early poetry, where it typically stands for purity, insight, or clarity of vision. Some representative examples: "I see you clear enough" ("Sub Terra," 1917); "I for whom the world is a clear stream" ("In San Marco, Venezia," 1912); "A spring in whose depth / white sand bubbles / overflows / clear" ("The Source," 1928); "let me examine / those varying shades / of

orange, clear as an electric / bulb on fire" ("This Florida: 1924," 1932); "Think: / the clear stream" ("Sluggishly," 1934).

In the image of the electric bulb we see an example of Williams's frequent mingling of clearness, glass, and light. The same imagery is constellated in a 1923 poem that concludes with "the radiant nothing / of crystalline / spring."[75] The link between glass and acute powers of perception recurs in Williams's 1928 poem, "The Lily," which I quote in its entirety:

> The Lily
>
> The branching head of
> tiger-lilies through the window
> in the air—
>
> A humming bird
> is still on whirring wings
> above the flowers—
>
> By spotted petals curling back
> and tongues that hang
> the air is seen—
>
> It's raining—
> water's caught
> among the curled-back petals
>
> Caught and held
> and there's a fly—
> are blossoming[76]

Williams places the figure of the observing poet at a glassed-in remove from the lily that is the object of contemplation, looking "through the window." The scene is one of stasis, and feels like a *tableau vivant*. Despite his earlier complaints about prepositions, Williams uses them to structure his lines and avoid using few verbs besides "to be," which is employed six times. Williams also scatters quiet gerunds throughout the stanzas, all describing movements so small and slight as to be imperceptible to any but the most acute observer ("branching," "curling," "blossoming," "humming," "whirring"). Even the potentially more obtrusive "raining" is muted

by the poet's observation that the rain is only perceptible because water is pooling in the lily's petals.

The feeling of stillness is compounded by the image of the hovering humming bird, the water "caught and held" in the lily's petals ("caught" is repeated twice), and the "tongues" (stamen) that "hang," as well as by the fidelity to the present tense. The scene evokes the opening paragraphs of Oscar Wilde's novel *The Picture of Dorian Gray*, which also presents an artist looking out the window at a still garden scene; Williams's choice of a lily would seem to nod to the Aesthetes.

Though the visual is primary in "The Lily," the poem invokes all the senses in its fourteen lines: sound ("humming"), taste ("tongues"), touch ("held"), and smell ("blossoming"). In each case, the senses are more powerful than might be expected: the "humming bird" (note that Williams changes the name of the bird to two words and not one, emphasizing sound) would be very hard to hear, the touch needed to hold the water in the petal extremely delicate, and the flower's scent is implied rather than expressed. Still, the feats of vision in "The Lily" are by far the most impressive. In the eighth line, for instance, "the air is seen," and this is a very pure air, not the diseased exhalation described by Hornibrook above. The strength of the poet's visual capacity shows in his description of the rainwater, since the clarity of focus needed to glimpse the water pooling in a petal's indentation is considerable. One wonders if the poet's gaze is acute enough to freeze the blurred wings of a hovering hummingbird in a stationary frame. The poet is given to us here as a highly acute and aware observer of the natural world but not as someone who is himself of that world. The poet keeps back behind glass, perhaps heightening his perceptive abilities (as a microscope would do), perhaps ensuring the objectivity of his vision.

Pound's and Williams's comparison of the scientist with the poet certainly seems to animate Williams's conception of the observing figure in "The Lily," and perhaps to recall the extraordinary value associated with the superior sensory ability also linked to science. Poetic clarity, modeled on scientific clarity, might also be understood to compete with scientific clarity

by offering a richer and more telling view of the natural world, one that, as in painting, creates the world rather than merely representing it. If we recall *The Magic Mountain*'s Dr. Hofrat, whose portraits are accurate without being great works of art, we may hear Mann telling us that the work of the artist is a necessary complement to that of the scientist.

Clarity, as "The Lily" shows us, is the poet's chief responsibility; clarity encompasses all the senses—though vision is primary; clarity requires objectivity, close observation, and heightened sensorial ability. In his post-humously published book *The Embodiment of Knowledge* (composed 1928–30), Williams further develops his sense of what clarity means for poetry: "Clarity is the word," Williams writes. "A clean wind through the chaff of truth. Alive again: This is what throws off poetry. Direct vision—knowledge to action, to knowledge: Clarity is rare."[77] As with "clear," the word "clarity" recurs throughout his work and has a talismanic value for Williams. It figures in his well-known 1923 work "Spring and All," where he writes, "One by one objects are defined— / It quickens: clarity, outline of leaf."[78] "Clarity" subtends the act of visual focusing, in which the outline of objects moves from blurry to sharp, suggesting the action of a mechanical lens.

Clarity of observation is a principle readily applicable to both poetry and science, but hygiene would appear to belong to science alone. Yet Williams's and Pound's modernist poetics were equally reliant on the scientific concept of hygiene and often conflated clarity with hygiene—a pairing that we have already seen in this chapter in modern architecture and design. "It is unclean / which is not straight to the mark—" as Williams writes in one of the poems in *Spring and All*, asserting a perfect identity between hygiene and clarity.[79] To lack clarity is to be dirty; Williams's choice of the word "unclean," of course, goes beyond dirt and filth and directly into the zone of taboo, contagion, and the range of purification safeguards famously described by Mary Douglas in *Purity and Danger*.

For the post-Imagist Pound, however, hygiene came to signify in poetry in quite a different register. Pound had a lifelong interest in bacteriology; Olga Rudge recalls, "EP was reading the PARADISO aloud to her and a

book on microorganisms," a book of sufficient sophistication that Olga could make nothing of it.[80] Like many others, Pound saw in microscopic life a source of possible contamination, and made hygiene a core value in his modernist poetics. Pound, unlike Williams, in returning to Europe made common cause with the Futurists, or as the English strain of the movement named it, the Vorticists. Marinetti, in his famous hyper-masculinist 1909 manifesto for Futurism, called war "the world's only hygiene," though Wyndham Lewis, Pound's collaborator in Vorticism, criticized Marinetti's high-blown rhetoric about the cleansing value of war (perhaps because Lewis had fought in the trenches). However, in Pound's hands the association developed into a personal cosmology that separated the contaminated from the clean in racial and religious terms. As Zygmunt Bauman writes,

> Pound's mind moved between two universes. One was bright, harmonious, beautiful, elevated—because transparent and orderly. The second was dark and impenetrable, populated by microbes, germs, bacilli, fungus. (Let us note that bacteria, viruses and other inhabitants of the microscopic universe have two attributes in common: because of their *corrosive*, disintegrating action they are by nature enemies of health and organic balance; and they are *invisible*, and thus difficult to spot and to keep at a safe distance. The same two traits define all ambiguity; in particular, they define the Jews— assimilated or eager to assimilate—as seen from the control desk of the ordering project.)[81]

For Pound, the Jews came to represent the unclean, the formless, the blurry, and had to be combated with prophylaxes that ranged from hygiene to violent eradication. Williams's conception of hygiene, however, did not follow Pound into racialized or anti-Semitic concepts, but rather understood hygiene as a value in language that was paired with clarity.[82]

It seems worth asking why Williams repeatedly characterizes clarity as so difficult to achieve and so easily lost. He sees much of his youthful writing as failed exactly because it lacked clarity; as he recalls, "I think often of my earlier work and what it has cost me not to have been clear."[83] He appears to see language itself as naturally inhibiting to clarity. Given that the modernist sensorium glories in the radical expansion of sensory

capacity—for sight most of all—why is clarity, here equated with "direct vision" experienced as elusive? Why does the poet's task of close observation so often tumble into failure, at least from the writer's perspective?

The answer may lie in the connection Williams forges between clarity and hygiene. Williams sought to produce what he termed "hygienic writing," and saw in Pound a fellow practitioner; reviewing the Pisan Cantos he praised Pound for "A new hygiene of the words, cleanliness."[84] How can verbal clarity of expression rely on cleanliness, when no word is particularly cleaner than any other? The tenuousness of the link between these two terms is what makes Williams's faith in their interconnection so interesting. Why does he see cleanliness in clarity? The question might recall us to the equally tenuous link between cleanliness and glass architecture, or cleanliness and planar surfaces, both adduced in modernist architecture and design, and neither a guarantor of hygiene in any straightforward way. Compare, for instance, Le Corbusier's praise of whitewash in his celebrated 1925 essay, "A Code of Whitewash: The Law of Ripolin," where he writes of the modern home with its white walls: "*His home* is made clean. There are no more dirty, dark corners. *Everything is shown as it is.*"[85] Why should whitewash render the domestic interior clean? Yet for Le Corbusier, it does. Clarity, acuteness of vision, cleanliness; for the architect these qualities are joined in the service of sweeping away a derelict past—and bear in mind that the Victorians were mostly likely to paint interior walls in the home dark blue or black.

For Williams, on the other hand, the association between cleanliness and clarity serves to define the poet's role in forging modernity—so that the poet depends not on what Wigley terms a "hygiene of vision," but rather *vision as hygiene.* In other words, the acuity of the poet's gaze renders the world clean by representing it with a new clarity. In this way, the poet's vision helps to create the world, rather than merely describing it; to change the world by writing about it. In recognizing the emergence of cleanliness as a value in disparate modernist forms, we can adduce both the soaring cultural importance of a specific kind of cleanliness in the early twentieth century, together with a set of meanings that seem specifically to attach to

cleanliness and which we have already discussed: precision of outline, sensorial acuity, and asepsis.

In Williams's work, the best-known assemblage of the dynamic I am tracing appears in the titular poem of *Spring and All*, which was published the year after *The Waste Land* (and the year before *The Magic Mountain*) and begins with the following lines:

> By the road to the contagious hospital
> under the surge of the blue
> mottled clouds driven from the
> northeast—a cold wind. Beyond, the
> waste of broad, muddy fields
> brown with dried weeds, standing and fallen[86]

The scene is one of desolation and emptiness, the tone set by the reference to the contagious hospital, an institution designed to isolate infectious patients. The weeds represent the hospitalized patients, "standing and fallen," as some weeds have survived the winter and others have not. The reference to "waste" further invokes sanitation and hygiene—as well as conjuring Eliot's poem, successful and celebrated from the time of its publication and serving as a kind of goad to Williams to make his own name as a poet. The cold wind, by contrast, suggests a cleansing movement; elsewhere, Williams associates wind moving across a field with clarity ("A clean wind through the chaff of truth"). In the opening of "Spring and All," the wind is moving the blue mottled clouds, the messiness of mottling presumably the confusion that the clarifying wind will resolve. "Mottling" (derived from "motley") refers to a pigmentation that is indistinct and usually a sign of ill health; by the end of the poem the coming of spring will have resolved this epidemic confusion. In the movement from mottled to defined, we see one account of the equivalence between *clean* and *clear*.

The impression of confused states established by "mottled" is continued in the poem's brief second stanza, which reads in full, "patches of standing water / the scattering of tall trees." "Patches" and "scattering," like "mottled,"

invoke an appearance of blotchiness on the landscape's complexion, while the "standing water" (echoing "standing and fallen" in the previous line) is a notorious marker for the breeding of infectious diseases like malaria. Williams is asking us to imagine spring as a time when life and health separate themselves from the dead land of winter; this process stands in for the emergence of clarity from confusion. As the poem continues, the language of blotch and mottle resolves decisively into well-defined silhouettes:

> Lifeless in appearance, sluggish
> dazed spring approaches—
>
> They enter the new world naked,
> cold, uncertain of all
> save that they enter. All about them
> the cold, familiar wind—
>
> Now the grass, tomorrow
> the stiff curl of wildcarrot leaf
>
> One by one objects are defined—
> It quickens: clarity, outline of leaf

The "cold wind" blows through the poem twice, and the second time it brings the cleansing breath of clarity. The landscape, which had been one of nonfeeling (lifeless, sluggish, dazed) is reborn into sensation and movement. The spondaic opening "Now the grass" feels insistent and mood-changing; following this foot Williams employs hard consonants (carrot, curl, quickens) in order to sonically reinforce the idea of sharpness; he also includes words that themselves stand for acuity: defined, clarity, outline. It is clarity of perception, the expanded functioning of the senses, that is associated with well-being.

The overall movement of "Spring and All" is from death to birth, sickness to health, numbness to feeling, blurriness to clarity. The conjoining of these four trajectories argues for the significance of sense-perception in life and health; it also follows the logic of germ theory, which links enhanced sense perception with health and hygiene and lack of feeling and

confusion with infection and morbidity. Williams's emphasis throughout is on clarity, a watchword in both his poetry and his prose, and a property that partakes simultaneously of sonority, acuity, insight, splendor, and renown. Clarity is a property of thought, form, and expression; in "Spring and All," as elsewhere in Williams's work, it is also cleansing. The wind that blows around them drives out contagion, removes any residuum and reveals objects in what Williams terms their "stark dignity" in the poem's final stanza.

As with "clear," the word "clean" recurs over and over in Williams's poetry, often in concert with sense impression. He writes of "a / clean air, high up, unoffended / by gross odors" in "All the Fancy Things" of 1927. In "A Crystal Maze" (1932) he praises "an uncalled for body clean / to the eye—." Cleanliness is delightful to the senses, but more than that, it is a condition that the poet can bring about in language. In an open letter to Robert Creeley, Williams articulated what he considered his "moral program" as a poet. He wrote, in the letter's conclusion, "Bad art is then that which does not serve in the continual service of cleansing the language of all fixations upon dead, stinking dead, usages of the past. Sanitation and hygiene or sanitation that we may have hygienic writing."[87]

Language, like the body, is in need of periodic rejuvenation and cleansing that the poet can provide. The poet's vision offers a means to compensate for the inability of the human eye to perceive the microbial world. The word "clean" rings through Williams's works in what can be read as an attempt to forge, through poetry, a kind of purity. Such purity seemed inaccessible in the dirty real world and perhaps more particularly in the world of Williams's medical practice, represented by him in his short fiction as squalid and messy, lacking in clarity. The practice of poetry, unlike the practice of medicine, can see what it wants in the world, can, indeed, create the world through seeing it, create it as transparent, as viewable.

"Hygienic writing" is writing that has been cleansed and that can convey a healthy clarity. Williams's mingling of clarity and hygiene suggests an important impulse in his poetry that might almost be characterized as

bacteriological in its logic.[88] By this, I mean that he believes that the task of the poet is to use the senses to isolate, identify, and describe his subject, much in the way of the scientist. The value he places on glass, sensory precision, sensory enhancement, and hygiene all extend his vision of the poet/scientist as one whose powers of perception can and should be placed in the service of hygiene, which in poetry means clarity—the ability to render the object of representation with fidelity and to, more broadly, cleanse and disinfect language. The poet's vision has the power to cleanse. Yet Williams's concern—shared with Pound—that clarity in language is a difficult if not impossible project, seems joined to an experience of the senses as incapable of doing what is asked of them in the age of germ theory.[89] This sensory failure is an inevitable consequence of coping with a world where vision cannot discern bacterial threats. But by forging a poetic language as transparent as glass, the poet creates a world where perfect vision is possible. "Good prose," George Orwell wrote, "is like a windowpane."[90] For Orwell, only such window prose was worth writing. Seeing with a clarity they identified with transparency, modernist writers sought to render the world through the hygiene of their vision.

Notes

1. Lynn McDonald, "Florence Nightingale A Hundred Years On: Who She Was and What She Was Not," *Women's History Review* 19.5 (November 2010): 721–40.
2. Anne Hardy, *The Epidemic Streets: Infectious Disease and the Rise of Preventive Medicine, 1856–1900* (Oxford: Clarendon Press, 1993), 3.
3. Abdel R. Omran, "The Epidemiologic Transition: A Theory of the Epidemiology of Population Change," *The Milbank Quarterly* 83:4 (December 2005): 731–57.
4. See, for instance, Bruno Latour, *The Pasteurization of France* (Cambridge, MA: Harvard University Press, 1993); Nancy Tomes, *The Gospel of Germs: Men, Women and the Microbe in American Life* (Cambridge, MA: Harvard University Press, 1998); and John Waller, *The Discovery of the Germ: Twenty Years that Transformed the Way We Think About Disease* (New York: Columbia University Press, 2002).
5. Alexandra M. Levitt, D. Peter Drotman, and Stephen Ostroff, "Control of Infectious Diseases: A Twentieth-Century Public Health Achievement," in *Silent Victories: The*

History and Practice of Public Health in Twentieth Century America, ed. John W. Ward and Christian Warren (Oxford: Oxford University Press, 2006), 2.

6. Tomes, *The Gospel of Germs*, 7.
7. See Atul Gawande, "Slow Ideas," *The New Yorker*, July 29, 2013.
8. "The Germ Theory: Is It True?" *Life* 55, no. 1427 (March 1910): 379.
9. Joseph A. Amato, *Dust: A History of the Small and the Invisible* (Berkeley: University of California Press, 2000), 111.
10. Marilyn Thornton Williams, *Washing "The Great Unwashed": Public Baths in Urban America, 1840–1920* (Columbus: Ohio State University Press, 1991), 134. See also Priscilla Wald, *Contagious: Cultures, Carriers, and the Outbreak Narrative* (Durham, NC and London: Duke University Press, 2008) for a post-1945 perspective.
11. Eileen Cleere, *The Sanitary Arts: Aesthetic Culture and the Victorian Cleanliness Campaigns* (Columbus: Ohio State University Press, 2014), 110. See also Suellen Hoy, *Chasing Dirt: The American Pursuit of Cleanliness* (Oxford: Oxford University Press, 1996).
12. Tomes, *The Gospel of Germs*, 10.
13. "The Passing of the Beard," *Harper's Weekly* 47 (1903): 102.
14. Hoy, *Chasing Dirt*, 107.
15. Rosie Cox, "Dishing the Dirt: Dirt in the Home," in *Dirt: The Filthy Reality of Everyday Life*, ed. Cox (London: Profile Books in association with the Wellcome Trust, 2011), 44.
16. Isabella Beeton, *Beeton's Book of Household Management* (S. O. Beeton Publishing, 1861). Further references given parenthetically in the text.
17. See Elizabeth Langland, *Nobody's Angels: Middle-Class Women and Domestic Ideology in Victorian Culture* (Ithaca, NY and London: Cornell University Press, 1995).
18. Lytton Strachey, "Lancaster Gate," in *Lytton Strachey By Himself*, ed. Michael Holroyd (London: Vintage, 1994), 25.
19. Lydia Martens, "The Visible and the Invisible: (De)regulation in Contemporary Cleaning Practices," in *Dirt: New Geographies of Cleanliness and Contamination*, ed. Ben Campkin and Rosie Cox (London and New York: I.B. Tauris, 2007), 39.
20. Kate Kennedy, *The Science of Home-Making* (London: Thomas Nelson and Sons, n.d.), 230.
21. P. L. Garbutt, "Care and Cleaning of Floors," in *The Hygiene of Life and Safer Motherhood*, ed. Sir W. Arbuthnot Lane (London and Toronto: British Books Ltd., 1934), 258.
22. Jean Broadhurst, *Home and Community Hygiene: A Text-Book of Personal and Public Health*, 2nd edn, revised and enlarged (Philadelphia, PA and London: J. B. Lippincott Company, 1923).
23. Waller, *Discovery of the Germ*, 189.
24. B. Liber, *The Child and the Home: Essays on the Rational Bringing-Up of Children* (New York: Vanguard Press, 1927), 166. This work was translated into French, German, and Rumanian.
25. See Anne McClintock, "Soft-Soaping Empire: Commodity Racism and Imperial Advertising," in *Imperial Leather: Race, Gender and Sexuality in the Colonial Contest* (New York and London: Routledge, 1995).

26. Robin G. Schulze, *The Degenerate Muse: American Nature, Modernist Poetry and the Problem of Cultural Hygiene* (New York: Oxford University Press, 2013), 32–4.

27. "Germs cannot be seen so there are no obvious indicators of their effective elimination. Questions about how and how much to clean consequently arise on a daily basis. Such questions carry with them a burden of responsibility." Elizabeth Shove, *Comfort, Cleanliness and Convenience: The Social Organization of Normality* (New York: Berg, 2003), 87.

28. W. H. Hornibrook, "The Ideal House," in *The Hygiene of Life and Safer Motherhood*, ed. Sir W. Arbuthnot Lane (London and Toronto: British Books Ltd., 1934), 235.

29. The changing nature of hygiene was not solely stimulated by science. As Adrian Forty and others have argued, "the rapid social change and disintegrating social boundaries that came with the increasing political power of the working class to be behind the middle-class and preoccupation with bodily, domestic, and public cleanliness." Forty, *Objects of Desire: Design and Society since 1750* (London: Thames and Hudson, 1986), 8.

30. All these buildings were influenced by The Crystal Palace constructed for the 1851 Great Exhibition in London. For a rich history of the use of glass in architecture, see Brent Richards, *New Glass Architecture* (New Haven, CT: Yale University Press, 2006).

31. Jeffrey Schnapp, "Crystalline Bodies: Fragments of a Cultural History of Glass," *West 86th* 20.2 (2013): 173–94, 185.

32. Christine Brecht and Sybilla Nikolow, "Displaying the Invisible: *Volkskrankheiten* on Exhibition in Imperial Germany," *Studies in the Historical of Biological and Biomedical Sciences* 31.4 (2000): 511–30.

33. Margaret Campbell, "What Tuberculosis Did For Modernism: The Influence of a Curative Environment on Modernist Design and Architecture," *Medical History* 49.4 (October 2005): 463–8.

34. Virginia Smith, *Clean: A History of Personal Hygiene and Purity* (Oxford: Oxford University Press, 2007), 314.

35. *Electrical Merchandising* (January 1932): 29. The actual figures were 30,500,500 and 20,441,000, respectively.

36. Christine Frederick, "The Well-Planned Kitchen," *The Pittsburgh Press*, June 25, 1922.

37. The continuing belief that dust and household dirt could spread disease was also a miasma holdover; as Nancy Tomes has argued, "[A]ssumptions that pathogenic microorganisms were extremely hardy and widely broadcast in the environment, strongly colored the first generation of preventive strategies advocated in the name of germ theory." Tomes, *The Gospel of Germs*, 38.

38. Juliann Sivulka, *Stronger than Dirt: A Cultural History of Advertising Personal Hygiene in America, 1875–1940* (New York: Humanity Books, 2001), 117.

39. Williams, *Public Baths in Urban America*, 137.

40. Sigfried Giedion, *Mechanization Takes Command: A Contribution to Anonymous History* (New York: Norton, 1948), 685.

41. Paul Overy, *Light, Air and Openness: Modern Architecture Between the Wars* (New York: Thames and Hudson, 2008), 68.

42. Le Corbusier, *Towards a New Architecture*, trans. Frederick Etchells (1931; Courier Dover, 1986), 14.

43. Leo Stein, "American Optimism," *The Seven Arts* 2 (1917): 81.

44. Brian Howard, "The New Poetry," *Eton Candle* (March 1922): 17, reprinted in Eric Homberger, ed., *Ezra Pound: The Critical Heritage* (London and New York: Routledge, 1972).

45. William W. Braham, "Sigfried Giedion and the Fascination of the Tub," in *Plumbing: Sounding Modern Architecture*, ed. Nadir Lahiji and D. S. Friedman (New York: Princeton Architectural Press, 1997), 208.

46. Miriam Bratu Hansen, "The Mass Production of the Senses: Classical Cinema as Vernacular Modernism," *Modernism/Modernity*, 6.2 (1999): 69–71.

47. Jeffrey Schnapp, "Crash (Speed as Engine of Individuation)," *Modernism/Modernity* 6.1 (1999): 27.

48. Tim Armstrong, *Modernism, Technology and the Body: A Cultural Study* (Cambridge: Cambridge University Press, 1998), 78.

49. Sara Danius, *The Senses of Modernism: Technology, Perception, and Aesthetics* (Ithaca, NY: Cornell University Press, 2002), 194.

50. At the same time, there is a robust critical counter-narrative that tracks a skeptical discourse of the sensory (and of vision in particular) in modernism. This counter-narrative can be seen through psychoanalysis, Marxism, and existentialism, all asserting in ontological terms the partiality of sense-data and amounting to what Martin Jay has called "a crisis in ocularcentrism." See Karen Jacobs, *The Eye's Mind: Literary Modernism and Visual Culture* (Ithaca, NY and London: Cornell University Press, 2001), 2.

51. "The Influenza Outbreak," *JAMA*, October 5, 1918: 1138.

52. H. G. Wells, *The Stolen Bacillus and Other Incidents* (London: Methuen & Co., 1895).

53. H. G. Wells, *The War of the Worlds* (1897; New York: Tribeca Books, 2013), 1.

54. Henrik Ibsen, *An Enemy of the People*, trans. R. Farquharson Sharp. Project Gutenberg EBook 2446. Posted February 27, 2010. Accessed December 20, 2014: https://www.gutenberg.org/files/2446/2446-h/2446-h.htm.

55. Timothy Carlo Matos, "Choleric Fictions: Epidemiology, Medical Authority, and *An Enemy of the People*," *Modern Drama* 51: (2008): 365.

56. Sinclair Lewis, *Arrowsmith* (1925; Garden City, NY: International Collectors Library, 1953), 10. Further references given parenthetically in the text.

57. Thomas Mann, *The Magic Mountain*, trans. H. T. Lowe-Porter (1924; New York: Vintage Books, 1969), 259. Further references given parenthetically in the text.

58. As Danius points out, this scene recasts Röntgen's moment of discovering X-rays and their ability to illuminate the body's interior, when Röntgen placed his hand between the firing cathode ray tube and a screen, showing the bones of his own hand: see Danius, *Senses of Modernism*, 81.

59. The knowledge of the bacterial world, once understood, cannot be unlearned. In Somerset Maugham's *The Painted Veil* (1925), a bacteriologist who has been sent to cope with a cholera epidemic in China eats salad for dinner every night out of a

suicidal impulse, knowing well that what he cannot see on the leaves could kill him; eventually, it does, and he dies in full awareness of the irony of the manner of his death.

60. Mark Wigley, *White Walls, Designer Dresses: The Fashioning of Modern Architecture* (Cambridge, MA: MIT Press, 2001), 5.

61. William Carlos Williams, *The Embodiment of Knowledge* (New York: New Directions, 1974), 6.

62. While my discussion focuses on the 1920s and 1930s, for a view from the middle of the twentieth century see Peter Middleton, "Poetry, Physics, and the Scientific Attitude at Mid-Century," *Modernism/Modernity* 21.1 (2014): 147–68.

63. "William Carlos Williams," the Poetry Foundation: https://www.poetryfoundation.org/poets/william-carlos-williams, accessed February 1, 2015.

64. Herbert Leibowitz, *"Something Urgent I Have to Say to You": The Life and Works of William Carlos Williams* (New York: Farrar, Straus and Giroux, 2011).

65. William Carlos Williams, "The Practice (from *The Autobiography*)," in *The Doctor Stories*, compiled by Robert Coles (New York: New Directions, 1984), 120.

66. Ezra Pound, "Meditatio: I," *Egoist* 3.3 (March 1916), 37–8, qtd in Kimberly Kyle Howey, "Ezra Pound and the Rhetoric of Science, 1901–1922," unpub. diss., University College London, 2009, 234: http://discovery.ucl.ac.uk/17429/1/17429.pdf. Italics in original.

67. Ezra Pound, "A Serious Artist," in *Literary Essays of Ezra Pound* (New York: New Directions, 1918), 43.

68. Pound, "A Serious Artist," *Literary Essays*, 45.

69. Ezra Pound, *ABC of Reading* (1934; New York: New Directions, 2010), 17.

70. Pound, "How to Read," *Literary Essays*, 21.

71. The Vortoscope produced prismatic images called "Vortographs." Howey writes, "[Alvin] Coburn and Pound created at least 40 Vortographs during the winter of 1916–1917, culminating in an exhibition in February 1917 at London's Camera Club, in which 18 of the Vortographs were displayed. The exhibition proved to be one of the last functions of Vorticism; the final official function of the united Vorticist artists being held the same year at New York's Penguin Club, to indifferent critical response." Howey, "Ezra Pound and the Rhetoric of Science" 275.

72. William Carlos Williams, *The Collected Poems of William Carlos Williams, Vol. I 1909–1939*, ed. A Walton Litz and Christopher McGowan (New York: New Directions, 1986), 188. Note Williams's language of "vitality" and "waste," invoking a rhetoric of health and sanitation that I will return to discuss in relationship to the pursuit of poetic clarity.

73. Williams, *Collected Poems*, 226.

74. Ezra Pound, Letter to Amy Lowell dated 1 August 1914, in *Selected Letters of Ezra Pound 1907–1941*, ed. D. D. Paige (London: Faber and Faber, 1951), 77–8, 78.

75. Williams, *Collected Poems*, 252.

76. Williams, *Collected Poems*, 286.

77. Williams, *The Embodiment of Knowledge*, 33–4.

78. Williams, *Collected Poems*, 183.
79. Williams, *Collected Poems*, 200.
80. Qtd in Robert Casillo, *The Genealogy of Demons: Anti-Semitism, Fascism, and the Myths of Ezra Pound* (Evanston, IL: Northwestern University Press, 1988), 3.
81. Zygmunt Bauman, *Modernity and Ambivalence* (Cambridge: Polity Press, 1991), 151.
82. For more on Pound's different anti-Semitic rhetorics, see Casillo, *The Genealogy of Demons*.
83. Williams, *Collected Poems*, 202.
84. William Carlos Williams, review of the *Pisan Cantos*, *Imagi* (Spring 1949), iv, 10–11, reprinted in Homberger, *Ezra Pound*, 371.
85. Le Corbusier, *The Decorative Art of Today*, trans. James I. Dunnet (1925; Cambridge, MA: The MIT Press, 1987). Italics in original.
86. Williams, *Collected Poems*, 183. Though there are many readings of "Spring and All," one in particular harmony with mine is Mark Goble's, in his *Beautiful Circuits: Modernism and the Mediated Life* (New York: Columbia University Press, 2010), 257–8.
87. William Carlos Williams, "Letter to Robert Creeley," *Origin* 1.1 (1951): 34.
88. Previous critics have briefly noted Williams's interest in hygiene, and have seen in it either an interest in bringing technology to poetry or the pursuit of an American rejuvenation. Lisa Steinman argues that "Williams appropriates features of technological products—accuracy, effectiveness, practicality, cleanliness—and then applies them first to the scientific process and then to poetic creation and poems": Steinman, *Made in America: Science, Technology, and American Modernist Poets* (New Haven, CT and London: Yale University Press, 1987), 55. For T. Hugh Crawford, Williams's "rejection of a stale tradition and the desire for clean, pure language are…tied to a sanitation/apocalyptic vision." Crawford, *Modernism, Medicine, & William Carlos Williams* (Norman and London: University of Oklahoma Press, 1993), 129.
89. Robin Schulze has recently argued that, "Ultimately, however, even the stripped-down aesthetic of Imagism and the Chinese translations and paraphrases that followed did not seem hygienic enough to Pound, in part because the transparent natural language that he craved was a utopian dream." *The Degenerate Muse* (153).
90. George Orwell, "Why I Write," in A Collection of Essays (San Diego, CA: Harvest/HBJ, 1946), 316.

4

"REGULAR HOURS . . . AND REGULAR IDEAS"

Originality in an age of standardization

In his essay, "Let's All Be Alike!" (1935), Osbert Sitwell complained that in the machine age, people as well as objects were now being produced according to a standard type, such that people became "creatures of uniform stature and capacity, mental as much as physical...."[1] Though standardization began with Henry Ford's assembly lines, Sitwell groused about its expansion from the world of work and industry into the home, where houses now ran according to the same labor-saving principles governing the factory: "Everyone is the same; and so are the houses they inhabit."[2] But the crowning indignity was that literature too had become a uniform product: "all read—and write...the same poems; poems of an etiolated but slightly menacing despair.... Their poems are those of disillusioned bank clerks sitting in the popular cafes."[3] (The last jab perhaps directed at T. S. Eliot, a friend of Sitwell's.) For Sitwell, the doctrine of standardization, while increasing industrial production, debased the individual and sapped the originality of literature.[4]

From a contemporary perspective, it may seem unbelievable that in 1935 Sitwell felt literature had become a uniform and tedious product. The previous three years alone had seen the publication of major works by Gertrude Stein, W. H. Auden, Bertolt Brecht, André Malraux, and Aldous Huxley; Sitwell, at the center of London literary life, would have known them all. Moreover, the accusation of homogeneity flew in the face of modernist writers' programmatic and public claims to have created a

literature that, according to Eliot and many others, represented nothing short of a poetic revolution.

Though Sitwell's conclusions are hard to countenance, his line of argument is credible. Standardization, the cause of Sitwell's ire and the focus of my discussion, was an aspect of a broader trend toward rationalization, with its origins in science and industry. Standardization involves the creation of an ideal or normed type which is then replicated through the technologies of mass production. Like the objects of domestic life, literature can be standardized, either by norming language itself[5] or by standardizing literary production, as Sitwell describes, so that all works of literature are alike. If standardization represents a slide into homogeneity, then it finds a counterpart within literary texts themselves in the form of repetition, which I consider as analogous to (though not identical with, as I'll go on to explain) standardization. Standardization, like repetition, involves iteration, uniformity and process; both terms repudiate the value of originality. To draw an initial distinction between the two, it might be said broadly that standardization is an act that takes place in space, while (in language, at least) repetition happens in time: repetition is performed through the time experience of reading or listening.

Sitwell was not the only writer who saw a troubling connection between the advent of standardization and the decline of originality in contemporary literature. Many of the same writers self-consciously dedicated to the creation of an original literature to reflect modernity's ruptures also made this connection. For Sitwell, as for others, the modern condition seemed to be one of inauthenticity and sameness—people were all alike, mindless copies of each other rather than separate individuals. This standardization of humanity, epitomized by Siegfried Kracauer's famous image of the Tiller Girls, seemed connected to the status of originality in modern literature.[6] Sitwell clearly longed for a revaluation of originality's importance, in literature and in life, as did many of his modernist contemporaries.

This chapter will explore the idea that modernism's investment in its own originality arose in part from concern about the degradation and devaluation of originality in a culture that seemed increasingly seduced

by copies, standard forms, artificial experience, and fake sensations. Technology contributed to some of modernism's most dramatic innovations, from the formal influence of industrial efficiency studies on Imagist poetry, to the mechanical aesthetics of Vorticism to the trench poetry of the World War I. But many modernist writers believed that the migration of science and technology into the private sphere would stifle creativity rather than inspire it, and that standardization represented a particular threat to the value placed on creativity, originality, and the arts. The tension between the modernist celebration of technology in public and fear of it in private generates a rhetoric of originality that cuts against itself.

T. S. Eliot is one of the central subjects of my discussion. Eliot was as committed to the originality of modernism as he was certain that the public sphere was in the process of engulfing the private, with disastrous social consequences. There are few representations of the depredations of standardization in modern literature as bleak as the scene of a typist and her lover, "the young man carbuncular," in *The Waste Land* (1922), which in many ways offers a catalogue of the degradations of modernity. The texts I will analyze in conjunction with Eliot's poem, including E. M. Forster's short story "The Machine Stops" (1909) and George Orwell's *1984* (1949), by contrast, are set in imaginary futures. The extremity of the scenarios depicted in the dystopic futures of Forster and Orwell throws into high relief what were considered the most singular features of standardization, features that acquired frightening aspects when they were translated from the realm of work into domestic life.

"The discourse of originality," as Rosalind Krauss has termed it, has long occupied a central place in discussions of modernist literature. Both modernist writers (who frequently and loudly proclaimed their break with the past) and scholars of modernist literature take the originality of modernism to be one of its defining qualities. Even as modernist writers trumpeted the originality of their aesthetic program in manifestoes and magazines, they expressed concern about the fate of originality in a culture that seemed to have acquired a preference for copies, second-hand ideas, and artificiality. These writers repeatedly draw a connection between the standardization of

private life and the decline of original literature, a connection that gives both direction and force to the discourse of modernist originality. Paradoxically, the practices of modernist originality, the formal and ideological innovations of literary modernism, were themselves shaped by prevalent ideas about standardization and repetition. Modernist texts were influenced by the very practices of standardization and repetition they criticized so often and these texts encode a profound ambivalence about the changing nature of life in the machine age.

Standardization was essential to the development of efficient industrial practices and had two related aspects, the first based on the specialization of human labor and the second on the mass production of uniform goods. While the aesthetics of standardization in design emerged primarily from Europe, America originated the technologies of mass production and the assembly line. Efficiency experts began with motion studies of the process they wished to modernize, breaking a task into its component parts and then identifying the single most efficient way to perform it. Henry Ford was able to drastically cut the prices of his automobiles by creating a system of mass production, in which product parts, the process of assembling the finished product, and the tasks that workers performed to assemble the product, were all made uniform—standardized. Ford's assembly line, implemented in Michigan in 1914, increased labor productivity ten times over; the price of his signature Model T decreased by half in four years. Around the same time, Frederick Taylor developed his theory of scientific management, separating out rote tasks in production and allowing workers to be readily trained to perform the same motions over and over as part of the production process.

A signal event in the reception of standardization was the 1914 debate between Hermann Muthesius and Henry Van de Velde at the Deutsche Werkbund, with Muthesius defending the notion of standard types and Van de Velde holding out for creative individualism. Muthesius, the author of *The English House* (1904–5), a study of the English Arts and Crafts style, subsequently argued that architecture finds its fulfillment in

standardization: "More than any other art, architecture strives toward the typical."[7] Van de Velde began his career as a painter and worked in the Art Nouveau style. At the 1914 debate, while Muthesius argued that standardization embodies the collective judgment regarding taste, Van de Velde maintained that artists were individualists and would never conform to the discipline of standard types. As Reyner Banham points out, standardization and mechanization got a boost from current events: they became economic necessities because of the production pressures occasioned by World War I.[8] The struggle to choose between or reconcile standardization with individuality, as we shall see, was also waged in literature.

Sitwell's satiric remarks on the pitfalls of standardization captured some aspects of what made standardization a profitable innovation in the factory. The aesthetics of artisanship and craft associated with figures like William Morris gave way, through standardization, to an emphasis on uniformity. Like Ford's Model T, available in any color as long as it was black, modern commodities were envisioned as best when most uniform. Walter Gropius, founder of the Bauhaus, pronounced one of the founding principles of the school to be that "The creation of standard types for all practical commodities of everyday use is a social necessity."[9]

The introduction of standardization into the modern home was especially fraught because of the ways in which, as Walter Benjamin argued, the nineteenth-century home was meant to support the expression of individuality. The kitchen was the workplace of the home, and as such its work processes could be analyzed and organized. Its fittings were standardized, and design books and magazines from the 1920s and 1930s are full of images of standardized kitchens. Noel Carrington, prominent British design critic and brother of painter Dora Carrington, published many advertisements showing such kitchens in his books on home décor. He praises the kitchen shown in Figure 4.1 for the continuous surface level of the table, cooker (stove), and sink.

The specialization of human labor was a potential boon for housework and home design. Lillian Gilbreth, wife of the efficiency expert Frank,

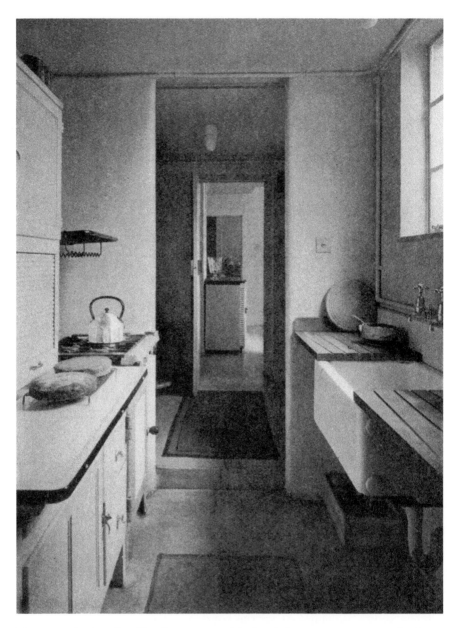

Figure 4.1 Rationalized kitchen reprinted in Noel Carrington, *Design in the Home* (1933).

advocated what she dubbed "The One Best Way" method and chastised housewives who resisted it: "Standardization applies to all parts of the household procedure where it is felt best to stereotype the work. Some natures, even some tiny children, find such standardization a restriction. We believe it should never be forced if it offends an aesthetic taste or a feeling of individuality, but that we should know what the lack of it costs."[10] Gilbreth's use of the word "costs" speaks to the economic rationale for standardization—that it saved money by increasing productivity. She and her husband ran their house and raised their twelve children in accordance with the principles of standardization, efficiency, and mass production. For the housewife, the cost of inefficiency was paid not in money but in time. She urged women to see individuality as a wasteful luxury and to think of their labor in industrial terms, despite the objections that first, the housewife's solitude obviated the assembly line system and second, housework was repetitive, not productive work. Standardization of the work process made an uneasy transition from an industrial context to a domestic one. Gilbreth's suggestion that individuals might balk at standardization in the home was an admission that this principle was a harder sell than others.

If housewives resisted standardizations, many arbiters of taste delighted in it. Philip Johnson touted the new household objects with excitement in his capacity as chairman of the Department of Architecture at the New York Museum of Modern Art. In 1934 Johnson assembled a path-breaking exhibition, entitled *Machine Art*, that literally put home appliances on pedestals (Figure 4.2). Less than twenty years earlier, Marcel Duchamp had exhibited a mass-produced urinal in a museum, in a gesture that was both revolutionary and flippant. But there was nothing playful about the *Machine Art* show, as curated by Johnson, who would later describe his catalogue introduction as "a piece of propaganda."[11] Objects in the exhibition were grouped into six categories: "industrial units," "household and office equipment," "kitchenware," "house furnishings and accessories," "scientific instruments," and "laboratory glass and porcelain," placing the accouterments of domestic life on the same plane as those from the public

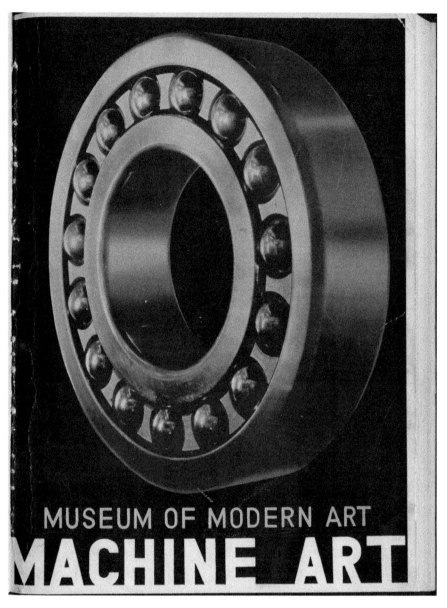

Figure 4.2 Josef Albers, *Machine Art* catalogue cover (1934).

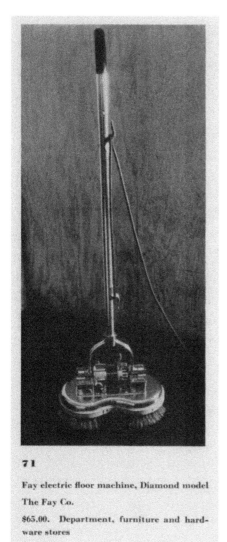

7 1

Fay electric floor machine, Diamond model

The Fay Co.

$65.00. Department, furniture and hard-ware stores

Figure 4.3 Fay electric floor machine, from the *Machine Art* exhibition (1934).

The Museum of Modern Art Library, The Museum of Modern Art, New York, NY USA. Digital image © The Museum of Modern Art/Licensed by SCALA/Art Resource, NY.

worlds of industry and the laboratory while also making the controversial claim that the product of a machine could be considered art. Removed from their context of use, burnished to a high gleam, and juxtaposed with industrial objects, these appliances, ashtrays, salad bowls, vases, and the like, take on an air of sanctity and seriousness (Figure 4.3). Come and worship at the temple of mass production, they seem to suggest.

Controversy greeted the drive to mass-produce both houses and the objects they contained. Le Corbusier predicted in *Towards a New Architecture* that, "We shall arrive at the 'House-Machine,' the mass-production house, healthy (and morally so too) and beautiful in the same way that the working tools and instruments which accompany our existence are beautiful."[12] Like Eliot, Corbusier saw the home as an institution with moral content, but where Eliot found the application of man's industrial science to private life distasteful and corrupt, Corbusier envisioned gleaming new cities comprised of identical houses. For Eliot, standardization meant a degenerative slide into unoriginality. In 1921 he lamented that, "Both middle class and lower class are finding safety in Regular Hours, Regular Wages, Regular Pensions, and Regular Ideas."[13] Mass production meant the proliferation of mediocrity and the devaluation of what was rare and difficult.

Eliot's typist in *The Waste Land* is a symbol of the horrors that standardization could produce when imposed on the private sphere.[14] For Eliot, standardization was especially dreadful when applied to private life. He feared that standardized architecture, objects, and housework would give way to standardized love, mass-produced culture, and interchangeable homes. In his later pageant play, *The Rock*, he described deracinated city inhabitants who dwell in a profane uniformity:

> Where there is no temple there shall be no homes,
> Though you have shelters and institutions,
> Precarious lodgings while the rent is paid,
> Subsiding basements where the rat breeds
> Or sanitary dwellings with numbered doors
> Or a house a little better than your neighbour's[15]

City dwellers are relegated to houses that are virtually indistinguishable, identified only by number. The image of "sanitary households" with numbered doors suggests that the rational household has arrived, offering improved hygiene but at the cost of standardization. The practice of

house numbering in London dates from the eighteenth century, but it takes on a different aspect in an era that sets special value on sameness, substituting numbers for the individuality of names.

Though standardization affects other characters in *The Waste Land*, the typist's victimization is explored at greatest length and is linked directly to the perils of the rational household. The forty lines of the typist's story appear in the longest section of the poem, "The Fire Sermon," the title of which derives from Buddha's exhortation to his disciples to give up earthly pleasures and seek enlightenment; modern material objects that debase their owners surround the typist and her seducer. Together with Tiresias, we observe the typist as she cleans up her breakfast, prepares her teatime meal, does her laundry, then entertains her gentleman caller and has sex with him.

While the other characters in the poem are identified by name, the typist and her lover are unique in being identified only by their professions (he is "a small house agent's clerk"). The exclusive use of professional sobriquets in a domestic setting suggests both the dehumanizing transfer of the realm of work into the home and the generic quality that has degraded individuality in the age of standardization. Even in her home, she is a nameless typist. Lawrence Rainey has described how the female typist was a stock figure in contemporary literature of the 1920s and that Eliot drew on many of the elements associated with this figure in *The Waste Land*.[16] The typist's introduction in the poem leans heavily on the importance of the domestic realm:

> At the violet hour, the evening hour that strives
> Homeward, and brings the sailor home from sea,
> The typist home at teatime . . . [17]

"Home" is heard three times within the space of two lines, indicating that the poem has shifted into a domestic interlude and characterizing "home" as a place of safety and rest, as it was for the sailor.

But the typist's home is not a refuge; it is a place of work that is organized, as in the professional sphere, according to an efficient process. The poem continues:

> The typist home at teatime, clears her breakfast, lights
> Her stove, and lays out food in tins.
> Out of the window perilously spread
> Her drying combinations . . . (ll. 222–4)

The typist moves seamlessly from washing up one meal to preparing the next, on a schedule that renders all moments equivalent.[18] The typist's food is of the most modern type, relying on the technology of canning, still new in the 1920s. It is labor-saving; she only needs to light the stove to heat the water for her tea. But what has been sacrificed to efficiency is the sensory pleasure normally associated with food. It may save time to leave the dirty breakfast dishes sitting out until teatime, but it is scarcely appetizing. Earlier drafts of the poem emphasize even more the way that standardization has vitiated the pleasures of food. Eliot originally referred to the typist's breakfast as "broken," a word more likely to be applied to a machine than to a meal. He used the word "squalid" to describe the teatime foodstuffs and preserved the reference to "tins" despite Pound's suggestion that he strike it out.[19] That the typist does not transfer the food onto dishes but serves or eats directly from the tins is another instance of her favoring efficiency over aesthetics or sensuality. The deleted "squalid," with its dual associations of filth and immorality, was perhaps considered too heavy-handed to retain, but conveys the tone of the vignette. The principles of standardization demand that the typist's meal be wholly generic and so we are never told what it is that she is eating; it is just "breakfast" or "food." Standardization not only disengages the typist's sensual relationship to food but also evacuates the category of food of semantic content (and gustatory pleasure).

Eliot uses the rhythms of mass production, conveyed by commas, to chop the first two lines into segments: "The typist home at teatime, | clears her breakfast, | lights / Her stove, | and lays out food in tins." The three

caesuras in these two lines are compounded in their effect by Eliot's use of monosyllables. One feels the assembly line jerking along as the typist moves through her chores. The comma after "teatime" is especially notable because it is ungrammatical and splits the line. Indeed, the episode of the typist is formally distinct within the poem because of its adherence to iambic pentameter and its regular end rhymes; at certain points in the episode there are near-complete sonnets embedded in the text.[20] Against the free verse background of the rest of *The Waste Land*, the eruption of rhymed pentameter evokes mechanization, never more so than during the sex act:

> The meal is ended, she is bored and tired,
> Endeavours to engage her in caresses
> Which still are unreproved, if undesired.
> Flushed and decided, he assaults at once (ll. 236–9)

Having finished eating out of tins, they move on to another canned experience, a rote form of lovemaking. Again we find caesuras that further accentuate the choppy, mechanical rhythms that characterize this less-than-personal encounter.

Eating and intercourse seem to be parallel experiences for the typist: both provoke sensory pleasure; both should express individual tastes; both feed natural appetites. But in the typist's household, both are standardized practices. The standardization of human desires has, in both cases, the effect of banishing specificity, sensory experience, individual preference, and pleasure. The typist and her lover are machines performing work processes, not individuals seeking satisfaction. After he leaves, "Her brain allows one half-formed thought to pass: / 'Well now that's done: and I'm glad it's over'" (ll. 251–2). The latter line evokes the thoughts of a worker leaving his factory shift rather than a woman bidding goodbye to her lover. This line is also the only explicit speech of the typist's in the poem and it is notable for its reliance on pronouns and contractions ("that's," "I'm," "it's") and its lack of proper nouns or verbs other than "to be." (By contrast, the

previous long episode in *The Waste Land*, which takes place in a pub, is chiefly dialogue and uses nouns and verbs in character speech to establish specificity; e.g. "When Lil's husband got demobbed, I said" (l. 139).) The typist thinks in generic terms and uses contractions as a form of efficiency, apparently to get the process of thinking finished as quickly as possible. Like other lines in this episode, the line has an extra pause inserted into the middle that underlines the sense of mindless, mechanized process, the staccato jerk of an object moving along the line.

The typist continues her mechanical ways after the quick departure of her lover and the episode concludes with her in solitude:

> When lovely woman stoops to folly and
> Paces about her room again, alone,
> She smooths her hair with automatic hand,
> And puts a record on the gramophone. (ll. 253–6)

The gramophone signifies the typist's preference for artificial sense experience mediated by technology and for repetition; unlike a live performance that is different at each utterance, a record sounds the same at every playing. As with the tinned food, the record is generic, not a particular piece of music. The typist's "automatic hand" becomes an extension of the machine she operates, literally the hand at the end of the gramophone's arm. The hand often represents original creation ("made by hand") but here the hand is turned to the labor of thoughtless repetition.[21] Repetition is also signaled in the word "again," the more strikingly because there is no original behind this copy; this is the only time in the poem that the typist "paces." The typist's section of the poem concludes as she "smooths her hair with automatic hand" (l. 255), suggesting that her body is composed of standard mechanical parts, even as her persistent humanity is suggested by her desire for music, a desire that has no machine equivalent.

The generic personal life of Eliot's typist typifies a dark side of human standardization. A far less controversial approach to the standardization of human activity took place in the public sphere: the organization of the work process in industry. Standardizing human motions in this setting

increased production and created a more consistent product. The attendant depersonalization of human beings was mitigated by the fact that the workers submitted voluntarily and received generally higher wages for their work—though many reportedly quit because they hated the tedium of their job. Moving into the domain of private life, the transfer of standardized labor to the domestic sphere and to the woman homemaker was more troubling because homemaking was traditionally considered a natural role rather than a contractual assignment. To standardize housework was to claim the home as a space for professional activity. But most disturbing of all was the possibility that human emotion and personal relations could be standardized. In other words, if the image of Eliot's typist opening tins seemed somewhat degenerate, the image of her having sex by rote was far more alarming.

Beyond the literary world, and in distinct contrast to Eliot's pessimism, Lewis Mumford, who began his career as a literary critic but developed into a historian of technology and urban life, displayed a tremendous and perhaps characteristically American enthusiasm about humanity's relation to technology in his early work. Mumford was also an editor and contributor for *The Dial* magazine, which published the first American edition of *The Waste Land*. Mumford's defense of the standardization of human social behavior was an attempt to redeem what might seem the least appealing aspect of efficiency science. He writes in *Technics and Civilization* (1934) that, "Standardization and repetition have in fact the part in our social economy that habit has in the human organism: by pushing below the level of consciousness certain recurrent elements in our experience, they free attention for the non-mechanical, the unexpected, the personal."[22] Standardization and repetition are not as new as they might appear, Mumford asserts; they have long enabled the creativity of the individual. Mumford was not the first to defend the role of habit in human behavior in the context of mechanization. In his 1890 work *The Principles of Psychology*, William James praises habit and writes, "the more details of our daily life we can hand over to the effortless custody of automatism, the more our higher powers of mind will be set free for their own proper work."[23] James implicitly

compares habit to automatization, rethought through the innovations of the machine age.

Mumford links standardization to repetition, seeing them as analogous processes. Mass production was a means of shunting focus away from the responsibilities of ordinary life and making room for what was most unusual and diverse. Mumford's use of the verb "free" was responsive to concerns that standardization straitjacketed the individual. Even Mumford does not defend standardization of human behavior on its individual merits; instead he equates the non-mechanical with the personal and appoints standardization as a kind of handmaid to human creativity. In effect, he argues that there is a legitimate role for repetition in personal life and further, that such repetition might characterize the creative individual. Some of the most celebrated architects and critics of his time joined in his beliefs; Gropius, for instance, writes in 1925 that, "The fear that individuality will be crushed out by the growing 'tyranny' of standardization is the sort of myth which cannot sustain the briefest examination...it is a commonplace that repetition of the same things for the same purposes exercises a settling and civilizing influence on men's minds."[24] What Gropius considers a "commonplace," however, was anything but obvious.

Mumford's argument that standardization and repetition were merely the equivalent of human habit was enticing but for many, unsustainable. He is critical of "those who look upon uniformity as in itself bad, and upon variation as in itself good," those who argued that standardization in the social realm might have the effect of taking what Mumford called "the non-mechanical, the unexpected, the personal" and rendering it all deadly uniform, flattening even the most intimate regions of human behavior into a "one best way" or maximally efficient standard.

Sigmund Freud's essay *Beyond the Pleasure Principle* (1920; translated into English, 1922) was far more negative than Mumford about the role of repetition in human behavior. For Freud, repetition is a psychic tool for coping with unhappy events or emotions; in his famous Fort/Da example, the little boy who repeatedly pushes a toy away from himself is restaging his mother's absence to place himself symbolically in control of her

movements and to master his feelings of abandonment. But repetition can also be part of a more pathological and unproductive mental process, as when the neurotic compulsively restages a repressed traumatic event in symbolic form. Freud outlined this variety of repetition in his 1914 essay, "Remembering, Repeating, and Working-Through," where he describes repetition as a fundamental characteristic of the psychoanalytic patient:

> The patient yields to the compulsion to repeat, which now replaces the impulsion to remember, not only in his personal attitude to his doctor but also in every other activity and relationship which may occupy his life at the time—if, for instance, he falls in love or undertakes a task or starts an enterprise during the treatment. [25]

The repetition compulsion is not limited to symbolic actions but may be discerned in any part of the patient's behavior. Elsewhere, Freud describes a case in which the overzealous performance of housecleaning, "housewife's psychosis," indicates the presence of neurosis. [26] In cases of pathological repetition, the task of the analyst is to reduce repetitive behavior in the patient: "It has been the physician's endeavour . . . to force as much as possible into the channel of memory and to allow as little as possible to emerge as repetition." [27] The analyst helps the patient to systematically dismantle his or her habits of repetition by uncovering the repressions that produced the repetition and thus clear the way for original and creative action.

Both these forms of repetition, the normal and the pathological, fall into the domain of the pleasure principle, the law that directs all human behavior toward the pursuit of happiness and is only tempered by the later introduction of the reality principle and the ability to defer pleasure. In his return to the subject of human repetition in 1920, however, after the devastations of World War I, Freud outlines a third variety of repetition that, uniquely, "include[s] no possibility of pleasure" [28] and yet may be the basis of all living organisms: "The elementary living entity would from its very beginning have had no wish to change; if conditions remained the same, it would do no more than constantly repeat the same course of

life."[29] In animals as well as humans, the tendency to repeat often serves no cause but a programmatic adherence to the principle of conservatism; Freud gives the example of fish that return annually to the same areas to spawn because they were long ago the site of colonies. This line of thinking leads Freud to posit a death drive, a desire on the part of every being to die of internal causes, "to follow its own path to death." Freud's attempt to categorize repetition as a type of human behavior suggests the visibility of human repetition as a category in his time. Despite his statement that repetition is normative, his characterizations of it range from the dubious to the sinister, as when he states that repetitive behavior in children gives the appearance of a "'daemonic' force at work."[30] He characterizes his theory of the death drive as "strange" and adds that it represents "an extreme line of thought."[31]

Both Freud and Mumford need to explain and assess human repetition as a category. This exigency is characteristically modern because of its relation to the new forms of repetitive and mechanical movement endemic to the machine age. Early in *Beyond the Pleasure Principle*, Freud states that

> A condition has long been known and described which occurs after severe mechanical concussions, railway disasters and other accidents involving a risk to life; it has been given the name of "traumatic neurosis." The terrible war which has just ended gave rise to a great number of illnesses of this kind . . . [32]

The devastating injuries inflicted by machines and that give rise to traumatic repetition compulsion are the central context for Freud's concern with repetition; in fact, these remarks are the prelude to Freud's discussion of the little boy who repeatedly throws away his toy. Despite its touted trans-species normativity, repetition is a suspicious category for Freud, pointed toward death rather than pleasure and often concealing painful secrets.

The application of standardization to the conduct of private life was worrisome to Eliot and his contemporaries, in part because of their overbearing concern that the rise of standardization might have dire

implications for literature. This concern derived both from the potential for standardization to erode literature's source material and from the way standardization undercuts the value of originality by favoring the uniform over the differentiated. Modernist writers often offered pessimistic accounts of the future of literature in a standardized culture even as they formulated modernist aesthetics that were shaped by standardization and its attendant practices.

The debate about the significance of human standardization and repetition appears as a central thread in modern culture and one that is also deeply significant for modernism. I could list many paradigms of repetition and standardization in modernist literature here, including (but not limited to) Nietzsche's eternal recurrence, Benjamin's mechanical reproduction, Yeatsian gyres, Surrealist automatic writing, Bergsonian time, the *nouveau roman*, experimental syntax, and psychological illnesses associated with modernity including amnesia, obsession, paranoia, and echolalia.[33] My project in this chapter is not to catalogue these forms but rather to examine an organizing polarity in modernism between a fascination with and reliance on repetition and standardization on the one hand and a somewhat defensive claim to absolute originality on the other. If the rise of standardization seemed in some ways to portend the death of original literature, it also provided material for the creation of such a literature.

* * *

Modernism's originality, its vaunted break with the past and commitment to the parthenogenetic creation of an autonomous aesthetic practice, is first among the movement's qualities in the accounts of both its practitioners and its critics. "Make it new," charged Ezra Pound. Human nature changed in 1910, Woolf asserted. For D. H. Lawrence, "It was in 1915 the old world ended."[34] Modernist writers and artists alike aimed to deliver "the shock of the new." Critics have followed this line from the earliest days. Malcolm Bradbury and James McFarlane's classic 1976 collection *Modernism* opens with a dramatic characterization of the movement's originality, arguing

that modernist literature was a change of the greatest possible magnitude, one of

> those overwhelming dislocations, those cataclysmic upheavals of culture, those fundamental convulsions of the creative human spirit that seem to topple even the most solid and substantial of our beliefs and assumptions, leave great areas of the past in ruins . . . question an entire civilization or culture, and stimulate frenzied rebuilding.[35]

The metaphor is seismic: modernism cleared the ground and built an entirely fresh architecture, not a renovation or a restoration. Modernism, at its core, is an aesthetics of change. Revolution and renewal are its signature elements. The manifesto is its signature document. It blurs the lines between culture and politics by setting out the founding principles of the new poetic republic.[36] The manifesto is a clear example of how the modernist *discourse* of originality runs alongside but is not identical to, the actual originality of modernist aesthetics. In other words, the assertion of the claim to self-invention is distinct from and equally if not more important than whatever was truly new about modernism.[37]

In "The Originality of the Avant-Garde," Krauss uses the posthumous casting of Rodin's works as the jumping-off point for a discussion of the meaning of originality in works by modernist and avant-garde artists who were as committed as their literary counterparts to a total reinvention of their medium. Krauss concludes that originality in art has much more than a narrow aesthetic significance. She writes,

> modernism and the avant-garde are functions of what we could call the discourse of originality, and . . . that discourse serves much wider interests— and is thus fueled by more diverse institutions—than the restricted circle of professional art-making. The theme of originality, encompassing as it does the notions of authenticity, originals, and origins, is the shared discursive practice of the museum, the historian, and the maker of art.[38]

This discourse circulates among the different locations, personal or institutional, that have interests in nourishing it. Although the discourse of

originality takes particular forms in the visual arts for which there are no literary equivalents (e.g. casting, connoisseurship), literature and art both accord a certain totemic value to the discourse of originality. However, Anglo-American modernist literature, certainly in Eliot's account of it, was not playful about the need for originality or authenticity, as certain avant-garde artists like Marcel Duchamp or Man Ray could be.

Modernist writers tend to state their claims to originality more seriously. Ezra Pound proclaims that, "Any work of art which is not a beginning, an invention, a discovery is of little worth."[39] Eliot, like Pound, was deeply invested in the self-conscious creation of a new literature for his time. Looking back on the modern movement from the late vantage point of 1953, Eliot wrote:

> From time to time there occurs some revolution, or sudden mutation of form and content in literature. Then, some way of writing which has been practiced for a generation or more, is found by a few people to be out of date, and no longer to respond to contemporary modes of thought, feeling and speech. A new kind of writing appears . . . We might now consider that such a revolution as that which has taken place in poetry, both in England and in America, during the last forty years.[40]

Eliot believes that the originality of modernist literature springs from and feeds on a similarly sizeable shift in human character.[41] He makes the same point in his earlier essay "Tradition and the Individual Talent" (1919), when he writes, "[The poet] must be aware that the mind of Europe . . . is a mind which changes."[42] Woolf affirms this idea in "Mr. Bennett and Mrs. Brown" where she says, "when human relations change there is at the same time a change in religion, conduct, politics, and literature."[43] The notion may seem self-evident, but more than is the case in the visual arts, literature represents and reflects the details of contemporary human behavior. Literature is primarily a chronicle of the history of private life or the private aspects of public life. What happens, these writers might wonder, if the change in human relations leads to a society with little interest in either their originality or that of their literature?

Eliot believes modernist literature's originality rests on the concurrent reinvention of private life and its ability to draw its vital energy from its diversity. However, the rational household was founded upon the defeat of diversity and its replacement with the "one best way" of living, with standard practices. Rather than create a home life that reflected the individual family, many experts suggested that families adapt themselves to standardized ways of living with demonstrated efficiency. One expert argued,

> It has so often been said that housework is made up of such a variety of tasks and so dependent upon the personal note that few, if any, time and motion studies could be taken in a home that would be useful as records or practice-instructions for any other class of home. This is not true if we reduce the task to be considered to its simplest units. There is but one best way of doing everything, just as there is but one best reason for its being done.[44]

Uniformity and standardization were put forth as the new ambitions of the household and analysis of the work process suggested to be its signature activity. Although it seems unlikely that the standardization of the work process could unravel the heterogeneity of private life, the idea that standardization had become the highest ideal of the home was discomfiting.

If domestic homogeneity was one dystopic future associated with the rise of the rational household, an even more troubling problem lay in the nature of any society that would deliberately pursue such a path. Eliot's greater concern was that a culture, however "revolutionary," that craved standardization in all aspects of its existence, would cease to value original and ambitious literature. He expressed this view forcefully in a 1937 essay on religious drama:

> Mechanisation comes to kill local life: with the universal picture palace, you may travel the world over and be unable to avoid Shirley Temple; television may have a still more deadly effect on local life; and just as food comes to be something you have got out of a tin, and not something you have grown for yourself, so drama may mean for millions of people something out of a box or thrown onto a screen.[45]

Mechanization results in a uniform literary "product," a product that is sadly lacking in merit. Eliot's parallel between the tin cans of the rational household and modern drama is instructive: both arrive offering convenience and accessibility but result in a shallow and ephemeral experience. Once schooled in the mechanized entertainment of movies and television, the audience's desire for more particularized and original forms declines. The image of drama "out of a box" represents literature as just one more packaged consumable that passes through the body like food. Eliot's expository prose is generally highly qualified; by contrast, his writing here, with the declarative "Mechanisation comes to kill local life" jumps off the page with its direct statement of menace.

If modern culture valued most what was canned and disposable, the difficulty and originality of modern literature could seem hopelessly out of step. Modernism's commitment to radical originality, generally understood as a defiant exuberance inspired by an age of unprecedented technological invention in the public sphere, is shadowed by anxiety that the same technology, when imported into private life, would hobble the expression of originality in literature. The very fervor with which modernism proclaims its originality points to the tension that powers such noisy insistence. This tension finds a place in the frequent association in modernist texts between the standardization of private life and the decline of original literature, an association that might otherwise seem random or implausible. Eliot's parallel between canned food and canned culture is not unique but only one instance of a widespread causal connection posited in literature and nonfiction by other writers at the time. The analogy takes different but related forms in a range of texts and elucidates the significance of both the discourse and practice of modernist originality.

E. M. Forster's 1909 short story "The Machine Stops," depicts life in an imaginary future where private life is fully automated. Individuals live in separate "cells" which they rarely leave because all their needs are met by The Machine. Life is so "labor-saving" that human bodies have atrophied; Vashti, the main character of the story is described as, "a swaddled lump of flesh—a woman, about five feet high, with a face as white as a fungus."[46]

Forster's use of organic (if revolting) terms to describe Vashti highlights the disparity between flesh and machine. In this society, physical contact between individuals is taboo and physical movement of any kind is frowned upon. The touch of a button supplies all desires and as a result humanity has become weak, infantile, and parasitical. Artificial sensation is considered an adequate or even preferable substitution for authentic sensation; for instance, the viewing plates that people use to see each other show no details, only "a general idea of people," which is considered good enough; similarly, they eat artificial food that does not attempt to convey "the imponderable bloom of the grape."

Most people pass their time in solitude, communicating with others through "pneumatic post" and the viewscreen. The main concern of the individuals in this culture is finding new ideas to discuss, but their preference is for ideas that are not original:

> "Beware of first-hand ideas!" exclaimed one of the most advanced of them. "First-hand ideas do not really exist. They are but the physical impressions produced by love and fear, and on this gross foundation who could erect a philosophy? Let your ideas be second-hand, and if possible tenth-hand, for then they will be far removed from that disturbing element—direct observation."[47]

Eliminating direct observation means eliminating the individual perspective, so that just as these people live in identical cells, they can think identical thoughts. Strong emotion is denigrated alongside originality. Their pursuit of mechanized comfort has led them to become habituated to the intervention of intermediaries; thus they see each other through The Machine, speak to each other through The Machine, and eat the synthetic food produced by The Machine. A natural extension of this prosthetic existence is a taste for similarly homogenized thoughts. This, for Forster, is one aspect of the connection between the standardization of human life and the decline of originality in writing. A people tutored by machines to prefer derivative or mediated experience will shun individual creativity. Indeed, in Vashti's home, literature is just another item on tap: "There was

the hot-bath button, by pressure of which a basin of (imitation) marble rose out of the floor, filled to the brim with a warm deodorized liquid. There was the cold bath button. There was the button that produced literature."[48] The sole physical book that exists in this world is *The Book of the Machine*; it is a complete instruction manual for navigating this mechanized world and every person has a copy. In this world, all physical books are literally identical.

In Forster, as in Aldous Huxley's *Brave New World* (discussed in Chapter 5), an economy of surplus gives rise to conditions unfavorable to original literature. Both these societies, with the aid of machines, increase production so dramatically that the supply of goods seems inexhaustible. Even literature is available at the touch of a button. But what kind of literature is produced by pressing a button? What is the status of literature when quantity, not quality, is set as the highest value? The goal of efficiency science was to increase productivity, rather than alter the product. The main purpose of analyzing the work process was to enable the worker to perform a task faster. What if this endeavor were extended to literature? In one of Eliot's choruses from *The Rock* he echoes Forster in his representation of godless urbanites indulging in literary overproduction,

> Engaged in devising the perfect refrigerator,
> Engaged in working out a rational morality,
> Engaged in printing as many books as possible . . . [49]

The close formal parallels among the three lines suggests a relation among refrigerators, morals, and books, all treated equivalently as commodities in the modern world. A natural extension of perfecting refrigerators and rationalizing morality is the application of a productivity ethic to literature. The close parallels among these lines suggest analogous processes, so that the printing of books becomes just one more aspect of modern culture's infatuation with its own industrial practices, in and out of the home.

For these writers, the machine age's preference for standardization threatened originality in literature by eliminating distinctions based on

quality in favor of quantity. If fast food's only virtue was that it was quick and cheap, and the public ate it up, then the public's desire for literature that was quick and cheap could only intensify. Looking to the avant-garde, the Surrealists had a more optimistic attitude about the fate of literature in modernity, though their mechanistic practice of "automatic writing" was, like Eliot's typist who does not allow herself to think, also intended to divorce writing from thinking. The degradation of literature in modernity is epitomized in *The Waste Land* by "that Shakespeherian Rag," (l. 128), perhaps literally a ragged form of Shakespeare, offered widely for easy entertainment in the form of a popular song.

If the link between standardization and the overproduction of bad literature seems far-fetched, it is the more notable that numerous writers closely reproduce this line of argument. In George Orwell's *The Road to Wigan Pier* (1937) Orwell offers a lengthy discussion of the relationship of Socialism to the advent of mechanical production. For Orwell, mechanization, in its pursuit of efficiency and predictability, ends in the promotion of human weakness, a quality he finds as disgusting as Forster does. Machines make life routine and predictable, while also replacing human effort of every kind. Orwell seconds Forster's presumption that it is the tendency of a mechanized society to begin to invent machines to assist in every part of life and the natural consequence is a degraded human preference for artificial, machine-made sensation over authentic sensory experience. His chief example is food: "In the highly mechanised countries, thanks to tinned food, cold storage, synthetic flavouring matters, etc., the palate is almost a dead organ."[50] Taste emerges as the bellwether sense for writers who wish to critique the mechanization of private life, perhaps because of its intimacy; taste also carries the alternative meaning of exercising judgment or making qualitative distinctions. Both sorts of taste seem threatened by the popularity of standardized experiences.

An extreme instance of efficiency overshadowing taste occurs in Samuel Beckett's first novel, *Watt*, in which the householder Mr Knott has all the foods he wishes to consume that week ("fish, eggs, game, poultry, meat, cheese, fruit, all of various kinds, and of course bread and butter, and it

contained also the more usual beverages…") mixed together in a pot and boiled for four hours.[51] Mr Knott consumes this mixture three times a day, seven days a week. Although Mr Knott keeps several servants, "This arrangement represented a great saving of labour. Coal was also economized."[52] For Orwell, a preference for modern food indicates that the mechanized has become broadly preferred to the natural. He writes, "Wherever you look you will see some slick machine-made article triumphing over the old-fashioned article that still tastes of something other than sawdust. And what applies to food applies also to furniture, houses, clothes, books, amusements and everything else that makes up our environment."[53] When mechanization moves out of industry and penetrates every area of life, society's values register a shift.

Orwell includes books in his list of items that have been subject to standardization. He argues, like Forster, that the advent of mechanization also leads to standardization and a decline in the originality of creative expression. This process, he writes, is already well underway. "The machine would even encroach upon the activities we now class as 'art'; it is doing so already, via the camera and the radio."[54] Like the people in "The Machine Stops," who have come to prefer derivative ideas and to want The Machine to think for them, contemporary society has lapsed into a state of weakness and passivity. "The tendency of mechanical progress, then, is to frustrate the human need for effort and creation."[55] As for Forster, the unplanned but inexorable consequence of building a society in which the uniform products of the machine are the ultimate achievement is to stifle creativity and even the desire for artistic creations.

At the time of writing *Wigan Pier*, Orwell's fear was that mechanization would cause people to become soft, lazy, and uninterested in art. Perhaps because of his experience opposing fascism in the Spanish Civil War and then living through World War II, by the time he turned (around 1944) to writing *1984*, his most fully developed account of the fate of a society that has embraced standardization at the expense of personal life, his concerns had changed. *1984* is the story of a society that has had the values of mechanization forced upon it, with disastrous results. As in earlier

examples, the rise of mechanization has the effect of eliminating private life and producing a culture that upholds uniformity over originality. "The Machine Stops" and *Wigan Pier* both make a connection between a fully mechanized society and the decline of original literature; *1984* develops this connection in even greater detail, which is why I have included it in this chapter despite its relatively late date. Alongside the novel's prominent political themes runs a concurrent claim about aesthetics: that the preservation of a distinct and diverse private life and the fate of original writing are indissolubly joined. In the totalitarian state depicted in *1984*, people must practice a rigid political orthodoxy and have been stripped of their private lives. For Winston Smith, the novel's main character, the only way to rebel against this standardization is to create a clandestine private life and become a writer of original texts.

Winston lives in a society where private life has been as nearly as possible eliminated: the state remotely monitors every home, romantic relationships and sexual pleasure are forbidden, and children are taught to report any ideological transgressions by their parents to the authorities. In place of conventional family ties, the state has created Big Brother, a hero whom everyone is required to love and whose ubiquitous presence and searching gaze are the incarnation of the surveillance state. "Always the eyes watching you and the voice enveloping you. Asleep or awake, working or eating, indoors or out of doors, in the bath or in bed—no escape."[56] When the Thought Police, who monitor all individuals for signs of unorthodoxy, discover such signs, the individual is tortured, brainwashed, and then killed. The goal of the constant monitoring and the elimination of private life is the creation of a society that is completely standardized in thought and action; Winston writes that he lives in the "age of uniformity" (28). The novel's first sentence introduces us to a rationalized society where science has replaced soul; Orwell would seem to be echoing Eliot's opening in *The Waste Land* as well: "It was a bright cold day in April and the clocks were striking thirteen" (1).

The ruling party's most ambitious project is the creation of a new language that will replace English and ensure the party's permanent

hegemony. Called Newspeak, the language eliminates individual variation and free-thinking of any kind, since the necessary words to express unorthodox opinions are eliminated. Works by Chaucer, Shakespeare, Milton, and Byron will be unrecognizable once translated into Newspeak (54). Individual thought itself will be abolished when the language enjoys broad usage, argues one of the language's creators: "The whole climate of thought will be different. In fact, there will *be* no thought, as we understand it now. Orthodoxy means not thinking—not needing to think. Orthodoxy is unconsciousness" (54). Like Eliot's typewriter girl whose brain grudgingly allows half-formed thoughts, this society seeks to eliminate thinking in favor of perfect homogeneity. Newspeak clearly invokes the labor-saving movement; among the chief goals of the new language are to eliminate all unnecessary words and to condense the necessary ones into the fewest possible letters (i.e. "Minitruth" for the Ministry of Truth). Newspeak converts language into a machine for the efficient production of dogma; as Orwell writes in his appendix to the novel, a Party member's speech should sound like "a machine gun spraying forth bullets . . . Ultimately it was hoped to make articulate speech issue from the larynx without involving the higher brain centers at all" (319).

Mechanization is an important tool in maintaining this standardized society. The ubiquitous telescreens, televisions that watch those who are watching, are only one of the new machines. These machines are not just directed at labor-saving; they also reproduce and distribute party ideology. Julia, who becomes Winston's lover, works in the Fiction Department on a novel-writing machine that mass-produces literature for the lower classes. The novels are standardized; Julia reports that "they only have six plots, but they swap them round a bit" (133). Only women participate in the manufacture of literature, because they are considered less susceptible to the unorthodox impulses that even this meager fictional fare might evoke. Richard Posner has argued that technology is beside the point in 1984, that the telescreen is "the only technological innovation that figures largely" in the novel and that it is "inessential."[57] Orwell, he writes in his conclusion, "was not particularly interested in technology."[58] What Posner overlooks is

that nearly all the new technologies in the novel are bound together by a common theme: they are technologies of communication. From the telescreens to the fiction-writing machines to the "speakwrite" into which Winston dictates his work, to the "versificator" that produces sentimental songs, to Newspeak itself, the new technologies of 1984 embrace the standardization of language and reduce it, through mass production and other means, to a few efficient slogans.

Following in outline the viewpoint expressed in *Wigan Pier*, Orwell draws a triangle that connects the disappearance of private life, the rise of machine-culture, and the production of standardized communication. Effective rebellion against this state consists in breaking each leg of the triangle. For Winston and Julia, their most significant act of transgression is the creation of a domestic space. They rent a room above a junk shop, a room that seems not to have a telescreen, and although they can visit the room only infrequently they consider it "almost a home . . . so long as they were actually in this room, they both felt, no harm could come to them" (153–5). Winston and Julia imbue the room with aspects of a more traditional domesticity: they consider it a haven of security and stability and Julia takes responsibility for the decoration, the cooking, and housekeeping. She purchases real food on the black market, rather than the artificial substitutes that are their usual fare. In their room, she uses makeup and scent, both forbidden, in order to present a feminine appearance.

Winston also challenges the rule of mechanization and the dominance of standardized language. In his professional role as an Outer Party member, Winston is a sort of writer. He spends his workdays altering past issues of newspapers to bring their content into line with the Party's current official line. For instance, if the government forecasted a level of production that was not actually achieved, Winston rewrites the forecast to accurately predict the actual production output. If Big Brother gives a speech lauding a particular person who was later found to be a subversive, then Winston rewrites the speech to eliminate the reference. His writing process is fully mechanized: he receives his instructions on slips of paper that issue from a

pneumatic tube and he dictates his work, in Newspeak, into the speakwrite on his desk. In short, he produces language that brings the past into alignment with Party orthodoxy.

His occupation as a writer brings particular force to Winston's first traitorous act, which takes place in the novel's opening pages. Secretly, he has acquired antiquated instruments of writing: "a penholder, a bottle of ink, and a thick, quarto-sized blank book with a red back and a marbled cover" (5). Moving out of range of the telescreen to keep his activity secret, he fits his penholder with a nib and begins to compose a diary—that is to say, an original account of the past, rendered without the aid of machines. As a form, a diary allows for the expression of an individual mind and the record of a personal account of events—it is the record of a personal past, not a collective, homogenized one. Julia, although she considers herself unliterary, also launches her career as an enemy of the state with an act of writing by hand. She stages an encounter with Winston at work in order to furtively pass him a slip of paper on which she has written the words "I love you." The love of one individual for another is a founding gesture of private life and it is what leads to Winston and Julia's love affair and quasi-domesticity. For both Winston and Julia then, acts of original handwriting set them apart as freethinkers who wish to preserve privacy, intimacy, and personal written expression. Their rebellion is not political or ideological in any traditional sense; the so-called "Brotherhood" of revolutionaries they briefly join is a trumped-up affair, designed by the state to cull out and entrap malcontents. Winston and Julia's crimes lie rather in the realms of private life and aesthetics.

1984 has long been read either as an anti-technology novel that decries the decline of personal privacy or as a critique of the Soviet Union and of totalitarian tendencies in putatively libertarian states. Alongside those readings I would place another: 1984 is deeply concerned with the fate of writing in a world where private life is being enveloped by the state and where standardization is perverting the process and content of writing. Orwell connects these transformations at many levels. He makes similar

associations in his essay "Politics and the English Language," written a few years later:

> When one watches some tired hack on the platform mechanically repeating the familiar phrases—bestial atrocities, iron heel, bloodstained tyranny, free peoples of the world, stand shoulder to shoulder—one often has a curious feeling that one is not watching a live human being but some kind of dummy: a feeling which suddenly becomes stronger at moments when the light catches the speaker's spectacles and turns them into blank discs which seem to have no eyes behind them. And this is not altogether fanciful. A speaker who uses that kind of phraseology has gone some distance toward turning himself into a machine. The appropriate noises are coming out of his larynx, but his brain is not involved as it would be if he were choosing his words for himself.[59]

This speaker has lost any trace of individualism and instead figures as a machine that manufactures unoriginal thoughts. Moreover, the speaker is a willing convert, happily participating in the process of self-automation. As Orwell argues in *Wigan Pier*, it is difficult to refuse the seemingly easier life produced by mechanization. Unlike this speaker, Winston goes down with a struggle, but he goes down. When, at the end of *1984*, Winston has capitulated to orthodoxy because of torture and brainwashing, he is given a slate and a stump of chalk to use when he is alone in his prison cell. He uses it to write the slogans of the Party. Moving from his first, defiant act of writing in indelible ink to the submissive quotation of doctrine in a readily erasable form, Winston is now the shell of a writer whose originality no longer exists. His role as a writer, both professionally and personally, makes him an apt symbol for the fate of writing in an era of rational private life. Writing becomes a tool for expressing conformity, rather than an outlet for individual thought.

Aldous Huxley's *Brave New World*, discussed in greater detail in Chapter 5, inscribes the reverse journey and shows a writer progressing from repetition to originality. For most of the story, Helmholtz Watson, a writer of considerable talent, works as an "Emotional Engineer"—"He wrote regularly for The Hourly Radio, composed feely scenarios, and had the happiest

knack for slogans and hypnopædic rhymes."[60] In Huxley's world of the future, there is neither intimacy nor family. Both have been eradicated in the interests of preserving social stability and individuals are mechanically engineered from birth to be content with their lot in life. "Individual" is actually a misnomer, for identical twins are produced on assembly lines by the dozen. Watson's writing is designed either for pacification or propaganda; in both cases, Watson finds it impossible to write originally in a world where there is nothing to say:

> Words can be like X-rays, if you use them properly—they'll go through anything. You read and you're pierced. That's one of the things I try to teach my students—how to write piercingly. But what on earth's the good of being pierced by an article about a Community Sing, or the latest improvement in scent organs? Besides, can you make words really piercing—you know, like the very hardest X-rays—when you're writing about that sort of thing? Can you say something about nothing? That's what it finally boils down to.[61]

In *Brave New World*'s era of perfect social stability, where no one has parents or children, no one falls in love, and no one has a desire that is not immediately gratified, modern literature is apparently impossible. Watson is finally ejected from this stable but shallow society and exiled to an island where he can write what he chooses. He requests adverse conditions in order to stimulate his productivity: "I should like a thoroughly bad climate . . . I believe one would write better if the climate were bad. If there were a lot of wind and storms, for example . . ."[62] The crisis of originality in *Brave New World* is a response to the replacement of intimacy with technology: Watson's romantic desire for violent weather speaks to his desire to rediscover authentic experience, the inspiration for creativity.

* * *

I have been arguing that numerous modern writers expressed a concern that the rise of standardization could whittle away at literature's source material and devalue the idea of original expression so intrinsic to literary

modernism. This idea was expressed thematically, but it also found representation in some of the formal elements of literary modernism that draw inspiration from standardization and its attendant practices. In an odd paradox, some of modernism's most original aesthetic practices represent an enactment of the crisis of originality posed by the standardization of private life. In other words, in what might seem a tail-swallowing move, literary modernism formulates original strategies to express a sense of mourning for the fate of literary originality in an age of mechanized intimacy, so that what constitutes the originality of modernism is colored by anxiety about the decline of originality. Eliot's typist in *The Waste Land* shows us how this might be the case.

The typist is, like Helmholtz Watson and Winston Smith, a debased writer, spending her workday copying documents and transcribing handwriting or dictation. Typists at the time duplicated outgoing documents with the use of carbon paper or created copies of incoming documents by retyping them. The typist exemplifies the unoriginal and fully mechanized writer, one who can only repeat other's words but generates no original prose of her own.[63] Because of her use of a typewriter, the very letters she sets down are uniform and without the marks of personal distinction visible in handwriting. The hand, typically a synecdoche for authorship has, in the typist's case, become exemplary of her repetitive practices, as here, in lines I discussed earlier:

> When lovely woman stoops to folly and
> Paces about her room again, alone,
> She smooths her hair with automatic hand,
> And puts a record on the gramophone. (ll. 253–6)

The mechanized hand reaches for the mechanized arm of the gramophone and has an aesthetic experience that is also an instance of repetition, since every playing of a record, unlike live performance, is identical. The typist is an extreme case of the authorship fostered by the conditions of modernity. Cut off from direct sensation and strong emotion and so drawn to repetition and standardization that she is half mechanical herself, the typist is the

kind of writer you might expect from a culture that places more value on mass production than it does on originality.[64]

Eliot typed much of the manuscript for *The Waste Land*, including the lines about the typist. And he too practices repetition in numerous ways in the poem, including his frequent allusions to other poets. For instance, in the lines cited above, he silently interpolates a line from Oliver Goldsmith (the passage continues, "When lovely woman stoops to folly, / And finds too late that men betray, / What charms can soothe her melancholy? / What art can wash her tears away?").[65]

Eliot's multi-linguistic quotations in this poem have typically been understood by critics as designed to self-consciously situate the work in literary tradition; or as an appeal to an educated elite; or as an ironic contrast between an idealized past and a wretched present.[66] They are also considered protective, "fragments I have shored against my ruins" (l. 430). I would argue that these and other forms of repetition in the poem link Eliot to the automatism of the typist and are a formal strategy suggested by the specific meanings of repetition in modernity. In the first draft version of this line, the fragments were "spelt into" the ruins, underlining Eliot's role as a copyist of these borrowed lines. His practice of writing his own endnotes for the poem to credit many of its sources can also be seen as foregrounding his use of recycled language.[67]

Eliot's allusions are not the only forms of repetition he employs in *The Waste Land*. Some characters in the poem repeat the same words over and over, as in "A Game of Chess": "Speak to me. Why do you never speak. Speak. / "What are you thinking of? What thinking? What?" (ll. 112–13), and later in this section, the five-times repeated refrain, "HURRY UP PLEASE ITS TIME" (l. 141). In the first instance, the repetition is a hysterical symptom of the kind described by Freud, the repetition of a desire that enacts the impossibility of its own satisfaction. The second instance, with its disembodied speaker, exact repetition, and emphatic capitals, is more mechanical and, interwoven as it is with the gabbling account of the history of Lil, creates the impression of a mechanized bartender inexorably intent on shutting down the personal exchanges of the women in the pub.

At other moments in *The Waste Land*, the poem seems to get stuck in a repetitive groove itself, sometimes within a single line, as here: "Twit twit twit / Jug jug jug jug jug jug" (ll. 203–4) or this, repeated twice: "Weialala leia / Wallala leialala" (ll. 277–8 and 290–1). These lines are apparent gibberish, reminding us of mechanization's intrinsic attraction to repetition, regardless of what is being repeated. At the same time, both these passages are also additional examples of allusive repetition in the poem, the first an invocation of the myth of Philomela and the second taken from Wagner's Götterdämmerung. The "stuck groove" effect can also stretch out across several lines, as here:

> If there were water
> And no rock
> If there were rock
> And also water
> And water (ll. 346–50)

This form of repetition takes the elements involved and rearranges them in all possible combinations. A similar effect occurs on a much more extended scale in *Watt*, where Mr Knott's habitual movements in his house are described:

> Here he moved, to and fro, from the door to the window, from the window to the door; from the window to the door, from the door to the window; from the fire to the bed, from the bed to the fire; from the bed to the fire, from the fire to the bed; from the door to the fire, from the fire to the door; from the fire to the door, from the door to the fire; from the window to the bed . . . [68]

Repetition here indicates either mechanical thoroughness or psychological obsession, though the two are not necessarily distinct. Machines can seem obsessive when they continue to repeat actions even when the conditions that originally rendered the repetition useful are absent. In Charlie Chaplin's film *Modern Times* (1936), the design of the Billows Feeding Machine makes eating lunch more efficient by feeding the subject with mechanical arms.

The machine malfunctions and pelts Chaplin with food, pausing at intervals to calmly repeat the gesture of wiping Chaplin's mouth with a napkin before resuming its tortures. For Eliot, the repeated lines about the quest for water suggest the futility of mechanically repeating an action that has not produced success in the past.

Not every modernist writer saw repetition as humanity's bleak destiny. The complexity and ambivalence that underlie the practices of repetition I have discussed are absent from the work of Gertrude Stein; she claimed, contrary to popular opinion, that there was no repetition in her work, although she admitted to being fascinated by repetition as a practice.[69] In her lecture "Portraits and Repetition," she said, "What I wrote was exciting although those that did not really see what it was thought it was repetition. If it had been repetition it would not have been exciting but it was exciting and it was not repetition. It never is. I never repeat that is while I am writing."[70] The repetition in Stein's work is a product of her wish to accurately portray the sequence of *nearly* identical repetitions of words and actions that she saw as constituting human behavior. In *The Making of Americans*, she writes,

> Sometimes in listening to a conversation which is very important to two men, to two women, to two men and women, sometimes then it is a wonderful thing to see how each one always is repeating everything they are saying and each time in repeating, what each one is saying has more meaning to each one of them and so they go on and on and on and on repeating and always to someone listening, repeating is a very wonderful thing . . . Repeating is what I am loving.[71]

For Stein, repetition was a natural and wonderful part of human life, something that the writer could record and celebrate.[72] Indeed, her disbelief in pure repetition as a category is an insistence on the irrepressible originality and diversity of humanity: the differences in each supposed repetition are there, if we look for them. Henri Bergson made a similar point, arguing that time defeats the possibility of repetition, because each so-called repetition takes place in a new moment.

Eliot and Stein might agree on one point; Eliot, like Stein, understood all literature as near-repetition, though not of ordinary speech, as Stein maintained. For Eliot, any time that a poet employed a word he was citing, knowingly or not, the full literary history of that word's usage. In 1922, Eliot wrote that,

> Whatever words a writer employs, he benefits by knowing . . . the *uses to which they have already been applied*. Such knowledge facilitates his task of giving to the word a new life and to the language a new idiom. The essential of tradition is in this; in getting as much as possible of the whole weight of the history of the language behind his word.[73]

Repetition, in this formulation, is a tool that the writer can use to make his work richer and more complex. Rather than seeing repetition as a deadening force, an echo of the inhuman rhythms of the machine, Eliot saw it as an instrument of renewal, the basis of modernism's originality rather than the enemy of it.

Eliot's work sustains this ambivalence regarding repetition in a productive tension. His repetitions are at once a making and an unmaking; read through a writerly identification with the typist, they simultaneously advocate for repetition as a means of connecting to a restorative tradition and decry it as an empty, even nihilistic gesture. Eliot's repetitions criticize the practice as a favoring of process over content but also create comfort through their stable rhythms. They represent an important aspect of modernist aesthetics while also standing for the degeneration of taste that portends the end of originality as a cultural value. They represent a collapse of meaning—in "Tradition and the Individual Talent," Eliot refers to "the susurrus of popular repetition," suggesting that repetition creates an indistinct blur[74]—but are also put forth as an important aid in forging a useable past. *The Waste Land*'s final, repetitive line, "shantih shantih shantih," taken from the Upanishads, does all this and more: the idea of a "peace which passeth understanding" might be taken simultaneously as a poetic defense of repetition's allure *and* a critique of its inadequacy as a defense against modernity's onslaught.

Repetition in the writing of Eliot and others was an important site for the elucidation, criticism, and assimilation of the growing emphasis on standardization in public and private lives. As I have suggested, human repetition was an anxious topic in the early twentieth century, considered both an eminently human sign of pathological neurosis and an inhuman technique of industry imposed on individuals and quashing their creative potential. Eliot shows his poem falling prey to the illness of the repetition he has diagnosed; he dramatizes the demise of original literature that he and other modernist writers associated with the emergence of standardized forms, practices, and affects. Eliot also struggles with the relationship of standardization and repetition to history, using repetition to invoke a constructive relation to literary tradition while also highlighting repetition's ahistoricity. In a number of the texts I have discussed, the functioning of a mechanized society is dependent on the suppression of history: in 1984 the past is continually rewritten into an eternal present and in *Brave New World* any history before the birth of Henry Ford, and old things in general, are suppressed. Repetition can echo the past, but it can also stagnate in an unending present.

Eliot's famous insistence on "the historical sense" in poets is a corrective to this process: "This historical sense, which is a sense of the timeless as well as of the temporal and of the timeless and of the temporal together, is what makes a writer traditional. And it is at the same time what makes a writer most acutely conscious of his place in time, of his contemporaneity."[75] Eliot's comments take on additional meaning when read in the context of the dehistoricizing tendency of mechanical reproduction; he argues that poets can preserve their identities as modern while still expressing their relation to literary history.[76] In other words, "Tradition and the Individual Talent" comes to the defense of tradition in part because modernity seems all too willing to do away with it.[77]

Mass production can seem to have a deracinating effect, eliciting literature's relation to other modern commodities (bathtubs, refrigerators) rather than its relation to the corpus of literature. Walter Benjamin touches on this effect in his well-known essay on the technological reproduction of

artworks: "*It might be stated as a general formula that the technology of reproduction detaches the reproduced object from the sphere of tradition.*"[78] As mass production spread to encompass many of the objects of everyday life, literature seems to stand in synchronic relation to these objects rather than in a more traditional diachronic relation to literary tradition. In 1926 Eliot wrote that "contemporary perception of rhythm had been affected by the internal combustion engine."[79] The repetitive hum of the engine became the beat of modern poetry. The hum also penetrated into individuals; in *The Waste Land* Eliot speaks of the end of the workday, "when the human engine waits / Like a taxi throbbing waiting" (ll. 216–17). The mechanical pulse of the engine has become the human pulse too; it travels from work to home without missing a beat; it is in the food we eat and the music we hear; it is both vehicle and tenor, function and form.

Notes

1. Osbert Sitwell, *Penny Foolish: A Book of Tirades and Panegyrics* (London: Macmillan Publishing, 1935), 94.
2. Sitwell, *Penny Foolish*, 96.
3. Sitwell, *Penny Foolish*, 96, 97.
4. See also Stefan Zweig's 1925 essay "The Monotonization of the World" ("Die Monotonisierung der Welt") in which Zweig bemoans the advent of standardization imposed by mechanization (which for Zweig, originated in America): "The complete end of individuality. It is not with impunity that everyone can dress the same, that women can go out in the same clothes, the same makeup; monotony necessarily penetrates the surface." *The Weimar Republic Sourcebook*, ed. Anton Kaes, Martin Jay, and Edward Dimendberg (Berkeley and Los Angeles: University of California Press, 1994), 398.
5. English was standardized for the most part in the seventeenth century, as the advent of the printing press gradually led to a national preference for the London dialect of English and codified rules of grammar and spelling.
6. See Siegfried Kracauer, *The Mass Ornament: Weimar Essays*, trans. Thomas Y. Levin (Cambridge, MA and London: Harvard University Press, 1995).
7. Cited in Reyner Banham, *Theory and Design in the First Machine Age*, 2nd edn (New York: Praeger, 1967), 75.
8. Banham, *Theory and Design*, 78.

9. Walter Gropius, "Bauhaus Dessau—Principles of Bauhaus Production, 1926," reprinted in *Form and Function: A Source Book for the History of Architecture and Design, 1890–1939*, ed. Tim Benton and Charlotte Benton, with Dennis Sharp (London: Crosby Lockwood Staples, 1975), 148.

10. Lillian Gilbreth, *The Home Maker and Her Job* (New York: D. Appleton & Co., 1927), 102.

11. Philip Johnson, "Preface to the 60th Anniversary Edition," *Machine Art* (New York: Harry Abrams, 1994), n.p.

12. Le Corbusier, *Towards A New Architecture*, ed. and trans. Frederick Etchells (New York: Dover Publications, 1986), 7.

13. T. S. Eliot, "London Letter, March 1921," in *Annotated Waste Land, with T.S. Eliot's Contemporary Prose*, ed. Lawrence Rainey (London and New Haven, CT: Yale University Press, 2005), 138.

14. For Hugh Kenner, it is the new technology of the telephone that exerts greatest influence over *The Waste Land*; see Kenner, *The Mechanic Muse* (New York and Oxford: Oxford University Press, 1987), 34–6.

15. T. S. Eliot, "Choruses from 'The Rock,'" in *Collected Poems 1909–1935* (New York: Harcourt, Brace and Company, 1930), 191.

16. Lawrence Rainey discusses the significance of the typist in Eliot, *Annotated Waste Land*, 108. His comments are further developed in his *Revisiting the Waste Land* (New Haven, CT and London: Yale University Press, 2005) where he examines the ambivalent status of the typist: on the one hand, she was a feminist figure of independent means, newly visible in the public sphere of work. Eliot had typists working for him at Lloyds. On the other hand, typists were underpaid, underfed, and often represented as figures of pathos in popular fiction.

17. T. S. Eliot, "The Waste Land," in *Collected Poems 1909–1935* (New York: Harcourt, Brace and Company, 1930), 80, ll. 220–2. Further references to this poem from this edition are given parenthetically as line numbers in the text.

18. Morag Shiach writes: "The typist as figure of alienated modern femininity gains a more specific class location in TS Eliot's The Waste Land (1922). Eliot's typist lives alone, in a chaotic and cramped bedsit. Her breakfast dishes and her washing litter her room, she eats tinned food. She is unmoved by the sexual encounter staged in the poem, which is marked by passivity and indifference. Her movements are automatic, her personality void, and as she reaches for the gramophone she expresses the falsity and alienation of mass culture and of modern woman": Shiach, "Modernity, Labour and the Typewriter," in *Modernist Sexualities*, ed. Caroline Howlett (Manchester and New York: Manchester University Press, 2000), 125.

19. T. S. Eliot, *The Waste Land: A Facsimile and Transcript of the Original Drafts Including the Annotations of Ezra Pound*, ed. Valerie Eliot (New York: Harcourt Brace Jovanovich, 1971), 33, 45.

20. For Michael North, "The Waste Land illustrates . . . formal imprisonment through its use of rhyme, which tends to come into the poem when its characters are acting

most automatically": North, *Reading 1922: A Return to the Scene of the Modern* (Cary, NC: Oxford University Press, 2001), 28.

21. Lawrence Rainey points out the hand's symbolic value: "the hand has been invoked to signal the critical difference between the human and the animal, at once the instrument of reason and its material counterpart": Rainey, *Revisiting the Waste Land*, 68.

22. Lewis Mumford, *Technics and Civilization* (New York: Harvest/Harcourt Brace, 1934), 278.

23. William James, *The Principles of Psychology* (New York: Henry Holt and Company, 1890), 123.

24. Walter Gropius, *The New Architecture and the Bauhaus*, trans. P. Morton Shand (Cambridge, MA: The MIT Press, 1965) 34–5.

25. Sigmund Freud, "Remembering, Repeating, and Working-Through," in *The Standard Edition of the Complete Psychological Works of Sigmund Freud*, Vol. 12, trans. and ed. James Strachey (London: Hogarth Press, 1962), 151.

26. In his account of the 1905 analysis of the patient he called "Dora," Freud writes that her mother "was occupied all day long in cleaning the house with its furniture and utensils and in keeping them clean—to such an extent as to make it almost impossible to use or enjoy them": Sigmund Freud, "Fragment of an Analysis of a Case of Hysteria," in *Dora: The Analysis of a Case of Hysteria* (New York: Macmillan, 1963), 34–5.

27. Sigmund Freud, *Beyond the Pleasure Principle*, trans. and ed. James Strachey (New York and London: W. W. Norton, 1961), 12–13.

28. Freud, *Beyond the Pleasure Principle*, 14.

29. Freud, *Beyond the Pleasure Principle*, 32.

30. Freud, *Beyond the Pleasure Principle*, 29.

31. Freud, *Beyond the Pleasure Principle*, 31, 31n3.

32. Freud, *Beyond the Pleasure Principle*, 6.

33. J. Hillis Miller analyzes the function of repetition in British nineteenth- and twentieth-century literature in *Fiction and Repetition: Seven English Novels* (Cambridge, MA: Harvard University Press, 1982). For Miller, theories of repetition are part of a broad philosophical tradition that begins, he writes, "like our culture generally, with the Bible on the one hand and with Homer, the Pre-Socratics, and Plato on the other" and extends to Gilles Deleuze (5). Bruce F. Kawin's *Telling It Again and Again: Repetition in Literature and Film* (Ithaca, NY and London: Cornell University Press, 1972) does not deal directly with modernism but does touch on some theories of repetition in literature as well.

34. D. H. Lawrence, *Kangaroo* (1923; rpt. New York: Viking, 1960), 220.

35. Malcolm Bradbury and James McFarlane, "The Name and Nature of Modernism," in Bradbury and McFarlane, eds, *Modernism: A Guide to European Literature 1890–1930* (London and New York: Penguin, 1991), 19.

36. See Martin Puchner's study of the relationship between political revolution and the artistic avant-garde through the manifesto form: *Poetry of the Revolution: Marx, Manifestos, and the Avant-Garde* (Princeton, NJ: Princeton University Press, 2005).

37. Numerous critics have pointed out the many continuities between the modernists and their Victorian predecessors. See, for example, Jessica Feldman, *Victorian Modernism: Pragmatism and the Varieties of Aesthetic Experience* (New York: Cambridge University Press, 2002).

38. Rosalind Krauss, "The Originality of the Avant-Garde," in *The Originality of the Avant-Garde and Other Modernist Myths* (Cambridge, MA: The MIT Press, 1985), 162.

39. Ezra Pound, "How I Began," in *Ezra Pound: Perspectives*, ed. Noel Stock (Chicago, IL: Henry Regnery, 1965), n.p. (frontispiece).

40. T. S. Eliot, "American Literature and the American Language," in *To Criticize the Critic and Other Writings* (Lincoln and London: University of Nebraska Press, 1992), 57.

41. Louis Menand discusses Eliot's struggle to give meaning to the idea of literary originality in his *Discovering Modernism: T. S. Eliot and His Context*, 2nd edn (New York: Oxford University Press, 2007), 70–7.

42. T. S. Eliot, "Tradition and the Individual Talent," in *The Sacred Wood* (London: Methuen, 1960), 51. Eliot goes on to say that the poet must take account of the change, even if it is only "based upon a complication in economics and machinery."

43. Virginia Woolf, "Mr. Bennett and Mrs. Brown," in *The Captain's Death Bed* (New York: Harcourt Brace, 1950), 96.

44. Mary Pattison, *Principles of Domestic Engineering, or The What Why and How of a Home* (New York: The Trow Press, 1915), 105.

45. T. S. Eliot, "Religious Drama: Medieval and Modern," *University of Edinburgh Journal* 9.1 (Autumn 1937): 17.

46. E. M. Forster, "The Machine Stops," in *The Collected Tales of E. M. Forster* (New York: Alfred A. Knopf, 1952), 144.

47. Forster, "The Machine Stops," 182.

48. Forster, "The Machine Stops," 149–50.

49. Eliot, *Collected Poems*, 192.

50. George Orwell, *The Complete Works of George Orwell, vol. V: The Road to Wigan Pier*, ed. Peter Davidson (London: Secker & Warburg, 1998), 189–90.

51. Samuel Beckett, *Watt* (New York: Grove Press, 1953), 87.

52. Beckett, *Watt*, 89.

53. Orwell, *Wigan Pier*, 190.

54. Orwell, *Wigan Pier*, 184.

55. Orwell, *Wigan Pier*, 186.

56. George Orwell, *Nineteen Eighty-Four* (1948; New York: Penguin, 1983), 27. Further page references given parenthetically in the text.

57. Richard Posner, "Orwell Versus Huxley: Economics, Technology, Privacy, and Satire," *Philosophy and Literature* 24.1 (2000): 16.

58. Posner, "Orwell Versus Huxley," 27.

59. George Orwell, "Politics and the English Language," in *George Orwell: The Collected Essays, Journalism and Letters, Vol. IV: In Front of Your Nose*, ed. Sonia Orwell and Ian Angus (Boston, MA: David Godine, 2000), 135–6.

60. Aldous Huxley, *Brave New World* (1932; New York: Harper Perennial, 2006), 44.

61. Huxley, *Brave New World*, 47.

62. Huxley, *Brave New World*, 156.

63. Rainey calls the typist "repetition personified": Rainey, *Revisiting the Waste Land*, 52.

64. Laura Frost writes, "The iconographic typist (for Eliot in The Waste Land, among other modernist fictions) stands in for a whole demographic of women consumers whose fantasies are apparently simple to comprehend, and who live out their lives in mindless imitation." Frost, "The Romance of Cliché: E. M. Hull, D. H. Lawrence, and Interwar Erotic Fiction," in *Bad Modernisms*, ed. Douglas Mao and Rebecca Walkowitz (Durham, NC and London: Duke University Press, 2006), 104.

65. Oliver Goldsmith, *The Vicar of Wakefield* (1766; London: Penguin Books, 2002).

66. Influential early interpretations of Eliot's allusions include John Hollander, *The Figure of Echo* (Berkeley: University of California Press, 1981); F. O. Matthiessen, *The Achievement of T. S. Eliot* (Oxford: Oxford University Press, 1935); and Grover Smith, *T. S. Eliot's Poetry and Plays: A Study in Sources and Meaning* (Chicago, IL: University of Chicago Press, 1959). Michael Levenson argues that the poem, "generates a wealth of cultural allusions, but it places them in no permanent order; the poem works and reworks its sense of the past": Levenson, *A Genealogy of Modernism: A Study of English Literary Doctrine 1908–1922* (Cambridge: Cambridge University Press, 1987), 201.

67. Sarah Cole discusses *The Waste Land* as a poem about transformation rather than creation in "Enchantment, Disenchantment, War, Literature," *PMLA* 124.5 (2009): 1632–47.

68. Beckett, *Watt*, 203–4.

69. For a consideration of Gertrude Stein's early psychological studies and publications on human automatism, see Susan McCabe, "'Delight in Dislocation': The Cinematic Modernism of Stein, Chaplin, and Man Ray," *Modernism/Modernity* 8.3 (2001): 429–52. Also see Tim Armstrong's discussion of Stein in his *Modernism, Technology and the Body: A Cultural Study* (Cambridge: Cambridge University Press, 1998), 197–211.

70. Gertrude Stein, "Portraits and Repetition," in *Lectures in America* (New York: Random House, 1935), 178–9.

71. Gertrude Stein, *The Making of Americans* (1925; New York: Harcourt Brace, 1966), 455.

72. Strother B. Purdy writes, "Repetition is asserted to be the basis of being and of exploring being, or of art, whose purpose that is. And as being able to dominate time, in dissolving the physical separation of different people at different times. Repetition allows us to recognize the lost one in the stranger, to capture the past and thus the future as well." Purdy, "Gertrude Stein at Marienbad," *PMLA* 85.5 (1970): 1097.

73. T. S. Eliot, "The Three Provincialities," *The Tyro* 1.2 (1922): 13. Italics in original. Jennifer Schiffer Levine makes a similar point about Joyce's palimpsestic use of

language in *Finnegans Wake*: Levine, "Originality and Repetition in *Finnegans Wake* and *Ulysses*," *PMLA* 94.1 (1979): 106–20.

74. T. S. Eliot, "Tradition and the Individual Talent," 53.

75. T. S. Eliot, "Tradition and the Individual Talent," 49.

76. Or history itself could figure as unceasing repetition. Damon Marcel DeCoste cogently articulates this viewpoint: "history, for the modernists, represents not a process of decline but rather a persistent repetition *of* the past, figured not as some forfeit Golden Age but as the site of senseless violence." See DeCoste, "Modernism's Shell-Shocked History: Amnesia, Repetition, and the War in Graham Greene's *The Ministry of Fear*," *Twentieth Century Literature* 45.4 (1999): 430.

77. Perry Meisel argues, "It is, then, literary modernism's implication in the history it seems to disdain that is the reflexive counterpart and defensive impetus of what it thematizes—the desire to seek a place outside of the tradition that enables it." Meisel, *The Myth of the Modern* (New Haven, CT and London: Yale University Press, 1987), 4.

78. Walter Benjamin, "The Work of Art in the Age of Its Technological Reproducibility," second version, trans. Edmund Jephcott and Harry Zohn, in Benjamin, *The Work of Art in the Age of Its Technological Reproducibility and Other Writings on Media*, ed. Michael W. Jennings, Brigid Doherty, and Thomas Y. Levin (Cambridge, MA and London: Harvard University Press, 2008), 22. Italics in original.

79. Qtd in John Morris, "The Emergent Stereotype of Man as Machine," in *Exploring Stereotyped Images in Victorian and Twentieth-Century Literature and Society* (London: Edwin Mellen Press, 1993) 263.

5

MODERNISM'S MISSING CHILDREN

Mass production and human reproduction

"**M**odernist literature isn't good for children." We can understand this apparent truism in several ways. For one, modernist literature appears ill-suited to child readers. It also appears too difficult for children—too difficult, in fact, for many adults. The demands modernism makes on the reader's erudition and concentration raise the bar far too high for most children to grasp. As Mark Van Doren lamented in 1930, "A reader...who had been brought up on the poetry familiar to his parents, the household poetry...which millions of school children had memorized...had every right to be bewildered a decade and a half ago."[1] Following after works like Robert Louis Stevenson's *Child's Garden of Verses* (1885), modernist poems seemed to preclude children's encounters with the poetry of the time.

Leaving aside the question of difficulty, modernist literature is also considered too dirty for children; indeed, it has been said to have the potential to do moral harm to children because of its focus on sexuality, scatology, and profanity. More than one modernist work was legally suppressed under obscenity laws put in place to protect child readers from corrupting influence. Several of modernism's most infamous banned books, like *Lady Chatterley's Lover* (1928) or *Ulysses* (1922), have come to epitomize exactly what conscientious parents are not supposed to allow their children to read. In Tsetse Dangarembga's *Nervous Conditions* (1988), set

in postcolonial Zimbabwe, a father is horrified to learn that his daughter has been reading *Lady Chatterley*: "No daughter of mine is going to read such books."[2]

If modernist literature isn't good for children to read, it also is considered actively unfriendly to children because of the way it leaves them out of the story. There are relatively few children in modernist texts, especially compared to the hordes running through the works of previous writers like Charles Dickens. Edward Said has noted that "Childless couples, orphaned children, aborted childbirths, and unregenerately celibate men and women populate the world of high modernism with remarkable insistence."[3] Even a modernist avatar like Sigmund Freud, whose psychological theories rest on ideas about the childish sexual imagination, very rarely discusses actual children in his work or engages them in his practice. To invoke D. H. Lawrence once more, Mellors the gamekeeper would seem to express a common modernist sentiment when he tells Lady Chatterley "I've a dread of puttin' children i' th' world."[4] (Though he does so nonetheless.)

Modernist literature makes a strong case for remaining childless by often equating parenting with suffering. If you are rash enough to have a child you can expect the relationship with your offspring to be characterized by mutual neglect, mistrust, resentment, and betrayal: ask Edna Pontellier in *The Awakening*, Stephen Gordon's mother in Radclyffe Hall's *The Well of Loneliness*, *The Great Gatsby*'s Daisy Buchanan, or Antoinette's mother in *Wide Sargasso Sea*. These mothers dislike their children, watch them suffer and die, or see them as obstacles to personal happiness. For fathers the case is not much brighter. Surveying the paternal situation of, for example, Thomas Sutpen in William Faulkner's *Absalom, Absalom*, James Tyrone in Eugene O'Neill's *Long Day's Journey into Night*, or Henry Wilcox in E. M. Forster's *Howards End*, we again encounter profound parental dissatisfaction. Children die, or are considered by their fathers to be depraved or inadequate in a host of ways. The animus runs both ways; Freud makes the case that if you are a father you can reasonably expect that your male child will wish you dead. Counterexamples can certainly be proposed, but the theme persists.

How do we understand this widespread childlessness and vexed parenting? Said takes on the former, expressing the generally accepted explanation of modernism's reproductive refusals and failures, that "the aridity, wastefulness, and sterility of modern life make filiation an unreasonable alternative at least, an unattainable one at most."[5] This would seem to be close to Mellors's viewpoint: he has nothing against children, but modern times are just not conducive to happy childhoods or parents. Said's reading resonates with the many modernist writers in whose works children are inconceivable or absent. Said's account, however, is a broad one, and perhaps more descriptive than explanatory. The childlessness of modernist protagonists can certainly be seen as an aspect of a broader sterility associated with modern life. But is it only that, and how does it correlate with other aspects of modernity?

Said does not account for the children who do appear in modernist literature, children who are undeniably noteworthy. These children do nothing to disabuse us of the idea that modernist literature is not good for children, since children in modernist literature are typically beset. Dead children are common and those who manage to survive are often physically atypical or more indefinably abnormal, as in Lawrence's "England, My England," Djuna Barnes's *Nightwood*, or Faulkner's *The Sound and the Fury* or *As I Lay Dying*. At other times the children of modernist literature do not seem to be children at all, but rather adults in small bodies, a disjuncture suggested by their thoroughly unchildlike actions and words, perhaps most famously in Henry James's "The Turn of the Screw," Virginia Woolf's *The Waves*, or James Joyce's "Araby." The oddness or outright creepiness of these children sets them well apart from either the Victorian figure of the child burdened by original sin or the Victorian child of perfect innocence—epitomized by Little Lord Fauntleroy or Beth in Louisa May Alcott's *Little Women*.

There are some exceptions to this catalogue of misfits, even among the writers I have already named. We do occasionally find youthful individuals in the work of modernist writers who are fully realized by their creators and look and act like typical children. In James's *What Maisie Knew*, Maisie

copes with the rather extraordinary behavior of her parents in a fashion that displays unusual poise but is not sinister after the manner of Miles and Flora in "Turn of the Screw." James Ramsay, in Woolf's *To the Lighthouse*, has familiar childhood fears and a fairly conventional Oedipal relation to his father, the patriarchal Mr. Ramsay. Joyce's Stephen, in *A Portrait of the Artist as a Young Man* at least, is certainly an unusual young man in a number of regards but he is still recognizably a young man with a young man's problems.

However, it seems fair to say that modernist children are often problem children, strange in a particular set of ways and, as I hope to show, significant through their presence as well as the absence that Said notes. Accordingly, one of my chief goals for this chapter is to go beyond the generalization that modernism is a childless literature by taking note of the distinctive breed of children who populate its pages. I am not interested specifically in the ways in which these children are represented—their particular features and peculiarities—but rather in the kinds of stories that are told about them, the narratives in which these children dwell. These are dramas of development, plotting the ways in which children change as they grow older. Modernist writers do not typically offer static portraits of strange children, a gallery of oddities resulting from the unsustainability of modern life. Rather, as I hope to show, it is child development that preoccupies them most.

The story of development is readily associated with the *Bildungsroman*, the novel of development that tells the story of a youth from early childhood to adulthood. If the subjects of this genre since its inception could be counted on to progress in a more or less linear fashion from something generally accepted as childish subjectivity to what the text sanctioned as maturity, the modernist version offered no such certainties and no consensus on the direction or landmarks of the individual's journey. Modernist writers preserved the central concept of the *Bildungsroman*, that of a narrative that takes its trajectory from the ubiquitous human story of growth and change. But they visualized that trajectory as taking a range of divergent directions. For Rachel Vinrace in Woolf's *The Voyage Out* (1915),

sudden illness and death abruptly terminate the story of a young woman's education and growth. In the case of F. Scott Fitzgerald's Jay Gatsby, an intransigent fixation on a woman skews the story. Child development becomes an eccentric process; consider Vardaman in Faulkner's As I Lay Dying (1930), paralyzed by his mother's death; or young Miles in James's "The Turn of the Screw," with his eerily premature poise. I will analyze development in the modernist Bildungsroman through a survey of a number of writers, but I will look in detail at the work of Aldous Huxley, whose novels offer up a range of nonlinear models for understanding human development. Huxley's broad interest in education and child psychology and his writings on the subject are a useful supplement to his novels and provide insight into how new ideas about child development in the 1920s and 1930s were received.

The developmental irregularities that I will argue characterize modernism's "problem children" constitute a reworking of the trajectory of the Bildungsroman but also relate to extra-literary narratives of child development. Child development presented itself as a significant and meaty problem to modernist writers, a preoccupation I will ascribe to the lively debates about child development that were prevalent at the time rather than to a general plaint about the sterility of modern life. The formal study of child development originated in the 1920s and 1930s, when scientists and psychologists first began conducting empirical studies of individual children and their growth. These innovations in the scientific community found expression in an extensive popular literature directed both at parents and the new child-care professionals. Scientific discourse did not, of course, exclusively determine the modernist reformulation of the Bildungsroman; my goal here is to try to reanimate the intricate traffic in ideas among the literary, scientific, and domestic spheres on this issue, all mutually influenced and influencing.

The 1920s and 1930s produced tremendous interest and public debate about child-rearing and child psychology, but these decades are not significant ones for children's literature. Critics consider the Victorian period to be a golden age for children's literature, the early twentieth century a

desert. Scholars of children's literature have argued that while "crossover" writing flourished in the nineteenth century—that is, books for adults attracting child readers and vice versa—this trend ended with modernism. Writers like Stevenson who cultivated crossover audiences were suspect because their work appealed to children.[6] Hope Hodgkins expresses a common sentiment when she writes that "Unashamed authorial cross-writing [writing for both children and adults] came to a screeching halt with Anglo-American high modernism."[7] The putative twentieth-century decline in crossover writing is yet another way in which critics have deemed modernism not good for children. This chapter is centrally concerned with children in modernist literature, and the representations of children in the texts I will consider are connected to the idea of the child reader with which I opened, the child who cannot or should not be reading modernist texts.

Children's literature is sometimes sidelined in literary criticism,[8] but even within the subfield of children's literature, works by modernist writers are rarely discussed. Critics are aware that nineteenth-century authors like Kipling, Twain, and Dickens wrote for both adults and children but typically overlook the same practice in modernist writers. Perhaps this discrepancy can be ascribed to the smaller quantity of modernist children's literature compared to the output of their predecessors. But I think it also is a product of the idea that nineteenth-century literature is child-friendly in a way that modernism is not. Thus, Dickens's children's literature is considered to be on a continuum with his "adult" novels with child protagonists, like *David Copperfield* or *Great Expectations*, while Graham Greene's children's books—he wrote many—seem utterly incongruous in relation to his writing for adults. As critics, we are far more likely to know about Greene's notorious statement, "how I dislike children" than we are to be familiar with his books *The Little Train* (1946), *The Little Fire Engine* (1950), *The Little Horse Bus* (1952), and *The Little Steamroller* (1952).

As Hodgkins's comment suggests, these works are barely visible in mainstream modernist studies, despite their sizeable numbers.[9] A partial list of writers associated with modernism who also wrote for children

includes Enid Bagnold, Arna Bontemps, Elizabeth Bowen, Leonora Carrington, Countee Cullen, e.e. cummings, Walter de la Mare, H. D., T. S. Eliot, William Faulkner, Ford Madox Ford, Robert Graves, Graham Greene, Thomas Hardy, Langston Hughes, Aldous Huxley, Randall Jarrell, James Joyce, Nella Larsen, Sinclair Lewis, Ezra Pound, Carl Sandburg, Gertrude Stein, Oscar Wilde, and Virginia Woolf. There is great diversity among these writers and their works, some of which were written for publication and some for family members. Some are picture books, some fairy tales, some primers, some histories, and some stories for older children. Some are fanciful, some didactic, some realistic. But to survey this body of work is to realize that like the critical generalization that modernism is a childless literature, the idea that modernist writers had nothing to say to children is in need of revision. Can we do more than set modernist children's literature aside as an anomaly or insignificant phenomenon? Accounting for this literature can allow us to do more than expand our bibliographies; it can provide another viewpoint from which to consider the missing and strange children who figure in modernist literature.

Discerning the relationship between modernist literature about children and children's literature by modernists would seem to lead to a paradox. Modernism writes *to* children although it does not often write *about* them; it is considered not good *for* children to read, but it tries to be good *to* children. From these apparent contradictions arise the two interrelated aims of this chapter. The first is to go beyond our generalization that modernism is a childless literature by trying to account, at least in part, for the disabled, disturbed, and dead children who recur in its pages. The second is to bring children's literature by modernist writers into focus and analyze its representation of children as both subjects and readers rather than the beleaguered children of modernist adult literature.[10]

Both these questions are part of my larger interest in elucidating modernism's relation to domesticity and specifically to the changes in the materiality of private life in the 1920s and 1930s, changes that cluster around the idea of modernization. Modernization meant running the home according to scientific principles; it meant mechanizing and

rationalizing housework; it meant reinventing hygiene and cleanliness rituals. And if the domestic "factory" could be said to have any product, that product was children. Child-rearing could be (and was) rethought along the rational lines propounded by the modern age. But what strange new generation would the rationalization of child-rearing produce?

* * *

It is not always children per se, but the modern approach to child development, that comes in for the sternest critique in modernist literature. It is true that children are sometimes horrid on their own, but most often it is modernity that has made them so, a sentiment some writers expressed explicitly. For Aldous Huxley, writing in 1930, it was clear that "the family is on the decline." The causes, he argued in an essay entitled "Babies—State Property?," were modernization and the outsourcing of child care, changes that had the effect of quashing individuality in children. In the near future, Huxley predicted, "The process of standardization will begin at the very moment of birth—that is to say, if it does not begin before birth! Which means that both the individual and the family are in for a very bad quarter of an hour."[11] Public institutions were invading the private sphere with destructive effects. Similarly, D. H. Lawrence proclaimed, "Our process of universal education is today so uncouth, so psychologically barbaric, that it is the most terrible menace to the existence of our race."[12]

In accordance with Huxley's and Lawrence's judgments, many of modernism's children from the fin-de-siècle all the way through the 1950s seem to be victims of the influence of modernizing forces both within and outside the family. The strangeness of these children was the apparent result of modern scientific theory. An extreme case of the inhumanity of the rational child can be found in Thomas Hardy's late novel *Jude the Obscure* (1895). Little Father Time (as he is called) and his siblings kill themselves because they feel their existence to be an excessive strain on their parents' resources. Their suicide note reads, "Done because we are too menny," evoking Thomas Malthus's harsh but rational Enlightenment theories of population control. The doctor who arrives—uselessly, since the children

are already dead—tries to explain the event to Jude: "The doctor says there are such boys springing up amongst us—boys of a sort unknown in the last generation—the outcome of new views of life."[13]

The rationalization of children and child care was a pervasive phenomenon. Even the Church seemed to be taking up modern methods. In W. B. Yeats's well-known poem "Among School Children" (1926), the poet, visiting a school, is unimpressed with the nun's explanations of how things now are run. "The children learn to cipher and to sing, / To study reading-books and history, / To cut and sew, be neat in everything / In the best modern way" (ll. 3–6).[14] Educated with dry efficiency, these children, Yeats laments, lack the fire and imagination of their predecessors. Far from conceiving the home as a refuge from modern influences, literary accounts of modern parenting depict a similar science invading the hearth. In Samuel Beckett's novel *Molloy* (1951; trans. 1955), for instance, Jacques Moran instructs his teenage son by rote: "Stop trying to understand. I said, just listen to what I am going to say," earning his son's obedience but not his love.[15] What runs through these accounts is a disapproval of bringing up children according to the dictates of science, with little room for creativity, spirituality, or affection. As with so many aspects of modernization, a number of modernist writers were dubious that the new approaches to child-rearing would yield any positive results.

Actual representations of modernized children and child care like these were only one way in which modernist writers responded to the sea changes taking place around children and their upbringing. To discern the broader impact on modernist literature we need to understand how much and in what ways children and child care shifted. The twentieth century was famously dubbed "The Century of the Child," a designation that pointed to the scrutiny that fell upon child-rearing in the century's first decades. Children experienced a new visibility, a shift driven in part by demographics and parents' increasing sense of control over their reproductive choices. Infant mortality in England and Wales peaked in 1901 at 161 deaths per thousand births (higher in the cities) but by 1928 had plummeted to 66 per thousand.[16] Similarly, in the United States, by

1920 infant mortality had declined to 50 deaths for every thousand births; in 1850 the death rate was four times as high.

At the same time, information about birth control began to circulate more widely; in the United States Margaret Sanger opened her first birth control clinic in 1914, while in England Marie Stopes and the Malthusian League did so in 1921. Family size declined, as did the number of household servants employed in middle-class homes.[17] In the United States in the early nineteenth century, families typically had seven or eight children; by 1920 the average had declined to just over three. All this meant that parents (primarily mothers) invested more time, emotion, and ambition in a smaller number of children. While the Victorian nursery was a remote land whose inhabitants rarely ventured forth, modern children were both seen and heard. For children of working classes, Victorian child labor reforms meant that childhood became a more distinct phase of life.

An enormous array of experts instructed parents and educators on the best methods of caring for children. As with housework, child care became professionalized, lending it a heightened sense of importance and suggesting a need for more rigorous and scientific approaches. The American efficiency expert Lillian Gilbreth wrote, "At no age in the world has the child been so definitely accepted as the center of interest as at the present. Anything that the scientific method of attack on the home problems can contribute toward utilizing this interest in the child is worth while."[18] Gilbreth's use of the word "attack" suggests the vigor that was directed at the critique and reinvention of child-rearing. She and her husband Frank practiced what they preached and reared twelve children according to the principles of efficiency and mass production, as chronicled by two of the children in the memoir *Cheaper by the Dozen* (1948).

Like modernist writers, modern parents set out to repudiate their immediate predecessors. Doris Lessing, who was born in 1919, remembered how the new generation of experts guided her own mother:

[S]he read all kinds of advanced books, and was determined her children would not have the cold and arid upbringing she did. She studied Montessori

and Ruskin, and H. G. Wells, particularly *Joan and Peter*, with its ridicule of how children were deformed by upbringing. She told me all her contemporaries read *Joan and Peter* and were determined to do better.[19]

Lessing's mother's espousal of *Joan and Peter: The Story of an Education* was common at the time; the novel was very popular after it first appeared in 1918, though it is almost completely unknown now. Its philosophical mouthpiece is Oswald Sydenham, the guardian of the eponymous children after the premature death of their parents in a boating accident. Oswald's chief idea is that the fate of the nation and its empire rests on the education of the coming generation. At the novel's opening he explains, "I'm getting to be a fanatic about education.... We don't make half of what we *could* make of our children. We don't make a quarter—not a tenth. They could know ever so much more, think ever so much better."[20] Education, for Oswald, is not a Rousseauian journey of self-development but a pragmatic tool for enlarging the strength and hegemony of the British people. He wants to throw out Greek and Latin instruction in favor of labor and industry. And indeed Joan, the product of an education designed by Oswald, decides by the end of the novel to go into business designing efficient modern homes that will free women from household drudgery. The novel is a call to parents to rethink child-rearing and to orient their children's education to the production of citizens dedicated to a modern, mechanized future.

Children were commonly compared to the machines that filled both the home and the workplace, perhaps because machines seemed more understandable and predictable than children. As Nathan Giles and Dorothy Ellis wrote in the 1929 *Science of the Home*,

> If the "Spirit of St. Louis" had been filled with anything but the best fuel and oil, it would not have landed in Paris or made the wonderful flights from state to state. Just so with the human body; if we are to succeed and to raise children who will succeed, these delicate body mechanisms must be properly developed, maintained, and operated.[21]

If children were like machines, they should respond uniformly to a given program of treatment. They ought to be replicable, predictable, and most of

all, rational. John Watson, one of the most prominent child specialists of the 1930s, boasted:

> Give me a dozen healthy infants, well-formed, and my own specified world to bring them up in and I'll guarantee to take any one at random and train him to become any type of specialist I might select—into a doctor, lawyer, artist, merchant-chief, and yes, even into beggar-man and thief, regardless of his talents, penchants, tendencies, abilities, vocation and race of his ancestors.[22]

The interest in eugenics was part of the burgeoning idea that from conception onward, human development could be controlled and regulated from birth through to adulthood. "Scientific child rearing was expected to transform motherhood into a true profession," explains Alice Smuts, and the 1920s accordingly saw a huge expansion in the publication of prescriptive literature directed at parents.[23] In 1938 the popular *Parents' Magazine* offered a correspondence course to its readers: "Add Science to Love and Be A 'Perfect Mother.'"

Books that offered guidelines for caring for children at home frequently adopted their tone from science and industry. In Kate Kennedy's *The Science of Home-Making*, for instance, every task related to the care of infants was broken down into detailed steps and presented as a list: "Washing of Baby. Dressing of Baby. Feeding of Baby."[24] As Daniel Beekman ruefully observes, "Little was known about children in a scientific sense, but a good deal was known about production. Production demanded regularity, repetition, and scheduling."[25] Palpable in the new literature was a desire to bring the messy and various work of child care to heel through method, consistency, and control. "Developmental psychology," writes Susan Honeyman, "under the early influence of natural sciences, essentialized the highly variable social phenomenon of maturation to 'scientifically' translate children into primitive animals who need to develop through chronologically fixed, universal stages to reach civilized adulthood."[26] Yet a profound asymmetry underlay the analogy between child-rearing and factory production: the goal of the latter was efficiency, producing the greatest amount of product with the

smallest amount of time and effort. The goal of child-rearing was another matter altogether.

Behaviorism, as articulated by Pavlov and adapted by Watson, Truby King, and others, was the method for achieving the highest degrees of human malleability. Behaviorists argued that conditioning could control children's responses to all stimuli. Environment, not heredity, was key. Watson wrote, "There are no instincts. We build in at an early age every-thing that is later to appear."[27] The mother, recast as scientist, must think carefully about her every interaction with the child in the knowledge that early conditioning was decisive. Huxley famously satirized this approach in *Brave New World* (1932) with his state-run Conditioning Rooms and total separation between parents and children beginning before birth through the incubation of fetuses in artificial wombs.

In fact, the argument that children should be raised collectively by professionals and away from their parents was commonplace at the time. The Scottish novelist, poet, and feminist Naomi Mitchison wrote in her 1934 book *The Home*: "We must only observe the small nurseries, the crèches and nursery schools, which are gradually spreading among the intelligent of all classes, and which means that the children as well as the parents are getting out of the home, out of the small and now diminishing family into the great world of group play and group action."[28] In England, nursery schools had emerged during the Industrial Revolution to care for the children of the working poor, but they were new among the middle and upper classes.[29] Institutions and regulations pertaining to children proliferated in the period; in England legislation created mater-nity and infant welfare centers and sent the first "health visitors" into homes. The United States Children's Bureau, founded in 1912, and the Sheppard–Towner Act of 1921 provided federal funding for the welfare of women and children.

The collectivization of child care required the development of standard systems and methods. In the absence of outsourcing, Watson made a strong case for creating emotional distance between parent and child

through the elimination of displays of affection. "Never hug and kiss them," he stressed, "never let them sit in your lap."[30] Parental affection became parental indulgence; the new ideal, as Evelyn Waugh labeled it, was the "matter-of-fact mother of the new age."[31] For behaviorists, routine was paramount: Truby King, founder of Mothercraft, argued that perfect conformity to a set schedule of eating and sleeping was the basis for creating an obedient child. And not merely obedient, as argued in Newton Kugelmass's 1935 work, *Growing Superior Children*. This vision for child-rearing was both pervasive and short-lived, its rise and decline running parallel with that of high modernism. By the end of the 1930s, these new views were already being subject to revision; in the United States the publication of Anderson and May Aldrich's *Babies are Human Beings* (1938) did much to dethrone Watson.

Alongside behaviorism came a developmental approach to understanding children's growth. Though the idea of human development was not new, it was only now that psychologists and child experts articulated a scientific framework for assessing children's progress.[32] For the first time, benchmarks or "milestones" (which implicitly compared children to vehicles moving along a highway) were standardized and applied to all children. Milestones could be highly specific; at twelve months, for example, a child should weigh twenty-two pounds, have six teeth, and attempt to walk.[33] Freud's influence was discernible, with his notion of sexual development that involved passage through several distinct stages on the way to maturity. The prototypical Freudian child, a boy, progressed sequentially through the oral and anal stages and concluded with the genital stage that indicated the attainment of normal sexual maturity. But while Freud spent almost no time with children in developing his ideas (he met with Little Hans, for instance, only once), the new developmentalists based their work on close observation of infants and children.

Arnold Gesell was among the most prominent of the "child development" experts, with publications aimed at both professionals and parents. He worked to shift the paradigm of child study from fixed to dynamic, and by 1930 he was able to proclaim that "the term *child development* has become

a rival, if not a substitute, for that of child psychology."[34] His account of the growth process is both progressive and linear, viewing milestones not as isolated events but as part of a connected sequence:

> The interludes and the transitions are all but meaningless if they are regarded as separate episodes or fortuitous variations. They have a profound logic when viewed in the continuity of the single, biographic growth career. They show that everything which the infant or child does has a functional or symptomatic significance in the economy of development. Nothing is sheer nonsense, sheer deviltry, or sheer obstinacy. Every patterned action must have a rationale in the physiology of development.[35]

Gesell's model of child development rests on a broad set of assumptions, among them the idea that development is linear and continuous, that it is uniform across healthy individuals whatever their differences, that it halts at adulthood, that it is an all-encompassing process and always beneficial, that it is punctuated by regular "milestones," that it requires conscious and careful environmental support, and more. Many of these assumptions seem to reflect the impact of modernization, most particularly the repudiation of individual difference and the characterization of development as an efficient process in which nothing is wasted. Child development may be rich in pattern and texture, but—like the Freudian psychosexual template—it also has a lockstep regularity that does not admit much variation. As with the mass-produced vehicles to which children were frequently compared, deviance from the standard could only be understood as a defect.

From a literary standpoint, Gesell's words seem to proscribe a particular plot structure. Writers depict human development through any number of trajectories, including the episodic, the circular, or the climactic, to name only a few. But Gesell's model is none of these: it describes a sustained development from birth until adulthood, one in which every detail has a significance for the pattern of the whole. It is teleological, and its conclusion consists of the subject's acquisition of independence and the ability to act as a free agent. Literature seems to have provided the conceptual vocabulary for Gesell to imagine and describe the trajectory of children's

growth. He relies specifically on concepts of genre and narrative structure to explain development's course, choosing words including "interludes," "episodes," and "biographic." Gesell's ambitious claim that every human action is integral to the individual's plot (again seemingly also influenced by Freudian theories of everyday life) sustains a Flaubertian level of patterning and design that would almost seem to require an author behind the scenes. Gesell models the psychologist as literary critic; any given life has a "profound logic" and if we read closely, we will see the grand design begin to emerge.[36]

Gesell's statements about the universality, strife, and stages of child development are reminiscent of the structure of the nineteenth-century *Bildungsroman*, the novel of development that, in its most well-known form, follows a young person from birth through a series of trials and formative experiences, concluding with the attainment of maturity and prosperity.[37] Scholars who study the form generally understand its emergence in relation to historical events and philosophical currents: to the French Revolution; to Enlightenment ideas about the perpetuity of human progress; and to Romantic views of childhood and creativity.[38] As in the case of the *Bildungsroman*, Gesell's account of human development is linear, teleological, periodic, and directed toward a clear endpoint. There are differences as well: in the *Bildungsroman*, experience leads to development, whereas for Gesell stages of development are innate in the normal child. In the *Bildungsroman*, the subject is relatively autonomous, guided by advisors but not controlled by them. For Gesell, on the other hand, the role of the child's caretaker is critical in sustaining development. Overall, though, the overlap between literary and scientific imaginations is considerable.

Narratives of development are commonly but not exclusively associated with the *Bildungsroman*. I invoke the form in this chapter as an abstract ideal rather than as a format realized with exactness in any particular text.[39] Every critic who works on the *Bildungsroman* pauses at some point to offer the disclaimer that there is no novel that realizes all the putative aspects of the form. It is worth pausing to consider how this genre seems to generate a Platonic ideal of itself, or as Esty puts it, "why a phantom

genre is such a recurrent object of theoretical desire."[40] I think this idealizing is in part a product of the depiction of development as striving rather than as an unmotivated or automatic process like, for instance, the way we might describe the development of a caterpillar into a butterfly. Viewing human development as achieved through dedicated striving is so naturalized that it is hard to see this depiction as a narratological effect, but modernist writers did not universally concur that striving was a necessary feature of education and growth. Franz Kafka advises in an aphorism that

> It isn't necessary that you leave home. Sit at your desk and listen. Don't even listen, just wait. Don't wait, be still and alone. The whole world will offer itself to you to be unmasked, it can do no other, it will writhe before you in ecstasy.[41]

For Kafka, you need not work to ready yourself to join the world; it will come to you regardless. By contrast, the *Bildungsroman* is marked by the representation of development through purposeful endeavor as much or more than the passage through a prescribed set of incremental stages.

The rise of scientific approaches to child development like Gesell's was coincident with the changes in the *Bildungsroman* wrought by its modernist adopters. Modernist writers sometimes initially invoke the genre or assemble its ingredients, only to veer off into another direction entirely. "The aim of life is self-development," Lord Henry tells the young and naïve Dorian Gray.[42] But it is Dorian's portrait, rather than the boy himself, that undergoes a developmental process. If the *Bildungsroman* showed how wayward youth could lead to mature adulthood, modernist works became preoccupied with the ways development could stall or go awry.[43] In breaking with the *Bildungsroman*, modernist narratives went awry themselves, with plots that did not seem to progress or mature, or at least not in a linear fashion. Jed Esty has coined the term "anti-developmental fictions" to describe in particular the numerous modernist texts in which the protagonists simply do not grow up, as is the case in Joseph Conrad's *Lord Jim* (1900) and Joyce's *Portrait of the Artist as a Young Man* (1916). These characters, Esty writes, "cast

doubt on the ideology of progress through the figure of stunted youth or perpetual adolescence."[44]

For Esty, colonial modernity undermines the *Bildungsroman*'s easy faith in the ongoing expansion of national capitalism and national culture. The harsh and uneven developmental logic of imperialism finds a counterpart in "a non-teleological model of subject formation" that, over time, becomes a signal feature of literary modernism.[45] Esty allows that modernist narrative experimentation is not actuated solely by colonial problematics and, indeed, other critics have offered different explanations; for Peter Brooks, to take one example, the shift away from structured and linear plotting is not historically motivated but rather a cyclical swing of the pendulum in the history of narrative: "With the advent of Modernism came an era of suspicion toward plot, engendered perhaps by an over-elaboration of and overdependence on plots in the nineteenth century."[46] Too much plot succeeds too little.

For Franco Moretti, on the other hand, the dismantling of the European *Bildungsroman* was well underway in the first decades of the twentieth century, but grew after the onset of World War I: "If one wonders about the disappearance of the novel of youth, then, the youth of 1919—maimed, shocked, speechless, decimated—provide quite a clear answer."[47] Moretti interprets the late *Bildungsroman* to entail something like a reversal of the form, yielding narratives of degeneration. "The relevant symbolic process," he argues, "is no longer growth but regression."[48] Whether through the war or another source, the *Bildungsroman* of this period represents experience as traumatic rather than educative or productive of individual growth.

In prizing apart the complex tangle of influences that led to the replacement of the *Bildungsroman*'s historical positivism with modernism's non-teleological narratives, these accounts complement rather than obviate one another. War, empire, trauma: Esty and Moretti's causative agents are well-known specters of modernity and strong candidates if we seek to enumerate the political forces and events that shape modernist narrative practices.

Yet insofar as literary-historical theories have been drawn to allegories of nation-building and international relations, they often exclude the

aesthetically generative role of domestic life. Private life does not simply register and react to the impact of outsize political forces; it also generates narratives of its own that ripple outward. In the case of the early twentieth-century emergence of developmental psychology, the affinity between literary and scientific discourses seems almost intuitive. Psychology and literature, from early sexological studies onward, had free exchange. Prominent scientific discourses of mental life inform literary method, and similarly Freud and some of his successors draw models from literature. This symbiosis continues today, as literary critics attend to current research in neuroscience, and fields like narrative medicine take literary depictions of mental suffering and turn them to account.

Accordingly, modernism's innovative language of development, its articulation of diverse developmental trajectories, and its parodic or subversive reproduction of more conventional developmental tropes seem connected in a variety of ways to the discourse of developmental psychology with which modernism shares its historical moment. An even more expanded historical frame could characterize the *Bildungsroman* itself as an artifact of post-Enlightenment views of human development.

I am less interested in showing a deterministic relationship between developmental psychology and modernist fiction than in assessing what explanatory value may lie in exploring the relationship of reciprocity between them.[49] The most tendentious (or biographical) formulation of my claim would argue that modernist writers' dismantling of the narrative of linear development is a kind of response to the universalism of the directives issued by the new childhood experts. A more nuanced version would suggest that modernist developmental narratives take part in the controversial early twentieth-century cultural conversation about how children do and do not grow up. Modernist variations on the theme of the *Bildungsroman*, in this latter account, are shaped by the institutionalization of child development in myriad ways. These narratives register, either through critique or imagined alternatives, the effects of living in a world where human development is understood to be both linear and uniform, and in which individuals must perform the

incremental steps of development in a particular time sequence or risk correction.

Modernist bellyaching over the processes of modernization is a familiar refrain, both in this book and elsewhere. The case of modernist response to child development has some unique features, however. Firstly, if the modernists generally found themselves on the losing side of the argument in their opposition to technology, in the case of child development their judgment has been affirmed by historians who find in Watson and his peers a particularly low moment in the history of experts on childhood. Additionally, the pronounced narrative qualities of developmental psychology create unusual possibilities for a direct and reciprocal exchange between literary and scientific discourses. The debate over how children grow up is readily cast as a narratological discussion. Rather than reduce the case of child development to another anti-modernity moment in literary history, I think we have the opportunity to examine the ways in which modernism—despite its reputation for elitism and autonomy— takes an important role in shaping a widespread debate about the meaning of human development and how best to support it.

What is development, in life or in the novel? In its starkest form, it is simply change over time. This is a formula that, if released from a linear mold, yields unlimited possibilities. I think we can understand modernist "anti-developmental fictions" (to continue Esty's phrase) in part as a rejection of the linear and progressive narrative of development broadly utilized to characterize human growth. Thus the wayward youths who populate modernist texts can be seen not only as melancholy artifacts of a barren modernity but also as markers of the myriad experimental narrative constructions of literary modernism. Modernism reflects the belief that modern children can no longer grow up in the same way as their predecessors. Modernist approaches to the *Bildungsroman* both resist the teleologies of narrative or psychological templates and express an atypical and putatively unique journey of individual growth. In other words, the modernist *Bildungsroman* gives form to an idea that might be understood to detour from its generic path: that *Bildung* is heterogeneous and cannot be made to fit the

constraints of any master narrative. For Joyce's Stephen Dedalus, the goal of development is "to express myself in some mode of life or art as freely as I can and as wholly as I can."[50] An infinitely variable self-expression rather than any universal marker (e.g. graduation, marriage, acquiring a home) is the stuff of development.

In rendering the teleological narrative of human growth as both singular and hegemonic, by contrast, child development experts went even further than Victorian writers in their commitment to a unified and progressive narrative form.[51] The nineteenth-century *Bildungsroman* offered a largely linear narrative, but it did not universalize this narrative or stipulate that deviation from the path of *Bildung* by any character was degenerate or morbid, as Freud and his successors would do. Developmental psychologists like Gesell designed lists of age-associated characteristics that were designed in part to separate out those who deviated from the normative timetable.[52] "Both benign and serious behavior deviations demand interpretation and treatment," Gesell mandated.[53] Perhaps inevitably, Esty and Moretti reproduce the disapproving discourse of normativity in their characterization of modernist narrative: Esty calls it "stunted" and Moretti dubs it "regressive." In the case of the latter, it is interesting to note that the *Oxford English Dictionary* ascribes the first use of "regression" in a psychological context to a 1910 translation of Freud: "The flight from the unsatisfying reality into what we call…disease…takes place over the path of regression."[54] Freud maintains that to stray from the path of normative development is to enter the realm of pathology; Esty and Moretti adopt this position as well.

My point is certainly not to dismiss either Moretti's or Esty's insightful and creative analyses of the nineteenth- and twentieth-century *Bildungsroman*. But an identification of the modernist *Bildungsroman* as "stunted" or "regressive" must rely on the historically specific psychological judgment that more linear and progressive narratives like the nineteenth-century *Bildungsroman* are healthful and the anti-developmental narratives of modernism are traumatized or pathological. In some cases, characters in modern fiction support this association: Stephen Gordon, in *The Well of*

Loneliness affirms the medical opinion that her sexual inversion is innate and sees herself as "maimed, hideously maimed and ugly."[55] The little boy Guido in *Nightwood* is described as "mentally deficient and emotionally excessive, an addict to death; at ten, barely as tall as a child of six."[56] In the judgment of the novel's Dr. Matthew O'Connor, Guido is "maladjusted." In the case of *The Well*, with its approving preface from psychologist Havelock Ellis, the distance between textual representation and psychological influence is particularly short. This novel explicitly imagines departures from normative development as pathological because Freudian and many post-Freudian development models say so; in *Nightwood*, too, it is a doctor who pronounces on Guido's strangeness. Rather than reproduce these value-laden assessments, we might look critically at how the emerging ideas of developmental psychology inform modernist narratives while downplaying psychology's harsh judgment on deviance. I am not suggesting a rejection of coercive psychological norms from a liberal standpoint, but rather as a way to assess modernist reconfigurations of the arc of human development without imposing judgments.

Modernist narrative seems to reject the linear and normative chronology of developmentalism in a range of ways, some of which are described in the psychological literature and many of which exceed that lexicon (as well fiction might). The terms "regression" and "stunted" both present specific ways of looking at stages of development; in the former the developmental clock runs backward and in the latter it stops prematurely. The complex time of modernist narrative might be seen as developmental time gone awry. And it is important to note that it goes awry in almost infinitely many ways, because merely to substitute the regressive for the teleological misses the point of the substitution, which is to challenge the idea that the education and development of an individual can only proceed in a single manner.

The annals of modern fiction register a range of non-linear developmental schema: Esty mentions metamorphosis (exemplified by Kafka), dilation (Proust), truncation (Wilde's Dorian Gray), consumption (Mann's Hans Castorp), and inversion (Kipling's Kim).[57] We might expand this catalogue

even farther and invoke the jagged trajectory of Hardy's Jude, the errant course of James's Lambert Strether, the reversed course of Fitzgerald's Benjamin Button, the oscillation of May Sinclair's Mary Oliver, the triangulation of Lawrence's Paul Morel, and the uneven and unending progression of Woolf's Clarissa Dalloway. Indeed, although we can discern some broad categories, like the frozen development described by Esty, in many ways each modernist *Bildungsroman* invents its own substitute for linear development.

In the modernist rejection of the more linear plot of the *Bildungsroman* we can discern an examination of both the idea of human normativity and the idea of development as striving that together underwrote theories of child development at the time. Fitzgerald explicitly mocks models of the discourse of childhood development when he writes of his backward-aging protagonist that, "Of the life of Benjamin Button between his twelfth and twenty-first year I intend to say little. Suffice to record that they were years of normal ungrowth."[58] Benjamin dies when, after seventy years, he finally reaches infancy. At the end of *Sons and Lovers*, Paul Morel blends characteristics of both child and adult, crying for his mother on the one hand and, on the other, turned toward the allurements of the modern city, associated with possibility and change.[59] Woolf's *Mrs. Dalloway* challenges the concept that development ends with the attainment of adulthood by showing us profound personal change in a woman in her fifties. Woolf makes clear that Clarissa's growth is not a result of striving but rather an unexpected gift that comes to her when she learns of the suicide of Septimus Smith.

* * *

To examine in greater detail the ways in which novelists critiqued mainstream developmental narratives by reworking the *Bildungsroman*, I turn to the work of Aldous Huxley and in particular to his best known novel, *Brave New World*. Huxley is both an obvious choice for this study and a surprising one. Obvious, because of his many novels concerned with human development on both an individual and species level, and his prominent status as an engaged intellectual and social critic of institutions. Huxley's

attraction to the novel of ideas and his extensive commentary on education in his time provide a prominent critique of developmental psychology articulated through storytelling, through the formal features of his novels, and through didactic interventions. Although many of Huxley's contemporaries wrote in ways that show the imprint of developmental psychology, it is Huxley who was deeply preoccupied with the topic throughout his work, making him a good candidate for an in-depth exploration of how modernist stories of development engage with their psychologist counterparts.

If Huxley seems a surprising choice here, it is perhaps because of his oscillating position in modernist studies. In the 1920s, Huxley's reputation as the leading literary light of the time surpassed even that of T. S. Eliot. Since then, he has come to occupy a lesser role. However, it does seem that scholars—perhaps in the wake of the publication of Huxley's *Complete Essays*—are again taking Huxley seriously as an intellectual figure and novelist. Laura Frost has recently identified Huxley as a key voice in early cinema, while David Garrett Izzo recently judged *Brave New World* "perhaps the most influential novel of the twentieth century," with an impact that is "not exclusively literary."[60] Huxley's fiction, like that of George Orwell and E. M. Forster, is often held apart from that of more technically innovative writers like Woolf and Joyce—despite Huxley's forays into experimental form in novels like *Point Counter Point* (1928) and *Eyeless in Gaza* (1936). While the modernist canon has expanded far beyond formalist definitions, perhaps Huxley is sometimes segregated precisely because he was reluctant to think of himself as part of a literary movement.[61] But Huxley's concern with human development was very close to that of many of his writing contemporaries.

In the readings that follow, I examine nonlinear human development in allegorical relation to plot structure and show how the shape of Huxley's narratives breaks with that of the traditional *Bildungsroman* in favor of a range of developmental narrative arcs. In both his fictional and nonfiction writing, Huxley is frequently preoccupied with human development and its response to the conditions of modernity. Huxley studied national trends in

education and bemoaned the uniform way in which children were treated. It is a fallacy, he argued, "that all minds are alike and can profit by the same system of training."[62] Huxley was explicitly critical of Watson and the behaviorist belief that individuals were totally malleable. He believed, despite the best attempts of an inflexible and dictatorial system to determine individuals, that human nature would reassert itself. Human nature was infinitely variable and largely resistant to both linear development and coercive norming.[63] For Huxley, individual difference was enormous and of primary importance; accordingly, he called for "a system of individual education."[64] Huxley's novels, as much or more than his reviews and essays, were a place for him to develop his ideas about human development. Many of his novels featured individuals who, for a variety of reasons, stepped off the normative path.

The problem of stalled or stopped personal growth is prominent in Huxley's best known novel *Brave New World* (1932), a work that offers a broad satire of the modernization of child care. *Brave New World* takes contemporaneous theories of child-rearing and child development to an extreme. The transfer of modern industrial practices into the domestic sphere is translated by Huxley into the literal production of children on an assembly line. The outsourcing of child care to professionals, in Huxley's hands, yields a society where parents do not know their children, who are born and reared en masse in "Hatchery and Conditioning Centres." Watsonian behaviorism runs rampant in these centers, where conditioning begins before birth and children learn advantageous consumer practices using negative reinforcements like electric shocks. The new emphasis on child development is represented here as the promotion of a permanent infantilism that fits the paternalistic world government. As Bernard Marx explains about the citizens of this new world, they are "'Adults intellectually and during working hours,'" and "'Infants where feeling and desire are concerned.'"[65] Behavioral norms are strictly enforced; when one young boy resists participating in "the ordinary erotic play," he is separated from the group and taken to see the Assistant Superintendent of Psychology, "just to see if anything's at all abnormal" (32). Huxley's rational children

have no ideas or feelings beyond what the state has poured into them. Even as adults, they have no individual identities or personalities and remain perpetually infantile, seeking only immediate sensory gratification. Their infantilism is characterized by a behaviorally conditioned acceptance of everything civilization provides; this lack of independent judgment, together with a mandated self-indulgence, prevents development from occurring.

Against the background of this damning critique of contemporary child-rearing, *Brave New World* presents the story of a young man growing up and making his way, a story of *Bildung*. John, whose mother Linda is accidentally stranded on an atavistic Savage Reservation where she gives birth to him the old-fashioned way, is a likely subject for a *Bildung* plot and his story illustrates many of the conventional elements of the genre: an account of childhood, an inter-generational saga, a journey from provincial origins to city life, a transformative love affair, and a pervasive sense of alienation. John is an extreme example of the *Bildungsroman*'s naïve young man from the provinces who craves experience. The fact that the novel concludes with John's death also suggests that John's journey is at the story's heart. John yearns for the growth brought by experience but he is very much one of the Peter Pan figures who appear frequently in Huxley's work, blocked from maturing into adulthood. Excluded from the reservation's tribal initiation rituals surrounding male puberty because of his origins, he tries to recreate the rituals on his own. When Bernard first meets him, John is frustrated because he has once again been shut out of the reservation's cultural ceremonies that would allow him "'to show that I'm a man'" (117). At least on the Savage Reservation where he is born and raised, John is not allowed to grow up.

His subsequent journey displays development, though not of a progressive type. Bernard's invitation to leave the reservation for the "civilized" world delights John. The expedition is couched as a social experiment, with Bernard dispatching intermittent reports on John's experiences to the World Controller, Mustapha Mond. The experiment mandates that John see as much of the modern world as possible: he tours a factory, goes to the

feelies, visits a school, and attends parties (hosted by Bernard) and crowded with the ranks of the socially prominent who are all eager to meet him. Initially, Bernard writes to the World Controller, "'The Savage...shows surprisingly little astonishment at, or awe of, civilized inventions'" (158). At first, John takes it all in passively, though he does have a visceral and strongly negative response when he encounters identical sets of twins performing identical tasks at the factory. But mostly he displays latency: blankness, confusion, and groping for guiding moral principles.

Clarity and action arrive during a visit to the facility housing his dying mother, Linda. Upon her return to the modern world, Linda is overjoyed to once again have all the modern comforts and in particular *soma*, the euphoric drug that is used to soothe over any difficulty or unpleasantness in modern civilization. She takes the drug in ever-increasing quantities until she dies from respiratory failure. John is overwhelmed by guilt at her death; when he leaves the building and sees the *soma* ration being distributed to masses of engineered twins, he suddenly sees a way to do for them what he could not do for Linda. "A reparation, a duty," he thinks. "And suddenly it was luminously clear to the Savage what he must do; it was as though a shutter had been opened, a curtain drawn back" (210). In the familiar lexicon of modernist thought, John undergoes an epiphany. He realizes he must remove the twins' dependency on the drug that killed his mother. He could not save *her*, but he can perhaps save *them*.

In rescuing the twins, he also sees a way to finally claim his manhood. John's guilt over his feeling of ruining his mother's life motivates his desire to rescue her. "'If it hadn't been for you,'" she tells him when he is a child, "'I might have got away. But not with a baby. That would have been too shameful'" (127). According to this logic, he trapped her on the reservation but can set her (or her substitutes, the twins) free from a dependence on this repugnant civilization. By saving her now, he can redress the harm he has unwittingly done to her and free himself to go forward to maturity. He can break out of his latency and ascend to manhood. His exhortations to the crowd of twins ("'Don't you want to be free and men? Don't you even understand what manhood and freedom are?'" (213)) would seem to also be

directed at himself. The value he places on "being a man" in this scene recalls his early frustration at being excluded from rituals that would allow him to develop and demonstrate his manhood on the reservation. As he fends off attackers he joyously proclaims, "Men at last!" (213).

But "maturity" continues to elude John. In the paradigm of his intense Oedipal guilt and rage, growth would mean setting aside his mother as a primary object and taking up with the woman he desires, Lenina. John attempts to demonstrate his new "adult" independence by running away from the parental protection of civilization and living without any of its conveniences, but his overwhelming guilt around his mother endures and grows; he feels he must atone for his "murderous unkindness" (247) to Linda. His loyalty to his mother after her death and at the expense of all else are, in the Freudian terms Huxley would seem to be explicitly deploying, a symptom of John's prolonged Oedipal drama. He idolizes his mother and considers the woman he loves to be a whore. His eventual suicide dramatizes the tensions that divide him, as his swinging feet post-hanging twist in different directions: "north, north-east, east, south-east, south," and so forth (259).

Why does John die a Peter Pan, unable to complete his Oedipal separation from his mother? The costs of reaching maturity in *Brave New World* are very high, indicating a basic incompatibility between maturity and modernity. Individuals in this society who demonstrate growth and do not display the infantilism expected of adults are transported to distant islands. Parenthood, the sequel to the attainment of adult sexuality, is forbidden. There is Linda, who believes motherhood ruined her, and the World Controller Mustapha Mond who, to take on his paternal role as head of state, had to renounce the creative scientific work that was most dear to him. Attaining any form of adulthood means leaving the community.

If *Brave New World* cannot accommodate a traditional tale of *Bildung* it does show us a youth grasping for growth in a world designed to preclude it. The very arc of John's story, which does not begin until almost halfway through the novel, shows the effects of growth suppression (a narrative form of the stunting drugs used in the novel on individuals

slated for lower-caste status). John does exhibit growth, moving from the childish latency of his life on the reservation into a rebellious adolescence. His suicide is the act of an angry and self-loathing teenager. For John, the experience of extreme difference (he is unique both on the reservation and in the modern world), a rebellious insistence on exercising judgment (as when he refuses to attend Bernard's party or tells Mustapha Mond that he wants to be unhappy), and self-mutilating practices are signs that, unlike the typical infantile citizen of civilization, he is adolescent. His impulse is for growth; he asks to be able to go and live on an island with the other social non-conformists developing according to their individual inclinations, but is refused.

Huxley is a didactic novelist. There are a number of lessons he wants to teach us in *Brave New World*—about the moral dangers of civilization's new pleasures, about the inevitable decline of art and culture in a world where the living is too easy, about the costs and benefits of eugenics. But in his novels following *Brave New World*, the dilemmas of human development in the modern era were what continued to preoccupy him. In John, he gives us a character whose every path toward development seems blocked—by the racist discrimination of the Indians on the pueblo, by his intransigent Oedipal fixation, but perhaps most of all by society's failure to give this bright young man the requisite set of trials and quests through which to locate and cultivate his latent manhood. John is thrilled with the "brave new world," but nothing he finds there exerts a maturing influence. "Our Ford loved infants," Lenina intones to Bernard (94). It seems as though the symbol of this society is the image with which the novel opens—the assembly line: repetition without change, without development.

A number of Huxley's post-*Brave New World* novels continue to focus on questions of human development, some even more explicitly. *After Many a Summer* (1939) takes as its subject individuals who refuse to keep to the schedule of normative development.[66] The story's plot focuses on Jo Stoyte, a wealthy man who is determined to find a scientific method to prevent and reverse aging. When a method involving the consumption of carp guts arrives, he seizes on it, even though it means that as time goes on he will turn into an ape. This conceit suggests that humans are neotenous,

developmentally stalled in an immature state that has a simian form as its natural endpoint. One of his characters explains the concept earlier in the novel: "A dog's a wolf that hasn't fully developed. It's more like the foetus of a wolf than an adult wolf; isn't that so?"[67] The developmental journey can cease at any time, a stoppage that does not mean development has been arrested in a pathological fashion; rather, the stoppage prevents a human from becoming an ape, or a dog a wolf. Stoyte himself appears to counter the idea that development is a linear process that begins in infancy and concludes in maturity; he is said to contain a "curiously perverse contrast between childishness and maturity".[68] If so-called "early" and "late" stages in development can coincide in an individual, they can hardly represent the beginning and ending of a linear process.

A further critique of the exclusivity and virtue of linear development appears in *After Many a Summer* in the character of the scholar Jeremy Pordage, who in middle-age is still unmarried and lives with his mother. Jeremy ponders the fact that despite all his and his mother's knowledge of "the Oedipus business, all the novels, from 'Sons and Lovers' downwards, about the dangers of too much filial devotion, the menace of excessive maternal love," he and his mother continue in a relationship of profound, mutual, and exclusive attachment that is pleasurable to them both.[69] Jeremy reasons that his domestic arrangement has multiple virtues. It frees him to pursue the scholarship he enjoys, while his brother Tom, who left home and married, finds himself driven by the need for income to support his family by doing the government's dirty work in the Foreign Office. As Tom's salary rises, the immorality of his work correspondingly sinks, until he cannot stand it anymore and his health suffers. Normative development—independence, a wife and children—rather than making the individual an asset to society, effectively leads him to exploit his fellows. Jeremy's refusal to take this path is morally preferable and he sets aside the *Bildungsroman*'s credo of striving: "There was really no reason why one should do anything much about anything."[70] In this context, as in *Brave New World*, being "normal"—that is, displaying, in appropriate sequence and timing, the normative behaviors promoted and sanctioned by social

institutions, leads to ethical transgression. Opting out of normativity is a kind of civil disobedience.

Peter Pan, for Huxley, is the perfect symbol of the willful and—at least in some spheres—desirable choice to step off the developmental track. Jeremy embraces this model: "Better Peter Pan and apron strings...better a thousand times" than pursuing, like his brother, normative adulthood.[71] In his subsequent novel *Time Must Have a Stop* (1944), Huxley invokes Peter Pan to symbolize the pursuit to stop time: "in an age that had invented Peter Pan and raised the monstrosity of arrested development to the rank of an ideal, he wasn't in any way exceptional. The world was full of septuagenarians playing at being in their thirties or even in their teens..."[72] The Peter Pan syndrome is a feature of the modern age, a connection that recurs in numerous Huxley novels, always with the same emphases. In *Point Counter Point* (1947), a character explains about another, "'He's never grown up. Can't you see that? He's a permanent adolescent...It's deplorable. The man's a sort of Peter Pan—much worse even than Barrie's disgusting little abortion, because he's got stuck at a sillier age.'"[73] And in the late novel *Island* (1962) we meet a doctor who has devoted himself to preventing the formation of Peter Pans, whom he regards as delinquents in the making. He gives them prophylactic medical treatment and scorns the contemporary development experts who utilize psychological approaches: "Most of my experts assured me that...[i]t was all a matter of mothers and toilet training, of early conditioning and traumatic environments." Instead, the doctor counsels, "For Peter-Panic delinquency, what you need is early diagnosis and three pink capsules a day before meals."[74] Modernity produces Peter Pans but the Freudian and behaviorist theories of the age are useless as cures for the syndrome.

In *Brave New World*, as in many of his other works, Huxley rejects the idea of norming and prefers outliers—even Peter Pans—to those who conform or cluster around fixed standards for behavior. Individual self-realization will never come about through the inculcation of Pavlovian reflexes, nor can the ends of development be known in advance of the process. Moreover, he also sets aside the presumption that development is effortful and

takes place through outward striving. As Anthony claims in *Eyeless in Gaza,* "'Who tells you I want to achieve anything?...I don't. I want to *be,* completely. And I want to *know*.'"[75] This novel undermines any simple idea of linear progression by repeatedly cutting back and forth in time, tangling episodes and giving the impression that different historical moments actually coexist.

Huxley might at first glance appear to offer a straightforward instance of the claims about modernist children with which I began. His novels are either child-free or filled with dreadful children, like the engineered twins who despoil the death of Linda, John's mother, in *Brave New World.* A closer reading suggests that these children are themselves corrupted by a matrix of child-rearing processes that insists on standardizing every aspect of child development, the better to control the child and curtail his outcomes. Huxley's novels, in this reading are not "bad for children"; rather, modern life is bad for children and Huxley defends children by dramatizing their plight. Huxley shares a belief with Watson that children can be readily molded, but where Watson sees this process as aimed toward the social good, Huxley sees it as an act of violence that only cripples the child. Education that seeks to enforce norms is, for Huxley, always destructive, and he faults education, not children.

What is true for Huxley seems equally true for many of the writers I mentioned at the outset: though their works have been characterized, taken together, as uninterested in or hostile to children, it is the contemporary practice of child-raising that is the real target of their disdain. Returning to some of the modernist "problem children" with which I began, we typically find the authors of these creations placing the burden of guilt on the circumstances of the upbringing, rather than on some inborn quality. In Lawrence's "England, My England" the child Joyce is born perfect, "a little mite with the white, slim, beautiful limbs of its father, and as it grew up the dancing, dainty movement of a wild little daisy-spirit," but she becomes deformed after she cuts herself on a sickle her father has left lying in the grass.[76] For Hardy, the strange, suicidal Little Father Time is a product of "new views of life." Certainly, in *Brave New World* the

lower-caste hordes of identical twins and the higher-caste children who are sent to the doctor if they do not engage in erotic play are all very much products (in the most explicit sense of the word) of the culture that has spawned and reared them.

If we take up the idea that modernist literature is not opposed to children but rather opposed to child psychology, we are better able to come to terms with what has been something of an unmentionable in modernist studies—the extensive body of children's literature produced by writers who were putatively uninterested in children. I began this chapter by asking if we might find a way to do more than set modernist children's literature aside as either an anomaly or an insignificant phenomenon. The observation of the paucity of critical attention given to this body of work is not new. "Reviewing the library stacks and online databases," as Karin Westman has written, "we find little discussion of the relationship between the two terms *children's literature* and *modernism*."[77]

Whatever the reasons behind the critical neglect of this body of work by modernist writers, I would suggest that we have something to learn from these texts, especially insofar as they tend to disrupt some received ideas about modernist literature. In literary studies, arguments for the reclamation of neglected texts tend to arise from archival research (a previously undiscovered text emerges), from identity politics (an author is a member of a group whose works have been subject to collective neglect), or from aesthetic claims (a book that has been dismissed by critics is resuscitated). With children's books by modernist writers, we would seem to be facing a different scenario—a body of work that does not seem to conform to some of our precepts about modernism. As the scope of modernist studies continues to enlarge, however, there may be space for a reconsideration of these texts. In that spirit, I will conclude this chapter with a brief look at how children's literature by modernist authors extends our understanding of the trajectories of individual development in modernist literature.

* * *

Aldous Huxley had a reasonable respect for children as readers. In his 1929 essay for *Vanity Fair*, "The Critic in the Crib," he wrote:

> I never knew a child who did not loathe the imbecile condescension of the people who pretend, when they write for children, to be stupider and sillier even than they really are. The sort of tripe which, to sentimental grown-ups, seems too sweetly childish, strikes children as being the most detestable rubbish. In this their taste is entirely sound.[78]

There is little that is sentimental in Huxley's children's book, *The Crows of Pearblossom*, written in 1944 for his niece Olivia de Haulleville, though not published until 1967. Written during wartime, this is a dark tale of suffering, malice, and revenge. Two crows find their efforts to reproduce thwarted by a rattlesnake who each day eats the egg laid by Mrs. Crow. To stop the snake, Mr. Crow consults with an owl, who helps him to create two sham eggs of clay. After eating the clay the snake dies in agony, whereupon the crows succeed in hatching their eggs and raising a family—four nests of seventeen baby birds apiece.

The villain of this piece is the snake, who personifies the danger of giving way to your every desire. The snake is a creature of selfish need; he sleeps around the clock, awakening only to slither up the tree and eat another egg. After swallowing an egg, the snake glories in his own inutility, singing, "I cannot fly—I have no wings; I cannot run—I have no legs; but I can creep where the black bird sings and eat her speckled eggs, ha, ha, and eat her speckled eggs."[79] As is the case with so many of the cases we have considered, the snake's churlishness is ascribed not to a fundamentally bad nature but rather to his poor rearing, as we are told that "his mother had neglected his education and he had very bad manners."

The climax of the tale is the snake's painful death after eating the clay eggs, which the text presents as a purple spectacle to pleasure the reader. The extended description of the death throes reads, in part,

> All at once [the snake] began to have the most frightful stomach ache. "Ow," he said. "ooh, aie, eeh." But the stomach ache only got worse and worse.

> "Ow, ooh, aie." Mr. Snake began to writhe and wriggle and twist and turn. And he twisted and turned so much that without knowing what he was doing he tied his neck in a running bowline knot around a branch and couldn't get loose again.[80]

Eventually, the snake's acute pain leads him to tie himself to the tree at both ends. He dies, crucified, and Mrs. Crow proceeds to use his corpse as a clothesline on which she hangs the diapers she is now busy laundering.

The spectacle of the snake's suffering, followed by his hamstrung death, recalls the similar fate faced by John at the end of *Brave New World*, in which John too suffers before the fascinated gaze of the crowd and ends by hanging himself. Huxley's choice to conclude such disparate works as *Brave New World* and *The Crows of Pearblossom* with a hanging is notable. The parallel speaks to his conviction that stalled development—eggs that cannot hatch in *Crows of Pearblossom*, children who cannot grow up in *Brave New World*—precipitates appalling indifference to the pain of others—the crowd that laughs as John whips himself, the crows' indifference as the snake dies in agony—and ends in blood sacrifice. The animating anxiety of both books is reproductive: *Brave New World* begins with the famous scenario of babies being manufactured on an assembly line and *Crows* with Mrs. Crow's discovery that her cherished eggs are disappearing into the snake's gullet.

My point here is not to argue that *The Crows of Pearblossom* deserves pride of place in the Huxley canon, but rather to question the common assumption that modernist literature is broadly anti-child and to suggest instead that this literature frequently works to criticize contemporary ideas about child development or child-rearing. When children are the audience, this critique sometimes unfolds through an assault on new paradigms that, in their reliance on science and rationality, can be explicitly anti-child. A striking example of this position can be found in Graham Greene's writing for children, and in particular the four picture books he produced starting in 1946.[81]

All four of these books concern modes of transportation (a steam engine, a balloon, a horse bus, a steamroller) that are becoming or are

It was called the Hygienic (which only means clean) Emporium (which only means shop) Company Limited (and that means it was owned by Sir William Popkins, who never came into the shop and never put lollipops in bags.

Figure 5.1 From Graham Greene, *The Little Horse Bus*, illus. Edward Ardizzone (1974).
© Estate of Edward Ardizzone.

already outdated. They show the human costs of innovation and argue that the old ways are the best ways and that the older equipment has a sense of responsibility and initiative that the new cannot match. In my favorite, *The Little Horse Bus*, the old-fashioned grocery store run by Mr. Potter, who gives away lollipops to children, gets into trouble when competition opens across the street (Figures 5.1 and 5.2). The new store, "a horrible shop with a horrible name," is called the Hygienic Emporium.

The Hygienic Emporium does not allow children inside and its owner "thought lollipops were cough-drops and you bought them at a druggist."[82] At first, the adults are captivated by the new rational grocery store, but through the triumphant intervention of the eponymous horse bus, they return in force to the messy Mr. Potter, who now advertises, "All sweets in stock free to children." The dirty, child-loving past has won out over the sterile and child-loathing present, at least for a while.

A third example of the association between a pro-children/anti-rationalization position can be found in a children's story by Virginia Woolf, *Nurse Lugton's Curtain*, the manuscript of which was found after Woolf's death mixed in with the manuscript of *Mrs. Dalloway*. In *Nurse Lugton's Curtain*, the strict Nurse Lugton—who is a nanny, not a hospital nurse—sits sewing a nursery curtain covered with images of animals. When she nods off by the fire, the animals hesitate, but then slowly come

Figure 5.2 From Graham Greene, *The Little Horse Bus*, illus. Dorothy Craigie (1954).
© Estate of Dorothy Craigie (presumed).

to life and begin their celebration. They consider Nurse Lugton a tyrant, but she is also their creator and "over them burnt Nurse Lugton's golden thimble like a sun."[83] While awake, she keeps fierce order among her creations, but when she sleeps her discipline relaxes and an imaginary world springs into being: "The elephants drank; and the giraffes snipped

217

off the leaves on the highest tulip trees; and the people who crossed the bridges threw bananas at them, and tossed pineapples up into the air, and beautiful golden rolls stuffed with quinces and rose leaves, for the monkeys loved them."[84] The story celebrates spontaneity, individuality, and creativity, and rejects forms of order and control. In Mrs. Dalloway, too, sewing is a valuable form of expression, and feelings are the highest good—Clarissa Dalloway is at her happiest when her emotions are unfettered, as in her youth with Sally Seton and at the end of the novel, when Septimus Smith's death somehow allows her to "feel the fun" of living.[85]

It is far beyond the scope of this chapter to encompass all children's literature by modernist writers. The relative neglect of this material strikes me as symptomatic of a mistaken assumption that modernism, to return to my initial formulation, is not good for children—excludes them, disparages them, frightens them. What we see in literary modernism is not, as Said has it, purely "a failure of the generative impulse," but rather a rejection of the rationalization of childhood, of the idea that human development is a process that can be organized by science into a linear, staged, and uniform path. What we find in modernist literature is less a rejection of childbearing than a recognition that children are radically different from one another and must be allowed to make their own ways. The relatively direct route of the subject of the ideal Bildungsroman toward maturity thus gives way to more peripatetic and convoluted paths, and to adults who refuse to "grow up" in any of the expected ways.

Notes

1. Qtd in Leonard Diepeveen, The Difficulties of Modernism (London and New York: Routledge, 2003), 257n24.
2. Tsetse Dangarembga, Nervous Conditions (New York: Seal Press, 2002), 81.
3. Edward Said, The World, The Text and The Critic (Cambridge, MA: Harvard University Press, 1983), 17. Similarly, Said observes that there is a "large group of late nineteenth- and early twentieth-century writers" who display a "failure of the generative impulse—the failure of the capacity to produce or generate children" (16).

4. D. H. Lawrence, *Lady Chatterley's Lover*, ed. Michael Squires (1928; London: Penguin, 1994), 278.

5. Said, *The World*, 17.

6. Sandra L. Beckett, *Crossover Fiction: Global and Historical Perspectives* (London and New York: Routledge, 2009), 88.

7. Hope Howell Hodgkins, "High Modernism for the Lowest: Children's Books by Woolf, Joyce, and Greene," *Children's Literature Association Quarterly* 32.4 (2007): 356.

8. See Beverly Lyon Clark, *Kiddie Lit: The Cultural Construction of Children's Literature in America* (Baltimore, MD: Johns Hopkins University Press, 2003) and Anne Lundin, *Constructing the Canon of Children's Literature* (New York: Routledge, 2004).

9. A 2007 special issue of the journal *Children's Literature Association Quarterly*, "Children's Literature and Modernism," edited by Karin Westman, is most concerned with trying to bring children's literature written during the modern period into the broader study of modernism.

10. I should clarify at the outset that my interest is not in thinking about children's literature of the 1920s and 1930s, but only those works that are "cross-overs," works by modernist writers whose main audience was adults.

11. Aldous Huxley, "Babies – State Property?" in *Aldous Huxley Complete Essays, Volume III, 1930–1935*, ed. Robert S. Baker and James Sexton (Chicago, IL: Ivan R. Dee, 2001), 231.

12. D. H. Lawrence, *Fantasia of the Unconscious and Psychoanalysis of the Unconscious* (London: Penguin, 1977), 82.

13. Thomas Hardy, *Jude the Obscure* (New York: Harper and Brothers, 1896), 400.

14. W. B. Yeats, *The Collected Poems of W.B. Yeats*, ed. Richard J. Finneran (New York: Collier Books, 1989), 215.

15. Samuel Beckett, *Molloy: A Novel*, trans. Patrick Bowles in collaboration with the author (New York: Grove Press, 1955), 195.

16. Christine Hardyment, *Dream Babies: Childcare Advice from John Locke to Gina Ford*, rev. edn (London: Frances Lincoln, 2007), 151.

17. See R. I. Woods, "Approaches to the Fertility Transition in Victorian England," *Population Studies* 41.2 (1987): 283–311.

18. Lillian Gilbreth, *The Home Maker and Her Job* (New York and London: D. Appleton & Co., 1927), 150. See also her *Living With Our Children* (New York: W. W. Norton, 1928).

19. Doris Lessing, *Under My Skin: Volume One of My Autobiography, to 1949* (New York: Harper Perennial, 1995), 5.

20. H. G. Wells, *Joan and Peter: An Education* (1918; New York: Macmillan, 1922), 27.

21. Nathan B. Giles and Dorothy G. Ellis, *Science of the Home* (London: Chapman and Hall; New York: John Wiley & Sons, 1929), 32.

22. Qtd in Daniel Beekman, *The Mechanical Child* (Westport, CT: Lawrence Hill & Company, 1977), 145–6.

23. Alice Boardman Smuts, *Science in the Service of Children, 1893–1935* (New Haven, CT and London: Yale University Press, 2006), 49.

24. Kate Kennedy, *The Science of Home-Making* (London: Thomas Nelson and Sons, n.d).

25. Beekman, *The Mechanical Child*, 113.

26. Susan Honeyman, *Elusive Childhood: Impossible Representations in Modern Fiction* (Columbus: Ohio State University Press, 2005), 81.

27. John B. Watson, *Psychological Care of Infant and Child* (New York: W. W. Norton, 1928), 38.

28. Naomi Mitchison, *The Home* (London: John Lane The Bodley Head, 1934), 89.

29. By contrast, in the United States, the first nursery schools were attached to universities and associated with research on the psychology and development of small children.

30. Watson, *Psychological Care*, 81.

31. Evelyn Waugh, "Matter-of-Fact Mothers of the New Age," *The Evening Standard*, April 8, 1929, p. 7.

32. A nineteenth-century precursor of modern developmental psychology, called Child Study, grew out of the work of Charles Darwin, who published a highly detailed account of the behavior of his own infant son in 1877. Holly Blackford looks at possible connections between Child Study and fictional methods in "Apertures in the House of Fiction: Novel Methods and Child Study, 1870–1910," *Children's Literature Association Quarterly* 32.4 (2007): 368–89.

33. Cited in Hardyment, *Dream Babies*, 153.

34. Cited in Ann Hurlbert, *Raising America: Experts, Parents, and a Century of Advice About Children* (New York: Alfred A. Knopf, 2003), 103. Italics in original.

35. Arnold Gesell and Frances Ilg, *Child Development: An Introduction to the Study of Human Growth* (New York: Harper & Brothers, 1949), 354.

36. Joseph Slaughter discusses the impact of what he terms the "discourse of development," in his account derived from international human rights law, on the postcolonial *Bildungsroman* in *Human Rights Inc.: The World Novel, Narrative Form, and International Law* (New York: Fordham University Press, 2007), 205–69.

37. This description is not meant to invoke any particular work but to recall the most prominent features of the genre. Jerome Buckley offers a longer prototypical description at the end of which he summarizes what he deems to be the "principal elements—childhood, the conflict of generations, provinciality, the larger society, self-education, alienation, ordeal by love, the search for a vocation and a working philosophy": Buckley, *Season of Youth: The Bildungsroman from Dickens to Golding* (Cambridge, MA: Harvard University Press, 1974), 18.

38. See, for instance, Susan Fraiman, *Unbecoming Women: British Women Writers and the Novel of Development* (New York: Columbia University Press, 1993).

39. As critics have pointed out, gender makes an enormous difference in the story of the *Bildungsroman*. See *The Voyage In: Fictions of Female Development*, ed. Elizabeth Abel, Marianne Hirsch, and Elizabeth Langland (Hanover and London: University Press of New England, 1983).

40. Jed Esty, "Virginia Woolf's Colony and the Adolescence of Modernist Fiction," in *Modernism and Colonialism: British and Irish Literature, 1899–1939*, ed. Richard Begam

and Michael Valdez Moses (Durham, NC and London: Duke University Press, 2007), 86.

41. Franz Kafka, *The Zürau Aphorisms*, trans. Michael Hoffman (New York: Schocken Books, 2006), 108.

42. Oscar Wilde, *The Picture of Dorian Gray*, ed. Robert Mighall (1891; London: Penguin Books, 2000), 20.

43. J. M. Barrie's Peter Pan story (1904) shows how stalled development can be corrected and its subject reintegrated into the social order. Peter, the boy who refused to grow up, allows himself to be domesticated by his foster mother, Wendy.

44. Jed Esty, "The Colonial Bildungsroman: *The Story of an African Farm* and the Ghost of Goethe," *Victorian Studies* 49. 3 (2007): 411, 412.

45. Esty, "Colonial Bildungsroman," 416. See also Jed Esty, "Virgins of Empire: *The Last September* and the Antidevelopmental Plot," *Modern Fiction Studies* 53.2 (2007): 257–75.

46. Peter Brooks, *Reading for the Plot* (New York: Alfred A. Knopf, 1984), 7. See also Gregory Castle, *Reading the Modernist* Bildungsroman (Gainesville: University Press of Florida, 2006).

47. Franco Moretti, *The Way of the World: The* Bildungsroman *in European Culture*, new edn, trans. Albert Sbragia (London and New York: Verso, 2000), 229.

48. Moretti, *The Way of the World*, 231.

49. As Esty writes, "If the conclusions I have drawn so far seem to indicate an improbably deterministic relationship between colonial conditions and modernist literature, I hasten to emphasize that my claim is neither that modernist writers were constrained by geopolitical factors to revise the traditional Bildungsroman nor that modernism's manifold experiments in the interruption of narrative flow need be understood exclusively according to the problematic of 'imperial time'": Esty, "Virginia Woolf's Colony," 84–5.

50. James Joyce, *A Portrait of the Artist as a Young Man* (1916; Harmondsworth: Penguin, 1964), 247.

51. This was not generally the case for early psychologists. Early empirical work, such as W. Preyer's *The Mind of the Child* (New York: D. Appleton, 1890) was extremely reluctant to articulate behavioral norms. "For the mental state of each man," Preyer wrote, "is so much the product of his experiences" (177).

52. "Normative summaries, in a measure, are abridged developmental schedules. They may therefore be utilized as cues for preliminary clinical orientation, and even for rough, approximate classification in cases of retardation": Arnold Gesell, *The Mental Growth of the Pre-School Child* (New York: Macmillan, 1925), 378.

53. Arnold Gesell and Frances Ilg, *Child Development: An Introduction to the Study of Human Growth* (New York: Harper & Brothers, 1949), 295.

54. "regression, n.3c." *OED Online*, Oxford University Press, June 2019, https://www.oed.com/view/Entry/161387 (accessed July 2, 2019).

55. Radclyffe Hall, *The Well of Loneliness* (1928; New York: Anchor Books, 1990), p. 204.

56. Djuna Barnes, *Nightwood* (New York: New Directions, 1937), 107.

57. Esty, "Colonial Bildungsroman," 411.

58. F. Scott Fitzgerald, *The Curious Case of Benjamin Button and Other Jazz Age Stories*, ed. Patrick O'Donnell (1920; London: Penguin, 2008), 327.

59. D. H. Lawrence, *Sons and Lovers* (1913; Oxford: Oxford University Press, 1995), 473.

60. Laura Frost, "Huxley's Feelies: The Cinema of Sensation in *Brave New World*," *Twentieth Century Literature* 52.4 (2006): 443–73; David Garrett Izzo, "Introduction," in *Huxley's* Brave New World: *Essays*, ed. Izzo and Kim Kirkpatrick (Jefferson, NC and London: McFarland & Company, 2008), 1.

61. Peter E. Firchow, "Aldous Huxley and the Modernist Canon," in *Reluctant Modernists: Aldous Huxley and Some Contemporaries*, ed. Peter Edgerly Firchow, Evelyn Scherabon Firchow, and Bernfried Nugel (Berlin: LIT Verlag, 2003), 159–78.

62. Aldous Huxley, *Aldous Huxley Complete Essays, Volume II, 1926–1929*, ed. Robert S. Baker and James Sexton (Chicago, IL: Ivan R. Dee, 2000), 198.

63. Not just humans. In 1920 Aldous's older brother Julian carried out a well-known series of experiments on a species of salamander that attained sexual maturity as a tadpole, a prime example of neoteny.

64. Huxley, *Complete Essays, Vol. II*, 203.

65. Aldous Huxley, *Brave New World* (1932; New York: Harper Perennial, 2006), 94. Further citations given parenthetically in the text.

66. In the United States the novel was published with the extended title *After Many a Summer Dies the Swan*, a more complete version of a line in Tennyson's poem "Tithonus."

67. Aldous Huxley, *After Many a Summer Dies the Swan* (New York and London: Harper & Brothers, 1939), 115.

68. Huxley, *After Many a Summer*, 51.

69. Huxley, *After Many a Summer*, 218.

70. Huxley, *After Many a Summer*, 223.

71. Huxley, *After Many a Summer*, 223.

72. Aldous Huxley, *Time Must Have a Stop* (1944; Chicago, IL: Dalkey Archive Press, 2001), 257.

73. Aldous Huxley, *Point Counter Point* (London: Chatto & Windus, 1947), 183–4.

74. Aldous Huxley, *Island* (New York: Harper and Brothers, 1962), 175, 176.

75. Aldous Huxley, *Eyeless in Gaza* (New York: Harper and Row, 1936), 90. Italics in original.

76. D. H. Lawrence, "England, My England," in *The Cambridge Edition of the Works of D. H. Lawrence: England, My England and Other Stories*, ed. Bruce Steele (Cambridge and New York: Cambridge University Press, 1990), 10.

77. Karin E. Westman, "Children's Literature and Modernism: The Space Between," *Children's Literature Association Quarterly* 32.4 (2007): 283. Italics in original. But see also Juliet Dusinberre's *Alice to the Lighthouse: Children's Books and Radical Experiments in Art* (New York: St. Martin's Press, 1987) and Peter Coveney, *The Image of Childhood*, rev. edn (New York: Penguin, 1967).

78. Aldous Huxley, "The Critic in the Crib," in *Aldous Huxley Complete Essays, Volume III, 1930–1935*, ed. Robert S. Baker and James Sexton (Chicago, IL: Ivan R. Dee, 2001), 11.

79. Aldous Huxley, *The Crows of Pearblossom* (New York: Random House, 1967). No page numbers.

80. Huxley, *Crows of Pearblossom*, n.p.

81. For more information about these books, see Brian Alderson, "The Four (Or Five?...Or Six?...Or Seven?...) Children's Books of Graham Greene," *Children's Literature in Education* 36.4 (2005): 325–42.

82. Graham Greene, *The Little Horse Bus* (Norwich: Jarrold and Sons, 1954), 5–6.

83. Virginia Woolf, "Nurse Lugton's Curtain," in *The Complete Shorter Fiction of Virginia Woolf*, ed. Susan Dick (New York: Harcourt Trade, 1999), 160.

84. Woolf, "Nurse Lugton," 161.

85. Virginia Woolf, *Mrs. Dalloway* (1925; San Diego, CA: Harcourt, 2005), 182.

6

THE HOUSE THAT VIRGINIA WOOLF BUILT (AND REBUILT)

For Virginia Woolf, books were buildings. As she wrote in, "How Should One Read A Book?"—an essay first delivered as a talk to a girls' school—"The thirty-two chapters of a novel…are an attempt to make something as formed and controlled as a building."[1] Similar analogies between books and buildings fill her diaries and essays. Her novels further signal Woolf's architectural approach to writing through their attention to particular built environments: Jacob's room, Pointz Hall, the Ramsays' summer home, and many more. When she considered the works of other writers, she did so in architectural terms; the books in question could be judged uninhabitable, as in the case of Arnold Bennett: "There is not so much as a draught between the frames of the windows, or a crack in the boards. And yet—if life should refuse to live there."[2] Or they could be harmonious structures like Jane Austen's: "when the book is finished…we see it shaped and symmetrical with dome and column complete, like *Pride and Prejudice* and *Emma*."[3] For Woolf, the relationship was an aspirational one: books sought with varying degrees of success to resemble buildings. "The whole building of a book" was what she endeavored to create.[4]

What Woolf thought books could learn from buildings, above all, was structure. She conceived the forms of her novels by imagining them in architectural terms, as in her diary in January 1920: "the approach will be entirely different this time: no scaffolding; scarcely a brick to be seen."[5] Her experiments in literary form originated in architectural analogy as she sought to derive new narrative strategies from aspects of building. Woolf's novels are each formally distinctive, foregrounding their structure. From *To*

the *Lighthouse* with its tripartite division and experimental central section to the chapterless flow of *Mrs. Dalloway* to the prominent chronology of *The Years*, Woolf wanted her readers to pay attention to her narrative organization, that is, to the architecture of each work. "Words," she wrote, were "more impalpable than bricks," but by imagining them as bricks, as physical objects that could be joined together, Woolf was able to construct organic shapes for her novels.[6] Imagining her words as bricks allowed Woolf to shift her attention from the level of ornament and detail to the expanded scale of the book/building as a whole.

Woolf's architectural endeavors, however, went considerably beyond building castles on the page. For much of her writing career, Woolf was also engaged in actual experiments in architecture at Monks House, the Sussex country home she shared with her husband Leonard Woolf from 1919 until her death in 1941. Compared with other Bloomsbury locations, Monks House has received relatively little critical attention, though scholars have noted that monks seem never to have actually lived there.[7] While the nearby Charleston, home of the painters Vanessa Bell (Virginia Woolf's sister) and Duncan Grant has come to be considered an important part of their post-Impressionist oeuvre, Monks House has received almost no critical treatment in relation to either of the Woolfs' work.[8] Christopher Reed's book *Bloomsbury Rooms* (2004) is the definitive work on Bloomsbury domesticity, yet it contains no discussion of Monks House.[9]

Monks House's lack of conspicuous allure may account for its neglect; the house is undeniably frowzy in comparison to its glamorous cousin Charleston. Monks House is also shy, open to the public for only a few hours a day, only six months of the year, while Charleston is much more welcoming to visitors. The Woolfs' house, now owned by the National Trust, is characterized in the official guidebook as a "welcome country retreat," suggesting a place for withdrawal, contemplation, and stasis.[10] This description is supported by the house's location in the village of Rodmell, which, though only forty-seven miles from London, possesses only a single street and in 1931, when the Woolfs were in residence, numbered 244 inhabitants (Figures 6.1 and 6.2).[11]

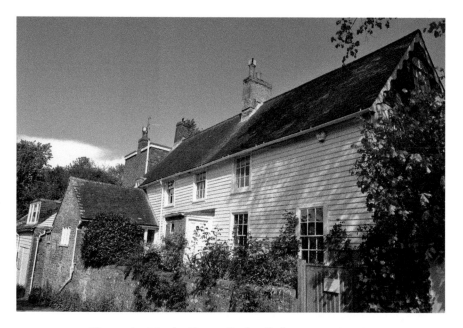

Figure 6.1 Monks House, Rodmell, front view (2017).
Wikimedia Commons, Elisa.rolle—Own work, CC BY-SA 4.0.

Certainly its street façade suggests a house that is totally unprepossessing—long and plain, seeming almost to be depressed into the earth rather than built atop it. "One stepped into it," recalled Angelica Garnett, the Woolfs' niece, "rather as though one steps into a boat."[12] The house seemed the antithesis of modern; at the 1919 auction where the Woolfs purchased it the catalogue described the house as "old fashioned," a characterization that alluded gracefully to its lack of electricity, bathrooms, and running water.

Yet like the house's name, this initial impression is somewhat deceptive. For the Woolfs, Monks House, like Charleston, became a kind of laboratory for the creation of a modern domestic environment. Charleston was the work of painters, a place where nearly every wall or piece of furniture came, over the years, to be covered in Bell and Grant's art. Monks House has few if any obvious visual flourishes. The experiments that took place at Monks House are integrated into the structure of the house rather

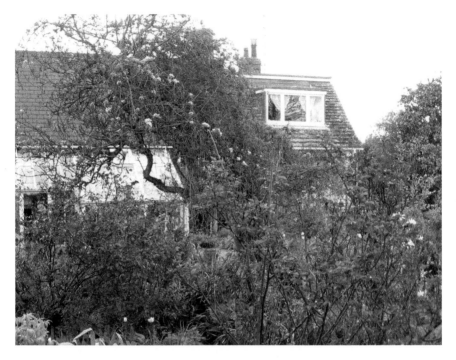

Figure 6.2 Monks House, Rodmell, rear view (2008).
author photo.

than painted on its surfaces and thus are not readily apparent to the general visitor or to the many Woolf admirers who make pilgrimages to the house. But over the course of the twenty years when they shared the house, records show that the Woolfs undertook almost that same number of enlargements or modernizations of the house and its grounds. In other words, the Woolfs were almost constantly planning and executing renovations. Why? Then as now, such projects tend to be messy, unsettling, and much more involved and expensive than originally thought. Yet no sooner had they completed one project then they were on to the next. Monks House was a long-running work-in-progress, a kind of architectural palimpsest. The work proceeded by increments, but by the time of Virginia Woolf's death, the house was substantially larger and far more modern in its provisions. What, beyond improved creature comforts, was at stake in

this constant remodeling? What might actual building have to do with the building of Virginia Woolf's books?

Virginia and Leonard Woolf's circle was dominated by artists, artisans, and decorators, people who saw the domestic environment as a vital site for determining what modern life meant and how it should be lived. Only a few years before the Woolfs moved into Monks House, for example, Bell and Grant, together with close friend and art critic Roger Fry, launched the Omega Workshops, a London-based interior design collective aimed at creating a new fusion of art and design and transforming the British domestic interior. All were engaged in innovative modernist experimentation at their own homes, as were many others in Virginia Woolf's intimate circle. With so many of her closest friends and colleagues actively engaged in ambitious reinventions of the materiality of domestic life, it seems clear that Virginia Woolf's numerous renovations of Monks House should be considered in this context and integrated with our thinking about her literary practice.

In *Bloomsbury Rooms*, Reed considers Virginia Woolf exclusively as a consumer of the interior decorations of Bell and Grant, but Woolf actively planned the changes at Monks House. The Woolfs never employed an architect for any of the work, hiring the local builder to execute their ideas. They invested time, care, and money, writing to and seeking design advice from friends, going back and forth with the builder about the work to be done, and commissioning decorative flourishes like post-Impressionist tiles for a fireplace surround. Virginia had a habit of sketching floor plans on the pages of her manuscripts, rendering her the de facto architect of the Monks House additions and gesturing toward the place of architecture among her works in both metaphorical and material form. In addition to being an architect in her writing, it might be said that Virginia (who is my focus here rather than Leonard), had an authorial relationship to Monks House.[13]

Let me say a word about the various archival sources in this chapter. Woolf seems to have had an occasional practice of planning design changes at Monks House herself, and those sketches she made on the pages of her manuscripts have been serendipitously preserved. I will

discuss a few of them in this chapter. My documentation of the evolving space of Monks House has led me not just to the Woolf manuscripts held in numerous libraries. I have also been able to trace through local sources builders' plans showing some of the various renovations executed at Monks House. These plans confirm that the many projects were carried out according to Virginia Woolf's specifications, as outlined both in her own sketches and in numerous passages in her letters and diaries. As such, I would argue that Virginia Woolf's architectural experiments at Monks House should be considered part of Woolf's body of work in relation to her literary practice. While previous chapters in this book have traced the articulation of tenets of modernization in modernist aesthetics, this chapter focuses on a single author across the arc of her life to show how Woolf's literary inventions combined with her agenda for domestic life. Bringing together Woolf's home projects with her writing shows how interrelated these practices were. Reading Woolf's literary output against her architectural and design endeavors allows us to understand the modern ideologies that informed her spatial practices; reading those spatial practices against her literary works allows us to understand the architectural approach that underwrote her inventions in literary form.

This chapter will tell the story of Monks House and how it changed over the decades that the Woolfs lived there. These changes are an overlooked aspect of Bloomsbury's domestic experiments and a way to see how architecture guided Virginia Woolf's approach to literary form. The story of Monks House reveals a close relationship between Woolf's writing and her building projects, something that can lead us to think about modernism as an interarts aesthetic. Finally, I think this story demonstrates how Virginia Woolf conceived her authorship, her very ability to write, as predicated on her ability to build. Why did Virginia Woolf continually rebuild Monks House? Perhaps because the house, in many ways, made for Woolf a world in which she could become someone with the legitimacy to write, as a woman and an author.

<p style="text-align:center">* * *</p>

The Woolfs knew they had taken on a challenge when they purchased Monks House in 1919 at an auction. Assessing the state of its facilities in her diary, Virginia wrote: "The kitchen is distinctly bad. Theres an oil stove, & no grate. Nor is there hot water, nor a bath, & and as for the E. C. I was never shown it."[14] Initially Woolf tried to romanticize the house's more primitive aspects. In January she wrote in her diary:

> Yet every part of the day here has its merits—even the breakfast without toast. . . . I go off to the romantic chamber over grass rough with frost & ground hard as brick. Then Mrs Dedman comes to receive orders—to give them, really, for she has planned our meals to suit her days cooking before she comes. We share her oven.[15]

Put more plainly, mornings began without toast and days ended with catered meals because the Monks House kitchen was not up to the job, just as its lack of facilities sent the occupants out back to the so-called "romantic chamber" for eliminations. By the end of May the kitchen walls had been knocked down and the space retooled such that food might be prepared there. A solid fuel-burning range was added; this was to be the first of many efforts directed at modernization.

From the first, modernization was established as the central motivation for almost all the alterations at the house. The relatively crude environs of Monks House may seem to have little in common with the rationalized, scientistic interiors described elsewhere in this book. But they shared similar values. As in the creation of the rational household, the Monks House renovations were directed explicitly at increasing efficiency, articulating new standards of hygiene, reconceiving the work of housekeeping, and valuing women's work. This last objective was expressed not just through mechanization but through the iterative construction of many potential rooms of one's own in the house. For Virginia Woolf, as for many others, the changing status of women was a signal feature of modernity. Reducing the burdens of housework and creating private spaces for women to do professional work like writing were both forms of modernization.

In Woolf's account, the development of literary modernism was closely bound up with modernization, and particularly for women writers. In her well-known essay "Mr. Bennett and Mrs. Brown," when Woolf turned to illustrate the advent of modernity that was producing a new kind of writing she dubbed "Georgian," she contrasted the pre-modern cook with her contemporary counterpart: "The Victorian cook lived like a leviathan in the lower depths, formidable, silent, obscure, inscrutable; the Georgian cook is a creature of sunshine and fresh air; in and out of the drawing room, now to borrow the *Daily Herald*, now to ask advice about a hat."[16] The difference between the Victorian cook and the Georgian cook stems from the demands of the Victorian kitchen relative to those of the Georgian kitchen. The Georgian cook lives in the sunshine because the burdens of her work have been lightened by modernization. But it was not only the cook that reaped the benefits of improved conditions. In the Victorian era, the woman writer too—Woolf's example is Jane Carlyle—spent her precious time "chasing beetles, scouring saucepans, instead of writing books."[17] Modernization made it possible both technologically and ideologically for Jane Carlyle to write rather than scour. For Woolf, it might be said that modernity was born in the kitchen.

It seems noteworthy, however, that what the liberated Georgian cook does with her newfound freedom in "Mr. Bennett and Mrs. Brown" is to interrupt her employers with various requests. We can presume that the individual being subjected to these interruptions is a woman, since the cook would be less likely to go to the master of the house for advice about a hat. Woolf would appear to see herself in the place of the interrupted employer, having trouble preserving the privacy she needs to write. In 1922, for instance, Woolf wrote in a typical passage from her diary about her own domestic worker, Lottie Hope: "I meant to make some notes of my reading...but Lottie's interminable gossip...frets me."[18] The same modernizations that liberated Lottie Hope could constrain her employer, but Woolf's hope was that through further modernization she could move towards obviating her dependence on live-in household help, always a vexing issue for her. As she wrote "the fault lies in the system. How can

an uneducated woman let herself in, alone, into our lives?"[19] She dreamed of a future in which "our domestic establishment is entirely controlled by one woman, a vacuum cleaner, & electric stoves."[20] It seems unlikely that Woolf imagined herself in the role of the "one woman." Writing this in 1924, she could not imagine a future in which domestic help could be eliminated completely; to reduce, through the aid of modern machines, to a single servant was the best to be hoped for. This sentiment was very much in keeping with the changing times; the servant population in England had been declining steadily since the 1890s as working women acquired other, more palatable career options than living in an employer's home and working for long hours for little money.[21]

One way to avoid the cook's interruptions was to hide oneself away. Shortly after taking up residence at Monks House, Woolf decided that, for the warmer months at least, she wanted to do her writing out of doors. A pre-existing tool shed in the garden was cleared and fitted out with the bare essentials of desk, chair, window, and door; writers, the shed indicated, could do without the elaborate upholstery, wood paneling, and oriental rugs that were staples of the Victorian study. The latter was a masculine model, realized by Woolf's father Leslie Stephen among many others; it was steeped in tradition and authority and expressed the writer's sense of power and self-importance. By contrast, Woolf's spartan aesthetic reflects her view of the immense poverty of women writers, poverty that was both material (no money for comforts) and archival (no received canon of women's literature to join). As at the women's college Woolf imagined a few years later in A Room of One's Own, given the exigencies facing women writers in her time, "the amenities ... will have to wait."[22] Her relocation to the backyard indicated her suspicion about the dangers of the private home for women writers, the domestic affairs that could easily engulf the unwary. The Georgian cook of "Mr. Bennett and Mrs. Brown" would find it more difficult to pop in for the newspaper or advice about a hat if the lady of the house were sequestered in the tool shed.

For a woman writer, more likely than her male counterpart to be called upon for any emergent domestic matter, writing outside the house was a way

to isolate herself from interruption.[23] The domestic sphere, as Woolf points out, is invariably characterized as female: "one has only to go into any room in any street for the whole of that extremely complex force of femininity to fly in one's face."[24] Writing outside the house, even as near as the backyard, was a way to step outside that web of encumbering associations. Woolf's attention to the physical spaces of authorship and in particular her choice of isolation resonates with the outrage she expressed in *A Room of One's Own* about the way in which Jane Austen, compelled to write in the family sitting room, had to whisk her work out of sight if anyone else entered the room. Florence Nightingale too, Woolf recorded, expressed frustration that "'women never have an half hour...that they can call their own.'"[25]

By comparison, Woolf's novels offer portraits of women's pleasure when they can claim their own private spaces. Clarissa Dalloway has a room at the top of her London home where she goes to remember her happy youth. In *Night and Day* (1919) Mary Datchet has her own flat, an arrangement that provokes the envy of her wealthy friend Katharine Hilberry, who lives with her parents. In Woolf's first novel, *The Voyage Out* (1915), 24-year-old Rachel Vinrace is delighted when her aunt provides her with "a room cut off from the rest of the house, large, private—a room in which she could play, read, think, defy the world, a fortress as well as a sanctuary."[26] This ideal of private built space is a touchstone for Woolf. Given its greatest prominence in *A Room of One's Own*, it is a motif throughout her work and has a significance, as I will argue below, that goes substantially beyond the association of modernity with women's privacy.

Yet with characteristic ambivalence, Woolf was unwilling to forsake the home completely as a potential working space for women writers. In 1923, while at work on the manuscript of "The Hours", Woolf sketched a plan for a more ambitious reorganization of Monk's House in which space for writing was front and center.

The sketch in Figure 6.3 shows two studies of equal size, side by side, at the front of the house, with "Vs study" sharing its other internal wall with the kitchen. This egalitarian arrangement is very different from the

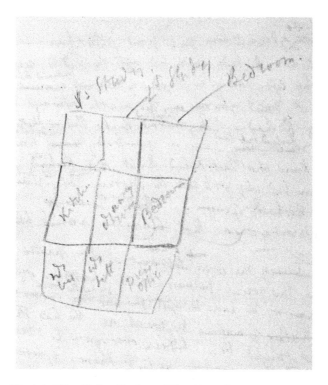

Figure 6.3 Virginia Woolf, doodle from "The Hours" ms, p. 94 verso.
The Society of Authors as the Literary Representative of the Estate of Virginia Woolf and © The British Library Board, Manuscript Collection.

traditional but uneven spatial allocation Woolf creates for Clarissa and Richard Dalloway in her novel. Clarissa's affairs are restricted to the family home, with brief jaunts into the city for shopping, while Richard has a much broader scope. The author protested the inequality of the Dalloways on the reverse side of the drawing; the words bleeding through the paper: "With twice his wits she had to see things through his eyes: (one of the tragedies of married life). With a mind of her own she must always be talking of Richard."[27] Her drawing offered a spatial solution to the problem, for the Woolfs if not for the Dalloways, and it would be interesting to know if the writing prompted the drawing, or vice versa. Virginia Woolf's desire to have both a writing shed outside of the house and a study within its walls suggests a dual strategy for the woman writer: claim a workplace

beyond the reach of domestic affairs while still ensuring that the plan of the house acknowledges the valid professional identities of both husband and wife.

Woolf made a number of comments in her diary during that summer of 1923 about her attempts to find useable forms for "The Hours", writing in August: "how I dig out beautiful caves behind my characters; I think that gives exactly what I want; humanity, humour, depth. The idea is that the caves shall connect..."[28] The metaphor is one of excavation; she returned to it in February, explaining that "I'm working at The Hours, & think it a very interesting attempt; I may have found my mine this time I think. I may get all my gold out."[29] This spatial model seems connected to Woolf's diachronic method of using stream-of-consciousness to constantly tunnel back and forth between present and past in the work that was eventually published as Mrs. Dalloway. The grid structure of her adjoining rooms in her sketch gave way to the time tunnels of her narrative.

Published in 1925, Mrs. Dalloway sold well, as did The Common Reader. In April, Woolf noted in her diary, "I'm out to make £300 this summer by writing, & build a bath & hot water range at Rodmell."[30] Writing served the ends of building and allowed her to continue modernizing the house. The plans for this addition drawn up by Philcox Bros., the local builders, name the client as "V. Woolf, Esq.," announcing Woolf's status as a professional woman, a woman who can order men to work (Figure 6.4). It was in 1926 that Virginia first began to out-earn Leonard, a trend that would continue. The plans show the juxtaposition of the new bathroom with the study, matter with mind.

Later the same year the builders were back at the house, this time to knock down a wall and create a large drawing and dining room. Virginia exulted in these transformations, writing in her diary, "Yes, Rodmell is a perfect triumph, I consider—but L. advises me not to say so. In particular, our large combined drawing eating room, with its 5 windows, its beams down the middle, & flowers & leaves nodding in all around us. The bath boils quickly; the water closets gush & surge (not quite sufficiently though)."[31] As the water closets show, modernization was an always

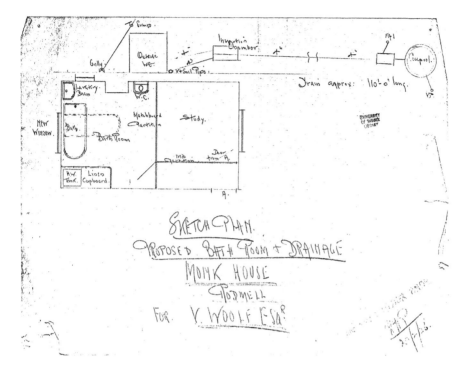

Figure 6.4 Sketch Plan, Proposed Bath & Drainage for Monk House, Rodmell, For V. Woolf ESQ.

Monk House plans created by Philcox Bros. (archive reference SxMs13/2/1/3/E), Leonard Woolf Papers, University of Sussex Special Collections at The Keep.

incomplete process. The informality of the combined rooms represented a break from the many and distinct rooms in traditional English country homes. The Woolfs' room, though homely, was modern in certain regards. Its Omega Workshops textiles and dining set indicated the owners' interest in avant-garde and artisanal furnishings. Its his-and-her arm chairs nodded to the same kind of gender equivalence that Virginia Woolf sketched in her plan for adjacent studies.

By the end of that year Woolf was sketching plans again. She had complained that in cold weather she had no place to write when in Rodmell: "until I have a room, I cannot go there meaning to work."[32] There were rooms, of course; they were two people in a substantial

Figure 6.5 Virginia Woolf, sketch for Monks House renovation.

The Society of Authors as the Literary Representative of the Estate of Virginia Woolf and Henry W. and Albert A. Berg Collection of English and American Literature, The New York Public Library, Astor, Lenox and Tilden Foundations.

home. But the continual creation of writing spaces seems to have been for Woolf a necessary precondition for writing. On the back of a page in one of her reading notebooks, she outlined a plan for another combination of study and bath (Figure 6.5).[33] Again she fused her dual vision of

modernity—modernization and space for women's writing—into one architectural schema.

Her initial drawing was modest, but in March the tone she took in her diary regarding this project was practically magisterial: "After all, I say, I made £1000 all from willing it early one morning. No more poverty I said; & poverty has ceased. I am summoning Philcox next week to plan a room—I have money to build it, money to furnish it."[34] She argued in *A Room of One's Own* that women needed money and a room in order to be writers; this plan put her claims into action. Her unusual grandiosity (recalling Leonard's caution to her not to go about proclaiming the "triumph" at Rodmell), more pronounced than any boasts she made on behalf of her writing in the diary, points to the house's singular status for Woolf. The money made from writing, rather than the writing itself, is her major point of pride. And money signifies not as a pure indicator of wealth but rather as a potential to create yet another room.

In addition to *A Room*, Woolf was working at this time on *Orlando*, as well as her long essay "Phases of Fiction," a grand survey of British and Continental literature. In all these works, architecture offers a formal model for literary craft. In *A Room*, for example, a novel "is a structure leaving a shape on the mind's eye, built now in squares, now pagoda shaped, now throwing out wings and arcades, now solidly compact and domed."[35] In "Phases," we learn of a book in which "the whole subsists complete by itself, like a house which is miraculously habitable without the help of walls, staircases, or partitions."[36] Architecture is both imaginary and solidly material, offering ready-made structures for the novelist to adapt, spatial forms into which narrative can be poured. Woolf's sketches of plans for Monks House on the backs of manuscript pages suggest how related the two activities—writing and architecture—were for her.

The values that guided the changes at Monks House centered on hygiene, efficiency, privacy, a balance between material and mental life, and the egalitarian division of gendered space. In *A Room of One's Own*, we see many of these architectural values enacted in narrative form: from the repeated staging of interruptions when the narrator trespasses into masculine

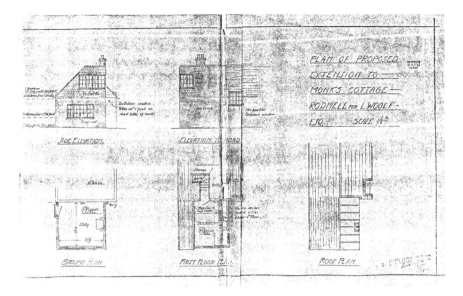

Figure 6.6 Plan of Proposed Extension to Monks Cottage for L. Woolf Esq.
Monk House plans created by Philcox Bros. (archive reference SxMs13/2/1/3/E), Leonard Woolf Papers, University of Sussex Special Collections at The Keep.

palaces of knowledge at Oxbridge and the British Museum; to the narrator's concern over the poverty of female undergraduates; to her final refuge in her own library, where she is able to construct a tradition of women's literature to supplement the men's. In addition to these practical parallels, there is an abiding contrast in *A Room* between the idealized figure of the writer hidden away in her study, and the invisible interconnections that bind individuals together, a contrast between what the narrator terms "the common life" on the one hand and "the separate life" on the other. The former invokes the self in relation to others; the latter an isolated individual. Woolf's earlier sketch of a grid of rooms is the relational model, while her later one bodied forth isolation.

The renovation that followed Woolf's small sketch surpassed all previous efforts. A two-story extension was added, with a bedroom for Virginia on the ground floor and upstairs a sitting room, two bedrooms, and a bath (Figure 6.6). The house was further modernized as well, with the addition of a hot water boiler and a self-setting range. Outside, a heated greenhouse

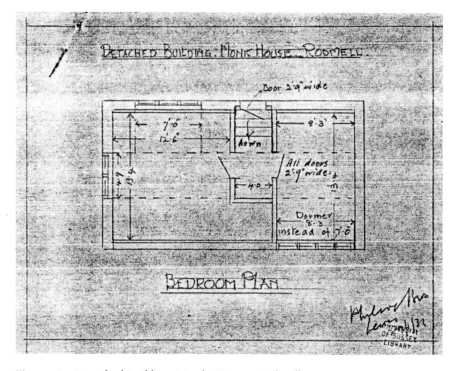

Figure 6.7 Detached Building, Monks House, Rodmell.
Monk House plans created by Philcox Bros. (archive reference SxMs13/2/1/3/E), Leonard Woolf Papers, University of Sussex Special Collections at The Keep.

was built. In dividing up the cost of this project, Leonard paid £80, the cost of the outdoor work, while Virginia contributed £454 from the unusually abundant profits of *Orlando*.

The new ground-floor bedroom designated for Virginia (she and Leonard did not share a room) took her quest for privacy to a new level. It lacked an interior door; that is to say, it could not be accessed directly from the rest of the house but had to be entered from the yard. Here was another architectural approach to the problem of authorial privacy, since Virginia used this room for writing. With her room closed off to the rest of the house, she could come and go unobserved and make it inconvenient for others to intrude. When Philcox returned to work on this room further in 1931, he labeled it "detached," an apt characterization of her desired state of mind (Figure 6.7). As a word that slides between space and self,

"detachment" is a term that inflects Woolf's notion of the relationship between the two. For Woolf, individuals could lead lives that were separate or common; or, in architectural terms, detached or attached.

Woolf's writing advocates for both "detachment" and "attachment" at different times. A large body of psychoanalytically inflected criticism has explicated the Woolfian model of the attached or intersubjective self. Carole Rodier describes "a writing of unity, of universal interconnection."[37] For Jessica Berman, "Woolf...constitutes subjectivity as coming into being always in fluctuating relation to a small group of affiliated yet singular others."[38] Woolf provides an ample basis for such readings, perhaps most conspicuously in her diary when she writes that "We're splinters & mosaics; not, as they used to hold, immaculate, monolithic, consistent wholes."[39]

But in Woolf's architectural inclinations a yearning for detachment is clearly discernible, and other critics have found evidence in Woolf's work for a detached conception of selfhood, often expressed through images of isolation.[40] In describing Woolf's run-up to writing *The Years*, Hermione Lee writes that "the new book coincided with, and took fire from, her desire to be immune, detached, 'withdrawn & concentrated.'"[41] Woolf's ideas about interconnection and commonality are held in tension with a complementary pull toward detachment and a sense of the authority that detachment can command, as seen in the Outsiders Society of *Three Guineas* or the lady sitting between windows writing in Elvedon in *The Waves*. The self shifts between community and isolation, between attachment and detachment. Woolf dramatizes attachment by connecting spaces to one another in proper alignment. Detachment, on the other hand, is expressed through spatial isolation. This distinction is so basic to her work that most of her titles refer to one position or the other, either to the relational movement of attachment (*To the Lighthouse*, *Between the Acts*, *The Voyage Out*) or to the isolation of detachment (*A Room of One's Own*, *Jacob's Room*, *Orlando*, *Mrs. Dalloway*).

These different spatial models find expression in the design of Woolf's novels as well. *To the Lighthouse* (1927), for instance, is organized around the movement between the Ramsays' summer home and the lighthouse, two

places that are attached to each other by the characters' desire to go from one to the other. The novel opens with the goal of traveling from house to lighthouse and concludes when that journey is complete. At the same time, having received the knowledge that the lighthouse has been reached, the painter Lily Briscoe is suddenly able to complete the circuit of attachment in the painting with which she had been struggling. She draws a line across the center of the canvas that resolves the question of the relation of the masses in her composition. Woolf's climactic juxtaposition of the boat's movement from house to lighthouse with the movement of Lily's brush across the canvas suggests that spatial movement and artistic production can perform congruent gestures of attachment. The first and third long sections of the novel, attached to one another by the fluid central section, model a similar equation.

Against this larger backdrop of attachment, Lily stands apart as a figure of detachment, a position Woolf associates with her role as an artist. She pushes people away: Mr. Ramsay, Charles Tansley, even Mr. Bankes. More often than not, she wants to be left alone to work but she is exquisitely sensitive to interruption: "[Mr. Ramsay] was walking up and down the terrace—ruin approached, chaos approached. She could not paint."[42] As a woman, her preference for solitude is an aberration, as she well knows: "she would urge her own exemption from the universal law; plead for it; she liked to be alone."[43] Like Woolf's, Lily's hunger for isolation proceeds from the demands of the creative process. But for Lily, the desire for solitude is part of a larger and more universal sense of detachment. In the last section of the novel, visiting the Ramsays at their summer home once again, she is isolated despite her long history with both the place and its inhabitants: "The house, the place, the morning, all seemed strangers to her. She had no attachment here, she felt, no relations with it..."[44] But Lily's detachment enables her creativity.

Detachment, for Woolf, was a mode conducive to work, but it was also a virtue in itself. She saw the modernization of Monks House, in part, as allowing her to be more frequently alone, more detached. Her diary entry for September 25, 1929 begins,

But what interests me is of course my oil stove. . . . At this moment it is cooking my dinner in the glass dishes perfectly I hope, without smell, waste, or confusion: one turns handles, there is a thermometer. And so I see myself freer, more independent—& all one's life is a struggle for freedom—able to come down here with a chop in a bag & live on my own.[45]

"Live on my own." Woolf's hope that the mechanization of the home might transport her into a hygienic and orderly existence is connected to the value she places on independence and freedom. These values might suggest a number of things—financial or statutory independence, freedom from social convention or civil constraint—but for Woolf freedom and independence seem chiefly to mean the ability to be alone. Modernization, like a room of one's own, could reduce the potential for interruption. She imagines automating food preparation to the point of eliminating the cook altogether. Her vision of automatism is wholly modern and very much in keeping with the way that new kitchen machinery was being marketed to housewives. This is on a number of levels a self-centered vision, bypassing the freedom of the women who have worked for years for her domestic comforts. In Woolf's vision the food cooks itself and the prospective diner merely needs to occasionally "turn handles." Mechanization is designed to reduce labor. Concluding the entry she writes, "I must go into the kitchen to see my stove cooking ham now."[46] Her words have a curious passivity, as she looks at but does not touch the marvel of household mechanization.

As with "The Hours," there are suggestive connections between the work going on at the house and the novel Woolf was working on around this time. *Orlando* is the story of a young man of the landed aristocracy who loses his ancestral country house when he becomes a woman. The book, as is well known, was dedicated to Vita Sackville-West, who like Orlando, had no claim on her family's estate, Knole, because of the gender-based laws of entail. Orlando goes on at length about the importance of investing in and extending your family home. S/he venerates the past generations of his family "all working together with their spades and their needles" who devoted themselves to the elaboration and upkeep of the house.[47] S/he sees in his own attempts to become a writer an insubstantial folly: "For it

seemed vain and arrogant in the extreme to try to better that anonymous work of creation; the labours of those vanished hands. Better was it to go unknown and leave behind you an arch, a potting shed, a wall where peaches ripen, than to burn like a meteor and leave no dust."[48] Building is a nobler legacy than writing, s/he decides, and dedicates her/his time and fortune to the improvement of the house.

Yet when her/his work is done and s/he has filled the house with guests to animate its interiors, s/he turns his back on it all and goes in search of privacy: "[W]hen the feasting was at its height and his guests were at their revels, he was apt to take himself off to his private room alone. There when the door was shut, and he was certain of privacy, he would have out an old writing book...In this he would write till midnight chimed and long after"[49] Despite her/his ideas about vanity and futility of authorship, s/he cannot resist returning to his manuscript. Taken in this light, Woolf's continual attention to improving Monk's House suggests a desire for a greater sense of permanence than her publications afforded. The house, even more than the books, was a creative work that would outlive her and give comfort to future generations. Certainly, Orlando's relationship with the house is the deepest and most lasting one s/he forms over the course of the novel; the relationship is explicitly familial: "As soon would she come home and leave her own grandmother without a kiss as come back and leave the house unvisited."[50] The title of Orlando's manuscript, "The Oak Tree," literalizes his/her search for a rooted permanence. Further, Orlando's "certain" privacy, his/her intense concentration as the party rages around him/her, is a perfect image of the isolated writer, his/her craft sheltered in a private room. *Orlando*, generally understood as a novel about mutability and change, also displays a deep attraction to a specifically architectural mode of permanence and stability.

Similarly, in *Between the Acts* (1941), attachment is incarnated in the old country house Pointz Hall. Human history itself is brief compared to the ancientness of the house: "Only something over a hundred and twenty years the Olivers had been there," but the structure itself precedes the Reformation.[51] Each generation contributes something to the house,

which contains the collective memory of all those who have passed through. Detachment, on the other hand, is expressed through Miss La Trobe's pageant. Miss La Trobe's name references the well-known architect Benjamin Latrobe, though like Woolf, Miss La Trobe is an architect of works of art rather than of buildings. She personifies Woolfian detachment with her lesbian status (though currently single), her unknown origins, and her loathing of interruption. ("O . . . the torture of these interruptions," she growls when someone comes late to the play.[52]) When the pageant is over, Miss La Trobe slouches off, ever the outsider: "She was an outcast. Nature had somehow set her apart from her kind. Yet she had scribbled in the margin of her manuscript, 'I am the slave of my audience.'"[53] Not unlike Orlando, Woolf depicts Miss Latrobe moving between the extremes of detached alienation and intense cathexis. Pointz Hall triangulates the relationship, offering a forum and audience for Miss La Trobe's creativity but not allowing her the shelter of social sanction.

Woolf reliably alternated between books and buildings for the rest of her life. A Room of One's Own was published in October of 1929; it was to sell 22,000 copies in six months. Despite the scale of the spring renovation, the Woolfs put the profits into the house before the year was out, adding an attic sitting-room for Virginia. Again the imagined room seemed to represent for Woolf a perfected space of privacy for writing. "The bedroom will be a lovely wonderful room," she fantasized, "what I've always hoped for."[54] The perfect room seemed to always lie just one more project into the future; she could chase but not catch it.

Modernization of the mechanical type continued as well. The house was electrified and acquired lights, electric fires in the bedrooms, and a Frigidaire in the kitchen. In 1932 the Woolfs got telephone service and in 1934 they went on the mains water system. Virginia Woolf delighted in these additions and wrote to her friends about the joys of central heating, flush toilets, and her expanding experiments in cooking. In a 1931 diary entry she noted,

When the electric light fused, we could hardly tolerate Aladdin lamps, so soon is the soul corrupted by comfort. Yesterday men were in the house all

day boring holes for electric fires. What comfort can we acquire? And, though the moralists say, when one has a thing one at once finds it hollow, I dont at all agree. I enjoy my luxuries at every turn, & think them wholly good for what I am pleased to call the soul.[55]

Woolf's new comforts symbolized a modernity that she was eager to embrace. Many of her novels, including *To The Lighthouse* (1927), *Orlando* (1928), and *The Years* (1937), explored how war, expanded opportunities for women, and changing social mores, all put pressure on the home and compelled it to change in accordance with the times, changes that, in the main, meant less drudgery for women. Her "luxuries" of light and heat went on pleasing her because they eliminated labor and allowed for an increased dedication to creative rather than custodial activity. With the proceeds from *Flush* the Woolfs went on to make extensive improvements to the grounds as well.

At Monks House, mechanical initiatives seemed to alternate with the construction of new spaces for writing. Woolf began to plan construction of her second writing lodge, replacing the old converted shed. This lodge is still extant, though enlarged since her death (Figure 6.8).

This writerly wanderlust is noteworthy since, as Diana Fuss reminds us, writers are often closely identified with a single space of composition.[56] Woolf's father Leslie Stephen, for example, is depicted by Woolf as the epitome of attachment, rooted in a single spot in his Hyde Park Gate study: "he had written all his books lying sunk in that deep rocking chair."[57] Woolf shifted spaces all the time, even working in the bathtub. Her numerous changes in location suggest a refusal to become too comfortable or settled, to insist, as it were, on shifting her perspective with frequency. Indeed, in planning the second lodge, her concern was to capture the broadest view of the Downs allowable. When Leonard wrote to the builder to accept his estimate he requested certain changes in the proposed design: "The alterations which I have in view are as follows: the window on the south side would be as planned but on the north side there should be two windows with a double door in the centre, the doors to have glass in their

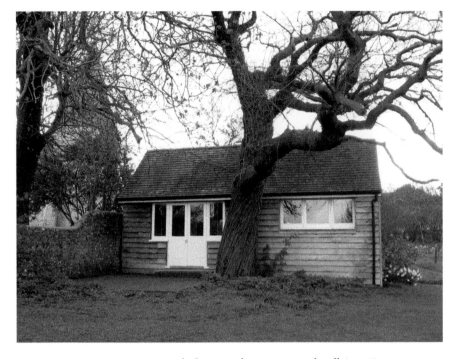

Figure 6.8 Writing lodge, Monks House, Rodmell (2008).
author photo.

upper halves."[58] A great deal of glass was employed in the final construction, opening up the lodge's view of the Downs.

For Woolf, spatial detachment could facilitate flexibility of mind. This idea emerges in her diaries as early as 1903, when Woolf (then Virginia Stephen) was 21 years old. Women in her family, she writes, "are equally at home everywhere—(not at all, that is to say)".[59] While living at Hyde Park Gate she tried to imagine a way of living that would allow one to move around continually and avoid the mental limits imposed by fixed dwelling. In another early diary entry she writes,

I never see a gipsy cart without longing to be inside it. A house that is rooted to no one spot but can travel as quickly as you change your mind, & is complete in itself is surely the most desirable of houses. Our modern house with its cumbersome walls & its foundations planted deep in the ground is

248

nothing better than a prison; [] & more & more prison like does it become the longer we live there & wear fetters of association & sentiment, painful to wear—still more painful to break.[60]

These sentiments seem directly at odds with those expressed in *A Room of One's Own*; for Woolf, the attached and detached positions both had virtues and disadvantages. Is the writer's study a palace or a prison? In Woolf's spatial wanderlust we can discern the tension between her ideal of detached privacy on the one hand and freedom to roam on the other. Shifting her spaces of writing was a way to combine them. It also, she argued, inculcated a desirable mental flexibility, the opposite of her father's fixity.

She converted this preference into a political practice in *Three Guineas* (1938), the sequel to *A Room of One's Own*, when she rhetorically proposed the creation of an activist group of women to be dubbed the Outsider's Society. "Broadly speaking," she wrote to her imaginary male interlocutor in the book, "the main distinction between us who are outside society and you who are inside society must be that whereas you will make use of the means provided by your position...we, remaining outside, will experiment not with public means in public but with private means in private."[61] The idea of the outsider who is free from obligation and can maintain a detached outlook runs throughout Woolf's work; in addition to the Outsider's Society we find Lily Briscoe, who does her painting outside; the pageant in *Between the Acts* that is held outdoors; *The Waves*, which begins and ends with the vastness of the ocean; *Mrs. Dalloway*'s Septimus Smith, who leaps out of his window to escape his pursuers; and others.

The final renovation at Monks House reflected Virginia Woolf's increasing politicization in the 1930s. Settled in her new writing lodge at Rodmell she received the news in 1935 that Mussolini had invaded Ethiopia, the first stirrings of the larger conflict to come. As the possibility of British involvement in the war grew, Leonard increasingly gave speeches and participated in committees and pressure groups. By 1937 Labour Party meetings were being held in the Monk's House drawing room.[62] When England entered the war both the Woolfs became increasingly involved in local community

organizing: Leonard joined the local fire brigade and donated their pots and pans for scrap metal, while Virginia spoke to the Women's Institute about "Women and the War" and later became its treasurer.[63]

Alongside this political activity, Virginia Woolf continued to plan alterations at Monk's House. In March of 1938 she recorded in her diary that "we have asked Mr Wicks to estimate for a library at MH. in spite of Hitler."[64] This new project was of the "attached" variety; it aimed to convert existing loft space into a library with a new staircase built beneath for access (Figure 6.9).

Woolf's reference to Hitler seems incongruous in the context: what difference could the building of another room at Monks House make to the Third Reich? With the war looming, conditions for building were not ideal. She seemed to understand the building of the library as a form of war resistance: first, an insistence on not letting the threat of Hitler undermine normal life, second, a celebration of liberal intellectual values in the face of a regime that was trying to stamp them out, and last, an affirmation of belief in the durability and permanence of their home in the face of threats. Her idea of "building to spite Hitler" may have been a form of whistling in the dark, of trying to ward off her growing sense that the forces of darkness were overtaking her domestic peace. As late as February of 1940 the Woolfs were pushing forward with their modernization, installing a new electric stove in the Monks House kitchen.

By the end of that year, the bombs could be heard in Rodmell. In contrast to their building work, the Woolfs saw homes destroyed on a daily basis. London too was under attack and bombed nightly; this was considered an immediate precursor to invasion. The Blitz rebutted Woolf's belief in the permanence of buildings compared to the flimsiness of books. In September 1940 the Woolfs learned that their home in London's Mecklenburgh Square had been damaged, with windows broken and ceilings collapsed. Woolf asked in her diary, "Why did we ever leave Tavistock?" their long-time London home from which they had moved only recently.[65] But a month later Tavistock Square too was reduced to rubble. The Woolfs went to London and picked through the remains of both houses. At

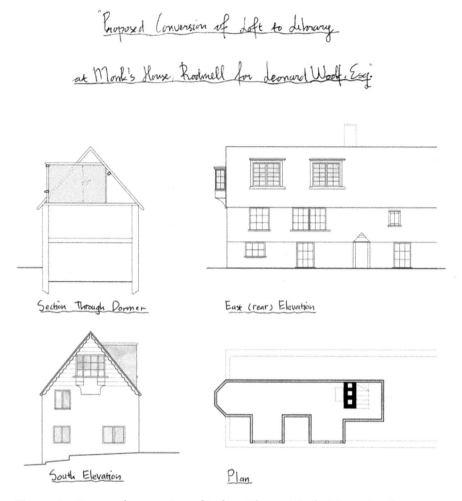

Figure 6.9 Proposed conversion of Loft to Library, Monks House (1938).
Redrawn by Kevin Sani. Original design by P. R. Wicks.

Tavistock Square: "I cd just see a piece of my studio wall standing: other-wise rubble where I wrote so many books."[66] At Mecklenburgh, she wrote, "In my sitting room glass all over Mrs Hunter's cabinet—& so on. Only the drawing room with windows almost whole. A wind blowing through. I began to hunt out diaries. What cd we salvage...?"[67] The books survived, but the buildings were leveled. The image of the ruined house, of

domesticity destroyed, was tragic, but for Virginia Woolf it was also liberating, as she fell back on her ideal of detachment: "But its odd—the relief at losing possessions. I shd like to start life, in peace, almost bare— free to go anywhere."[68] As in the gipsy fantasy of her younger days, she found a certain relief in the idea of shrugging off possessions, responsibilities, and social hierarchies, taking refuge in detachment.

Building was, above all, an optimistic activity for Woolf, encoding her idea that the fruits of labor could endure and the future made better than the past. Even her late work depicts architecture as a source of structured continuity, as something that like Pointz Hall and Orlando's home, can persist. In "A Sketch of the Past" (1940), for instance, the village of her childhood summers is "much as it must have been in the sixteenth century- ... a scramble of granite houses crusting the slope in the hollow under the Island."[69] The renovations at Monks House were never directed at the creation of "modern architecture." Rather, Woolf's aesthetic, reflected in works such as *Orlando*, *Between the Acts*, and *To the Lighthouse*, was a steady arc of modernization. *Orlando* moves through history into the present day; *Between the Acts* looks forward to new plots, new plays; *To the Lighthouse* sees the passing of Mrs. Ramsay's generation of women and the formation of a new one. Modernization, in each of these works, also means finding a place for the artist whose work reflects (literally, in *Between the Acts* when a mirror is held to the audience) his or her times. Despite the strong tether of mimetic representation, in each of these works the artist resists the attached or relational mode and isolates him or herself. As with Woolf at work in the shed, for the artists in these texts detachment is the necessary counterweight to the Woolfian relational self.

Architectural space outlined the lineaments of this contrast for Woolf. On a more abstract level, her admiration for architecture's logical and organic structure informed her search for new narrative forms: "We see the shape [of a completed book] from start to finish," she wrote, "it is a barn, a pig-sty, or a cathedral."[70] Since Joseph Frank, it has been a critical commonplace that modernist prose substitutes space for time, a claim that looks harder at the breakdown of linear chronology than it does at

the creation of spatial form. For Woolf, with her general suspicion of disembodied or theoretical language, thinking about spatial form through the material practice of architecture was a way to bring the making of modernist prose to ground. Structure was proper to the practice of architecture and so Woolf imagined herself as a literary architect when she planned her works. "Its not the writing but the architecting that strains," Woolf noted in her diary.[71]

While Woolf's architectural analogies invariably focused on the organic unity of the built structure, "the whole building of a book," her approach to actual building at Monks House was always partial. In adding onto the house, that is, she never seemed to consider the overall plan of the building. Her sketches show only pieces of the house. In her initial description of Monks House in her 1919 diary she characterized it as "a house of many doors," and certainly the Woolfs' alterations only added to the hodgepodge quality of the house. Perhaps it's no surprise to discover that Woolf was better at writing books than she was at designing houses. Monks House itself was an example of architecture that was not exemplary and its conspicuous frailty in the face of the Blitz showed that despite what Woolf wrote, architecture could be vulnerable—books could and did outlast buildings.

Monks House was not an aesthetic vision but a house built in increments, a statement about the value of continuing to build that sheds light on the buildings that were her books. Monks House was, above all, a work that needed to be continually in progress and under construction as a material enactment both of Woolf's success as a writer and of her desire to pursue the elusive goal of full modernization. Woolf's pursuit of modernization went hand in hand with her ideas about middle-class women's ability to reappropriate the house as a space of intellectual and not domestic work. Mechanizing the house was a way of achieving the privacy so long denied to women in the private home, of constructing and claiming spaces of creativity and self-expression. Woolf's renovations re-staged the dramas of isolation and connection that also animated her writing. The autonomous and relational selves both found spatial expression at Monk's

House, expressed through the isolation, the interconnection, and the parallels between rooms. Woolf's use of Monks House as a vehicle for working through her ideas about gender, space, writing, building, and dwelling might lead us to think more expansively about how we describe the interarts aesthetics of modernism. Woolf's work at Monks House was a far cry from the totalizing vision and avant-garde forms of the International Style, and yet in linking the spaces in which she dwelt to her own experience of a modern identity, Woolf surely participated in the work of modernist cultural production writ large.

Modern kitchen reformers would have praised Woolf for her progressive efforts to modernize her home and reduce through automation the labor of housekeeping. Woolf's design projects at Monks House show us that any understanding of her work is incomplete without seeing how important is was for her to embody her ideas about creativity, women, and modernization in the built space of her home. Woolf's long reach into architecture to give spatial form to the ideas in her books is indicative of an impulse to blend art with craft, thinking with doing, and to extend the scope of artistic practice beyond aesthetics or representation into making a new world in which modern subjects could dwell.

Notes

1. Virginia Woolf, "How Should One Read a Book?" in *The Essays of Virginia Woolf*, Vol. V, ed. Stuart N. Clarke (London: Hogarth Press, 2009), 574.
2. Virginia Woolf, "Modern Fiction," in *The Essays of Virginia Woolf*, Vol. IV, ed. Andrew McNeillie (London: Hogarth Press, 1994), 158–9.
3. Woolf, "Phases of Fiction," in *The Essays of Virginia Woolf*, Vol. V, 82.
4. Virginia Woolf, *The Diaries of Virginia Woolf*, Vol. V, ed. Anne Olivier Bell (New York and London: Harcourt Brace Jovanovich, 1984), 274.
5. Virginia Woolf, *The Diaries of Virginia Woolf*, Vol. II, ed. Anne Olivier Bell (New York and London: Harcourt Brace Jovanovich, 1978), 13.
6. Woolf, *Essays*, Vol. V, 574.
7. Katherine C. Hill-Miller is one of the few critics to investigate the influence of Monk's House on Virginia Woolf's work, though she too casts the house as a retreat, arguing that its appeal lay in the "quiet" and "seclusion" it offered: Hill-Miller,

Gardens and the Work of Virginia Woolf (London: Cecil Woolf, 2001), 244. For Anna Snaith, Monk's House was a place where Woolf "attempted to carve out a private space": Snaith, *Virginia Woolf: Public and Private Negotiations* (London: Palgrave Macmillan, 2003), 132. See also Nuala Hancock's *Gardens and the Work of Virginia Woolf* (London: Cecil Woolf, 2005).

8. Critics tend to focus on Woolf's relationship to London. See, for instance, Jean Moorcroft Wilson, *Virginia Woolf, Life, and London: A Biography of Place* (London: Cecil Woolf, 1987) and Susan Squier, *Virginia Woolf and London: The Sexual Politics of A City* (Chapel Hill: University of North Carolina Press, 1985). See also Nuala Hancock, *Charleston and Monk's House: The Intimate House Museums of Virginia Woolf and Vanessa Bell* (Edinburgh: Edinburgh University Press, 2012).

9. Christopher Reed, *Bloomsbury Rooms: Modernism, Subculture, Domesticity* (New York and London: Yale University Press, 2004).

10. The National Trust, *Virginia Woolf and Monk's House* (Salisbury: The National Trust, 1998), 3.

11. L. F. Salzman, ed. (1940), "Parishes: Rodmell," in *The Victoria History of the County of Sussex: Volume 7, The Rape of Lewes* (London: Oxford University Press for the University of London, Institute of Historical Research, 1940), 69.

12. Angelica Garnett, "Virginia and Leonard Woolf," in *The Bloomsbury Group: A Collection of Memoirs and Commentary*, rev. edn, ed. S. P. Rosenbaum (Toronto: University of Toronto Press, 1995), 251.

13. I shall refer to Virginia Woolf primarily as "Woolf," though I will of course distinguish her from Leonard when necessary.

14. Virginia Woolf, *The Diaries of Virginia Woolf*, Vol. I, ed. Anne Olivier Bell (New York and London: Harcourt Brace Jovanovich, 1977), 286.

15. Woolf, *Diaries*, Vol. II, 3.

16. Virginia Woolf, "Mr. Bennett and Mrs. Brown," *Collected Essays*, Vol. I (New York: Harcourt, Brace, 1925), 320.

17. "Mr. Bennett and Mrs. Brown," 321.

18. Woolf, *Diaries*, Vol. II, 162.

19. Virginia Woolf, *The Diaries of Virginia Woolf*, Vol. III, ed. Anne Olivier Bell (New York and London: Harcourt Brace Jovanovich, 1980), 220.

20. Woolf, *Diaries*, Vol. II, 281.

21. Alison Light, *Mrs. Woolf and the Servants: The Hidden Heart of Domestic Service*, (London: Penguin, 2007), 179.

22. Virginia Woolf, *A Room of One's Own* (San Diego, CA: Harcourt Brace Jovanovich, 1957), 20.

23. Previous critics have commented on the significance of what Jane Goldman calls Woolf's "modernist discourse of interruption." See Jane Goldman, *The Feminist Aesthetics of Virginia Woolf: Modernism, Post-Impressionism and the Politics of the Visual* (Cambridge: Cambridge University Press, 2001). See also Peggy Kamuf, "Penelope at Work: Interruptions in *A Room of One's Own*," *Novel* 16.1 (1982): 5–18.

24. Woolf, *Room of One's Own*, 87.

25. Woolf, *Room of One's Own*, 66.
26. Virginia Woolf, *The Voyage Out* (New York: George H. Doran, 1923), 123.
27. Virginia Woolf, *The Hours: The British Museum Manuscript of* Mrs. Dalloway, ed. Helen M. Wussow (New York: Pace University Press, 1997), 94.
28. Woolf, *Diaries*, Vol. II, 262.
29. Woolf, *Diaries*, Vol. II, 292.
30. Woolf, *Diaries*, Vol. III, 9.
31. Woolf, *Diaries*, Vol. III, 89.
32. Woolf, *Diaries*, Vol. III, 220.
33. The reading notes on the flip side refer to Geraldine Endsor Jewsbury's *Zoe: The History of Two Lives*, vols 1–2 (of 3) (London: Chapman & Hall, 1845). See Woolf's essay, "Geraldine and Jane," in *Essays*, Vol. V, 10–27.
34. Woolf, *Diaries*, Vol. III, 219–20.
35. Woolf, *Room of One's Own*, 71.
36. Woolf, "Phases of Fiction" in *Essays*, Vol. V, 75.
37. Carole Rodier, "The French Reception of Woolf," in *The Reception of Virginia Woolf in Europe*, ed. Mary Ann Caws and Nicola Luckhurst (New York: Continuum International Publishing, 2002), 44.
38. Jessica Berman, *Modernist Fiction, Cosmopolitanism and the Politics of Community* (Cambridge: Cambridge University Press, 2001). See also, for example, Makiko Minow-Pinkney, *Virginia Woolf and the Problem of the Subject* (Brighton: Harvester, 1987) and James Naremore, *The World Without a Self: Virginia Woolf and the Novel* (New Haven, CT and London: Yale University Press, 1973).
39. Woolf, *Diaries*, Vol. II, 314.
40. I am grateful to Margaret Homans for her help in developing this point.
41. Hermione Lee, *Virginia Woolf* (New York: Vintage Books, 1999), 625.
42. Virginia Woolf, *To the Lighthouse* (1927; New York: Harcourt Brace Jovanovich, 1981), 148.
43. Woolf, *To the Lighthouse*, 50.
44. Woolf, *To the Lighthouse*, 146.
45. Woolf, *Diaries*, Vol. III, 257.
46. Woolf, *Diaries*, Vol. III, 258.
47. Virginia Woolf, *Orlando* (San Diego, CA: Houghton Mifflin Harcourt, 1973), 106.
48. Woolf, *Orlando*, 106–7.
49. Woolf, *Orlando*, 112–13.
50. Woolf, *Orlando*, 156.
51. Virginia Woolf, *Between the Acts* (San Diego, CA: Harvest/HBJ, 1941), 32.
52. Woolf, *Between the Acts*, 79.
53. Woolf, *Between the Acts*, 211.
54. Woolf, *Diaries*, Vol. III, 267.
55. Virginia Woolf, *The Diaries of Virginia Woolf*, Vol. IV, ed. Anne Olivier Bell (New York and London: Harcourt Brace Jovanovich, 1982), 27–8.

56. Diana Fuss, *The Sense of an Interior: Four Writers and the Rooms that Shaped Them* (New York: Routledge, 2004).

57. Virginia Woolf, *Moments of Being*, 2nd edn, ed. Jeanne Schulkind (San Diego, CA: Harcourt Trade, 1985), 119.

58. Leonard Woolf, Letter to P. R. Wicks, October 23, 1934, unpub. ms. Monks House Papers, University of Sussex.

59. Virginia Woolf, *A Passionate Apprentice: The Early Journals of Virginia Woolf 1897–1909*, ed. Mitchell Alexander Leaska (London: Hogarth Press, 1990), 167.

60. Woolf, *Passionate Apprentice*, 208.

61. Virginia Woolf, *Three Guineas*, ed. Jane Marcus (San Diego, CA: Houghton Mifflin Harcourt, 2006), 134.

62. As discussed in the minutes of the Rodmell Labour Party, found in the Leonard Woolf papers. See Clara Jones, "Case Study: Bloomsbury's Rural Cross-Class Encounters," in *The Handbook to the Bloomsbury Group*, ed. Derek Ryan and Stephen Ross (London: Bloomsbury Academic, 2018), 190.

63. Victoria Glendinning, *Leonard Woolf: A Biography* (New York: Free Press, 2006), 319.

64. Woolf, *Diaries*, Vol. V, 130.

65. Woolf, *Diaries*, Vol. V, 322.

66. Woolf, *Diaries*, Vol. V, 331.

67. Woolf, *Diaries*, Vol. V, 331.

68. Woolf, *Diaries*, Vol. V, 332.

69. Woolf, *Moments of Being*, 128.

70. Woolf, *Essays*, Vol. V, 579.

71. Woolf, *Diaries*, Vol. IV, 306.

7

CODA

In *Machines for Living*, my emphasis has been on the living as well as the machines. The image on the cover of this book, from the work of the midcentury architectural historian Osbert Lancaster, shows a house turned into a machine, with right angles, concrete construction, extensive use of glass, and minimally furnished interior. Titled "Twentieth Century Functional," the drawing serves as the concluding illustration in Lancaster's 1938 work *From Pillar to Post: English Architecture without Tears*, with accompanying text that explains what the author sees as the project of architectural modernism:

> Shortly before the War a number of accomplished, disinterested and original architects came to the sad conclusion that architecture had died somewhere about the end of the first quarter of the nineteenth century . . . Modern life, they argued, was governed by mechanical principles, and therefore the rules which held good for the construction of machines must now be applied to architecture.[1]

Lancaster goes on to explain that the new architecture rested on commitment to austerity and above all else to the principle of "fitness for purpose," otherwise known as functionalism. This ideology worked well for designing institutions: for "factories, airports, hospitals and other utilitarian buildings." However, he goes on, "when the same principle was applied to domestic architecture, the success was not always so marked."[2]

Lancaster's illustration for "Twentieth Century Functional" offers a visual depiction of the misalignment of the principle of functionalism with domestic life. Though the house depicted may be a machine for living, its

inhabitants are in no way mechanical. Rather, the two sun-bathing figures on the roof bring their own flair and individuality to the scene. Sun-glassed, pipe-smoking, and bikini-clad, they are not creatures of the machine. Neither are they fearful of it. They climb on the roof and make the house their own. Their lived experience of the home is organized around leisure rather than productivity. And by staking out space for leisure, they convert functionalist design into its nemesis—they convert it to a style.

If it has one, the function of this home, as defined by its owners, is to provide a platform for contemplation and expression. To underline the point, the puffs of smoke emanating from the owner's pipe mirror the clouds in the sky, connecting the mundane and the transcendent. Content on their rooftop, the couple seem engaged in what Walter Benjamin considered the particular grace of the individual dwelling place: access to "the phantasmagorias of the interior."[3] When the creed of functionalism enters the home, it might be said, its clarity of purpose devolves into smoke and mist.

The question of function was an abiding preoccupation for engineers and artists alike in the early twentieth century. Many of the writers discussed in *Machines for Living* share an implicit concern with the fate of literature in a rational age that sometimes seemed to prefer nonliterary qualities like efficiency, hygiene, standardization, and speed. The dilatory, reflective manner of literature and art could seem out of step with its modern moment. In 1934 the poet and critic Herbert Read wondered whether mechanization and art were inversely related, so that the rise of one meant the fall of the other. "If we decide that the product of the machine can be a work of art," Read worried, "then what is to become of the artist who is displaced by the machine? Has he any function in a machine-age society, or must he reconcile himself to a purely dilettante role—must he become, as most contemporary artists have become, merely a society entertainer?"[4] Could the work of the artist be characterized as functional by contemporary standards, let alone "Twentieth Century Functional"? Could the artist be said to have any function at all?

These questions felt potent and pressing to Read and his contemporaries, but they do not seem nearly as important now. If we step back from the

notion that aesthetics and technics are adversaries, competing with each other to establish cultural value, we can see the play of ideas between and among them as itself a defining feature of modernism and modernity. Read's concerns devolve into an artifact of the era, a sign of the anxiety of the times rather than a threat to the viability and relevance of art. Pierre Francastel wrote in 1953 that, "Many theorists of the industrial age display a contemptuous scorn for the disinterested values of art. Conversely, artists have an equal disdain for the utilitarian attitudes of the engineer."[5] I opened *Machines for Living* with examples of this disdain, with modernist writers' outspoken antipathy for the Machine Age, both because of principled objections and because of the perceived threat to art. In fact, it might be argued that the specter of a looming final showdown between art and the machine had a generative effect rather than a destructive one.

If literature and domestic life both seemed somehow at risk in the Machine Age, with its focus on work, uniformity, and productivity, it is perhaps because their fates have always been intertwined. Lancaster wisely observed that the spirit of domestic life would always defeat the functionalist project. As he noted, "the conception of a house as 'une machine à habiter,' presupposes a barrenness of spirit to which, despite every indication of its ultimate achievement, we have not yet quite attained."[6] In Lancaster's illustration for "Twentieth Century Functional," the humanity of domestic life overcomes the functionalist imperative and turns it to its own account. Similarly, for many modernist writers, the doctrines of the engineer provided a robust conceptual vocabulary—a vocabulary which writers enriched and expanded.

Domestic life breaks down distinctions between art and utility, function and form, and mechanization and individuality—that writers and engineers alike deployed to sustain their mutual critique. In this context, domestic life is not antithetical to modernism, but essential to it—it is the space of development, of interior life, and of invention. Decades at a distance, what continues most compelling about modernism is the capacity of its aesthetic, as large as its stated goal of imagining a new way of life.

Notes

1. Osbert Lancaster, *From Pillar to Post: English Architecture without Tears* (London: John Murray, 1938), 80.
2. Lancaster, *Pillar to Post*, 80.
3. Walter Benjamin, *The Arcades Project*, ed. Rolf Tiedemann, trans. Howard Eiland and Kevin McLaughlin (Cambridge, MA and London: Belknap Press of Harvard University Press, 1999), 9.
4. Herbert Read, *Art and Industry: The Principles of Industrial Design* (London: Faber and Faber, 1934), 6.
5. Pierre Francastel, "Technics and Aesthetics," *The Journal of Aesthetics and Art Criticism* 11.3 (March 1953), 187. Translated from "Technique and Esthétique" by Alfred and Emily Stafford (1948).
6. Lancaster, *Pillar to Post*, 80.

WORKS CITED

Abel, Elizabeth, Marianne Hirsch, and Elizabeth Langland, eds. *The Voyage In: Fictions of Female Development*. Hanover and London: University Press of New England, 1983.

Alderson, Brian. "The Four (Or Five?...Or Six?...Or Seven?...) Children's Books of Graham Greene." *Children's Literature in Education* 36.4 (2005): 325–42.

Amato, Joseph A. *Dust: A History of the Small and the Invisible*. Berkeley: University of California Press, 2000.

Armstrong, Tim. *Modernism, Technology and the Body: A Cultural Study*. Cambridge: Cambridge University Press, 1998.

Ayers, David. "Modernism's Missing Modernity." In *Moving Modernisms: Motion, Technology, and Modernity*, ed. David Bradshaw, Laura Marcus, and Rebecca Roach. Oxford: Oxford University Press, 2016. 43–56.

Baker, Kenneth. *Minimalism: Art of Circumstance*. New York: Abbeville Press, 1988.

Banham, Reyner. *Theory and Design in the First Machine Age*, 2nd edn. New York and Washington: Praeger Publishers, 1960.

Banta, Martha. *Taylored Lives: Narrative Productions in the Age of Taylor, Veblen and Ford*. Chicago, IL and London: University of Chicago Press, 1993.

Barnes, Djuna. *Nightwood*. New York: New Directions, 1937.

Bauman, Zygmunt. *Modernity and Ambivalence*. Cambridge: Polity Press, 1991.

Beckett, Samuel. *Molloy*, trans. Patrick Bowles in collaboration with the author. New York: Grove Press, 1955.

Beckett, Samuel. *Watt*. New York: Grove Press, 1953.

Beckett, Sandra L. *Crossover Fiction: Global and Historical Perspectives*. Routledge: London and New York, 2009.

Beekman, Daniel. *The Mechanical Child*. Westport, CT: Lawrence Hill & Company, 1977.

Beeton, Isabella. *Beeton's Book of Household Management*. S. O. Beeton Publishing, 1861.

Behne, Adolf. *The Modern Functional Building*, ed. Rosemarie Haag Bletter, trans. Michael Robinson. Santa Monica, CA: The Getty Research Institute for the History of Art and the Humanities, 1996.

Bell, Clive. *Art*, ed. J. B. Bullen. 1914; Oxford: Oxford University Press, 1987.

Bell, L. A. J. "Between Ethics and Aesthetics: The Residual in Samuel Beckett's Minimalism." *Journal of Beckett Studies* 20.1 (2011): 32–53.

Bemis, Alfred. *The Evolving House*. Cambridge, MA: Technology Press, 1933–6.

Benjamin, Thelma H. *Everyday in My Home*. London: Ivor Nicholson and Watson, 1936.

Benjamin, Walter. *The Arcades Project*, ed. Rolf Tiedemann, trans. Howard Eiland and Kevin McLaughlin. Cambridge, MA and London: The Belknap Press of Harvard University Press, 1999.

Benjamin, Walter. *The Work of Art in the Age of Its Technological Reproducibility and Other Writings on Media*, ed. Michael W. Jennings, Brigid Doherty, and Thomas Y. Levin. Cambridge, MA and London: Harvard University Press, 2008.

Benton, Tim and Charlotte Benton, with Dennis Sharp, eds. *Form and Function: A Source Book for the History of Architecture and Design, 1890–1939*. London: Crosby Lockwood Staples, 1975.

Berman, Jessica. *Modernist Fiction, Cosmopolitanism and the Politics of Community*. Cambridge: Cambridge University Press, 2001.

Blackford, Holly. "Apertures in the House of Fiction: Novel Methods and Child Study, 1870–1910." *Children's Literature Association Quarterly* 32.4 (2007): 368–89.

Bloom, Harold, ed. *Bloom's Modern Critical Interpretations: Ernest Hemingway's A Farewell to Arms*. New York: Infobase Publishing, 2009.

Bowen, Elizabeth. "Ivy Compton-Burnett I–II," *Collected Impressions*. London: Longmans, Green and Co., 1950.

Bradbury, Malcolm, ed. *Modernism: A Guide to European Literature 1890–1930*. London and New York: Penguin, 1991.

Brecht, Christine and Sybilla Nikolow. "Displaying the Invisible: *Volkskrankheiten* on Exhibition in Imperial Germany." *Studies in the Historical of Biological and Biomedical Sciences* 31.4 (2000): 511–30.

Broadhurst, Jean. *Home and Community Hygiene: A Text-Book of Personal and Public Health*, 2nd edn, revised and enlarged. Philadelphia, PA and London: J. B. Lippincott Company, 1923.

Brooks, Peter. *Reading for the Plot*. New York: Alfred A. Knopf, 1984.

Buckley, Jerome. *Season of Youth: The Bildungsroman from Dickens to Golding*. Cambridge, MA: Harvard University Press, 1974.

Buzard, James. "Perpetual Revolution." *Modernism/Modernity* 8.4 (2001): 559–81.

Campbell, Margaret. "What Tuberculosis Did For Modernism: The Influence of a Curative Environment on Modernist Design and Architecture." *Medical History* 49.4 (October 2005): 463–8.

Campkin, Ben and Rosie Cox, eds. *Dirt: New Geographies of Cleanliness and Contamination*. London and New York: I.B. Tauris, 2007.

Cant, Sarah E. "In Search of 'Lessness': Translation and Minimalism in Beckett's Theatre." *Forum for Modern Language Studies* 35.2 (1999): 138–57.

Casillo, Robert. *The Genealogy of Demons: Anti-Semitism, Fascism, and the Myths of Ezra Pound*. Evanston, IL: Northwestern University Press, 1988.

Castle, Gregory. *Reading the Modernist Bildungsroman*. Gainesville: University Press of Florida, 2006.

Caws, Mary Ann and Nicola Luckhurst. *The Reception of Virginia Woolf in Europe*. New York: Continuum International Publishing, 2002.

Chase, Judith and Michael Levenson. *The Spectacle of Intimacy: A Public Life for the Victorian Family*. Princeton, NJ and Oxford: Princeton University Press, 2000.

Cheng, Anne Anlin. *Second Skin: Josephine Baker and the Modern Surface*. New York: Oxford University Press, 2011.

Clark, Beverly Lyon. *Kiddie Lit: The Cultural Construction of Children's Literature in America*. Baltimore, MD: Johns Hopkins University Press, 2003.

Clark, Robert C. *American Literary Minimalism*. Tuscaloosa: University of Alabama Press, 2014.

Cleere, Eileen. *The Sanitary Arts: Aesthetic Culture and the Victorian Cleanliness Campaigns*. Columbus: Ohio State University Press, 2014.

Cohen, William. *Sex Scandal: The Private Parts of Victorian Fiction*. Durham, NC: Duke University Press, 1996.

Cole, Sarah. "Enchantment, Disenchantment, War, Literature." *PMLA* 124.5 (2009): 1632–47.

Compton-Burnett, Ivy. *More Women than Men*. 1933; London: Eyre & Spottiswoode, 1948.

Compton-Burnett, Ivy. *Pastors and Masters*. 1925; London, Hesperus Press, 2009.

Cooter, Roger and Stephen Pumfrey. "Separate Spheres and Public Places: Reflections on the History of Science Popularization and Science in Popular Culture." *History of Science* 32 (1994): 237–67.

Le Corbusier. *The Decorative Art of Today*, trans. James I. Dunnett. Cambridge, MA: The MIT Press, 1987.

Le Corbusier. *Towards a New Architecture*, ed. and trans. Frederick Etchells. New York: Dover Publications, 1986.

Le Corbusier and Amédée Ozenfant. "Purism." Reprinted in *Modern Artists on Art*, 2nd edn, ed. and trans. Robert L. Herbert. New York: Dover Publications, 2000. 52–65.

Coveney, Peter. *The Image of Childhood*, rev. edn. New York: Penguin, 1967.

Cox, Rosie. "Dishing the Dirt: Dirt in the Home." In *Dirt: The Filthy Reality of Everyday Life*, ed. Cox. London: Profile Books in association with the Wellcome Trust, 2011. 37–74.

Crary, Jonathan. *Suspensions of Perception: Attention, Spectacle, and Modern Culture*. London and Cambridge, MA: The MIT Press, 1999.

Crawford, T. Hugh. *Modernism, Medicine, & William Carlos Williams*. Norman and London: University of Oklahoma Press, 1993.

Crossland, Rachel. "Exposing the Bones of Desire: Virginia Woolf's X-Ray Visions." *Virginia Woolf Miscellany* 85 (Spring 2014): 18–20.

Dangarembga, Tsetse. *Nervous Conditions*. New York: Seal Press, 2002.

Danius, Sara. *The Senses of Modernism: Technology, Perception and Aesthetics*. Ithaca, NY and London: Cornell University Press, 2002.

Davidson, Caroline. *A Woman's Work is Never Done: A History of Housework in the British Isles, 1650–1950*. London: Chatto and Windus, 1982.

DeCoste, Damon Marcel. "Modernism's Shell-Shocked History: Amnesia, Repetition, and the War in Graham Greene's *The Ministry of Fear*." *Twentieth-Century Literature* 45.4 (1999): 428–51.

Diepeveen, Leonard. *The Difficulties of Modernism*. London and New York: Routledge, 2003.

H.D. (Doolittle, Hilda, writing as John Helforth). *Nights*. 1930; New York: New Directions, 1986.

Duffy, Enda. *The Speed Handbook: Velocity, Pleasure, Modernism*. Durham, NC: Duke University Press, 2009.

Dusinberre, Juliet. *Alice to the Lighthouse: Children's Books and Radical Experiments in Art*. New York: St. Martin's Press, 1987.

Edwards, A. Trystan. *Architectural Style*. London: Faber and Gwyer, 1926.

Eliot, T. S. *Annotated Waste Land, with T.S. Eliot's Contemporary Prose*, ed. Lawrence Rainey. London and New Haven, CT: Yale University Press, 2005.

Eliot, T. S. *Christianity and Culture*. San Diego, CA and New York: Harcourt, 1960.

Eliot, T. S. *Collected Poems 1909–1935*. New York: Harcourt, Brace and Company, 1930.

Eliot, T. S. "Religious Drama: Medieval and Modern." *University of Edinburgh Journal* 9.1 (Autumn 1937): 8–17.

Eliot, T. S. *The Sacred Wood*. 1920; London: Methuen, 1960.

Eliot, T. S. "The Three Provincialities." *The Tyro* 1.2 (1922): 11–13.

Eliot, T. S. *To Criticize the Critic and Other Writings*. Lincoln and London: University of Nebraska Press, 1992.

Eliot, T. S. *The Waste Land: A Facsimile and Transcript of the Original Drafts Including the Annotations of Ezra Pound*, ed. Valerie Eliot. New York: Harcourt Brace Jovanovich, 1971.

Esty, Jed. "The Colonial Bildungsroman: *The Story of an African Farm* and the Ghost of Goethe." *Victorian Studies* 49.3 (2007): 407–30.

Esty, Jed. *Unseasonable Youth: Modernism, Colonialism, and the Fiction of Development*. New York: Oxford University Press, 2012.

Esty, Jed. "Virginia Woolf's Colony and the Adolescence of Modernist Fiction." In *Modernism and Colonialism: British and Irish Literature, 1899–1939*, ed. Richard Begam and Michael Moses. Durham, NC and London: Duke University Press, 2007. 70–90.

Esty, Jed. "Virgins of Empire: *The Last September* and the Antidevelopmental Plot." *Modern Fiction Studies* 53.2 (2007): 257–75.

Eysteinsson, Astradur. *The Concept of Modernism*. Ithaca, NY and London: Cornell University Press, 1990.

Eysteinsson, Astradur and Vivian Liska. *Modernism: A Comparative History of Literatures in European Languages*. Amsterdam and Philadelphia, PA: John Benjamins Publishing Company, 2007.

Feldman, Jessica. *Victorian Modernism: Pragmatism and the Varieties of Aesthetic Experience*. New York: Cambridge University Press, 2002.

Firchow, Peter Edgerly, Evelyn Scherabon Firchow, and Bernfried Nugel, eds. *Reluctant Modernists: Aldous Huxley and Some Contemporaries*. Berlin: LIT Verlag, 2003.

Fitzgerald, F. Scott. *The Curious Case of Benjamin Button and Other Jazz Age Stories*, ed. Patrick O'Donnell. 1920; London: Penguin, 2008.

Ford, Madox Ford. "Introduction." In A Farewell to Arms by Ernest Hemingway. New York: Modern Library, 1932.

Forster, E. M. *The Collected Tales of E. M. Forster*. New York: Alfred A. Knopf, 1952.

Forty, Adrian. *Objects of Desire: Design and Society Since 1750*. London: Thames and Hudson, 1992.

Foster, Hal. *Prosthetic Gods*. Cambridge, MA and London: The MIT Press, 2004.

Foster, Hal. *The Return of the Real: The Avant-Garde at the End of the Century*. Cambridge, MA and London: The MIT Press, 1996.

Fraiman, Susan. *Unbecoming Women: British Women Writers and the Novel of Development*. New York: Columbia University Press, 1993.

Francastel, Pierre. "Technics and Aesthetics." *The Journal of Aesthetics and Art Criticism* 11.3 (March 1953): 187–97.

Frederick, Christine. *Come Into My Kitchen*. Sheboygan, WI: The Vollrath Co., 1922.

Frederick, Christine. *The New Housekeeping*. Garden City, NY: Doubleday, Page & Company, 1913.

Freud, Sigmund. *Beyond the Pleasure Principle*, trans. and ed. James Strachey. New York and London: W. W. Norton, 1961.

Freud, Sigmund. *Dora: The Analysis of a Case of Hysteria*. New York: Macmillan, 1963.

Freud, Sigmund. *The Standard Edition of the Complete Psychological Works of Sigmund Freud*, Vol. 12, trans. and ed. James Strachey. London: Hogarth Press, 1962.

Frost, Laura. "Huxley's Feelies: The Cinema of Sensation in *Brave New World*." *Twentieth-Century Literature* 52.4 (2006): 443–73.

Fuss, Diana. *The Sense of an Interior: Four Writers and the Rooms that Shaped Them*. New York: Routledge, 2004.

Gaston, Bruce. "'But that's not what it was built for': The Use of Architecture in Evelyn Waugh's Work." *AAA: Arbeiten aus Anglistic und Amerikanistik* 41.2 (2016): 23–48.

Gawande, Atul. "Slow Ideas." *The New Yorker*, July 29, 2013: https://www.newyorker.com/magazine/2013/07/29/slow-ideas.

"The Germ Theory: Is It True?" *Life* 55.1427 (March 1910): 379.

Gesell, Arnold. *The Mental Growth of the Pre-School Child*. New York: Macmillan, 1925.

Gesell, Arnold and Frances Ilg. *Child Development: An Introduction to the Study of Human Growth*. New York: Harper & Brothers, 1949.

Giedion, Sigfried. *Mechanization Takes Command: A Contribution to Anonymous History*. 1948; New York: W. W. Norton, 1969.

Gilbreth, Lillian. *The Home Maker and Her Job*. New York: D. Appleton & Co., 1927.

Giles, Nathan B. and Dorothy G. Ellis. *Science of the Home*. London: Chapman and Hall; New York: John Wiley & Sons, 1929.

Glendinning, Victoria. *Leonard Woolf: A Biography*. New York: Free Press, 2006.

Goble, Mark. *Beautiful Circuits: Modernism and the Mediated Life*. New York: Columbia University Press, 2010.

Goldman, Jane. *The Feminist Aesthetics of Virginia Woolf: Modernism, Post-Impressionism and the Politics of the Visual*. Cambridge: Cambridge University Press, 2001.

Goldsmith, Oliver. *The Vicar of Wakefield*. 1766; London: Penguin Books, 2002.

Goody, Alex. *Technology, Literature and Culture*. Cambridge: Polity Press, 2011.

Gopnik, Adam. "A New Man: Ernest Hemingway, Revised and Revisited." *The New Yorker* 92.21 (2017): 61–6.

Greene, Graham. *The Little Horse Bus*, illus. Dorothy Craigie. Norwich: Jarrold and Sons, 1954.

Gropius, Walter. *The New Architecture and the Bauhaus*, trans. P. Morton Shand. Cambridge, MA: The MIT Press, 1965.

Guedes, Amâncio. "The Paintings and Sculptures of Le Corbusier." *Architecture SA/ Argitektuur SA* (Johannesburg) (January–February 1988): 250–5.

Gilbreth, Jr., Frank B. and Ernestine Carey. *Cheaper By the Dozen*. New York: Thomas Y. Crowell Company, 1948.

Gilbreth, Lillian. *The Home Maker and Her Job*. New York and London: D. Appleton & Co., 1927.

Gilbreth, Lillian. *Living With Our Children*. New York: W. W. Norton, 1928.

Hall, Radclyffe. *The Well of Loneliness*. 1928; New York: Anchor Books, 1990.

Hallett, Cynthia Whitney. *Minimalism and the Short Story—Raymond Carver, Amy Hempel, and Mary Robison*. Lewiston, NY: Edwin Mellen Press, 1999.

Hancock, Nuala. *Charleston and Monk's House: The Intimate House Museums of Virginia Woolf and Vanessa Bell*. Edinburgh: Edinburgh University Press, 2012.

Hancock, Nuala. *Gardens and the Work of Virginia Woolf*. London: Cecil Woolf, 2005.

Hansen, Miriam Bratu. "The Mass Production of the Senses: Classical Cinema as Vernacular Modernism." *Modernism/Modernity* 6.2 (1999): 59–77.

Hardy, Anne. *The Epidemic Streets: Infectious Disease and the Rise of Preventive Medicine, 1856–1900*. Oxford: Clarendon Press, 1993.

Hardy, Barbara. *Ivy Compton-Burnett*. Edinburgh: Edinburgh University Press, 2016.

Hardy, Thomas. *Jude the Obscure*. New York: Harper and Brothers, 1896.

Hardyment, Christina. *Dream Babies: Childcare Advice from John Locke to Gina Ford*, rev. edn. London: Frances Lincoln, 2007.

Hardyment, Christina. *From Mangle to Microwave: The Mechanization of Household Work*. London: Basil Blackwell, 1990.

Hayden, Dolores. *The Grand Domestic Revolution: A History of Feminist Designs for American Homes, Neighborhoods, and Cities*. Cambridge, MA: The MIT Press, 1982.

Hemingway, Ernest. *Death in the Afternoon*. 1932; New York: Scribner, 2002.

Hemingway, Ernest. *A Moveable Feast*. New York: Charles Scribner's Sons, 1964.

Hill-Miller, Katherine C. *Gardens and the Work of Virginia Woolf*. London: Cecil Woolf, 2001.

Hodgkins, Hope Howell. "High Modernism for the Lowest: Children's Books by Woolf, Joyce, and Greene." *Children's Literature Association Quarterly* 32.4 (2007): 353–67.

Holder, Julian. "'Design in Everyday Things': Promoting Modernism in Britain, 1912–1944." In *Modernism in Design*, ed. Paul Greenhalgh. London: Reaktion Books, 1990. n.p.

Hollander, John. *The Figure of Echo*. Berkeley: University of California Press, 1981.

Holroyd, Michael, ed. *Lytton Strachey by Himself*. London: Vintage, 1994.

Homberger, Eric, ed. *Ezra Pound: The Critical Heritage*. London and New York: Routledge, 1972.

Honeyman, Susan. *Elusive Childhood: Impossible Representations in Modern Fiction*. Columbus: Ohio State University Press, 2005.

Howey, Kimberly Kyle. "Ezra Pound and the Rhetoric of Science, 1901–1922." Unpub. diss. University College London, 2009.

Howlett, Caroline, ed. *Modernist Sexualities*. Manchester and New York: Manchester University Press, 2000.

Hoy, Suellen. *Chasing Dirt: The American Pursuit of Cleanliness*. Oxford: Oxford University Press, 1996.

Hueffer, Ford Madox. "On Impressionism." *Poetry and Drama* II (June 6, 1914): 169–70.

Hurlbert, Ann. *Raising America: Experts, Parents, and a Century of Advice About Children*. New York: Alfred A. Knopf, 2003.

Huxley, Aldous. *After Many a Summer Dies the Swan*. New York and London: Harper & Brothers, 1939.

Huxley, Aldous. *Aldous Huxley Complete Essays, Volume II, 1926–1929*, ed. Robert S. Baker and James Sexton. Chicago, IL: Ivan R. Dee, 2000.

Huxley, Aldous. *Aldous Huxley Complete Essays, Volume III, 1930–1935*, ed. Robert S. Baker and James Sexton. Chicago, IL: Ivan R. Dee, 2001.

Huxley, Aldous. *Brave New World*. 1932; New York: Harper Perennial, 2006.

Huxley, Aldous. *The Crows of Pearblossom*. New York: Random House, 1967.

Huxley, Aldous. *Eyeless in Gaza*. New York: Harper and Row, 1936.

Huxley, Aldous. *Island*. New York: Harper and Brothers, 1962.

Huxley, Aldous. *Point Counter Point*. London: Chatto & Windus, 1947.

Huxley, Aldous. *Time Must Have a Stop*. 1944; Chicago, IL: Dalkey Archive Press, 2001.

Ibsen, Henrik. *An Enemy of the People*, trans. R. Farquharson Sharp. Project Gutenberg EBook 2446. Posted February 27, 2010: https://www.gutenberg.org/files/2446/2446-h/2446-h.htm (accessed December 20, 2014).

Izzo, David Garrett and Kim Kirkpatrick, eds. *Huxley's Brave New World: Essays*. Jefferson, NC and London: McFarland & Company, 2008.

Jacobs, Karen. *The Eye's Mind: Literary Modernism and Visual Culture*. Ithaca, NY and London: Cornell University Press, 2001.

James, William. *The Principles of Psychology*. New York: Henry Holt and Company, 1890.

Jameson, Frederic. *A Singular Modernity: Essay on the Ontology of the Present*. London and New York: Verso, 2002.

Jewsbury, Geraldine Endsor. *Zoe: The History of Two Lives*, Vols 1–2 (of 3). London: Chapman & Hall, 1845.

Johnson, Philip. "Preface to the 60th Anniversary Edition." In *Machine Art*. New York: Harry Abrams, 1994. n.p.

Jones, Clara. "Case Study: Bloomsbury's Rural Cross-Class Encounters." In *The Handbook to the Bloomsbury Group*, ed. Derek Ryan and Stephen Ross. London: Bloomsbury Academic, 2018. 183–96.

Jourdain, Margaret and F. Rose. *English Furniture: The Georgian Period (1750–1830)*. London: Batsford, 1953.

Joyce, James. *A Portrait of the Artist as a Young Man*. 1916; Harmondsworth: Penguin, 1964.

Kafka, Franz. *The Zürau Aphorisms*, trans. Michael Hoffman. New York: Schocken Books, 2006.

Kamuf, Peggy. "Penelope at Work: Interruptions in *A Room of One's Own*." *Novel* 16.1 (1982): 5–18.

Kawin, Bruce F. *Telling It Again and Again: Repetition in Literature and Film*. Ithaca, NY and London: Cornell University Press, 1972.

Kennedy, Kate. *The Science of Home-Making*. London: Thomas Nelson and Sons, n.d.

Kenner, Hugh. *The Mechanic Muse*. New York: Oxford University Press, 1987.

Kenner, Hugh. *The Pound Era*. Berkeley and Los Angeles: University of California Press 1971.

Kern, Stephen. *The Culture of Time and Space 1880–1918*. Cambridge, MA and London: Harvard University Press, 2003.

Kinchin, Juliet and Aidan O'Connor. *Counter Space: Design and the Modern Kitchen*. New York: The Museum of Modern Art, 2011.

Kittler, Friedrich. *Gramophone, Film, Typewriter*, trans. Geoffrey Winthrop-Young and Michael Wutz. Stanford, CA: Stanford University Press, 1999.

Kracauer, Siegfried. *The Mass Ornament: Weimar Essays*, trans. Thomas Y. Levin. Cambridge, MA and London: Harvard University Press, 1995.

Krauss, Rosalind. *The Originality of the Avant-Garde and Other Modernist Myths*. Cambridge, MA: The MIT Press, 1985.

Kunin, Aaron. "Decoration, Modernism, Cruelty." *Modernism/Modernity* 17.1 (2010): 87–107.

Lahiji, Nadir and D. S. Friedman, eds. *Plumbing: Sounding Modern Architecture*. New York: Princeton Architectural Press, 1997.

Lancaster, Osbert. *From Pillar to Post: English Architecture without Tears*. London: John Murray, 1938.

Lane, Sir W. Arbuthnot, ed. *The Hygiene of Life and Safer Motherhood*. London and Toronto: British Books Ltd, 1934.

Langland, Elizabeth. *Nobody's Angels: Middle-Class Women and Domestic Ideology in Victorian Culture*. Ithaca, NY and London: Cornell University Press, 1995.

Latour, Bruno. *The Pasteurization of France*. Cambridge, MA: Harvard University Press, 1993.

Lawrence, D. H. *The Cambridge Edition of the Works of D. H. Lawrence: England, My England and Other Stories*, ed. Bruce Steele. Cambridge and New York: Cambridge University Press, 1990.

Lawrence, D. H. *Fantasia of the Unconscious and Psychoanalysis of the Unconscious*. London: Penguin, 1977.

Lawrence, D. H. *Kangaroo*. 1923; rpt. New York: Viking, 1960.

Lawrence, D. H. *Lady Chatterley's Lover*. 1928; New York: Bantam, 1983.

Lawrence, D. H. *Sons and Lovers*. 1913; Oxford: Oxford University Press, 1995.

Lawrence, D. H. *Women in Love*. 1920; New York: Penguin, 1995.

Lee, Hermione. *Virginia Woolf*. New York: Vintage Books, 1999.

Lees-Milne, James. "(Emily) Margaret Jourdain," rev. Hilary Spurling, *Oxford Dictionary of National Biography*, ed. H. C. G. Matthew and Brian Harrison. Oxford: Oxford University Press, 2004.

Leibowitz, Herbert. "*Something Urgent I Have to Say to You*": *The Life and Works of William Carlos Williams*. New York: Farrar, Straus and Giroux, 2011.

Lessing, Doris. *Under My Skin: Volume One of My Autobiography, to 1949*. New York: Harper Perennial, 1995.

Levenson, Michael. *A Genealogy of Modernism: A Study of English Literary Doctrine 1908–1922*. Cambridge: Cambridge University Press, 1987.

Levine, George, ed. *One Culture: Essays in Science and Literature*. Madison: University of Wisconsin Press, 1988.

Levine, Jennifer Schiffer. "Originality and Repetition in *Finnegans Wake* and *Ulysses*." *PMLA* 94.1 (1979): 106–20.

Levitt, Alexandra M., D. Peter Drotman, and Stephen Ostroff. "Control of Infectious Diseases: A Twentieth-Century Public Health Achievement." In *Silent Victories: The History and Practice of Public Health in Twentieth-Century America*, ed. John W. Ward and Christian Warren. Oxford: Oxford University Press, 2006. 3–17.

Lewis, Sinclair. *Arrowsmith*. 1925; Garden City, NY: International Collectors Library, 1953.

Liber, B. *The Child and the Home: Essays on the Rational Bringing-Up of Children*. New York: Vanguard Press, 1927.

Light, Alison. *Mrs. Woolf and the Servants: The Hidden Heart of Domestic Service*. London: Penguin, 2007.

Lodge, David. *The Art of Fiction*. New York: Viking Penguin, 1992.

Logan, William. "Pound's Metro." *The New Criterion* 33.8 (April 2015): 20.

Long, Christopher. "The Origins and Contexts of Adolf Loos's 'Ornament and Crime.'" *Journal of the Society of Architectural Historians* 68.2 (June 2009): 200–23.

Loos, Adolf. *Trotzdem, 1900–1930*. Vienna: G. Prachner, 1931.

Loos, Adolf. *Ornament and Crime: Selected Essays*, trans. Michael Mitchell. Riverside, CA: Ariadne Press, 1998.

Lundin, Anne. *Constructing the Canon of Children's Literature*. New York: Routledge, 2004.

Lupton, Ellen. *Mechanical Brides: Women and Machines from Home to Office*. New York: Princeton Architectural Press, 1993.

McCabe, Susan. "'Delight in Dislocation': The Cinematic Modernism of Stein, Chaplin, and Man Ray." *Modernism/Modernity* 8.3 (2001): 429–52.

McClintock, Anne. *Imperial Leather: Race, Gender, and Sex in the Colonial Contest*. New York: Routledge, 1995.

McDonald, Lynn. "Florence Nightingale A Hundred Years On: Who She Was and What She Was Not." *Women's History Review* 19.5 (November 2010): 721–40.

McKellar, Elizabeth. "Representing the Georgian: Constructing Interiors in Early Twentieth-Century Publications, 1890–1930." *Journal of Design History* 20.4 (2007): 325–44.

McLeod, Mary. "Domestic Reform and European Modern Architecture: Charlotte Perriand, Grete Lihotzky, and Elizabeth Denby." In *Modern Women: Women Artists at the Museum of Modern Art*, ed. Cornelia Butler and Alexandra Schwartz. New York: The Museum of Modern Art, 2010. 174–91.

McLuhan, Marshall. "Pound, Eliot, and the Rhetoric of *The Waste Land*." *New Literary History* 10.3 (1979): 557–80.

Malcolm, Janet. *Two Lives: Gertrude and Alice*. New Haven, CT and London: Yale University Press, 2007.

Mann, Thomas. *The Magic Mountain*, trans. H. T. Lowe-Porter. 1924; New York: Vintage Books, 1969.

Mao, Douglas and Rebecca Walkowitz. *Bad Modernisms*. Durham, NC and London: Duke University Press, 2006.

Matos, Timothy Carlo. "Choleric Fictions: Epidemiology, Medical Authority, and an Enemy of the People." *Modern Drama* 51 (2008): 353–68.

Matthews, Glenna. *"Just a Housewife": The Rise and Fall of Domesticity in America*. New York and Oxford: Oxford University Press, 1987.

Matthiessen, F. O. *The Achievement of T. S. Eliot*. Oxford: Oxford University Press, 1935.

Meisel, Perry. *The Myth of the Modern*. New Haven, CT and London: Yale University Press, 1987.

Menand, Louis. *Discovering Modernism: T. S. Eliot and His Context*, 2nd edn. New York: Oxford University Press, 2007.

Micale, Mark, ed. *The Mind of Modernism: Medicine, Psychology, and the Cultural Arts in Europe and America, 1880–1940*. Stanford, CA: Stanford University Press, 2003.

Middleton, Peter. "Poetry, Physics, and the Scientific Attitude at Mid-Century." *Modernism/Modernity* 21.1 (2014): 147–68.

Miljački, Ana. *The Optimum Imperative: Czech Architecture for the Socialist Lifestyle, 1938–1968*. New York: Routledge, 2017.

Miller, J. Hillis. *Fiction and Repetition: Seven English Novels*. Cambridge, MA: Harvard University Press, 1982.

Minow-Pinkney, Makiko. *Virginia Woolf and the Problem of the Subject*. Brighton: Harvester, 1987.

Mitchison, Naomi. *The Home*. London: John Lane The Bodley Head, 1934.

Moretti, Franco. *The Way of the World: The* Bildungsroman *in European Culture*, new edn, trans. Albert Sbragia. London and New York: Verso, 2000.

Morris, John. "The Emergent Stereotype of Man as Machine." In *Exploring Stereotyped Images in Victorian and Twentieth-Century Literature and Society*. London: Edwin Mellen Press, 1993. 247–84.

Morrisson, Mark. *Modernism, Science, and Technology*. London and New York: Bloomsbury Academic, 2017.

Motte, Warren. *Small Worlds: Minimalism in Contemporary French Literature*. Lincoln and London: University of Nebraska Press, 1999.

Mumford, Lewis. *Technics and Civilization*. 1934; San Diego, CA: Harvest, 1963.

Naremore, James. *The World Without a Self: Virginia Woolf and the Novel*. New Haven, CT and London: Yale University Press, 1973.

The National Trust. *Virginia Woolf and Monk's House*. Salisbury: The National Trust, 1998.

North, Michael. *Reading 1922: A Return to the Scene of the Modern*. New York: Oxford University Press, 2001.

Omran, Abdel R. "The Epidemiologic Transition: A Theory of the Epidemiology of Population Change." *The Milbank Quarterly* 83:4 (December 2005): 731–57.

Orwell, George. *The Complete Works of George Orwell, Vol. V: The Road to Wigan Pier*, ed. Peter Davidson. London: Secker & Warburg, 1998.

Orwell, George. *George Orwell: The Collected Essays, Journalism and Letters, Vol. IV: In Front of Your Nose*, ed. Sonia Orwell and Ian Angus. Boston, MA: David Godine, 2000.

Orwell, George. *Nineteen Eighty-Four*. 1948; New York: Penguin, 1983.

Overy, Paul. *Light, Air and Openness: Modern Architecture Between the Wars*. New York: Thames and Hudson, 2008.

Painter, Kirsten Blythe. *Flint on a Bright Stone: A Revolution of Precision and Restraint in American, Russian, and German Modernism*. Stanford, CA: Stanford University Press, 2005.

Parton, James. "Caricature in the Hogarthian Period." *Harper's Magazine* 51 (June 1, 1875): 35–49.

Patmore, Derek. *I Decorate My Home*. London: Putnam, 1936.

Pattison, Mary. *Principles of Domestic Engineering, or The What Why and How of a Home*. New York: The Trow Press, 1915.

Peppis, Paul. *Sciences of Modernism: Ethnography, Sexology, and Psychology*. Cambridge: Cambridge University Press, 2014.

Posner, Richard. "Orwell Versus Huxley: Economics, Technology, Privacy, and Satire." *Philosophy and Literature* 24.1 (2000): 1–33.

Pound, Ezra. *Ezra Pound: Perspectives*, ed. Noel Stock. Chicago, IL: Henry Regnery, 1965.

Pound, Ezra. "A Few Don'ts by an Imagiste." *Poetry* 1.6 (March 1913): 200–6.

Pound, Ezra. *Literary Essays of Ezra Pound*. New York: New Directions, 1918.

Pound, Ezra. "Meditatio: I." *Egoist* 3.3 (March 1, 1916): 37–8.

Pound, Ezra. *Pound/Ford: The Story of a Literary Friendship*, ed. Brita Lindberg Seyersted. New York: New Directions, 1982.

Pound, Ezra. *Selected Letters of Ezra Pound 1907–1941*, ed. D. D. Paige. London: Faber and Faber, 1951.

Pound, Ezra. "Vorticism." *Fortnightly Review* NS 96 (September 1914): 461–71.

Preyer, W. *The Mind of the Child*. New York: D. Appleton, 1890.

Puchner, Martin. *Poetry of the Revolution: Marx, Manifestos, and the Avant-Garde*. Princeton, NJ: Princeton University Press, 2005.

Purdy, Strother B. "Gertrude Stein at Marienbad," *PMLA* 85.5 (1970): 1096–105.

Rainey, Lawrence. *Revisiting the Waste Land*. New Haven, CT and London: Yale University Press, 2005.

Rainey, Lawrence and Robert von Halberg. "Editorial/Introduction." *Modernism/Modernity* 1.1 (1994): 1–3.

Read, Herbert. *Art and Industry: The Principles of Industrial Design*. London: Faber and Faber, 1934.

Reed, Christopher. *Bloomsbury Rooms: Modernism, Subculture, Domesticity*. New York and London: Yale University Press, 2004.

Reed, Christopher, ed. *Not at Home: The Suppression of Domesticity in Modern Art and Architecture*. London: Thames and Hudson, 1996.

Richards, Brent. *New Glass Architecture*. New Haven, CT: Yale University Press, 2006.

Richards, J. M. "Towards a Rational Aesthetic." In The Rationalists: Theory and Design in the Modern Movement. Ed. Dennis Sharp. California: Architectural Press, 1978.

Robertson, Howard. *Modern Architectural Design*. London: The Architectural Press, 1932.

Rosenbaum, S. P., ed. *The Bloomsbury Group: A Collection of Memoirs and Commentary*, rev. edn. Toronto: University of Toronto Press, 1995.

Roston, Murray. *Modernist Patterns in Literature and the Visual Arts*. Basingstoke and London: Macmillan Press, 2000.

Rubenstein, Michael. *Public Works: Infrastructure, Irish Modernism, and the Postcolonial*. Notre Dame, IN: University of Notre Dame Press, 2010.

Rutsky, R. L. *High Techne: Art and Technology from the Machine Aesthetic to the Posthuman*. Minneapolis and London: University of Minnesota Press, 1999.

Said, Edward. *The World, The Text and The Critic*. Cambridge, MA: Harvard University Press, 1983.

Salzman, L. F., ed. *The Victoria History of the County of Sussex: Volume 7, The Rape of Lewes*. London: Oxford University Press for the University of London, Institute of Historical Research, 1940.

Schaffner, Anna Katharina. *Modernism and Perversion: Sexual Deviance in Sexology and Literature 1850–1930*. Basingstoke and New York: Palgrave Macmillan, 2012.

Scheerbart, Paul. "Glass Architecture." In *Form and Function: A Source Book for the History of Architecture and Design 1890–1939*, ed. Tim Benton and Charlotte Benton with Dennis Sharp. London: Crosby Lockwood Staples in association with The Open University Press, 1975.

Schnapp, Jeffrey T. "Crash (Speed as Engine of Individuation)." *Modernism/Modernity* 6.1 (1999): 1–49.

Schnapp, Jeffrey T. "Crystalline Bodies: Fragments of a Cultural History of Glass," *West 86th* 20.2 (2013): 173–94.

Schor, Naomi. *Reading in Detail: Aesthetics and the Feminine*. New York: Routledge, 2007.

Schulze, Robin G. *The Degenerate Muse: American Nature, Modernist Poetry and the Problem of Cultural Hygiene*. New York: Oxford University Press, 2013.

Seltzer, Mark. *Bodies and Machines*. New York and London: Routledge, 1992.

Shiach, Morag. *Modernism, Labour and Selfhood in British Literature and Culture, 1890–1930*. Cambridge: Cambridge University Press, 2004.

Shivelbusch, Wolfgang. *Disenchanted Night: The Industrialization of Light in the Nineteenth Century*, trans. Angela Davies. Berkeley, Los Angeles, and London: University of California Press, 1988.

Shove, Elizabeth. *Comfort, Cleanliness and Convenience: The Social Organization of Normality*. New York: Berg, 2003.

Sitwell, Osbert. *Penny Foolish: A Book of Tirades and Panegyrics*. London: Macmillan Publishing, 1935.

Sivulka, Juliann. *Stronger than Dirt: A Cultural History of Advertising Personal Hygiene in America, 1875–1940*. New York: Humanity Books, 2001.

Slaughter, Joseph. *Human Rights Inc.: The World Novel, Narrative Form, and International Law*. New York: Fordham University Press, 2007.

Smith, Grover. *T. S. Eliot's Poetry and Plays: A Study in Sources and Meaning*. Chicago, IL: University of Chicago Press, 1959.

Smith, Virginia. *Clean: A History of Personal Hygiene and Purity*. Oxford: Oxford University Press, 2007.

Smuts, Alice Boardman. *Science in the Service of Children, 1893–1935*. New Haven, CT and London: Yale University Press, 2006.

Snaith, Anna. *Virginia Woolf: Public and Private Negotiations*. London: Palgrave Macmillan, 2003.

Snow, C. P. *The Two Cultures* and *A Second Look*. Cambridge: Cambridge University Press, 1965.

Spurling, Hilary. "I. Compton-Burnett: Not One of Those Modern People." *Twentieth-Century Literature* 25.2 (1979): 153–64.

Squier, Susan. *Virginia Woolf and London: The Sexual Politics of the City*. Chapel Hill: University of North Carolina Press, 1985.

Stein, Gertrude. *Lectures in America*. New York: Random House, 1935.

Stein, Gertrude. *The Making of Americans*. 1925; New York: Harcourt Brace, 1966.

Stein, Leon. "American Optimism." *The Seven Arts* 2 (1917): 81.

Steinman, Lisa M. *Made in America: Science, Technology, and American Modernist Poets*. New Haven, CT and London: Yale University Press, 1987.

Stewart, Janet. *Fashioning Vienna: Adolf Loos's Cultural Criticism*. London: Routledge, 2000.

Strunk, Jr., William. *The Elements of Style*. New York: Harcourt, Brace and Company, 1918.

Teige, Karel. *The Minimum Dwelling*, trans. Eric Dluhosch. Cambridge, MA and London: The MIT Press (in association with the Graham Foundation for Advanced Studies in the Fine Arts), 2002.

Tichi, Celia. *Shifting Gears: Technology, Literature, Culture*. Chapel Hill and London: University of North Carolina Press, 1987.

Tomes, Nancy. *The Gospel of Germs: Men, Women and the Microbe in American Life*. Cambridge, MA: Harvard University Press, 1998.

Tristram, Phillipa. "Ivy Compton-Burnett, An Embalmer's Art." *Studies in the Literary Imagination* 11.2 (Fall 1978): 27–8.

Van de Velde, Henry. *Die Renaissance im modernen Kunstgewerbe*. Berlin: Bruno and Paul Cassirer, 1901.

Wald, Priscilla. *Contagious: Cultures, Carriers, and the Outbreak Narrative*. Durham, NC and London: Duke University Press, 2008.

Waller, John. *The Discovery of the Germ: Twenty Years that Transformed the Way We Think About Disease*. New York: Columbia University Press, 2002.

Watson, John B. *Psychological Care of Infant and Child*. New York: W. W. Norton, 1928.

Watt, Ian. *The Rise of the Novel: Studies in Defoe, Richardson, and Fielding*. Berkeley and Los Angeles: University of California Press, 2001.

Waugh, Evelyn. *Decline and Fall*. 1928; Boston, MA: Little, Brown and Company, 1956.

Waugh, Evelyn. "Matter-of-Fact Mothers of the New Age." *The Evening Standard*, April 8, 1929, p. 7.

Wells, H. G. *Joan and Peter: An Education*. 1918; New York: Macmillan, 1922.

Wells, H. G. *The Stolen Bacillus and Other Incidents*. London: Methuen & Co., 1895.

Wells, H. G. *Tono-Bungay*. 1909; Lincoln and London: University of Nebraska Press, 1966.

Wells, H. G. *The War of the Worlds*. 1898; New York: Tribeca Books, 2013.

Westman, Karin, ed. "Children's Literature and Modernism." Special issue, *Children's Literature Association Quarterly* 32.4 (2007).

Whitworth, Michael. "Physics." In *A Concise Companion to Modernism*, ed. David Bradshaw. Oxford: Blackwell, 2003. 200–20.

Wigley, Mark. *White Walls, Designer Dresses: The Fashioning of Modern Architecture*. Cambridge, MA: The MIT Press, 1996.

Wilde, Oscar. *The Picture of Dorian Gray*, ed. Robert Mighall. 1891; London: Penguin Books, 2000.

Williams, Marilyn Thornton. *Washing "The Great Unwashed": Public Baths in Urban America, 1840–1920*. Columbus: Ohio State University Press, 1991.

Williams, William Carlos. *The Collected Poems of William Carlos Williams, vol. 1, 1900–1939*, ed. A. Walton Litz and Christopher McGowan. New York: New Directions, 1986.

Williams, William Carlos. *The Doctor Stories*, compiled by Robert Coles. New York: New Directions, 1984.

Williams, William Carlos. *The Embodiment of Knowledge*. New York: New Directions, 1974.

Williams, William Carlos. "Letter to Robert Creeley." *Origin* 1.1 (1951): 34.

Wilson, Jean Moorcroft. *Virginia Woolf, Life, and London: A Biography of Place*. London: Cecil Woolf, 1987.

Wilson, Mary. *The Labors of Modernism: Domesticity, Servants, and Authorship in Modernist Fiction*. New York and London: Routledge, 2016.

Woods, R. I. "Approaches to the Fertility Transition in Victorian England." *Population Studies* 41.2 (1987): 283–311.

Woolf, Leonard. *Downhill All the Way: An Autobiography of the Years 1919–1939*. New York: Harcourt, Brace & World, 1967.

Woolf, Virginia. *Between the Acts*. San Diego, CA: Harvest/HBJ, 1941.

Woolf, Virginia. *Between the Acts*, ed. Susan Dick and Mary S. Millar. Oxford: Shakespeare Head, 2002.

Woolf, Virginia. *The Captain's Death Bed*. New York: Harcourt, Brace, 1950.

Woolf, Virginia. *Collected Essays*. Vol. 1. New York: Harcourt, Brace, 1925.

Woolf, Virginia. *The Complete Shorter Fiction of Virginia Woolf*, ed. Susan Dick. New York: Harcourt Trade, 1999.

Woolf, Virginia. *The Diaries of Virginia Woolf*, Vol. I, ed. Anne Olivier Bell. New York and London: Harcourt Brace Jovanovich, 1977.

Woolf, Virginia. *The Diaries of Virginia Woolf*, Vol. II, ed. Anne Olivier Bell. New York and London: Harcourt Brace Jovanovich, 1978.

Woolf, Virginia. *The Diaries of Virginia Woolf*, Vol. III, ed. Anne Olivier Bell. New York and London: Harcourt Brace Jovanovich, 1980.

Woolf, Virginia. *The Diaries of Virginia Woolf*, Vol. IV, ed. Anne Olivier Bell. New York and London: Harcourt Brace Jovanovich, 1982.

Woolf, Virginia. *The Diaries of Virginia Woolf*, Vol. V, ed. Anne Olivier Bell. New York and London: Harcourt Brace Jovanovich, 1984.

Woolf, Virginia. *The Essays of Virginia Woolf*, Vol. IV, ed. Andrew McNeillie. London: Hogarth Press, 1994.

Woolf, Virginia. *The Essays of Virginia Woolf*, Vol. V, ed. Stuart N. Clarke. London: Hogarth Press, 2009.

Woolf, Virginia. *The Hours: The British Museum Manuscript of Mrs. Dalloway*, ed. Helen M. Wussow. New York: Pace University Press, 1997.

Woolf, Virginia. *Moments of Being*, 2nd edn, ed. Jeanne Schulkind. San Diego, CA: Harvest/HBJ, 1985.

Woolf, Virginia. Mrs. Dalloway. 1925; San Diego, CA: Harcourt, 2005.

Woolf, Virginia. *Orlando*. 1928; San Diego, CA: Houghton Mifflin Harcourt, 1973.

Woolf, Virginia. *A Passionate Apprentice: The Early Journals of Virginia Woolf 1897–1909*, ed. Mitchell Alexander Leaska. London: Hogarth Press, 1990.

Woolf, Virginia. *A Room of One's Own*. 1928; San Diego, CA: Harcourt Brace Jovanovich, 1957.

Woolf, Virginia. *Three Guineas*, ed. Jane Marcus. 1938; San Diego, CA: Houghton Mifflin Harcourt, 2006.

Woolf, Virginia. *To the Lighthouse*. 1927; New York: Harcourt Brace Jovanovich, 1981.

Woolf, Virginia. *To the Lighthouse*, ed. Sandra Kemp. London and New York: Routledge, 1994.

Woolf, Virginia. *The Voyage Out*. New York: George H. Doran, 1923.

Yeats, W. B. *The Collected Poems of W.B. Yeats*, ed. Richard J. Finneran. New York: Collier Books, 1989.

Zweig, Stefan. "The Monotonization of the World." In *The Weimar Republic Sourcebook*, ed. Anton Kaes, Martin Jay, and Edward Dimendberg. Berkeley and Los Angeles: University of California Press, 1994. 397–400.

INDEX

Note: Figures and boxes are indicated by an italic "*f*" and "*b*", respectively, following the page number

For the benefit of digital users, indexed terms that span two pages (e.g., 52–53) may, on occasion, appear on only one of those pages.